THIS LEONARDO DA VINCI

by

Riccardo Magnani

Translated from the Italian by Free Mind Publications

Free Mind Publications

First published in Italian as *Ceci n'est pas Leonardo*, May 2020

Copyright © 2020 Riccardo Magnani.
All rights reserved.
All photographic credits have been respected.
In the event that the rights holders have been unavailable, the author is at disposal for any fees.
Italian language cover design by Stefano Trevisi, Giovanna Marronese and Marion H. Arras
Illustration by Giuseppe and Salvatore Vara—April 2020.
English language edition 1.
English language edition copyright © 2020 Free Mind Publications.

ISBN: 978-0-6450675-1-4

To my wife Marion and my children Luca, Baldino and Alice, first architects of my researching.
But also to my friend Stefano, of which I do not forget, till the last, the insatiable thirst for knowledge and the enviable ability to review one's own certainties.

And many were his whims, and while philosophizing about natural things, he came to understand the property of herbs, continuing and observing the movement of the sky, the course of the moon, and the evolutions of the sun. All these sparked in his soul a concept surely heretical that was not akin to any religion whatsoever, as he appreciated much more the adventure of being a philosopher than a Christian.

Giorgio Vasari

CONTENTS

INTRODUCTION

I decided to write a few things about the Last Supper
painted by Leonardo da Vinci in the Convento alle Grazie in
Milan, because what has been written so far about such a
beautiful work didn't seem to suffice, neither for the curiosity
of the knowledgeable, nor for the education of scholars.[1]

In 1810, with these opening words, Giuseppe Bossi[2] justified the need
to create a new work that would finally shed light on one of Leonardo da
Vinci's most iconic paintings: The Last Supper.

With the same spirit and driven by a visceral and inalienable love for
knowledge, on the celebration of the 500th anniversary of Leonardo's
death, I accepted the invitation to put in writing part of the results of my
studies so that we could restore decorum and originality to the image and
work of a character who has contributed more than any other to shape
the collective knowledge and the artistic and scientific imprint of the
generations that succeeded him.

For better or for worse, much has been said and written over the
centuries.

In addition to the Renaissance artists, all indebted to him, Leonardo
has always exerted a particular fascination on many modern artists who,
for various reasons, wanted to give their personal interpretation of
Leonardo's work.

It is only in recent years, though, that mass attention has developed
around this extraordinary artist-scientist.

That is, since the American writer Dan Brown made him extremely
popular all over the world thanks to his bestseller, *The Da Vinci Code*.

The result of the success of that book has been to generate in the mass
audience an insatiable curiosity, emphasized even more by an equally
stellar movie success that made the fortune of the Louvre Museum in
Paris, the Rosslyn Chapel in Scotland and many Roman places of
worship depicted in the story, turning the Tuscan artist Leonardo into a

[1] Del Cenacolo di Leonardo da Vinci: libri quattro, by Giuseppe Bossi—Stamperia Reale
in Milan, 1810
[2] Painter, writer and art collector, he was one of the protagonists of Milanese
neoclassicism together with Foscolo, Porta, Manzoni and Parini.
He collected many drawings and notes by Leonardo, which after his death ended up in
the Gallerie dell'Accademia in Venice and Turin.

modern icon of genius and mystery and inspiring a modern tourist incursion.

According to the modern rules of show biz, in fact, Leonardo has become a real pop star, a character to turn the limelight on and milk every last drop—not to know his art and extract its precious contents, but to make money or seek glory, as is the case of the creators of all those bizarre and sensationalist theories that have multiplied immeasurably in recent years.

In these last few years, a truly immense wealth of attention has coalesced around Leonardo, considering that most of what has been written and narrated in recent years does not correspond to the truth. This is true regarding the biographical aspects and content of his work, which has been inscribed by critics through the clichéd and unreliable lens of Catholic iconography.

Any readings external to this repetitive cliché are immediately accused of esotericism and promptly obstructed by academic and orthodox critics, resulting in a firm constraint in the knowledge and understanding of this unique character's legacy.

An act of ostracism has been perpetrated against Leonardo over the centuries in both the artistic and the scientific fields.

Leonardo's scientific work spans every field of human knowledge: from his countless studies on anatomy, to the course of water, the flight of birds, and even machinery of all kinds, whose invention is sometimes mistakenly attributed to him, as it is for many other everyday "solutions"—such as, for example, some kitchen accessories[3].

Many of the things Leonardo drew did not necessarily come from his proverbial ingenuity; they simply already existed.

Moved by an innate curiosity, in fact, the Tuscan artist limited himself to reproducing[4] in his notebooks everything he came across, taking notes or making a pencil sketch, a mathematical calculation, a description of the lunar motion, a list of books he studied.

[3] The fork and the napkin, for example.
The fork is already mentioned in the middle of the 15th century, in the Memoirs of Benedict Dei: "*I was in that year in Brabant* [Belgium] and in Cologne and I touched and ate with the silver fork." Ms. II.ii.333 f. 37—National Library, Florence
[4] See the Ferry of Canonica included in one of the drawings of the Royal Collection of Windsor, or the one I recently discovered in Cassano d'Adda, contained in Manuscript L kept at the Institut de France.

Many things can be said about Leonardo, except that he was a man with little education.

Some of his drawings and writings, as well as some of the paintings attributed to him, are not even made by him[5].

Others, instead, concern discoveries that had been analyzed centuries before, such as the attempt by Tommaso Masini from Peretola[6] to fly over Florence, taking off with a sort of hang-glider from Monte Ceceri[7].

In fact, six centuries before Leonardo's birth, the same experiment was conducted in 875 by Abbās ibn Firnās, a Berber scientist and inventor who lived in Cordoba during the Muslim occupation of Andalusia.

Firnās became famous for his multifaceted studies and his discoveries in the fields of physics, chemistry and astronomy. Leonardo may have even had some of Firnās' texts in his personal library, which he often references in his codex and notebooks. Leonardo's knowledge of Avicenna[8] and Averroé, two of the greatest philosophers and scientists of the Islamic world that inspired his education, is also documented by direct quotations.

Other works were made by Leonardo with a completely different purpose to that attributed to him. These unfounded interpretations provided by scholars and historians often accord to a fanciful and superficial logic[9] that is the product of a limited knowledge of the subject.

Leonardo was so enraptured by his observation of the surrounding world that he could appear absent to others, detached from the social context; almost apathetic. This is the testimony of Matteo Bandello, a Catholic bishop who lived between the 15th and 16th century, and considered the greatest storyteller of the Renaissance.

Matteo Bandello was the grandson of one Vincenzo Bandello, prior of the Dominican Convent of Santa Maria delle Grazie, in whose refectory the Last Supper was painted. Leonardo quarreled with Vincenzo Bandello for his continuous calls to complete the work swiftly. The

[5] This is the case of the bicycle drawn on the back of Sheet 133 of the Codex Atlanticus, at the Ambrosiana library or the letter addressed to the Duke of Milan to be received at court.

[6] Tommaso Masini from Peretola, nicknamed Zoroaster, not by chance.

[7] In 1506.

[8] Manuscript F, Institut de France,—Sheet II cop r.
Anatomical Drawings Royal Collection Windsor. Sheets 0o35 r and 113 r.

[9] See the musical ca(n)non drawn on Sheet 136 r of the Arundel Code, actually a music box to play a four-voice canon.

insistence of the monk was such that Leonardo had to request Duke Ludovico to intervene personally in order to make him stop, making the impatient and intolerant prior even more irate.

At the age of 12, Bandello was accustomed to going to the convent to visit his uncle Vincenzo, where he was lucky enough to see Leonardo at work.

As a result of these adolescent visits, Bandello included in one of his famous novels a direct testimony of the way the artist composed his work. Although from the memory of an immature twelve-year-old boy and presumably influenced by his uncle's anger at Leonardo's attitude, this testimony has remained famous over time because it traces the profile of a lazy and indolent artist:

> [Leonardo] used to [...] go in the morning at an early hour to mount on the scaffolding, because the *Last Supper* is quite far above the ground; he would continue to paint, as I say, from the rising of the sun until dusk in the evening, never taking the brush out of his hand, and forgetting to eat and drink. There would have been two, three, four days then, that he would not put his hand to it, and yet he remained there at times for an hour or two of the day, solely in contemplation, lost in thought, judging his figures. I have also seen him, on a whim or a tantrum, leave at midday, when the sun is in Leo, from the old court where that wonderful clay horse was composing, and come straight to the Graces and ascend onto the scaffolding to take the brush and give one or two strokes to one of those figures, and then leave and go elsewhere.[10]

Although it is unknown whether this memory of Bandello's was realistic, or conditioned by the judgment of his uncle the prior, it was precisely this memory, rather than what has been written by other biographers, that has contributed over time to the false reputation of Leonardo as a lazy, fickle and listless man.

In reality Leonardo was anything but lazy and listless.

His mind was in continuous evolution, stimulated by an innate curiosity for everything that surrounded him, and this could make him appear apathetic, detached and at times even listless to those who knew him superficially, or had to endure his apparent intellectual distraction. Leonardo was literally obsessed with discovery and continually moved by an insatiable thirst for knowledge, more so

[10] Matteo Bandello, Novel 57

from continuous observation and experimentation[11] than the study of books.

As proof of this, it is not uncommon in his countless writings to come across a statement that is repeated almost like an obsessive mantra, addressed to whom, I don't know:

…tell me if it was ever done…[12]

Leonardo was very different from the myth that is told.
Deeply different.

Today, more than ever, we find ourselves immersed in an alarming condition in which the interpretation of facts replaces reality[13]; or it is replaced by an infinite number of partial truths that, in a cultural, economic and political context now globalized, take on the universal value of incontestable truth.

The contributing factors of this socio-cultural relativism are multiple and this work of mine is certainly not the most opportune place to discuss it.

One fact, however, must be emphasized.

In this condition, reality loses the objective requirement of an absolute reference point in favor of an infinite number of subjective interpretations[14] which tear the social fabric into a thousand rabidly opposed factions.

It is the same consequence that leads to two principles, the *postulate*[15] and the *dogma*[16]. Their function is to establish binding elements around which to build a false and artificial reality. This false, virtual, and conventional reality, thanks to an inertial process extended across time, becomes indisputable for those who determine it and for the social context that acquires it.

The generation of more virtual realities that are shared by different communities creates divisions and conflicts. This was the case for religions in the past; and today, politics itself builds its own consensus based on separation and opposition, certainly not on ideals. Advertising is the same.

[11] Forster Codex III Sheet 141 r
[12] Codex Atlanticus, Sheets 521 r, 579 r, 693 r., 719 r, 785 r, 972 r, 1026 v, Codex Arundel Sheet 251 r
[13] First theorized by Nietzsche
[14] Hence partials
[15] Not demonstrated principle whose validity is admitted a priori by evidence or convention in order to provide an explanation of certain facts or to construct a theory.
[16] Principle accepted for true or right, without critical examination or discussion.

Once the excellence of a product or service was advertised; today, through legalized comparative advertising, the aim is to discriminate against one's competitor.

The narration about Leonardo is no exception. His biography has been tainted over the centuries by an endless series of presumptive and deliberately distorting elements that, over time, have become binding only because they were appreciated or imposed by those who had an interest in presenting a partial image.

This limited *modus pensandi* determines by nature a *modus operandi* that is most inadequate in approaching the study and knowledge of Leonardo da Vinci. Paradoxically, da Vinci made an absolute existential and procedural constraint based on the precise observation of reality and its understanding. This could cause him to interrupt the execution of a work at the exact moment he realized that he could not reproduce the perfection his subject embodied.

It is Vasari[17] himself who says so. In weaving the praises of the Tuscan artist, he bluntly admonishes those who, out of envy and prejudice, would criticize da Vinci's actions and mistake them for eternal incompleteness or laziness:

> There were those who had had the opinion (as various are human judgements, many times out of malicious envy) that Lionardo (as with many of his works) started it without the desire to finish it because being so big, and wanting to cast it all in once, he found it extremely difficult… And it may be believed that from this outcome many could have come to this conclusion, since many of his works remained imperfect. But the truth one can believe is that his great and excellent soul, impeded by his excessive generosity and by the constant desire to seek excellence above excellence and perfection above perfection, was the cause of it, so that the work was delayed by desire, as our Petrarch said.[18]

Unfortunately Vasari's warning has been unheeded. We can see how in recent years art historians and critics have contributed to the papier-mâché myth of Leonardo today.

[17] Perhaps the greatest Renaissance biographer.

[18] Giorgio Vasari—The Lives of the Most Excellent Painters, Sculptors and Architects, Giunti Edizioni, 1568

But Leonardo himself was unheard, when, in one of the notes put in his codices in his usual scattered order, he wrote:

> The acquisition of any knowledge is always useful to the intellect, because it can drive away useless things and retain the good ones. Because nothing can be loved or hated without prior knowledge of it.[19]

Knowledge is the path that leads to a certain reality. This path should be experienced by each of us as an opportunity for personal growth and to form over time a monolithic collective knowledge, which finds in the objective character of reality itself an element of aggregation and sharing. Instead, this path is today lived in an individualistic and self-referential way—when it is not shared by close circles of people as a matter of elitist and opportunistic convenience.

This is how knowledge is perceived in every sphere of our daily life, be it working, interpersonal, social, academic, etc. Every action or thought of ours today is subordinate to an opportunistic fact. It is no coincidence that ideals no longer exist, having been replaced by more venal factors of convenience.

But if we want to grasp the essence of a given reality in its entirety and objectivity, the path to this knowledge cannot admit shortcuts or half-formed ideas. Moreover, it cannot be conditioned by restrictive constraints and limitations, such as postulates and dogmas, which by definition aim to alter the result of an analytical process and to induce strongly manufactured views.

Over the centuries and millennia, instead, we have witnessed an actual crumbling of that monochromatic cultural identity in which ancient civilizations—some more, some less—distinguish themselves. Monotheistic religious mythologies have played a fundamental role in this process of cognitive distortion. They have led humanity to make interpretations of elements that should only reveal knowledge, precisely because of their objective character (such as natural, physical, and astronomical events).

Each of these interpretations, whose purpose is to move us away from objective reality and get us closer to a subjective truth, was born of the spasmodic desire to chase a supremacy through which the faith of people and benefits can be obtained.

The primary cause of the biases that are today the antithesis of knowledge is the imposition of questions, such as those assumed by

[19] Sheet 0616 r of the Codex Atlanticus, preserved in the Ambrosiana Library in Milan

monotheistic doctrines, as criteria of absolute truthfulness. These are questions such as "who said it?" or "where is it written?" rather than the sound "prove it" of the Greek philosophical world. The end result of this concept is "fake news"—clearly unfounded information used in various ways to condition the orientation of the masses.

The entire history of humanity, indeed, is based on fake news. Just think of religious mythologies or the alleged discovery of America by Christopher Columbus. To this, add the aggravating circumstance that modern society, which is today oriented toward a global capitalism, has developed almost absolute levels of unquestioning. In a capitalist context pushed to the extreme, such as that which governs modern society, low levels of individual knowledge have facilitated the orientation of the masses in any field you care to name: consumer goods, false ideologies, electoral choices, etc.

It is for these reasons that Leonardo is today stripped of the cultural identity which infused his work, and which guided the daily cognitive process through which he gained knowledge of the reality of the surrounding world. What results is the image of a character lacking any aspects that could be offensive to monotheistic religious institutions or to the current mode of unquestioning thought that underlies the Western capitalist model.

Today Leonardo is an iconic character, completely removed from the cultural context in which he was educated and which shaped his art and science. The "genius par excellence" is Leonardo today, a pop icon testimonial of a commercial brand that bears his name with the sole purpose of producing loads of money.

The reality is that Leonardo played a fundamental role in the evolutionary history of modern humanity. This was thanks to an investiture that made him the witness and translator of the ancient knowledge that arrived in Florence in 1439 in the shape of the Council of Florence for the reunification of the Eastern and Western Churches, set up to face the Turkish advance aimed to conquer Constantinople.

The Council, convened in 1431 in Basel by Martin V[20], took place in 1438 in Ferrara, but soon had to be moved to Florence because of a pestilential epidemic.

[20] The purposes for which the Council was convened were primarily to deal with the union with the Eastern Orthodox Church and to reform the Church.

The main referee of that epochal movement of cultural renewal was Giorgio Gemistus Pletho[21] (Plethon), to whom, after his death in 1452, Leonardo succeeded.

The investiture came from Plethon himself, who gave Leonardo the duty of taking over the cultural heritage. This heritage would later be celebrated by the greatest artists of the Renaissance[22] in their own works.

This investiture made the Tuscan artist a primary reference for all his contemporaries who were inspired by him, both artistically and culturally. This was not only in the making of art, but more so in the underlying iconographic choices, rooted in the paganism of the Greek, Egyptian and Byzantine civilizations in which Leonardo's work is saturated. So is that of the most important artists of the Renaissance.

In approaching Leonardo's work, neglecting this handover and the role accorded to him by his contemporaries is an unforgivable mistake. It is essential in order to understand a multifaceted mind like Leonardo's beyond the lens of Catholic iconography[23]; an expedient necessary for every Renaissance artist to overcome the tight measures of censorship and the Inquisition.

More than any other artist of his time, Leonardo transmits through his work the pagan knowledge acquired via the study of the ancients. He does it through details inserted in his works that are superficially insignificant, as their reading and understanding over the years has been consciously inhibited through a strategic distortion of cultural values to which all these artists referred.

This distortion was carried out first by Vatican ministers, and then supported over the years by complacent art critics and reviewers, with the declared intention of preventing the spread of this ancient knowledge, as it was deemed dangerous for the survival of the dogmatic Catholic doctrine.

The consequence of this systematic blockade is the widespread inability to identify in the works of that period the real underlying narrative. Precisely because of the insufficiency of the cognitive process derived from the imposition of dogmatic truths, the German poet Johan

[21] Byzantine Neoplatonic philosopher, he was the first author of the revival of the humanistic sciences of the Renaissance in an attempt to exercise an ideal of unification of different religions in the wake of the astronomical solar cult.

[22] Benozzo Gozzoli, Bellini, Mantegna, Domenico Veneziano.

[23] The iconographic choice adopted by Leonardo is always innovative, dictating the way of painting of his contemporary artists.

Wolfgang Goethe classified the ability to recognize what is before our eyes as one of the most difficult things in the world[24].

The difficulty to which Goethe, a great friend of Alessandro Manzoni[25], alludes is clearly due to multiple causes, certainly not only the distorting activity of cultural and documentary sources.

Some of these causes, such as the sensory abilities and knowledge in our own minds, are naturally subjective. To these, however, must be added those causes determined by a historical process of distortion generated according to criteria of cultural convenience, such as those described above.

We can even identify a precise moment in the evolution of our history when, more than in any other era, it was established what was convenient to see in a work, what could be told, or which books could be read.

This moment coincides exactly with the period in which Leonardo expressed his art[26].

Although more than five centuries have passed since then, and despite the achievement of an apparent full intellectual and cultural freedom, we still see so much partiality in the stories about Leonardo. We have almost completely lost the real sense of his person and work, even though he was and still is considered one of the most important and intelligent characters of human history.

This paradox is well summarized by the fact that although there are a substantial number of works in which he is portrayed, today almost all exhibitions, editorial initiatives or articles about Leonardo are accompanied by an image of him taken from posthumous portraits that are a mere caricature of his unmistakable physiognomy, whose beauty and physical prowess is underlined by all his historical biographers[27].

[24] "What is the most difficult thing of all? The one that seems the easiest: to see with your eyes what lies before them" J.W. von Goethe.

[25] A. Manzoni, The Betrothed.

[26] Just think of the Index Librorum Prohibitorum, the list created in 1559 by Pope Paul IV, of publications prohibited by the Catholic Church, abolished only in 1966, which made illustrious victims in the literary, scientific, philosophical and historiographic world.

[27] "This is what men saw in Lionardo da Vinci, in whom, beside the beauty of the body, which is never praised enough, was the infinite grace in any of his actions, and so great was his gift that whatever difficult things his soul turned to, he made them with ease. Great was the strength in him, combined with dexterity, spirit, and valor, he was always regal and magnanimous." G. Vasari, The Lives—1550.

To inscribe Leonardo's work through the lens of Catholicism is an absolute distortion, a historical and artistic crime.

As Vasari[28] will also write, in fact, Leonardo was profoundly Neoplatonic.

Neoplatonism is that particular interpretation of Plato's thought that sums up several other elements of Greek philosophy, becoming the main ancient philosophical school and the cultural and philosophical foundation of the Renaissance movement.

Leonardo was so Neoplatonic that he was portrayed by Raphael as Plato himself in the famous fresco in the Vatican Rooms *The School of Athens*[29] and as St. Augustine by Benozzo Gozzoli in San Gimignano[30]. He was also very attentive to the study and knowledge of the motion of the stars, so heretical in soul that he considered himself equidistant from any religion, preferring "*being a philosopher than Christian*"[31].

Caution, though.

Often one falls into error by attributing to words a meaning different to their original intent. When Vasari writes "And many were his whims, and while philosophizing about natural things, he came to understand the property of herbs, continuing and observing the motion of the sky, the course of the moon and the evolutions of the sun," it does not mean that he was *whimsical*, as I read in many reviews and biographies, but it means that he had many *interests*.

In the same way, when we talk about Leonardo the "philosopher" it is intended in the way Galileo Galilei describes philosophy:

> Philosophy is written in this great book that is constantly open before our eyes (I say the universe), but it cannot be understood unless we first learn to understand the language, and know the characters in which it is written. It is written in mathematical language, and the characters are triangles, circles, and other geometrical figures, without which it is impossible

[28] "And many were his whims, and while philosophizing about natural things, he came to understand the property of herbs, continuing and observing the movement of the sky, the course of the moon, and the evolutions of the sun. All these sparked in his soul a concept surely heretical that was not akin to any religion whatsoever, as he appreciated much more the adventure of being a philosopher than a Christian."

[29] Raphael Sanzio—Room of the Signature, Vatican State.

[30] Cycle on the life of St. Augustine, Benozzo Gozzoli, Church of St. Augustine in San Gimignano, 1465.

[31] "*Motion is the cause of any life.*" Leonardo da Vinci, Manuscript H, Sheet 141 r, Institut de France.

> to understand it humanly; without them it is a vain
> wandering through a dark labyrinth.[32]

In the time of Galileo there was no distinction between being a philosopher and being a scientist, because through philosophy the scientific dynamics were told.

To know the surrounding reality, it was necessary to know the laws of the four liberal mathematical arts that composed the "corpus" of superior education, the *quadrivium*[33]: *arithmetic, geometry, music and astronomy.*

To this we must add the study and knowledge of human anatomy, which draws the first rules of its proportions and functioning from the combination of these four subjects, as expressed by Leonardo with the Vitruvian Man. Here is explained Leonardo's eclecticism and why he was well prepared in all these subjects, including the study of human anatomy, which he then translated into his paintings and countless notes, according to the canons expressed by the golden laws determined by the motion of the celestial stars.

The liberal mathematical arts were contrasted by the rhetorical ones, the *trivium*, which in turn was composed by *grammar, rhetoric* and *dialectics.*

To take the concept to extremes, we can qualify the subjects contained in the quadrivium as those that express the scientific world (i.e. the natural rules alluded to by Galilei in the quote, whose narration proceeds according to objective criteria), and the subjects in the trivium as those with which to narrate it (i.e. translating objectivity into subjectivity) or interpret it as necessary (if inconvenient).

It is precisely this contrast between the two branches of the arts that Raphael's representation in *The School of Athens* refers to; portraying Leonardo in the role of Plato, the Urbino artist Raphael wished to emphasize the source of inspiration for Leonardo's cultural and scientific education. Neoplatonism indeed.

In reality, Raphael portrays Leonardo in the frescoes of the Vatican Rooms at least five more times, but it seems to have been hitherto unnoticed[34].

[32] Il Saggiatore, 1623

[33] Literally "*four ways,*" it indicated in the Middle Ages, together with *trivio*, the training necessary for theological and philosophical teaching.

[34] A second time in *The School of Athens*, next to Raphael's self-portrait and Zoroaster, and four more times in *The Disputation of the Holy Sacrament.*

Although in the basic iconology Leonardo's art refers to Catholic culture, it is always innovative in its iconography, dictating a style that would be emulated by his students and fellow artists. In order to fully understand Leonardo's soul, therefore, it is useful to retrace with a very brief aside the thought of Gemistus Pletho, his mentor.

Plethon saw in Plato's philosophy the legacy of Zoroastrianism, which is the reason Raphael portrays himself close to Leonardo and Zoroaster[35] in *The School of Athens*.

Zoroastrianism is the Asian cult centered on the solar movement throughout the year, especially at the points of solstice and equinox.

Of it, Giorgio da Trebisonda[36] wrote:

> I myself listened to him in Florence, as he came to the Council together with the Greeks, saying that the whole world, after a few years, would adhere to one only and identical religion, with only one soul, mind, teaching. And when I asked him: "That of Christ or of Mohammed," he replied: "Neither, but one not different from that of the Gentiles"[37].
>
> I was so scandalized by these words that I always hated him and feared him like a poisonous viper, and I could no longer bear to see or hear him. I also learned from some Greeks, who had fled from the Peloponnese to here, that he had publicly stated, about three years before his death, that— not many years after his death—Muhammad and Christ would be forgotten and the actual truth would triumph in every part of the world.[38]

Gemistus Pletho's idea was to reunify the Western church with the Eastern one. This was the primary purpose for which the Council of Florence was convened, leading back to the original theology of pagan solar worship, from which many religious mythologies have taken their inspiration.

This obviously did not please the Vatican ministers, who did everything possible to oppose the cultural movement that followed the Council, universally known as the *Renaissance*, a term suggested for the first time by Vasari himself.

[35] Maybe Tommaso Masini da Peretola.

[36] A Byzantine philosopher and humanist, known as Trapeziunzio, he actively contributed to the development of the Greek language and the translation of Greek classics into Italy.

[37] Pagans (a/n).

[38] Comparationes philosophus Aristoteles et Platonis, III, XIX (Venice, 1523).

Leonardo was not at all self-taught, as we are told; some of his first masters were among those who accompanied Gemistus Pletho to Florence, such as Giovanni Argiropulo[39], also master of the young Lorenzo and Giuliano de' Medici[40].

Leonardo, thanks to the undoubted intellectual and artistic abilities with which he was naturally gifted[41], soon became an exemplar, a guiding light—the polar star for every artist who would not only be inspired by him, but implicitly recognize Leonardo's cultural leadership by including Leonardo's portrait in their own paintings and sculptures.

The identification of these works is very important in the process of understanding Leonardo's character. They portray him from an early age—as a demonstration of an investiture received by birth, you might say—and because he is the son of parents not exactly anonymous and insignificant. This is contrary to the very scarce and contrasting information that until recently has been the prevailing wisdom, identifying the notary Ser Piero da Vinci as his illegitimate father.

Thanks to these portraits and contemporary documentation—until now ignored by scholars—we are finally able to shed light on the infinite areas of shadow inherent in his first 30 years of Leonardo's life. Even then, Leonardo enjoyed an excellent reputation as a painter, sculptor, musician, philosopher and scientist without equal.

It is almost inconceivable that there are no earlier writings of his than those available today. Except for sporadic cases, these cover a period from about 1478 onwards; yet his undoubted talents were known from his early years, as Vasari testifies:

> This is what men saw in Lionardo da Vinci, in whom,
> beside the beauty of the body, which is never praised
> enough, was the infinite grace in any of his actions, and so
> great was his gift that whatever difficult things his soul
> turned to, he made them with ease. Great was the strength
> in him, combined with dexterity, spirit, and valor, he was
> always regal and magnanimous.

[39] Giovanni Argiropulo (1416—1487), was a humanist, writer, translator, academic and Byzantine rector, one of the first promoters of the rediscovery of ancient authors in Western Europe.

[40] Benozzo Gozzoli will dedicate more than one painting cycle to the educational path of the young Leonardo: San Gimignano, Montefalco, Florence.

[41] A true divine gift, as Vasari wrote when he began writing his biography.

> And the fame of his name spread so much that not only in
> his time was he held in high esteem but even more in posterity
> after his death.[42]

The Neoplatonic[43] pagan approach developed by Leonardo has been distorted over time by historians and scholars who debated it, blinded by the desire—in some more, in some less concealed—to attribute his every gesture to the Catholic foundation that permeates European culture.

In reality the major part of Renaissance history and works of the time suffered the same distortion. So much so that when you enter a museum today or open an art history book, you are faced with a story based on narrative and descriptive interpretations that are far from the spirit in which the works were executed.

One cannot read Renaissance art without taking an esoteric approach to it.

It would be a totally useless exercise.

Yet this is what is regularly happening.

The narration of the art of that period, as well as the historical events and characters who distinguished it, is subordinate to priorities other than the cognitive. It is bound to only one imperative: convenience.

Initially it was a matter of cultural convenience, imposed in a coercive form by the Catholic Church to protect its theological ideology from the reconsidered Neoplatonic foundation. To this was soon added an element of political and economic convenience; a result of the first trips to America and the undue splitting of the territories belonging to the native populations, long before the tale of Christopher Columbus.

Today is a period in which the reference values are only partially subverted compared to then. The economy has taken over on everything—conditioning every cultural aspect of modern society (Leonardo included, therefore)—becoming the trigger for the most disparate[44] interpretations based upon commercial speculative

[42] *The Lives of the Most Excellent Painters, Sculptors, and Architects* is a series of biographies of artists, written in the 16th century by the painter and architect Giorgio Vasari from Arezzo. It is often called simply *The Lives*. Vasari's treatise was published for the first time in 1550 by Torrentini and had an extraordinary success that led the author to edit a second widely enlarged and revised edition, published in 1568 by the Giunti family.

[43] Interpretation of Plato's thought that will influence Western philosophy. In Florence, in 1459, a real Neoplatonic Academy was founded by Marsilio Ficino, on behalf of Cosimo de' Medici the Elder, who plausibly forged the philosophical orientation of the young Leonardo.

[44] Some of which at the limit of decency that would even make one doubt the intelligence of their proponents.

convenience, or even worse, the vanity and self-referential spirit of some *parvenu*[45]. It doesn't seem to matter that these interpretations don't correspond to the real historical past of a character or the contents of his work. Many are the result of presumptions without foundation and denied by the documents themselves, as well as by simple analytical and deductive logic.

What matters is that these interpretations are aligned with a particular type of cultural *imprinting* and respond to the binding imperative of attracting an audience that justifies a return, both in terms of image and, above all, economics.

There is an additional variable that is totally neglected in analyzing that extraordinary historical period, but which perhaps more than any other has contributed to determining the socio-political order of the Western world. I am referring to those first trips to America that strongly influenced the entire historical evolution of that fundamental transition period between two eras: the Middle Ages and the Renaissance.

More than any other event, transoceanic travel fundamentally and directly influenced the artistic, economic, political and social development of Renaissance society. It laid the foundations of the geopolitical, economic and financial structure of modern society, and therefore cannot be left out of any analysis of the period.

The result of these first journeys to America caused the emergence of a climate of extreme conflict, mirroring what occurred at a cultural level as a consequence of the rediscovery of the classics of pagan culture. This conflict created a deep split in the political orientation of half of Europe, leading to the birth of two very clear-cut factions. It would be overly simplistic to confine this split in the historical Tuscan-Florentine opposition between Guelphs and Ghibellines, of which Dante also gave an account.

It is in this climate of deep political hostility, exacerbated by a cultural dualism between the sacred and profane, that the great revival of the humanistic and scientific subjects marked one of the most artistically relevant periods.

Art would play a fundamental role in the narration of the events, so much so that one could compare the most famous artists of the time to correspondents in the tradition of modern journalism, so

[45] A person who has rapidly elevated himself to a higher economic, cultural and social condition, without however having acquired the manners, style, culture that would be appropriated for the new state.

precise was their experience of life passed on to us with their work. This often meant exposing themselves to risks that could jeopardize their artistic career, or if discovered, cost their life.

Certainly they did not do it on their own initiative, but always on behalf of clients and patrons who were the protagonists of their artistic work.

If art has undergone a beneficial impulse deriving from the indirect need to transmit a historical narrative that went well beyond the narrow filter of papal censorship, we cannot say the same about the conditioning suffered by biographers and historians in general, and those of Leonardo in particular. In various ways they have transmitted his biographical traits, described his work, his education and his wanderings through the European courts[46].

It is only thanks to the artists of the Renaissance that we can today reconstruct the variables that determined the geopolitical, cultural and financial structures of modern society, minus the partisan reconstructions that have accompanied the reporting of the various historic periods. To use a well-worn phrase, history is written by the winners, modifying its real course according to the dictates of propaganda.

The analysis of some details traced back to the events of the first transoceanic journeys, therefore, becomes important for two reasons: because on the one hand, it strongly influenced Leonardo's life and work; and on the other, allows a more faithful reading for many of the most famous works of the Renaissance.

Unexpectedly, but only until you have acquired it by looking at it with your own eyes, artists of caliber such as Pisanello, Piero della Francesca, Sandro Botticelli, Benozzo Gozzoli, Basinio da Parma, Masaccio, Agostino di Duccio and Leonardo himself have transmitted to us a vast and precious pictorial, sculptural and manuscript documentation, inclusive of elements that until today were considered anachronistic due to the assumption that America was discovered by Christopher Columbus in October 1492.

But things did not go that way at all.

The artistic elements mentioned above are so solid that today we can, briefly but with an indisputable punctuality, reconstruct the historical, political, and artistic development of those years. Without going through this kind of analysis it would not be possible to understand the art of the

[46] Mainly between Milan, Florence and France, with short breaks in Pavia, Vigevano, Cesena, Rimini and Pesaro.

early Renaissance[47], which is the most critical for its contents and painting technique.

In the same way, without this type of investigation it is not possible to understand the profile and experience of the individual characters, whose personal events were inevitably conditioned by the political climate that the renewed cultural orientation and the resolution of new borders and political alliances brought about.

It is Leonardo himself who suggested, after all, that:

> The acquisition of any knowledge is always useful to the intellect, because it can drive away useless things and retain the good ones. Because nothing can be loved or hated without prior knowledge of it.

If this method is applicable to the whole Renaissance, even more so for Leonardo, around whom all the artistic and scientific development of the Renaissance revolves.

Without taking into consideration all the information contained in the various biographical and artistic contributions of that period, we could continue, as we have done so far, to celebrate a minor character, a papier-mâché myth shaped around the needs of a church. With the intent to protect its dogmas, the church raised insurmountable barriers around the understanding and knowledge not only of the Renaissance period, essential for understanding what we are today—with all our weaknesses, tensions, fragility and conflict— but of the whole Renaissance art. In its own right, this art is at the center of the cultural and touristic life of Europe, even if, alas, only for commercial and not didactic or cultural purposes.

It is said that the good historian cannot change the course of history, and this is a fact. But it is equally true that only by knowing our past can we know our present.

With this motivation, therefore, after various requests, I accepted the many invitations to write this work, through which I share the fruit of my studies. On the basis of these, I hope, the foundations for a renewed way of understanding the art of Leonardo and the Renaissance in general can now be laid.

I wish that what is presented in the following pages can contribute to ensuring that knowledge, pure and unconditional, is once again the path to which humanity returns, allowing us to become re-integrated with the deep dynamics that govern the

[47] The one related to the 15th Century

universe, unlike the current state of affairs where—in contravention of the most elementary ethical rules—humanity has now turned itself into a threat to itself and the entire ecosystem.

CH. I—LEONARDO, THE MAN

WHO LIVED TWICE.

1452.
My nephew was born, son of my son Sir Piero, on the day
15 of April at 3 o'clock at night on Saturday. He was named
Lionardo. Baptized by priest Piero di Bartolomeo da Vinci.[48]

With these simple words noted on the last sheet of a notarial
protocol[49], the alleged grandfather of Leonardo da Vinci announced the
birth of what would soon become the universally celebrated greatest
genius of modern history.

On the same sheet, Antonio noted four other births in the past:

- on 19 April 1426, that of his son Sir Piero, Leonardo's

father, who later became notary in Florence;

- on 8 May 1428, that of his second son Giuliano;

- on 31 May 1432, that of the third son, Violante;

- on 14 August 1436, that of the last-born son, Francesco.

Although Leonardo is considered to be the illegitimate son of Sir
Piero, it is curious to see that Sir Antonio, in his notes, mentions the
name of the priest who celebrated the baptism followed by the name of
the five godmothers and five godfathers, all from Vinci, who attended
that event.

In fact, the condition of illegitimacy, which is linked to an alleged
extramarital relationship of Sir Piero's, should be incompatible with the

[48] Note on the birth of Leonardo da Vinci, by Antonio of Sir Piero of Sir Guido, father of
Sir Piero notary in Vinci—Florence, State Archives, Notary Antecosimiano 16912, f.
105v.
[49] It is the register in which notaries once transcribed the text of documents, in
abbreviated or extended form, stipulated by them.

sacredness of the Catholic baptism. It is equally strange that no reference is made in the note as to the details of the mother of little Lionardo, while care is taken to indicate the ten witnesses.

Sir Piero, at that time almost twenty-six years old, had a well-established notary office in Florence. Documentation shows that, since at least 1451, the office was located in the Popolo of Santo Stefano della Badia, in the Santa Croce district.

From the end of the 1460s, Sir Piero's notary office was located in Via del Palagio del Podestà[50], a section of the current Via Ghibellina. This places it near, if not in the same building, where today the famous Enoteca Pinchiorri and the Relais Santa Croce are located.

Only one year after Leonardo's birth (according to his grandfather Antonio's note), Sir Piero will marry Albiera di Giovanni Amadori, the first of four wives. Eleven years later, she would give him his only daughter, Antonia, who died only one month after her birth. Sir Piero would have to wait for his third marriage, with Margherita di Francesco Giulli, and 1476—that is, twenty-four years later—to have a second child, who was followed then by another eighteen.

Let's say that Sir Piero started late to procreate, but he managed to catch up.

If we also consider Leonardo, in fact, Sir Piero would have had twenty children in total.

In a declaration for the Florentine cadaster, written and completed on behalf of his father by the notary Sir Piero himself on the 28 of February 1458, it is reported that Sir Antonio was eighty-five years old at the time and was married to Lucia, aged sixty-four. He lived in the Popolo of Santa Croce, in Vinci, and had as sons Francesco and Piero, who was aged thirty at the time and married to the twenty-one-year-old Albiera. Despite the fact that in this document the ages and dates do not coincide with those of the characters mentioned, and despite the fact that it was written by a notary who cites self-referential[51] data, it is the first and only time that a direct reference to Leonardo's mother appears in a public document.

[50] About Caterina, Leonardo's mother. Old and new hypotheses—Elisabetta Ulivi, University of Florence, Department of Mathematics and Computer Science.
[51] In 1458, Sir Piero would have been 32 years old, while Albiera, born in 1433, would have been 25 and not 21, as reported.

The document, in fact, states that living with Antonio and Lucia da Vinci at the time was

> Lionardo son of Sir Piero non-legitimate, born from him
> and from Chaterina, at present woman of the Troublemaker of
> Piero del Vaccha da Vinci, 5 years of age.[52]

Troublemaker was the nickname of Giovanni Buti, son of Piero del Vacca, in whose land register "his woman," a certain Caterina[53], actually appeared twice[54]. With them were listed the children Piera, Maria, Lisabetta, Francesco, and Sandra.

The document mentioned above, as noted, is currently the only script in a public register that offers documentary support for the thesis that Leonardo's mother name was Chaterina.

Curious, isn't it?

Certainly it makes you wonder about the fact that, although it was written by the notary Sir Piero himself, the document refers to him in third person. And it is completely wrong regarding both his own age and that of his wife Albiera, while it is accurate in describing the age of "Lionardo son of Sir Piero...five years of age." This fully agrees with the note marked on the last page of the notarial protocol by his father Antonio in 1452, with which we opened the chapter.

I don't know the date on which this land register was found, but unlike Antonio's private note announcing Leonardo's birth, this annotation remains a document in the official records of the state archives of Florence. According to this document, in 1458 it was publicly attested that the young Leonardo was five years old and was with his paternal grandparents in the Portata di Santa Croce a Vinci.

Both documents—that is, both that of his grandfather announcing his birth and this last one here—would moreover implicitly attest the paternity of Sir Piero da Vinci for Leonardo, even if, in the second case, nominally the exact wording used is "son [...], non-legitimate."

In summary, therefore, according to the documents registered at the Florentine cadaster, Leonardo is officially the illegitimate son of Sir Piero and a woman called "Chaterina." However, we cannot say whether this is her real name or a nickname, since her husband was mentioned with

[52] Florence, State Archives, Cadaster office 796, c. 596r.

[53] *About Caterina, Leonardo's mother. Old and new hypotheses*—Elisabetta Ulivi, University of Florence, Department of Mathematics and Computer Science.

[54] Both in a script of 1459 and of 1487.

the nickname, "Troublemaker." Yet the fact remains that this is the only existing documentary element regarding Leonardo's mother.

From here on, an endless series of presumptions about the figure of the mother begins. According to scholars and art historians, Leonardo mentioned her in his codices at least four times. The first time in a sheet of the Codex Atlanticus, in what appears to be the preparatory draft for a letter whose addressee is unknown:

> te te te tell me how things come by, and tell me if
> Catelina wants to do…
> Te tell me how things…
> Spar…[55]

A second time a certain "Catelina" is mentioned in the Forster Codex III[56]:

> on the day 16 of July
> Catelina came on the 16 of July 1493.

In an expense note in Manuscript H, on the other hand, a certain "Caterina" is mentioned twice consecutively with the same amount of expenditure next to it[57]:

"29th of January 1494	
cloth for socks	s.5
cloth	s.16
invoice	s.8
Salai	s. 8
diasspi ring s	s.13
starry stone	s.11
Caterina	s.10
Caterina	s.10"

Finally, one last time a "Catelina" appears mentioned in the Forster Codex II, within a relative summary list of the expenses incurred for her burial:

55 Codex Atlanticus, sheet 195r—Ambrosiana Library—Milan
56 Codex Forster III, sheet 88r—Victoria and Albert Museum—London
57 Manuscript H, sheet 64v—Institut de France—Paris

"Catelina burying expenses:

In 3 pounds of wax _____	s. 27
for the *stretcher* _____	s. 8
hay on *stretcher* _____	s. 12
carrying and placing of the cross ____	s. 4
carrying of the dead _____	s. 8
for 4 priests and 4 clerics_____	s. 20
bell, book, sponge _____	s. 2
for the grave diggers s. _____	s. 16
to the elder _____	s. 8
for the licence to the officials _____	s. 1

	106
To the doctor_____	s. 5
Sugar and candles _____	s. 12

	123" [58]

As a matter of fact, the death of a "Catharina of Florence, age 60, at febre terzana [...]"[59] was noted on 26 June 1494, in a document that still today is preserved in the Parish of Saints Narbore and Felice in the Milanese district where Leonardo had his residence during his stay in Milan, in Porta Vercellina.

As I mentioned above, however, there is no certainty that "Chaterina," "Catelina," "Caterina," and "Chatarina" are the same person, let alone that they are Leonardo's mother as referred to by the notary Sir Piero in the document registered in the cadaster in 1458. There is also no written evidence that the "Catharina of Florence, age 60, at febre terzana [...]" recorded in the registers of the Parish of Saints Narbore and Felice is the same one mentioned by Sir Piero. In the cadaster of Antonio Buti[60], the inscription of a "Mona Chatterina woman of Anttonio aged 60"[61] appears in 1487, information in complete conflict with the mortuary announcement of 1494 mentioned above. If we were talking about the same woman, in fact, she should have been sixty-seven and not sixty years old, as recorded.

And here it starts to get tangled up.

[58] Codex Forster II, sheet 64v—Victoria and Albert Museum—London

[59] E. Villata, professor of history and history of art at the University of the Sacro Cuore in Milan

[60] The Troublemaker employed at a kiln in Vinci mentioned by Sir Piero in 1458.

[61] ASF, Cadastre 1130, c. 29v.

Let us return to the document by Sir Piero's father, written in his own hand, in which he announced the birth of his nephew Lionardo on "15 of April at 3 o'clock at night on Saturday."

Taking this inscription as valid, let's start by clarifying that "15 of April" of 1452 and "3 o'clock at night" have no direct correspondence in 2020. At that time, night hours were calculated from when the sun set. In the Renaissance, when "3 o'clock at night" was spoken of, they were referring to the third hour after sunset. Since in Florence in April the sun sets around eight p.m., a modern clock would have recorded eleven p.m. Give or take.

Second, and taking for good the biography of Leonardo that today is universally accepted, there is another aspect that we cannot underestimate: in 1452 the Julian calendar was still being used. This calendar was developed in 46 BCE by the Egyptian astronomer Sosigenes of Alexandria and promulgated by Julius Caesar in his capacity as the highest pontiff of the Roman religion. To compensate for the fact that the duration of the calendar year did not correspond to a whole number of days, leap years were used. It was established that one of every four years was to be a leap year, so that the average duration of the year, according to the Julian calendar, was 365 days and a quarter. With this quadrennial arrangement, the difference between the calendar and the calendar year was only about 11 minutes and 14 seconds[62].

This difference, however, increased considerably over the centuries. From a purely astronomical point of view, the starting date of the seasons moved backward by one day every 128 years or so. To remedy this inconvenience, in 1582 the Gregorian calendar[63] was introduced, based on the measurements of the astronomer Nicolaus Copernicus. It was published in 1543 under the title De

[62] The Romans used to count the monthly days by subtracting them from certain holidays. In the case of Ides and Calends, counting also the day of departure, the holidays fell between February 24t and March 1st (which coincides with the Calends of March), for a total duration of six days. In leap years (bissextus in Latin, meaning bi-sixth), with the addition of one day to compensate for the duration of the calendar year in whole days, February became 29 days long; the 24th on the month, the sixth day, in that year it would become the seventh day. But given that the seventh day would fall on the 23rd, not being able to call the 24th as seventh day, they called it bi-sixth day. From here the name of "bi-sixth", leap in the English language.

[63] The Julian Calendar takes its name from Pope Gregory XIII, who introduced it on the 4th October 1582 with the papal bull *Inter gravissimas*.

Revolutionibus orbium coelestium libri sex ("Six books on the
revolutions of the celestial spheres"). Thanks to this calendar, still in use
today, the difference between astronomical time and the calendar year has
fallen to just 26 seconds, corresponding to one day every 3,323 years or
so, as compared to 128 in the previous calendar.

It is clear, therefore, that from a purely nominal and astrological point
of view the 15 April 1452—a year in which the Julian calendar was in
use—does not find a direct astronomical correspondence in today's 15
April, where the Gregorian calendar is in use. In order to have an
"astronomical" correspondence between the two dates, we should
therefore add to the date of 15 April 1452, something like another eleven
days plus a bit.

Apart from this minor detail, being purely nominal and having a
substantial value only in the case of an astrological investigation, there are
many other inconsistencies in the biographies of Leonardo's life that are
shared by all historians and academics today. For instance, I must point
out that the date of birth of what would soon become the greatest and
most celebrated genius in modern history was only discovered in 1746.
Yes, you read right: 1746! Three centuries after the words of the notary
Sir Antonio in Vinci, father of Sir Piero, were written.

This was confirmed by Carlo Amoretti[64] in 1804, in one of his
precious studies on the life and works of Leonardo da Vinci. In his
research, he found that in 1746 a Tuscan antiquarian named Giovan
Battista Dei[65] had discovered that Leonardo had been born in 1452. Dei
had been commissioned to make the family tree of the da Vinci family by
the Count Della Torre di Rezzonico of Como, a well-known
commentator on Pliny's Works[66].

Near the beginning of his work, Amoretti writes:

> Lionardo was born in Vinci, a small castle situated in
> Valdarno not far from the lake of Fucecchio, near the borders
> of Pistoia; and he was born, not in the year 1445, as generally
> mentioned by the Writers of his Life, but in 1452, as detected

[64] Librarian in the Ambrosiana of Milan, member of the National Institute of the Italian
Society of the Science, of the Academy of Sc. F. B. L. of Turin, etc.
[65] Antiquarium of the Grand Duke of Tuscany, author of a text preserved at the
Accademia dei Lincei in Rome—Da Vinci family tree made in 1746
[66] Disquisitiones Plinianae, in quibus de utriusque Plinii patria, rebus gestis, scriptis,
codicibus, editionibus atque interpreterbus agitur, two voll. in folio, both published in
Parma, the first one in 1763 dedicated to the heir apparent of France, and the second one
in 1767 to Ferdinando di Parma.

by Mr. Dei from the original registers of that time, who wrote the genealogy, not by consulting the old papers of the da Vinci family but through the public archives.[67]

In a note associated with Dei's name, Amoretti adds:

> In the family tree of the da Vinci family, which is still preserved today, there is:
> Sir Piero notary of the Signoria in 1484

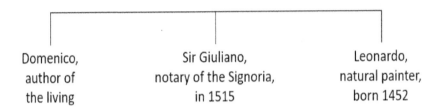

| Domenico, author of the living | Sir Giuliano, notary of the Signoria, in 1515 | Leonardo, natural painter, born 1452 |

This was detected by Mr. Dei from the Cadaster of Decima in Florence in the year 1469, Santo Spirito district, Drago, Cadaster in which all names of those who made up the de' Vinci family in that year, with their respective age, were mentioned, and read: Sir Piero d'Antonio, age 40. Francesca Lanfredini (his wife), age 20, and lastly Lionardo, son of Sir Piero, not-legitimate, age 17. See Stories of portraits of famous Tuscan men. N. XXV., to what the first part of this genealogy refers.

Although it was possible for Dei to examine the authentic memories preserved by some members of the family—and therefore the notarial protocol of Leonardo's alleged grandfather in which the announcement of his birth appears—Dei would have deduced Leonardo's age not so much from the papers shown to him by the descendants of the notary family in Vinci but from a cadastral document of 1469 preserved in the state archives of Florence. This document is different from that compiled in 1458 and seen in the previous pages.

From what Amoretti writes—i.e., that Leonardo "was born, not in the year 1445, as generally mentioned by the Writers of his Life, but in 1452"—it seems clear to me that until then, no one was aware of either the 1458 land register or the announcement made by his

[67] Carlo Amoretti, *Memorie storiche sulla vita e gli studi e le opere di Leonardo da Vinci*—Milan, by Tipografia di Giusti, Ferrario e C.o editori de' classici italiani, contrada di S. Margherita, n. 1118, 1804

grandfather Antonio. This is valid whether the biographers were his contemporaries, like Benedetto Dei[68] and Antonio de Beatis[69], or later, as Vasari, the Anonimo Gaddiano, and de Pagave[70].

It was only in 1746, after finding Leonardo mentioned in that document of 1469, Dei deduces 1452 as the actual year of Leonardo's birth. And so he noted it in the family tree he compiled for Count Rezzonico. Until that moment all biographers who wrote in various ways about Leonardo's life placed his date of birth before 1452. Long before that. I remind you that we are talking about one of the most famous, celebrated, and admired figures in our history. Don't you find it bizarre that none of his biographers, even those who had the fortune to know him and to frequent him in life, knew his real date of birth?

Among the various biographers mentioned let's have a look to Paolo Giovio[71], who personally spent time with Leonardo in 1507 in Pavia and later in Rome at the time of Pope Leo X[72] and his brother Giuliano de' Medici, both sons of Lorenzo the Magnificent.

In order to contextualize what is written about Leonardo in Giovio's biography, however, it is necessary to make a brief digression on the years that the artist spent in Rome, which were very complicated for him.

[68] Traveler, political informant, born in Florence on 4 March 1418, and dead there on the 2nd of August 1492. He made his debut at the service of Florence, but having then taken part in a conspiracy against Luca Pitti, Dei had to flee the homeland undertaking long journeys in Africa and Asia, until he settled for a few years in Constantinople, where he enjoyed the familiarity of the Grand Turk. Returned in 1468 to Florence, he returned to the service of the Medici and then of other Italian courts.
He left a *Chronicle*, a collection of different news (historical, geographical, political, statistical, of finance, art, etc.); in which is found, for the most part, summarized and rearranged the material of his other work, *The historical memories*, and which provides us with important data, on the Ottoman Empire but even more on Leonardo, as we will see.
[69] A native canon of Molfetta (Bari), he was the secretary of Cardinal Luigi d'Aragona, who on 10 and 11 October of 1517 he accompanied to visit Leonardo in the castle of Cloux, France, leaving us a precious testimony of the last years of life lived by the Florentine genius.
[70] Venanzio from Pagave, was one of the most zealous and active secretaries of government in Milan and later of the Council of State of the First Kingdom of Italy.
A profound connoisseur and expert in the Fine Arts, he left an important collection of drawings with related information to the Lombard artists, who, on his death in 1803, was bought by Giuseppe Bossi, the painter with a quotation of which I have started the introductory chapter of this writing.
[71] Paolo Giovio, born in Como on 21st of April 1483 and died in Florence on 12th of December 1552, was a Catholic bishop, educated humanist, historian, doctor, biographer and Italian museologist.
[72] Born as Giovanni de' Medici.

Called to the city in 1513 by Giuliano de Medici, Leonardo was given accommodation in the apartments of the Belvedere at the Vatican[73]. But the Florentine artist was soon excluded from the great works of the time. The projects for St. Peter's and the decoration of the Vatican Rooms were entrusted to artists who were inspired by him—Raphael, Botticelli, Ghirlandaio, Perugino—or who were in open conflict with him—Michelangelo.

In 1514, following an accusation of necromancy[74], a very precious personal treatise was stolen from Leonardo. It was believed that heretical formulas could be hidden inside the document, the De Vocie[75], and he was strongly hindered in his anatomy research. Despite the difficulties, Leonardo did not stop studying mathematics and science during this period, but it was enough to make him leave Rome in 1515.

In his notes relating to the Roman period, we can read a sentence written during this time that was definitely ambiguous if we think that there was never an open and declared hostility toward him by the Medici:

The Medici created and destroyed me.[76]

Paolo Giovio, as already mentioned, was in Rome during the same years as Leonardo. Compared to the Florentine painter, however, the bishop from Como had a completely different reception, so much so that when Leonardo returned to France in 1517, Pope Leo X appointed the Giovio as knight and gave him a pension. After leaving Rome for Florence in 1519, Giovio became deeply attached to the pope's cousin, Giulio Zanobi, another member of the Medici family who in turn became pope in 1523, under the name of Clement VII.

With the rise of Clement VII[77] on the papal throne, Giovio became a permanent member of the papal court and began to be

[73] The portion of the building that currently houses part of the Vatican Museums

[74] Divination through the spirits of the dead

[75] Edmondo Solmi. Leonardo da Vinci's Treaty on language ("De Vocie"), included in the Historical Archive Lombard : Journal of the historical society of Lombardy (1906:A. 33, set., 30, fasc. 11, series 4, vol. 6) and digitized by the Braidense Library in Milan

[76] Sheet 429r of the Codex Atlanticus, preserved in the Ambrosiana Library in Milan

[77] Natural son of Giuliano de' Medici, born in Florence in 1478, he died in Rome in 1534; exponent of the cadet branch of the Florentine family of Medici, he was the 219th Pope of the Catholic Church from 1523 until the death.

recognized as a person whose opinion had a big influence in the decisions
of the pope. This meant that the bishop from Como had a great influence
on a large number of people accredited to the Holy See. These people
did not, however, have great regard for Leonardo's neo-Platonic
inclinations. This cost Leonardo the exclusion from all pictorial
commissions in the Vatican rooms.

According to this brief and hasty reconstruction of Leonardo's and
Giovio's Roman experiences, it is not unthinkable that when, between
1523 and 1527, the humanist bishop of Como wrote three short but
important biographies dedicated to Leonardo da Vinci, Raffaello Sanzio,
and Michelangelo Buonarroti, he did so with knowledge of the facts but
also with a certain opportunistic disaffection for the Tuscan artist, who
was so frowned upon by the Roman Church.

In the brief biographical note written in Latin about Leonardo,
Giovio makes no mention of the fact that the artist was born in Vinci. In
fact, this news does not appear in any document of the state and cadastral
archives. That Leonardo was born in Vinci, in the house of his paternal
grandfather, moreover, is a piece of information that has been derived by
scholars only on the mere presumption of association and without any
documentary basis. It's due also to an excess of parochialism, I'd dare to
add.

On the other hand, Giovio concludes his narration on Leonardo with
a passage that, theoretically speaking, is very important in order to define
the year in which the artist was born:

> Being in France at the age of sixty-seven, he had ceased to
> live, with sensitive pity, among his friends, none of whom,
> despite being a great number of young people studying under
> his discipline, became a first-rate scholar.[78]

Now, all the greatest artists of the early Renaissance were strongly
influenced by Leonardo[79], borrowing from him the way to represent
landscapes, his sfumato technique, and his iconographic choices (which
were often innovative, thus providing a way in which to emulate him).
And there was a large number of so-called Leonardesque[80] artists due to

[78] This biography is reported in full by Giuseppe Bossi in the work already mentioned,
Del Cenacolo di Leonardo da Vinci: libri quattro—Royal Printworks of Milan, 1810.
[79] Giorgione, Albrecht Dürer, Raffaello Sanzio, Domenico del Ghirlandaio and others.
[80] Francesco Melzi (direct pupil), Gian Giacomo Caprotti called Salaì (direct pupil),
Ambrogio de Predis (direct collaborator), Bernardino Luini, Giovanni Antonio Boltraffio,

the way they replicated the style of the Florentine master. But according to Giovio's gloss, he did not form any first-class pupils, which suggests a certain partiality of judgement.

After all the rivalry between Como and Lecco is well known[81].

Joking aside—but not much, given that Leonardo spent probably more time in Lecco than in any other place—to understand the origin of the words of the prelate from Como, it is useful to remember that the biographical note written in Latin by Giovio was translated into Italian and corrected by Count Della Torre Rezzonico[82], the same man who commissioned the Tuscan antiquarian Giovan Battista Dei to reconstruct the genealogical events of the da Vinci family.

Bossi[83] writes:

> The life of Leonardo written in Latin by Giovio, and already made public by Tiraboschi[84], he was to appear in the light together with those of Michelagnolo and Raffaello, similarly printed in Literary History, all illustrated by copious notes by Count Anton Giuseppe Rezzonico. This erudite writer, after having translated them all into Italian, either seduced by the amenity of the subject or by the abundant of material collected from the notes, he was tempted to make a wider story of Leonardo in the two languages; but for whatever reason, unfortunately he did not finish it. Mr. Marco Cigalini, worthy heir of the Rezzonici, kindly communicated me the script from which it can be understood that Count Anton Giuseppe was not happy with the way in which the said lives were published, and that recognizing many errors and failures, by publishing his of Leonardo, he thought to add the various illustrations.

From this aside, and much later indirectly confirmed by Amoretti as well, it is clear that Count Rezzonico was dissatisfied with what Giovio wrote (the original copy of which cannot be found today), so

Cesare da Sesto, Andrea Solario, Giampietrino, Giovanni Agostino da Lodi, Francesco Napoletano, Marco d'Oggiono, just to name a few.

[81] Rivalry between the inhabitants of Como and those of Lecco (like myself) is proverbial, almost as much as the one between Pisa and Livorno.

[82] Preserved in the Biblioteca Ambrosiana, in the Fondo Bossi, under the sign S.P 6/13H

[83] Del Cenacolo di Leonardo da Vinci: libri quattro—Royal Printworks of Milan, 1810.

[84] Girolamo Tiraboschi, born in Bergamo in 1731 and died in Modena in 1794, was an erudite historian of Italian literature, belonging since 1746, the same year of the discovery of Dei, to the Company of Jesus.

much so that he made several changes. Was Leonardo's birth date among these modifications? Without the original manuscript, it is difficult to say whether the passage in which Giovio refers to Leonardo's age — "at the age of sixty-seven he ceased to live"— may have been corrected by Rezzonico precisely on the basis of Dei's.

The fact remains that until 1746, until Dei reconstructed for Count Rezzonico the biographical notes of Leonardo, all the Vincian biographies expressed an age older than seventy years. In the Anonimo Gaddiano, a manuscript that is about ten years older than the first version of The Lives by Giorgio Vasari, we read:

> And he died in Ambosia, a city of France, at the age of seventy-two in a place called Cloux, where he had made his home.[85]

According to this biography, if Leonardo died on 2 May 1519, he was born in 1447.

Anonimo Gaddiano is followed by the biographical note of Giorgio Vasari, composed for the first time in 1550:

> Where came to him a paroxysm, as a messenger of death. The king stood up at this and took his head to help him and offer him favor so that evil would lift from his spirit, which was divine. Knowing that he could have no greater honor, he died in the arms of that king at the age of seventy-five. The loss of Lionardo greatly saddened all those who had known him, because never had a person before him done so much honor to painting. He, with the splendor of his aura, which was so beautiful and soothed every sad soul, and with words turned all hardened intentions to a yes and a no.[86]

[85] Manuscript datable around 1540, kept at the National Central Library in Florence (Cod. Magliab. XVII, 17). Already belonging to the Gaddi family, the text then entered Antonio Magliabechi's collection. While the initial section is dedicated to the artists of ancient Greece, resuming substantially the story of Pliny the Elder, the most substantial part of this text is dedicated to the Florentine artists and their works. The manuscript represents the most complete document of Italian art before the edition of *The Lives* by Vasari: Vasari himself drew on it for a lot of information.

[86] *The Lives of the Most Excellent Painters, Sculptors, and Architects* is a series of biographies of artists, written in the 16th century by painter and architect Giorgio Vasari from Arezzo. It is often simply called *The Lives*. The treaty of Vasari was first published in 1550 by Torrentini and had such an extraordinary success that pushed the author to make a second edition, extensively enlarged and revised, published in 1568 by the Giunti family.

For Vasari, therefore, Leonardo was born in 1444.

For the record, it must be said that from a purely physiognomic point of view, all these dates would be more compatible with the age shown by the famous sanguine self-portrait from 1515 (but, as we will see, was created at least four years prior to this date) that is universally assumed to be the image of the genius[87].

At this point I imagine that you are wondering how such a lack of homogeneity of dates could have been created, especially since Leonardo was certainly not a character who could go unnoticed at the time when he lived. Both in the biographies and in the various land registers, there is not a single instance in which the ages of the people mentioned corresponded to the time elapsed between the date of birth and the moment at which the age is written down.

Let us take for example Sir Piero, the notary who according to historiography would be the father of Leonardo. Whether he was legitimate or not we shall see it later.

The inscription of the cadaster of 1469 would be the first document in which, thanks to the investigations carried out in 1746 by Dei, the definitive revision was made. This is the basis on which Leonardo's birth date is today fixed. Before then, and for three long centuries, he was unanimously considered by everyone, contemporary or historian, to have been born in the fourth decade of the fifteenth century. Curious, isn't it?

According to the inscription of 1469, as I noted, Leonardo would be the son of "Sir Piero d'Antonio aged 40." Yet on the same note, written by Piero's father Antonio on the last page of a family notarial book[88] in which appears the only mention of the date and time of Leonardo's birth, it is written that Sir Piero, his eldest son, was born on 19 April 1426. Therefore, since, mathematics is not an opinion, at the time of the inscription of 1469, which was written in his own hand, Sir Piero should have been forty-three years old.

The same is true for the land register of 1458[89], also written and delivered by the same notary. In this document it is reported that in the building of the Popolo of Santa Croce in Vinci lived the father Antonio, eight-five years old; husband of Lucia, sixty-four years old;

[87] Sanguine drawing on paper (33,5x21,6 cm) kept in the Royal Library of Turin, inside the Royal Museums of Turin.

[88] Florence, State Archives, Notary Antecosimiano 16912, f. 105v.

[89] Florence, State Archives, Cadaster 796, c. 596r.

father of his sons Francesco and Piero, who was thirty years old and married to Albiera, twenty-one years old. According to what his father Antonio wrote, in 1458 Sir Piero was thirty-two years old, while his wife Albiera was twenty-five[90] years old, and not twenty-one as written in the land register.

This is a coarse error that wouldn't be at all unusual if the document in question had not been written and completed by Sir Piero himself, who was also a notary by profession. There is not a matching date, if you notice.

While the dates of all the other characters vary in a fluctuating way, when it comes to writing down the data concerning Leonardo's age, all the notes correlate perfectly: "of 5 years old" in the register of 1458, "of 17 years old" in the register of 1469, and "at the age of sixty-seven" when he died in France, according to the biography of Giovio. This last was revised and corrected by Count Della Torre Rezzonico, perhaps with the intention of making the biographical data correlate with what Dei had found in the inscription of the register of Decima of Florence. If all these documentary references were indeed reliable, why then for three centuries did all the biographers of one of the most popular and admired personages write a date so different?

As such, it would be an unsolvable puzzle—were it not for the fact that, fortunately, there is a large amount of documentation that has not been taken into consideration by scholars and historians. It is this documentation that helps us to redeem the matter in an unequivocal way by giving a logical justification to all the biographies prior to the discovery of Dei's—and not only about the Leonardo's age, as we shall see.

To these other documents, moreover, we can add a basic characteristic of Renaissance artists who were neglected by scholars along with certain documentation. This allows us to obtain a series of important further information about the events of that period that are normally described in contrasting and misleading form. Deliberately misleading, I would add, given that in those years (and not only in those), much was done to give us a historiographical narrative different from the one that took place. I am talking about the extreme figurative realism of Renaissance works and how they became extremely valuable documentary supports.

[90] Being born in 1433

Let's proceed with the analysis of Leonardo's biography by integrating the information examined so far with some other documentation that is normally overlooked.

The only living biographer in Leonardo's time who briefs us on many elements related to his age, his state of health (which will be very important when we talk about the Gioconda), and the works he carried with him until his death on 2 May 1519, in the castle of Cloux in France, is Antonio de Beatis, a canon of Molfetta who was the personal secretary of Cardinal Louis of Aragon.

De Beatis turned out to be an occasional and involuntary biographer. During the journey the cardinal undertook in 1517 to visit Germany, Holland, France, Austria, and northern Italy, he kept a diary. This is today preserved in an original autograph manuscript in the National Library of Naples.

On 10 October 1517, the canon from Molfetta wrote down the details of the visit that the Cardinal of Aragon made to Leonardo in the manor of Clos-Lucé in Cloux, not far from Amboise. The testimony of that meeting, written by de Beatis himself and therefore very reliable, offers us much food for thought on Leonardo's age and also in relation to themes that we will deal with later in this book:

> In one of the villages, the Lord, along with the rest of us, went to see the Florentine Leonardo Vinci, more than seventy years old and a prominent painter of our times, who showed us three paintings: one of a certain Florentine lady, a painting with beautiful features made at the request of the now quondam[91] Magnifico Giuliano de' Medici, the second of a young St. John the Baptist; and one of the Madonna and her son, who are placed in the lap of St. Anne—all perfect, even if from him, for having contracted a certain paralysis on the right hand, much cannot be expected.
>
> He has formed a Milanese group that works very well. And although the Sir Leonardo cannot color with his usual delicacy, he can still make drawings and teach others.
>
> This gentleman has composed so many particular studies of anatomy, as demonstrated in his painting—limbs as well as muscles, nerves, veins, joints, and intestines of both men's and women's bodies—in a way that has never before been done by another person. This we have carefully observed, and he said he has already made

[91] Deceased

anatomy studies of more than thirty bodies between males and females of all ages. He has also composed the nature of the waters, different machines and other things, according to him, including an infinity of volumes all in the vernacular language, which if they come to light will be profitable and very enjoyable.[92]

This testimony was written in 1517, two years before Leonardo's death. Describing the elderly and suffering artist as "over seventy years old," de Beatis indirectly gives us an age at death exceeding seventy-three years. At least seventy-four.

Even de Beatis—who is the only known biographer to tell us Leonardo's age after meeting him in person—is in line with what was stated in the Anonimo Gaddiano, in Giorgio Vasari's The Lives, and was then repeated by all the biographers who in various periods of time[93] have written about him. These all agree in placing Leonardo's age at the time of his death between seventy-two and seventy-five years. Translated into a date, it means we can place his birth in a timeframe from 1443 (Vasari) to 1447 (Anonimo Gaddiano).

So far, therefore, on the basis of all the documents analyzed till now, we can assume with a certain confidence that:

- there is no documentary evidence that Leonardo was born in Vinci, let alone in the house of his paternal grandfather Antonio;
- there is only one generic reference to the fact that Leonardo's mother's name was Chaterina and that after giving birth, instead of taking him along with her husband and the other four children, she left him with her paternal grandfather to marry a hot-head from Vinci[94] who worked a kiln; and
- there is no certainty that the woman mentioned four times in the notes of the Florentine artist is Leonardo's mother, even if plausibly a Chaterina from Florence, aged sixty (not sixty-

[92] Ref. XF28, National Library of Naples

[93] Between 1519, the year of his death, and 1746, the period in which Dei found the Land Register of Florence.

[94] We learn that Leonardo's mother's name was Chaterina from notary Sir Piero himself, as we can deduct from his own written inscription in the Land Register of 1458 relating to the fact that his father Antonio and his mother Lucia, at that time, lived in Vinci and with them "*Lionardo son of Sir Piero non-legitimate, born from him and from Chaterina, at present woman of the Troublemaker of Piero del Vaccha da Vinci, 5 years of age.*"

seven) is buried near Leonardo's Milanese house in Porta
Vercellina.

The total lack of a patronymic reference[95] in the name of the
mother does not help to identify her better. This blank could have a
double meaning:

- On the one hand, it could mean that the origins of
the mother were really unknown, which is very unlikely. At
the time, there were not many people living in Vinci and its
surroundings.
- Or it could mean there was an attempt to keep the
true identity of the woman hidden, so much so that her name
does not even appear in the birth declaration noted by Sir
Antonio da Vinci on the last page of a family notarial book,
which instead mentions the five godfathers and five
godmothers who attended the religious baptism celebrated by
the priest of Vinci, Bartolomeo di Pietro da Vinci[96].

The reason for the woman's identity being kept hidden could
reside in the fact that Leonardo was an illegitimate son, and it was
inconvenient to identify her because of a question of hereditary rights
linked to her father's estate. Or maybe because it would not have
been convenient to reveal her true identity for political reasons, so to
speak.

A further documentary clue concerning Leonardo's mother can
be found in the three pages dedicated to him in the Anonimo
Gaddiano manuscript. In this description, reference is made both to
the identity of the mother and to the degree of kinship between
Leonardo and Sir Piero, notary in Vinci:

> Lionardo da Vincj, Florentine citizen, although he was
> (not) a legitimate son of Sir Piero, he was of his mother
> born of good blood.[97]

With regard to this passage, it should be pointed out that the
author of the manuscript[98] is firm in reiterating the fact that Leonardo

[95] Onomastic expression delegated to indicate the bond with one's father, such as, for
example, in Greek the Pelis Achilles (from the name of his father Pelaeus) or in Arabic the
term ibn "son of" (to which corresponds abu "father of").
[96] Florence, State Archives, Notary Antecosimiano 16912, f. 105v
[97] National Central Library of Florence (Cod. Magliab. XVII, 17)
[98] On which many hypotheses are made but there is no certainty.

was not only a Florentine citizen, but he was not even a legitimate son of Sir Piero in Vinci. This information, being preceded by that "although," sounds like an irrevocable sentence. So we must assume it to be definitively true, as it also appears in the two cadastral records of 1458 and 1469, which were both drawn up by the same notary. We can pass over for now establishing what is meant, from a legal point of view, by the expression "illegitimate child," but we shall certainly return to this aspect later on.

This first line of the biography reported in Anonimo Gaddiano, moreover, seems to be written in such a way as to underline the maternal condition:

> He was from mother born of good blood.

The grammatical construction of this first sentence, with its not incidental use of the word although[99]—later transformed by Vasari (who makes no mention of Leonardo's mother) into truly[100]—would seem to be deliberately chosen to argue that although it may be that Leonardo was not the legitimate son of Sir Piero, on behalf of his mother, he was born of good blood.

The statement contained in Anonimo Gaddiano has so far given rise to a series of interpretations contrary to the literary sense that the construction of the sentence would suggest, completely devoid of any documentary basis, according to which Leonardo's mother was a peasant girl from the Vincian countryside or, more likely, a slave. This thesis, if possible even more presumptuous than the others, is constructed on the basis of the meaning attributed by the scholars who support it to the appellative "born of good blood," as being similar to "of good and healthy constitution," the phrase used to classify and set prices for men, women, and children in the slave trade.

Some scholars even put forward the hypothesis that the mother was not only a slave, but even of Eastern origin. This hypothesis, which is completely fanciful and deprived of any foundation for how it was built, according to its proponents would find a justification on the basis of some partial fingerprints. One in particular is isolated among more than two hundred that have been identified on about fifty sheets of the Royal Collection of Windsor. There are two others left in the pigment—

[99] In this case the term has corrective-advertising value (Treccani Vocabulary)
[100] With truth, in accordance with truth, really (Treccani Vocabulary)

evidently still fresh—of two paintings by Leonardo[101], who used to blend the portraits by expanding the paint on the panel with his fingertip to obtain his signature sfumato.

The fingerprint that is the subject of this bizarre theory, which I report only to demonstrate the superficiality of some studies, was left by the thumb of a left hand. It would have certainly belonged to Leonardo, based on the common assumption that he was left-handed. Apart from the fact that Leonardo was ambidextrous—as I will show you later in discussing the Gioconda and the impairment of which de Beatis left us a memory—and it has been shown that he painted and wrote with both hands, there is no way to determine that the thumbprint belonged to the Florentine artist.

The author of the previous thesis, that the mother was a slave, would derive her Middle Eastern origin from the fact that the dermatoglyphics[102] of the analyzed thumbprint revealed a similarity with about 65 percent of the Arab population, due to the swirling structure and the Y-shaped branches, called the triradius. This would thus demonstrate Leonardo's Middle Eastern origin[103].

Apart from all the possible and imaginable gaps in this theory, Florence and almost all the Italian Renaissance courts were swarming with people of Middle Eastern origin, with whom Leonardo was in contact—emperors, patriarchs, bishops, scholars, theologians, astronomers, mathematicians, cartographers, merchants, navigators, and so on. So to think that this partial thumbprint is not only Leonardo's but also identifies his Middle Eastern origin is bizarre to say the least.

More interesting than this one, but only for some details that emerge from its construction and not for the conclusion, is the thesis

[101] The Portrait of Ginevra de' Benci and the Lady with ermine.

[102] Each of the skin grooves (or papillary ridges) that draw "figures" of various kinds on digital surfaces, which allow personal identification through the analysis of the fingerprints left.

[103] Studies on Leonardo's footprints were illustrated by Luigi Capasso, director of the Institute of anthropology and the Museum of the History of Biomedical Sciences of the University of Chieti and Pescara, and by Alessandro Vezzosi, director of the Museo Ideale di Vinci.

put forward by Renzo Cianchi[104] that Leonardo's mother might have been a slave.

Before he died in 1985, Cianchi left his research on the "slave Caterina" in the drawer of his desk without ever publishing it. After discovering that he was seriously ill, however, he told his son Francesco of his work. After his father's death, Francesco decided to complete his research and publish it in 2008[105].

The slave to whom Renzo Cianchi alluded would have belonged to a rich Florentine banker, Niccolò of Sir Vanni. By testamentary bequest on 19 September 1449, he transmitted the property and all rights over the girl to his wife, Agnola di Piero Baroncelli[106]. On 29 November 1449, the will was supplemented with the addition of a series of codicils[107] that radically changed the distribution of the patrimony of Niccolò. Guess in whose favor?

It was distributed to the notary Sir Piero da Vinci, including the house in Via del Palagio del Podestà, between Via delle Rose and Via de' Pepi[108], where the notary would erect his own study in the 1460s. This means that Sir Piero, who in the meantime had also been appointed as

[104] Renzo Cianchi (1901-1985) was a great scholar of Leonardo Da Vinci, of his life, of his work and his thought. He founded in Vinci the Ideal Museum Leonardo Da Vinci. Cianchi published a large number of essays and books dedicated to Renaissance art and was the first to put forward the hypothesis that Caterina, Leonardo's mother, had been a slave, after he found some documents in the Land Registry of Florence relating to a will of a wealthy client of Sir Piero Da Vinci, dead in 1451, a usurer named Sir Vanni. He spoke of this discovery of his to Neera Fallaci, the sister of the writer Oriana Fallaci, who in 1975 published an article on the subject in the *Oggi* magazine.

[105] *Was Leonardo's Mother a slave?* text published by the Ideal Museum Leonardo Da Vinci in 2008 with the introduction by Carlo Pedretti.

[106] Item à left that the Chaterina slave of the said testator stay under the obedience and servitude of Mona Agnola her woman all the time of her life, that is of Mona Agnola, and in that way and that form that Mona Agnola will and please, and in her power is the will to retain it or sell it, or to make another contract for her. And if she was in need of another one at her service, the heritage of the above mentioned testator are kept for every expense and, if there was no money to re-buy her, it has to be given. About Catherine, Leonardo's mother. Old and new hypotheses—Elisabetta Ulivi, University of Florence, Department of Mathematics and Computer Science.

[107] At the same way Sir Piero to have the food and the house in Florence in the way, form and time and all what Sir Piero will desire."
About Catherine, Leonardo's mother. Old and new hypotheses—Elisabetta Ulivi, University of Florence, Department of Mathematics and Computer Science.

[108] In correspondence of which today there are the prestigious Enoteca Pinchiorri and the Relais Santa Croce.

one of the four executors of the will, was already working as a notary in Florence in 1449, at the age of only twenty-three years.

The appointment as the will executor—besides telling us how deep and trusting the relationship was between the young notary and the rich banker Niccolò di Sir Vanni—confirms that he was already well inside the circle of rich Florentine families that revolved around the business of Cosimo the Elder.

After Niccolò's death in 1451, a court case arose involving his heirs, the Florentine administration, and the then-archbishop of Florence, Antonino Pierozzi[109], former prior of the Convent of San Marco who was faithful to Cosimo the Elder. The latter, believing that Niccolò di Sir Vanni had become enriched through usury, contested his will and sold some goods. With the proceeds, Pierozzi settled some tax debts with the lordship, while a portion of the remaining funds was distributed to Niccolò's victims.

The father of Sir Piero in the register of 1458 (which we know was written by his son Piero himself), reports these testamentary dispositions of Niccolò of Sir Vanni toward his son and the intervention of Archbishop Antonino Pierozzi. It concludes with a vague "all extinguished and cancelled." It is not known whether this phrase alluded to the tacit agreement where Sir Piero granted the use and ownership of the house in Via del Palagio del Podestà to the widow of Niccolò of Sir Vanni or whether there was something else. Mona Agnola would live in this house in the company of an "assistant," not a slave. Cianchi believes—again, totally presumptuously—that the aforementioned slave followed Sir Piero to Vinci. As a consequence of a subsequent act of proxy[110], Renzo Cianchi would later identify the slave Chaterina as the "servant of Vanni" who was impregnated by Sir Piero[111].

[109] Prior of the Convent of San Marco in Florence, in the period in which Beato Angelico frescoed its cells. A profound humanist, he reorganized the city's charitable institutions, the so-called Compagnie di Dottrina: The Innocent Hospital for children, the Company of Goodmen of San Martino, the Company for the care of elderly priests. Antonio is part of that Florentine caring, caricatured, compassionate tradition of which the confraternities of Bigallo and Misericordia were part of.

[110] Stipulated in Vinci on the 3rd of February 1453 by the notary Sir Luca di Antonio dei Ticci, in which a compromise reached between Sir Piero and the heirs of Niccolò of Sir Vanni is mentioned.

[111] The slave that Vanni had listed in his document of the 28th of February 1447.

The deed in question would have been stipulated in Vinci in 1453, and according to Cianchi, it would have served to free Chaterina from the bond that relegated her to the condition of slave. At that point, after having taken away her son conceived in sin and therefore defined as illegitimate (Leonardo), the slave would have been diverted to a reparatory marriage with the Troublemaker.

This reconstruction is summarized with the words of Elisabetta Ulivi, from whom I have taken the documentary cues for the exhibition so far reported:

> The fact that, when she had Leonardo at the presumed age of about twenty-five, she was not married yet, the definition of the Codex Magliabechiano[112] "of good blood," like the slaves "of strong blood," the frequency and the role of the slaves in Florence, the fact that a law to protect their masters had been issued in 1452, Leonardo's interests for the East and his relations with Islam, the analyses on the imprint of the whole finger of a finger of the left hand of the genius that would present Arab characteristics.
>
> "In particular are convincing," remarks Vezzosi[113], "the data that emerge from how Leonardo was received in the family and in his native village, together with the lack of any rights for Caterina and to her marriage to Troublemaker […]. That Caterina was a slave is so far the only hypothesis able to reasonably answer any question about Leonardo's mother." And Francesco Cianchi writes: "From the research carried out so far, no Caterina in the village of Vinci, nor in the neighboring towns, can be traced back to the one who gave birth to Leonardo. The only Caterina who certainly could have been frequented assiduously by Sir Piero was evidently the one in Niccolò of Sir Vanni's house."

Further recent investigations conducted by Angelo Paratico[114] led to the hypothesis of a Chinese origin of the Vanni's slave[115].

Once again we are faced with an embarrassing series of presumptuous acts that over time have contributed to building that false image of the

[112] Another name by which the Anonimo Gaddiano is known

[113] Alessandro Vezzosi is an Italian art critic, Leonardo's scholar, artist, expert of interdisciplinary and creative museology study, he is author of hundreds of exhibitions, publications and conferences in Italy and abroad about Leonardo da Vinci and the Renaissance, contemporary art and design.

[114] Milanese journalist author of several articles and books on Leonardo da Vinci

[115] *About Caterina, Leonardo's mother. Old and new hypotheses*—Elisabetta Ulivi, University of Florence, Department of Mathematics and Computer Science.

self-taught genius as an illegitimate son of an uncertain mother. He's been described as slack, inconstant, and everything else that can be added and that has contributed, over the years, to the image of the psychotic and schizophrenic artist whose fruit of knowledge leads back only to his genius and not to a precise culture of reference. This must, on the contrary, disappear from his biographies as being in contrast with the Catholic culture.

This is exactly what has been systematically implemented over the centuries to support the linear development of European culture, strongly rooted in Catholic Christianity. Coercion and malice were imposed on the period in which Leonardo lived in order to contain the advent of more advanced cultures that were instead based on scientific knowledge derived from astronomy and the solar cult.

What we are celebrating today, five hundred years after his death, is a papier-mâché myth that has nothing to do with the man who—thanks to the protection guaranteed to him mainly by two families, the Florentine Medici and the Milanese Sforza—was able to live on art and science. He borrowed it from the ancients and spread it to his contemporaries, who drew inspiration and strength from him to give life to that extraordinary period, which saw the revival of the arts that today we call the Renaissance. I hope that, page after page, all this will become clear to everyone.

Let's go back to analyzing the documents. We were considering the biographical aspects related to Leonardo's mother. We are in one of those cases where the father is certain and the mother is unknown. Curious, isn't it?

Documentary sources considered orthodox, i.e. those in which, one can deduce information about the biographical data of Leonardo's mother based on written records end here. It does not matter whether what is written in these documents corresponds to the truth nor whether whoever wrote it did so based on a foundation of truthfulness or not. All that matters is that someone has written it somewhere.

A document, though, does not necessarily have to be in the written form. A photograph that places a given person in a given place, for example, is equally valid as documentary evidence. If I showed you an image without captions that portrays a highly popular character (Pope Francis, Maradona, the Beatles, Mickey Mouse) or an unmistakable place (Mont Blanc, the Great Wall of China, the pyramids of the Plain of Giza) or an iconic work (Munch's The

Scream, Van Gogh's Sunflowers, Botticelli's Birth of Venus), it would be an even more stringent documentary source than the written form as it is objective and recognizable by all. Correct? What do you say? You would have expected me to mention the Mona Lisa in the previous list, wouldn't you? The problem is that the Mona Lisa is not the one on display at the Louvre. Too many heresies all at once? Don't worry, I'll show you this too. One step at a time.

Returning to the documentary power of images when it comes to defining who Leonardo's mother really was, we will resume the discussion later. By relying on a few more elements, we will include images as a documentary element. After all, art is image and substance. The real substance. Not the one we interpret individually, or that art critics often arbitrarily associate with the canvases of the greatest artists, but the one that in the artist's intentions underlies his work.

Going back to discussing Leonardo's parents, while there are endless grey areas on the identification of the mother, apparently the discourse on the identity of the father is different. Here no historian or critic—except myself—has any doubts. Leonardo is the illegitimate son of the notary Sir Piero da Vinci. So it appears.

Leonardo's personal data as recorded in the land registry of 1458 and 1469 became known only after 1746. Before then, everything to do with Leonardo's biographical and family traits comes from the notes written by Giorgio Vasari in the 1568 version of The Lives. Let's have a look at them.

The passages that most strongly identifies the paternity of Leonardo in the biography written by Vasari is the one that I report below:

> This is what men saw in Lionardo da Vinci, in whom,
> beside the beauty of the body, which is never praised enough,
> was the infinite grace in any of his actions, and so great was his
> gift that whatever difficult things his soul turned to, he made
> them with ease. Great was the strength in him, combined with
> dexterity, spirit, and valor, he was always regal and
> magnanimous.
>
> And the fame of his name spread so much that not only in
> his time was he held in high esteem but even more in posterity
> after his death. Truly admirable and celestial was Lionardo, son
> of Sir Piero da Vinci, and in the erudition and principles of
> literature he would have made great profit if he had not been

so inconstant and unstable. As he dedicated himself to
learning many things, began them, and then abandoned
them.[116]

According to this, Leonardo is, without any chance for error, the
son of Sir Piero di Vinci.

Everything I have told you so far about his being the illegitimate
son of the notary or who his mother might have been, Vasari does
not even contemplate—unlike what is contained in Anonimo
Gaddiano. It would therefore seem that the version of the life of
Leonard da Vinci given by Vasari in The Lives may be the result of a
superficial, reductive, deficient, and often contradictory work. Or at
least these are the criticisms addressed to him to justify reconstructions
different from what he writes.

But it is not so. The misunderstanding arises from a precise fact.
Vasari's manuscript was compiled in Rimini very close to the time
when the Anonimo Gaddiano was supposed to have been published,
so much so that it is legitimate to think that Vasari, in part, drew
inspiration from it. Two editions of Vasari's The Lives have been
printed: one in 1568, from which the above passage was taken, as
edited by Giunti, and a previous one, edited in 1550 by Torrentini.
Both editors were Florentine.

Vasari, on the other hand, was a painter and architect from
Arezzo. He was not satisfied with the meagre biographies of the artists
written by Paolo Giovio in his work Illustrious Men and those
contained in the Anonimo Gaddiano, and he believed that he had a
greater say than Bishop Comasco, being an artist himself. So he
decided to compose an encyclopedic work that could give worthy
depth to the artists who were bolstering Italy's pride.

Vasari's book is considered the first detailed biography that
reached us that deals with the history of Western art. It's also
considered the first—and often the only—biographical source for
artists who lived between the Middle Ages and the Renaissance. In
composing his work, Vasari read the existing writings[117], but above all
he personally and meticulously reconstructed the documentation

[116] Giorgio Vasari—The Lives of the Most Excellent Painters, Sculptors, and Architects,
Giunti Edizioni, 1568.
[117] Among which are mentioned Ghiberti's *Commentaries*, Antonio Billi's *Book*, and the
several times mentioned Anonimo Gaddiano.

relating to the artists closest to him[118]. It would be impossible to explain otherwise why in speaking about Leonardo, whom Vasari lavishes with words of absolute praise, the author omits such important biographical details.

Vasari's thorough work was first published in 1550 by the ducal printer Lorenzo Torrentino of Florence. This first work consisted of two volumes (for a total of 992 pages), divided into three parts. It is said that given the success achieved, Vasari felt the need to rewrite the work and publish it a second time in 1568—eighteen years after the first book— updating many of the entries contained. The second edition is not much longer, except that it is divided into three volumes (for a total of 1,012 pages), and was printed by Giunti, a historic Florentine family of printers.

Compared to the first version, the second one is enriched by the engravings of the portraits of the listed artists, according to a method previously used by Giovio. The latter had accompanied the notes written on the Illustrious Men with a series of paintings in place of the engravings. These paintings were later collected in his villa museum in Borgovico, near Como, where Villa Gallia stands today.

Recreated from the sources available to him, the portraits included by Vasari in the second edition of The Lives were never fictional creations by the author (as proved by the many profiles whose portraits were left blank by the author himself). These portraits are therefore often the only evidence of the features of many artists of the past, especially the older ones, whose physiognomies came from works of art now lost.

As proof of this, I was able to find a direct testimony by consulting a very precious manuscript preserved in Trivulziana library in Milan[119]. Some believe this to be the work of a phantom Florentii Musici that was composed for Cardinal Ascanio Sforza[120] in 1485. In the manuscript commentary accompanying this codex, dated 1775, Count Carlo

[118] To prove Michelangelo's discipleship at Domenico Ghirlandaio, for example, he went personally to the workshop of Ridolfo del Ghirlandaio, where he found traces of payments to the very young budding artist.

[119] Liber Musices di Florentius, I-Mt 2146—Trivulziana Library, at Castello Sforzesco in Milan

[120] Ascanio Maria Sforza Visconti was the fifth-born son of Francesco Sforza, Duke of Milan, and Bianca Maria Visconti, younger brother of two Milanese Dukes, Galeazzo Maria Sforza and Ludovico il Moro. He played a fundamental role in the election of Rodrigo Borgia to the papal throne, under the name of Alexander VI.

Trivulzio[121] lets us know that he saw in the frontispiece a possible portrait of Leonardo. He notes its similarity to the engraving inserted by Vasari in the second version of The Lives:

> The one painted in the frontispiece that remains in the margin outside represents a portrait of a music master, old with long hair and a thick beard, with the cittern in his left hand, which is pressing the strings, and holding his right hand is if holding a pen with which to play the cittern. The other figure in the lower margin of the frontispiece shows a young man learning the lesson, looking toward the described old master. Now this old master looks very similar to the portrait of the famous Florentine painter Leonardo da Vinci shown in *The Lives of Painters* written by Vasari, except that in the portrait in Vasari, he wears a beret on his head, while here he goes without it, but as for facial features, it is very similar.

And further on he adds:

> On page 3 of these remarks, speaking of the portrait of Leonardo da Vinci, I said that it looks very similar to the portrait of that famous Painter in *The Lives of the Painters* written by Vasari, except that the one by Vasari wears a big beret on his head. Now we know that in the Gallery of the Ambrosian Library there is a portrait of Leonardo made in red pencil, without the beret on his head, and we can note that this portrait is of a man Leonardo's age or shortly after. As for that young man who is learning the lesson in front of Leonardo's portrait, who knows if he is not the boy called Solaj or Solajno of Milanese origin and a pupil of Leonardo's, a handsome young man, graceful and obscured because of the beautiful curly hair that Leonardo often used for painting angels or other figures.[122]

We will be able to see that the author of this very precious document, the Florentii Musici, completely encrusted in gold, is no phantom at all.

Returning to Vasari's text, it must be said that the difference between the first and the second versions does not only consist in the presence of the engravings showing the portraits of the artists

[121] Don Carlo Trivulzio, a very rich and educated man, was one of the most important collectors of the eighteenth century in Milan.
[122] Liber Musices di Florentius, I-Mt 2146—Trivulziana Library, at Castello Sforzesco in Milan.

described. At least in the case of Leonardo, there is a series of omissions and subtractions that, unlike what one would expect, concern the second edition when compared to the first and not vice versa.

Comparing the two editions, one immediately notices some substantial differences, one of which is by no means negligible. The second version has a different publisher, which could appear to be a marginal element, but an introduction is added to justify the new edition:

> WITH THEIR PORTRAITS
> And with the new lives from 1550 to 1567
> With copious charts of names, of works,
> And of the places where they are.

Notice how in that "where they are"[123] includes the French influence on Florentine society. Perhaps this note was dictated by the benevolent climate toward the king of France as a result of the marriage celebrated in 1532 by Clement VII between his great-granddaughter Caterina de' Medici and Henry of Valois, son of Francis I, who was king of France when Leonardo died in Amboise in 1519.

There is another substantial difference between the first and the second version to which I want to bring your attention, however. The 1568 version, revised and enlarged with portraits of the artists, is edited by Vasari:

> "WITH PERMIT AND PRIVILEGE OF PIUS V, AND
> OF THE DUKE OF FLORENCE AND SIENA."

Pius V, whose given name was Antonio Ghisleri, sat on the papal throne from 1566 until his death in 1572. In response to the growing uprisings of theological independence and against heresies and Protestant movements, Pius V was deeply involved in giving rise to the Counterreformation and extending the judicial rights of the Church itself.

In 1550, the year in which Vasari published the first version of The Lives, Antonio Ghisleri was appointed inquisitor in Como (conveniently the birthplace of Giovio), passing through Bergamo, until he became general commissioner of the Roman Inquisition in 1551.

The post that concerns us most closely came in 1556, when Ghisleri was appointed by Paul IV as chairman of the commission in charge of

[123] "où elle sono" in the original version

populating the Index Librorum Prohibitorum[124], a list of books that the Church found to be contrary to its theological foundation. Victims of this ignoble initiative, which lasted until few years ago, included Giordano Bruno, Galileo Galilei, Nicolaus Copernicus, and others—all authors very close to the scientific inclinations of Leonardo himself. It is therefore understandable how Leonardo himself was not well regarded in the clerical circles of the sixteenth century—as he was not in those of the fifteenth century either.

The Duke of Florence and Siena at the time was Cosimo I de' Medici, who the following year became the first Grand Duke of Tuscany, a position he held until his death in 1574. Cosimo I was part of the cadet branch of the Medici, known as the Popolani. They were descendants of Lorenzo, who was the brother of Cosimo the Elder, the first Lord of Florence. As the son of Giovanni[125] and great-grandson of Ludovico il Moro, Cosimo I lived in the shadow of the most famous members of the Sforza and Medici families, until 1537, when he brought the cadet branch of the Popolani to power, thus giving life to the Grand Ducal line.

We can therefore hypothesize that the "PERMIT AND PRIVILEGE" attached to the second version of The Lives by Vasari are not exactly a mark of objectivity. Especially in regard to Leonardo, an artist and a man of culture who embodied the Neoplatonic foundation against which Pius V was fighting and was protected by that branch of the Medici family that Cosimo I deeply envied.

In the light of these last considerations, therefore, let's analyze what was reported in the two versions of Vasari's work under "LIFE OF LEONARDO DA VINCI FLORENTINE PAINTER AND SCULPTOR."

In the later version, that of 1568, we find:

> Great gifts rain down from celestial influences on
> human bodies, many times naturally and sometimes
> unnaturally, filling one single body with beauty, grace, and
> virtue in such a way that whatever he approaches, each
> one of his actions is so divine that, leaving behind all other

[124] It's a list of publications forbidden by the Catholic Church, created in 1559 under the papacy of Paul IV. The list was kept up to date till the middle of the 20th century and was suppressed by the Congregation for the doctrine of the faith only on February 4th, 1966.
[125] Known as "of the *Black Mobs*"

men, he manifestly makes himself known for a deed (as it is) bestowed by God and not acquired by human nature.

This is what men saw in Lionardo da Vinci, in whom, beside the beauty of the body, which is never praised enough, was the infinite grace in any of his actions, and so great was his gift that whatever difficult things his soul turned to, he made them with ease. Great was the strength in him, combined with dexterity, spirit, and valor, he was always regal and magnanimous.

And the fame of his name spread so much that not only in his time was he held in high esteem but even more in posterity after his death."[126]

As you will notice from what follows, it is not particularly different from what the painter from Arezzo wrote in the 1550 version:

Great gifts are seen raining down from celestial influences on human bodies many times naturally, and sometimes unnaturally, overflowing into one sole body beauty, grace and virtue, in a way that whatever he approaches, each one of his actions is so divine that, leaving behind all other men, he manifestly makes himself known for deed (as it is) bestowed by God and not acquired by human nature.

This is what men saw in Lionardo da Vinci, in whom, beside the beauty of the body, never praised enough, was the infinite grace in any of his actions; and so great was his gift, that whatever difficult things the soul turned to, he made them with ease. Great was the strength in him, and combined with dexterity, the spirit and value, always royal and magnanimous.

And the fame of his name spread so much that not only in his time he was held in high esteem, but even more among posterity after his death.

And truly, heaven sometimes sends us some who do not represent only humanity but divinity itself, and by taking it as a model, imitating it, we can approach with the soul and with the excellence of the intellect to the highest parts of heaven. And through experience we can see those who with some accidental study turn to follow in the path of these marvelous spirits, if indeed they are helped by nature, when the spirit is not themselves, so close are they to their divine works that they are part of that divinity.[127]

[126] Giorgio Vasari—The Lives of the Most Excellent Painters, Sculptors, and Architects, Torrentini, 1568—Giunti Editore—Florence

[127] Giorgio Vasari—The Lives of the Most Excellent Painters, Sculptors, and Architects, Torrentini, 1550-Florence

Beautiful man, cultured, brilliant, loved by all and skillful in every initiative he took on thanks to the beneficial influences of heaven. The versions differ radically in what was contained in the following paragraph, the one that historically dictated the biographical line on Leonardo.

In the 1568 version, which is the one which all scholars turn because it is the latest one in the elaboration phase, Vasari writes:

> TRULY admirable and celestial was Lionardo, SON of Sir Piero da Vinci, and in the erudition and principles of literature he would have made great profit if he had not been so inconstant and unstable. As he dedicated himself to learning many things, began them, and then abandoned them."[128]

As mentioned before, here the difference between the two versions is substantial and fundamental. In the original version, in fact, we read a completely different text, which is justified by historians as an error made by Vasari in the first version and corrected in the written version: "WITH PERMIT AND PRIVILEGE OF PIUS V, AND OF THE DUKE OF FLORENCE AND SIENA."

Vasari writes:

> SO admirable and celestial was Lionardo, NEPHEW of Sir Piero da Vinci, who being a TRULY GOOD UNCLE and RELATIVE to him, helped him in his youth. And maximum in the erudition and principles of literature, in which he would have made great profit, if he had not been so inconstant and unstable. Because he dedicated himself to learn many things, began them, and then abandoned them.[129]

It is clear how, in the original version, Vasari draws a line of continuity from what was written in the Anonimo Gaddiano of few years before, with the only difference being that the relationship between Leonardo and the notary Sir Piero da Vinci is transformed from "illegitimate son" (as reported by Gaddiano) into a wider relationship of kinship, which sees the two as "nephew and uncle." Vasari then corrects the pitch again in the next version, in which each

[128] Giorgio Vasari—The Lives of the Most Excellent Painters, Sculptors, and Architects, 1568—Giunti Editore—Florence
[129] Giorgio Vasari—The Lives of the Most Excellent Painters, Sculptors, and Architects, Torrentini, 1550-Florence

noun decays and the relationship is transformed into a more direct "son of Sir Piero da Vinci."

In the second version, there are two other circumstances in which Vasari describes the relationship between Sir Piero and Leonardo. On one occasion he once again calls him "uncle" and on the other "father." Sir Piero is called "Lionardo's uncle" when talking about the cartoon of Adam and Eve in the earthly paradise, now lost:

> There he was summoned for a door, which was to be made in Flanders and woven of gold and silk, to send to the king of Portugal, with a cartoon of Adam and Eve when they sin in the earthly Paradise: Lionardo made with the brush, using shadow and bright white, an endless meadow of grass with animals, which in truth it can be said that, in faithfulness and naturalness with the divine world, genius could not make anything like it.
>
> Here is the fig tree beyond the leaves and the views of the branches, made with so much love that the mind gets lost to even think about how a man could have so much patience; there is also a palm tree, which has the curves of the circles of the palm worked with such great artistry and marvel that nothing but the patience and ingenuity of Lionardo could do it.
>
> But the work was not to be completed: so the cartoon is today in Florence in the happy home of the Magnificent Ottaviano de' Medici, donated to him recently by Lionardo's UNCLE.[130]

This passage is presented unchanged even in the original version.

When referring instead to a "wheel" painted by the young Leonardo, Sir Piero is defined as "father":

> Lionardo then, to create this effect, took it to a room of his that he would not enter if he was not alone, lizards, crickets, snakes, butterflies, locusts, bats, and other strange types of similar animals: from the multitude of which, variously combined together, he extracted a very horrible and frightening animal that could poison with its breath and made the air of fire.
>
> And he made it emerging from a dark and broken stone, blowing poison from its open throat, fire from its eyes, and smoke from its nose so strangely that it seemed a monstrous and horrible thing.

[130] Giorgio Vasari—The Lives of the Most Excellent Painters, Sculptors, and Architects, 1568—Giunti Editore—Florence

> And he struggled greatly in creating it, as in that room
> the stink of dead animals was too merciless, but Lionardo
> sensed it not, due to the great love that he had for art.
> When this work was finished, which neither the peasant
> nor his FATHER wanted any longer, Lionardo told his
> FATHER to send someone to collect the panel, that him
> it was.

Contrary to what is written in Anonimo Gaddiano, as already
stated, Vasari never alludes to Leonardo's mother in either the first or
in the second version. On the other hand, the relationship between
Leonardo and Sir Piero, except for those two passages just mentioned,
is always described as "uncle/grandson." It occurs once in the 1568
version, as we have seen, but up to six times in the 1550 version:

> - So admirable and celestial was Lionardo,
> NEPHEW of Sir Piero da Vinci, who being a truly
> good UNCLE and RELATIVE to him, helped him
> in his youth.
> - In his childhood he approached art, thanks to
> HIS UNCLE Sir Piero, along with Andrea del
> Verrocchio.
> - ... so the cartoon is today in Florence in the
> happy home of the Magnificent Ottaviano de'
> Medici, donated to him recently by Lionardo's
> UNCLE.
> - It was said that Sir Piero da Vinci, UNCLE
> of Lionardo.
> - When this work was finished, which neither
> the peasant nor his UNCLE wanted any longer.[131]

Vasari's use of the noun "uncle"—often in direct association with
the name of the notary Sir Piero—seems, in the intentions of the
author from Arezzo, to intentionally underline a different role from
that of father. It almost suggests that Sir Piero could play a sort of
"legal/tutorial" role toward Leonardo. It would not explain otherwise
why Vasari felt obliged to underline the fact that Sir Piero "was good
uncle and relative to him [Leonardo], helping him in his youth."
Who knows, perhaps the notarial deeds in which Sir Piero and Sir
Antonio were involved not only concerned the liberation of the

[131] Giorgio Vasari—The Lives of the Most Excellent Painters, Sculptors, and Architects,
Torrentini, 1550-Florence

mother from her slave status but Leonardo himself, in relation to whom the notary took on the role of legal guardian or adopter.

So far, whoever has dealt with the parental question of the Florentine artist has hypothesized that the relationship between Leonardo and the notary Sir Piero da Vinci was one of consanguinity, identifying the young notary as the one who impregnated the poor slave girl Chaterina, excluding that any other parental form or legal link might exist between them.

For information only, I would like to recall here that, before the various legal reforms of recent years, which have defined a different meaning for the terminology used, a child could be linked to a parent by a biological or legal relationship, i.e., adoptive.

A biological child was defined as:

- natural if born out of wedlock and not recognized by the father;
- illegitimate if born out of wedlock but recognized by the father; or
- legitimate if born in wedlock.

The adopted child, on the other hand, could have been natural, legitimate, or illegitimate in the case of living birth parents, or they could have been an orphan in the case of deceased birth parents. But in relation to the adoptive parent, the child was, from a purely lexical point of view, always and only an illegitimate child.

From the documentation that can still be consulted today—and of which I have given ample evidence in these pages—there is no possibility of establishing with absolute certainty whether Leonardo was the natural/biological son of Sir Piero da Vinci, as Giovan Battista Dei did in a completely arbitrary and subjective manner when drawing up the da Vinci family tree[132]. In 1746 he wrote:

> Leonardo Painter
> natural, born
> in 1452

Unless the adjective natural as used by Dei referred to the profession of painter and not to the status of son.

It is curious to note, moreover, that when the notary Sir Piero died in 1507, Leonardo communicated this through two short notes contained in

[132] See page 12.

two different codices. The two communications are very similar to each other, although one of them is meagre while the other is richer in qualifying details. Precisely because of their repetitiveness and the extremely formal way in which the second is written, these two communications offer a different interpretation.

The first annotation can be found in the Codex Atlanticus and reads:

> Wednesday at 7 a.m. Sir Piero da Vinci died on the
> 9th of July 1504.
> Wednesday near 7th hour[133]

The second annotation, contained in the Codex Arundel, reads:

> On the 9th of July 1504, on Wednesday at 7 o'clock,
> Sir Piero da Vinci, notary at the service of the podestà, my
> father, died at 7 o'clock; he was 80 years old, left 10 sons
> and 2 daughters.[134]

The detachment with which Leonardo composes the first announcement and the formality full of precise details of the second one is striking, especially considering that before then there was not a single moment in which Leonardo manifested any acridity towards Sir Piero to justify such a cold detachment. Furthermore, in giving the announcement, Leonardo mistakes both the age of the notary and the day of the week (9 July 9 was a Tuesday, not a Wednesday).

In that period Leonardo was involved in the testamentary dispute with Sir Piero's heirs, of which he was one of the beneficiaries. He is mentioned at least twice in the cadastral records and bore Sir Piero's patronymic[135]. Who knows, perhaps the second note, the only one in which Leonardo defines the notary as "my father," was needed to underline a hereditary right. As the protections offered him by the Medici and the Sforza families ceased, he might have needed extraordinary means of subsistence, which he had not had to worry about until then.

The uncertainty that hovers around the relationship between Leonardo and Sir Piero seems also emphasized by the term that precedes the description. Over time, it is defined in the biographies

[133] Codex Atlanticus, Sheet 196v—Ambrosiana Library—Milan
[134] Arundel Codex, Sheet 272r—British Library, London.
[135] Suffix "da Vinci"

contained in the Anonimo Gaddiano and in both editions of Vasari's work:

- although[136]
- so[137]
- truly[138]

The linear evolution of the relationship, as it appears from the three antithetical descriptions of the biographies analyzed, can be summarized as follows:

> "Although he was not a legitimate son" he became a
> closer "so he was nephew of Sir Piero, who was a good uncle
> and relative in helping him in his youth" to definitively
> transform himself into a very close "truly Sir Piero's son".

On the basis of all the above, therefore, for the moment we can only objectively assume that the true, legal nature or a possible blood relationship existing between Leonardo and the notary Sir Piero da Vinci is not properly documented or documentable in the terms in which, until today, would be universally recognized. Quite the opposite, I would say. There is much approximation and presumption in defining their relationship, just as there is in identifying Leonardo's mother, that Chatelina that he mentions in his notes.

The mother who, moreover, in the whole parental story of little Leonardo, takes on an evidently marginal role in the biographers' intentions. Only two authors talk about her, with minimal hints. The only one who expressly mentions Leonardo's mother is the notary Sir Piero, in the document of 1458:

> Lionardo son of Sir Piero non-legitimate, born from him
> and from Chaterina, at present woman of the Troublemaker of
> Piero del Vaccha da Vinci, 5 years of age.[139]

The author of Anonimo Gaddiano instead quotes her indirectly, where he stresses the fact that Leonardo "although he was (not) a legitimate son of Sir Piero, he was of his mother born of good blood"[140].

[136] Anonimo Gaddiano, 1540.

[137] *The Lives* by Giorgio Vasari, first edition, 1550

[138] *The Lives* by Giorgio Vasari, second edition, 1568

[139] Florence, State Archives, Cadaster 796, c. 596r.

[140] Manuscript datable around 1540, kept at the Central National Library in Florence (Cod. Magliab. XVII, 17).

Although it does not tell us anything explicit about the mother's details, this short passage offers us more than one deduction:

- First of all, it does not confirm at all that the mother was a slave (from the East, from China, from the Tuscan countryside, or wherever you want her to be from, it doesn't matter).
- Second, the aside contained in Anonimo Gaddiano offers us a further hypothetical element of reading compared to what has been universally assumed before now—in a totally presumptive form by the way. Who tells us that "Chaterina" was not a nickname or a diminutive? The notary calls the man the mother is in a relationship with by his nickname, so this same notary might call her by a nickname as well;
- Third, the emphasis on the fact that on his mother's side he was born of "good blood," being reinforced by the conjunction that precedes it ("although"), can certainly not be traced back to the healthy constitution with which one could qualify the goodness of a slave as some scholar would like to hypothesize.

Too often, and not only when speaking of Leonardo, one tends to give hasty, gratuitously speculative readings, void of any logical and documentary foundation. One of the many presumptions often found in the story of Leonardo, for example, to emphasize his recognized genius and detach it from the cultural context that built his cultural and scientific education[141], concerns his being considered a self-taught man on the grounds that, it is claimed, he boasted of being a "man with no literature." It is only from this hypothetical admission of the artist that the idea of his self-taught education derives, supported by his grandfather and uncle Francesco.

In reality, this definition that Leonardo gives of himself is inserted in a broader dialogue through which the artist elevates his criticism toward his innumerable censors:

> I know very well that, not being literatus, to some presumptuous person it will seem reasonable to criticize me for being an unlettered man. Foolish people!" They do not know that I could, as Mario said to the Roman

[141] As confirmed by the many lists of readings that are included in its codex.

patricians, reply by saying: Those who make themselves pride of other's studies, they will not consider mine. They will say that, not being literatus, I cannot articulate well what I want to debate. They do not know that my studies come more from experience than from other people's words, words that were master to those who well wrote them, and for master I will take them and I will add in all cases.[142]

This passage, often referred to by historians as an implicit admission of ignorance by the Florentine artist, was in reality born from a profound criticism addressed to all those who, not considering him an academic and a professor[143], rejected the fruit of his studies as being based solely on "experience."

To these, whom Leonardo calls "foolish people!" the Tuscan genius let know that his knowledge is indeed based more on experience than on what others have written, whose content he knows in any case and will attach in support of his thesis.

The bitter outburst reported here fully reveals what Leonardo's forma mentis was. It was naturally based on a scientific approach of Neoplatonic derivation, versus a criterion of dogmatic truthfulness—typical of religious fundamentalism, based on the written and spoken word, with the assertive weight of the demonstrative evidence.

This propensity for method brings to mind another famous expression attributed to this extraordinary character, which contains in essence the spark of his infinite knowledge:

Knowledge is the son of the experience, which...[144]

With regard to Leonardo's cultural education, by no means self-taught for the sake of truth, I would like to remind you what Vasari himself wrote:

In the few months that he took lessons on the abacus, he obtained so much knowledge that always putting forward doubts and difficulties often confused the teacher.[145]

This passage shows us once again how the brilliant and multifaceted Florentine artist was initiated from youth into study, in this case of mathematics, by a tenured teacher. And that's not all. Leonardo was able

[142] Codex Atlanticus, Sheet 327v, Ambrosiana Library—Milan.
[143] Literatus
[144] Forster Codex III, Sheet 014 r—Victoria Albert Museum—London
[145] *The Lives* by Giorgio Vasari, first and second edition, 1550-1568.

to give an immediate demonstration of his abilities to such an extent
that in a short time he was able to confuse and make things difficult
for his own teacher with infinite observations and questions deriving
from his innate and characteristic curiosity.

Returning to the phrase with which Leonardo defines "foolish
people" who criticize him, I would like to point out that the same
exclamation is preceded by a few words that summarize the whole
essence of his knowledge, focused on the observation of nature:

> Naturally the good men desire to know.[146]

In the presence of this sentence, I must admit that at first I was
misled by the fact that "good men" were once called the Cathars[147],
whose movement was fought and defeated in the thirteenth century
through the foundation of the Dominican Order[148] by Dominic of
Guzmàn[149]. I wasn't very far off, in fact, considering that the cycle of
Beato Angelico in the Dominican Convent of San Marco is dedicated
to the events of Dominic of Guzmàn. The convent was initially
entrusted to the Benedictine monks, but in 1418 they were accused
of decadence of the monastic rule, and so they were ordered to leave
the complex. It took the direct intervention of Pope Eugene IV and
the Council of Basel before the structure was finally left to the
Dominicans, observant from St. Dominic of Fiesole, in 1437.

Decisive in this case was the intervention of Cosimo the Elder,
who since his return from exile in Venice in 1434 had expressed his
desire to resettle an observant community of Dominicans in Florence.
Cosimo's closeness to the Dominicans is also testified by the presence
of a cell dedicated to him inside the convent, in which the Pater
Patriæ could retire in moments of meditation.

[146] Codex Atlanticus, Sheet 327v, Ambrosiana Library—Milan

[147] Catharism was a Christian heretical movement, widespread in different parts of Europe
(Languedoc and Occitanian in France, Italy, Bosnia, Bulgaria and the Byzantine Empire)
during the Middle Ages, between the 10th and 14th centuries.

[148] Male religious institute of pontifical right: the friars of this mendicant order were
commonly called Dominicans. The order arose at the beginning of the 13th century in
Languedoc thanks to the Spanish Dominic of Guzmán with the aim of fighting against the
spread of Catharism, the most important medieval heresy, with their own prerogatives,
i.e. both through preaching and through the example of severe personal asceticism, living
in poverty and begging.

[149] Dominic of Guzmán, (1170—1221), was a Spanish presbyter, founder of the Order of
Friars preachers

At first, therefore, I thought that Leonardo might have had something to do with the convent itself or with the Tornabuoni family[150], of which Lucrezia[151] was a member, who in 1444 married Cosimo's son, Piero, known as Gottoso[152]. At the end of the fourteenth century, it is said that for reasons related to the possibility of joining the political life, this family transformed its name, deriving it from the original name Tornaquinci.

I don't know whether this is the real motivation that induced the Tornaquinci family to change their surname. But the fact remains that, not far from their home in Piazza del Trebbio, one of those columns was raised as a public warning to remember the Cathars, who were persecuted and burned at the stake in the public squares, a bit like the Colonna Infame of Manzonian memory. The column of the Pisan school was erected over a well in the fourteenth century in memory of the victory in 1244 of the Dominican Inquisitor Pietro of Verona's militia—the so-called Knights of Santa Maria—against the heretics Cathar.

Again, I was not far off, as we shall see. Indeed, Leonardo's mother, along with the convent of San Marco and Antonino Pierozzi and Lucrezia Tornabuoni, had something to do with the notary Sir Piero after all. Sometimes intuitions arise precisely from the unconscious looking in the direction where reason would advise against it.

Lucrezia Tornabuoni, mother of Lorenzo the Magnificent, was a cultured woman who inspired many of the cultural and charitable initiatives that developed in the city. I would not exclude her having an active role in the political choices that influenced the second half of the fifteenth century. As a supporter of the Confraternity of Mercy, Lucrezia was close to Antonino Pierozzi, who, before becoming Bishop of the city

[150] The Tornabuoni family, who arrived in Florence in the 10th century, was formerly called *Tornaquinci*. Initially they were part of the *Guelph* faction; wanting later on to gain access to public office, and being their political ascent barred by anti-magnate laws, in 1393 the main branch of the family, which referred to Simone di Tieri Tornaquinci, decided to change his name for convenience, becoming "popular" and choosing the nickname Torna-Buoni

[151] Woman of overwhelming culture and intelligence, animator of the Florentine cultural life of the time, great strategist, mother of Lorenzo the Magnificent and grandmother of Pope Leo X, married Piero di Cosimo de' Medici, who took command of the *Signoria* after the death of his father.
The marriage between Lucrezia and Piero strengthened the alliance between the de' Medici and the Tornabuoni families, which helped Cosimo to regain control of the city at the beginning of the 15th century.

[152] Parents of Lorenzo, known as The Magnificent

of Florence, was prior of the Dominican Convent of San Marco wanted by Cosimo the Elder.

Their closeness over the years is also testified by a painting by Domenico Ghirlandaio, a Madonna of Mercy[153] preserved in the Vespucci Chapel in the Church of Ognissanti in Florence. In this painting, under the veil held up by the Virgin's arms to encircle the typically for the time heart-shaped map of the globe, both Antonino Pierozzi and Lucrezia Tornabuoni are grouped with the Vespucci family. This is why I would not exclude her involvement in the most biased and hostile political plots against the Medici family and their own children, such as the Congiura de' Pazzi, in the role of a modern Medea[154].

The Dominican prior Pierozzi, on the other hand, was the first person to reorganize the city's charitable institutions, the so-called Compagnie di Dottrina, which included the Hospital of the Innocent, created to house and shelter needy children. Through these institutions Pierozzi gave life to the Florentine tradition of a charitable, beneficial, and merciful nature to which the Confraternite del Bigallo and of Mercy belonged at that time and to which the Compagnia dei Buonomini di San Martino was added in 1441.

This last institution was born with the aim of helping "the shameful poor," i.e., wealthy families who had fallen into disgrace because of political struggles, economic upheavals, or anything else. Out of shame, they did not have the courage to expose themselves to public begging. Some say that the Compagnia dei Buonomini di San Martino was set up to welcome the rich people harassed by the tyranny of Cosimo de' Medici, but the closeness to Pierozzi in those years makes me think that it was one of the many scandals put into circulation to besmirch the memory of the Medici once they had fallen.

The Company of San Martino was initially made up of twelve men and was—and still is—located in the Oratory in the center of Florence. It still bears the same name and is exactly opposite what is today referred to as Dante's house. In reality, after the exile the Alighieri's houses were razed to the ground, according to the custom

153 Also known as Madonna of the Sailors, because it often conceals important background events related to the first transoceanic crossings.
154 Medea, whose name in Greek means *guile, cunning*, sacrificed her children to achieve her aims and scheming.

of the time, so the indication given today only concerns the place and not obviously the architectural structure. Here, we are no more than two or three hundred meters away from that via del Palagio del Podestà where the house of Niccolò di Sir Vanni was located. As a testamentary bequest, this house became the property of the notary who took care of the succession—by chance, Sir Piero da Vinci.

Following this inheritance you will remember that Sir Piero had a lawsuit with Antonino Pierozzi, who fought to obtain some of the properties of Niccolò of Sir Vanni as compensation for the damages caused by the usury practiced against some unfortunate Florentines, who ended up in the gutter because of him.

As you can see, Cosimo de Medici had little to do with it.

The first hypothesis linked to the Cathars (historically replaced by the Dominicans, who annihilated them) and the role played by Lucrezia Tornabuoni in supporting Antonino Pierozzi in his beneficial, merciful, and charitable initiatives, has gradually been joined by many others.

Careful—I did not say replaced, but rather joined, in an infinite series of hypotheses and findings, one linked to the other. This led me to hypothesize who Leonardo's real parents were and justify the tutorial and adoptive role played by the notary Sir Piero da Vinci, as I will explain in the final chapter.

Read in the light of these considerations, both what Vasari writes in the first edition of The Lives regarding the role played by Sir Piero, "who good uncle and relative was to him in helping him in his youth," and what written in Anonimo Gaddiano regarding his mother, that is "from mother born of good blood," take on a different meaning.

A huge contribution toward understanding who Leonardo's parents really were has been provided by the paintings and what the first witnesses of that time—that is the artists who executed them—wanted to transmit to us through the plots of their works. In the iconographic context of the Catholic matrix, they have inserted a whole series of elements. Thanks to these, today it is possible to overcome the countless documentary gaps and the even more dangerous interpretative drifts given by scholars and fans of the fantasy genre so far.

Before continuing in the direction just outlined, however, in order to reconstruct a more realistic biographical profile of Leonardo, allow me to deal in the next chapter with a further detailed analysis of the documents considered in this first part of the work. These have a documentary value in the most traditional sense of the term and carry much more information of a historical and biographical nature that has been neglected

until now. Or rather, they were discarded because they were considered unfounded, anachronistic, or not conforming to and respecting of the Catholic foundation that, by means of censorship, accusations of heresies, and burnings, has been protected over the centuries to the point of de-forming the Western culture of reference.

CH. II—THE YEARS OF THE

MILANESE OBLIVION

There are documentary elements that are discarded by scholars in their reconstructions of the facts because these documents are considered unreliable, both with regard to a personal temporal manifestation and to something that is assumed to be established and truthful. Recalling this malpractice, at the end of the introductory chapter I referred to how the introduction of postulates and dogmas are limiting in a diagnostic process, just as studies previously carried out by others become limiting if the scholar's fame is universally recognized. This same reasoning lies at the basis of the criticism made toward Leonardo by those he considered "foolish people!" which recognizes in an academic system of self-referential analysis the only approach worthy of consideration.

Sometimes, however, it happens that documents unexpectedly come out of some remote drawer, and rereading them allows us to open rooms of memory before then considered inaccessible. This allows us to see things from a different perspective and reveals details hitherto unexplored or untapped.

Since I am supporting totally innovative theses, I have to bear the burden of proof. In the same way that we have dealt with the inconsistencies relating to his origins, we'll analyze the period in which, according to orthodox reconstructions, Leonardo came to Milan.

I quote again the librarian of the Ambrosiana, Carlo Amoretti[155]:

> "V. Important matter in the history of Vinci is to fix the time of this writing, and therefore of his coming to Milan; around which, since he saw all the writers having been mistaken, Oltrocchi did some judicious research. Vasari, and with him almost all the biographers, states that Lionardo came to Milan in 1494; but we know from Vasari himself that Lorenzo de' Medici sent the architect Giuliano da San Gallo to

[155] Librarian in the Ambrosiana of Milan, member of the National Institute of the Italian Society of Sciences, of the Accad. of Sc. F. B. L. in Turin, etc. author of *Memorie storiche sulla vita e gli studi e le opere di Leonardo da Vinci*—Milano, dalla Tipografia di Giusti, Ferrario e C.o editori de' classici italiani, contrada di S. Margherita, n. 1118, 1804.

Lodovico il Moro; that he lived here and conversed with Lionardo, then he returned to Florence, and from there went to Prato, where, while he was waiting for the building of that cathedral, heard of Lorenzo's death with bitter sorrow. Now this Prince died in 1492: therefore much before this year Giuliano came here and met Lionardo, to whom, Vasari says, he gave good advice around the equestrian statue he was working on. If the Councilman De Pagave had genuinely read in the Atlantic Ambrosian codex on page 2 that Lionardo drew a pavilion in Milan in September 1482, as my friend P. Dellavalle writes to have found out from his Memoirs.; and if Lionardo, as he believes, had been the architect of the house of Count Giovanni Melzi built in Vaprio in the same 1482, owned today by his successor and excellent Vice-President of the Italian Republic Francesco Melzi, we would have two incontrovertible signs about Lionardo's coming to Milan in this year, or before. But although, as we shall see, this is not unlikely, nor that he was the architect of the Melzi house in Vaprio, it is only a conjecture, and Dellavalle does not prove it; and I doubt we can find the note reported by De Pagave since Oltrocchi, diligent scrutineer and copier of that codex, in which he looked mainly for clues to anticipate as much as he could the coming of Vinci to Milan, was not able to see it. He saw though the drawing of the pavilion, but drawn it in the bathroom of the Duchess who came here in 1490, and on the next page he found the year 1492.16. Neither Venturi saw that note, and he would have mentioned it in the news about Lionardo's epochs. Let us therefore look for more certain proofs."

As can be deduced from this brief aside, even in 1804 there reigned a certain confusion in those who tried to reconstruct the essential stages that marked Leonardo's life, despite the availability of many more authentic documents and works than we have today.

Leonardo's arrival in Milan is unanimously traced back to the spring of 1482. That's when, having to leave Florence for a series of reasons attributed to the most disparate causes, the artist presented himself to the Duke of Milan Ludovico il Moro. According to historians and academics, the reasons that brought Leonardo to Milan

should be found between an accusation of sodomy[156] (which he was accused of in 1476), a climate of hostility in Florence in those years (linked to the attempt to dismiss the Medici through the Congiura de' Pazzi[157]), and his alleged artistic rivalry with Botticelli.

The most reliable hypothesis for why Leonardo moved to Milan is certainly the one that identifies the cause in the hostile climate that arose in Florence following the Congiura de' Pazzi. Concluded on 26 April, 1478, the Congiura was a conspiracy ordered by the de' Pazzi family, Florentine bankers, in cahoots with Pope Sixtus IV, with the aim of crushing the political and financial hegemony of the Medici in Florence and taking over. Sixtus IV, who became pope in 1471, had already expressed his hostility toward the Medici by removing them from the administration of the papal finances and in favor of the Pazzi family. In addition to the papal support—from where the order to kill off the brothers Lorenzo and Giuliano probably came—the Congiura saw the external support of third parties, including the Republic of Siena (hostile to Florence since the time of Aeneas Piccolomini, who later became Pope Pius II), the Kingdom of Naples, and the Duchy of Urbino in the person of Federico di Montefeltro[158].

The conspiracy, in which the involvement of Bianca de' Medici[159] as wife of Guglielmo de' Pazzi is also hypothesized, took place in Santa

[156] On April 9, 1476, an anonymous complaint was filed against several people, including Leonardo. The accusation concerned the crime of sodomy committed against the seventeen year old Jacopo Saltarelli. The punishment for those who committed this type of crime was severe: eviction for adult sodomites and mutilation of a foot or hand for young people.
Among the other inquisitors there was Leonardo Tornabuoni, a young descendant of the powerful family related to the Medici and this played a fundamental role in favor of the accused, who saw the accusation dismissed and were all "*absoluti cum conditione ut retumburentur.*"

[157] Concluded on April 26, 1478, was a conspiracy ordered by the family of Florentine bankers de' Pazzi with the aim of crushing the hegemony of the Medici through the support of the papacy of Sixtus IV and other external subjects, including the Republic of Siena, the Kingdom of Naples and the Duchy of Urbino. The conspiracy led to the killing of Giuliano de' Medici and the wounding of Lorenzo the Magnificent, without however leading to the end of the Medici power over Florence, as it was in the plans of the conspirators.

[158] Of which a ciphered letter has recently been discovered that proves with certainty its fundamental involvement, thanks to the deployment in favor of the conspirators of 600 men at the gates of Florence.
Marcello Simonetta, *L'enigma Montefeltro*, Rizzoli University Library, January 2010

[159] Under the direction of Lucrezia Tornabuoni, in my opinion.

Maria del Fiore[160]. Although it led to the killing of Giuliano de' Medici and the wounding of Lorenzo the Magnificent, the conspiracy did not lead to the end of the Medici power over Florence, as the conspirators had planned.

Bernardo di Bandino Baroncelli, a merchant, was to physically murder Giuliano de' Medici. Baroncelli was arrested in Constantinople a year later and hanged, still wearing his Turkish clothes, on 29 December, 1479 in the Bargello Palace, as noted by Leonardo[161] himself. (See Figure 1.)

FIGURE 1 — SKETCH OF BERNARDO DI BANDINI BARONCELLI'S SUSPENDED CORPSE. LEONARDO DA VINCI, 1479 REF. 659, MUSÉE BONNAT—BAYONNE, FRANCE.

Whatever the real motivation was that induced Leonardo to leave Florence for Milan, it remains unquestionable that in those years in the Tuscan capital, the climate was not exactly peaceful, both from a

160 The Dome of Florence

161 "Tané beret, black satin doublet, black folded cioppa, tuchina jacket lined with fox throat, and the collar of the jacket dressed of velvet, black and red, Bernardo di Bandino Baroncigli; black socks."

Leonardo da Vinci, 1479—ref. 659, Musée Bonnat—Bayonne, France.

cultural and politic-economic point of view, as the author of Anonimo Gaddiano[162] himself reports.

What kind of duties Leonardo was given at the Sforza court in Milan can be deduced from a sort of letter of introduction addressed to Duke Ludovico. In this letter, the Florentine artist promoted his skills and knowledge, as a young graduate in search of work would do today by presenting a curriculum vitae.

I quote Amoretti again:

> "What he wrote and what he did at the duchy proves how many and which studies Lionardo did in his early years, given the vast and deep knowledge that in various sciences and arts he showed to have. To have an idea it is enough to read the letter he addressed to the ruling Lodovico il Moro, and little less than lord of the Duchy of Milan, when was summoned. Oltrocchi copied it from the Codex Atlanticus. Here it is, as we can read on sheet 382[163], despite Lionardo wrote it with the left hand, from right to left, in the Orientals manner:

> "Having, my Dist. Sir., seen and considered enough the evidence of all those who consider themselves masters and composers of war instruments; and that the inventions and use of such instruments are not alien to the common use: I will strive to serve Your Excellency exclusively: opening to you my secrets: and offering them to your service in a suitable time, I will hope all these things here below mentioned may be of use.

> 1. I can make very light bridges, easy to carry so to chase, and sometime to flee, the enemies: and others more robust to withstand fire and battle: easy to raise and drop. And ways of burning and crushing those of enmity.

> 2. In case of siege of a land I can take away the water from ditches and make infinite instruments pertinent to this purpose.

> 3. The same I could to in a siege, in case bombard are of no use due to the height of the embankment or fortress, ruining any rock or other fortress if it is not already founded on stone.

> 4. I also have convenient and easy to maneuver bombards: to throw minutes of storm: and with the smoke of them scaring the enmity causing damage and confusion.

[162] "and then either out of indignation or due to some other cause, while he was working in the Citizen Council Hall, he left and returned to Milan, where he served the duke for several years."
Cod. Magliab. XVII, 17—National Central Library of Florence
[163] Codex Atlanticus, Sheet 1082r, Library Ambrosiana—Milan.

5. I also have ways for tunnels and narrow and distorted streets made without any noise to come to close to the enemy, crossing under rivers or trenches.

6. I can also make carriages covered, safe and offensive proof: which enter enemies' line with its artillerymen: capable of breaking apart great multitude of people: and behind them infantry will be able to follow, without injuries or obstacles.

7. If necessary, I will also make mortal, bombards and cannons of beautiful and useful shapes, as never seen before.

8. Where bombards can't be used I will make catapults and other war machines of admirable effectiveness and never used prior: in conclusion, according to the variety of cases, I will fabricate various and infinite crafts to attack.

9. And when it should happen to be in the sea, I have many instruments to attack and defend: and ships to resist big bombards and dusts or fumes.

10. In time of peace, I believe that I can very much satisfy and compete with others in architecture, in the construction of public and private buildings: and in channel water from one place to another.

I'll make sculptures in marble, bronze and terracotta: same with painting, I'll do anything that can be done and seen from others.

And I could work on the bronze horse that will be immortal glory and eternal honor of the happy memory of your Father, and of the prestigious Casa Sforzesca.

And if any of the above to someone may seem impossible or unattainable, I'll commit myself in doing experiments in your park, or in any place Your Excellency will desire, to who humbly I beg etc."[164]

When I wrote that in the past scholars were able to access a larger number of documents than today, I was also referring to this letter. It is obviously not written in Leonardo's handwriting, as can also be deduced from what Amoretti wrote in the note:

"Oltrocchi considered the orthography to be Vincian, and I'm of the same opinion.

[164] Carlo Amoretti—Historical memoirs on the life and studies and works of Leonardo da Vinci—Milan, from the Tipografia di Giusti, Ferrario and C.o editor of classici italiani, contrada S. Margherita, n. 1118, 1804.

Certainly it is not the one adopted today, but there are some cases in which I find it reasonable. He generally does not recognize that the c and the g that we pronounce in front of e, and i, where he writes ca, co, cu, ga, go, gu where we write cia, cio, ciu, gia, gio, giù; and he adds the h to the c and the g where he wants them to be pronounced as we pronounce them before a, o, u. So he admits the gentle s alone, doubling it when pronounced strongly, even though sometimes it is impure. He often combines the article and the preposition with the name, as the first Italian writers did. We will have frequent examples of all this in the passages I will report from his writings; although he doesn't follow constantly these same principles."

As far as I know, there is no trace of the original manuscript written by Leonardo. This is confirmed by the narrative of the historian librarian of the Ambrosiana when he merely comments on the Vincian orthography[165] and not on the calligraphy.

Beyond considering what the alleged reasons given to justify Leonardo's coming to Milan and what tasks he was called upon to carry out, here the analysis becomes immeasurably entangled. In order to avoid getting bogged down, I will try to bring to your attention only those documentary elements that are useful in refuting the reconstructions proposed so far by historians[166]. I will add in comparison some further documentary elements that are usually not considered but that describe a completely different and more reliable story than the one just mentioned. Different and, obviously, verifiable on a documentary level, as you will have understood to be my practice.

For now allow me a first objective consideration: there is no element contained in this letter that can prove to be addressed to Ludovico il Moro. The only element that can clarify who the recipient of this letter was, provided that it was really written on Leonardo's instructions, is the reference to Duke Francesco, for whom the Florentine artist would undertake to make the bronze statue.

"And I could work on the bronze horse that will be immortal glory and eternal honor of the happy memory of your Father [...]."

[165] Meaning the way of writing corresponding to the grammatical standard that concerns the correct use of graphic and punctuation signs in a given language.
[166] It will be up to the reader, if need be, to deepen in the remaining parts for the own pleasure.

Sons of Francesco and the Dukes of Milan were in fact both Galeazzo Maria, who took over the regency of the Duchy in 1466 just after the death of his father and passed away in 1476, and Ludovico. Logically, therefore, it is reasonable to think that the promise to celebrate the recent death of his father Francesco with a bronze horse was addressed to Galeazzo Maria rather than to Ludovico.

As usual, Vasari comes to our aid, offering us two different versions of the same story. In the biography contained in the second version of The Lives, which is the one indirectly quoted by Amoretti and all the other scholars who refer to it, the Arezzo biographer traces Leonardo's arrival in Milan in derivation of the fact that Ludovico il Moro became duke in 1494:

> "It happened that when Giovan Galeazzo, duke of Milan, died and Lodovico Sforza took his place in the year 1494, Lionardo with great reputation was brought to the duke in Milan, who greatly enjoyed the sound of the lyre, to play: and Lionardo brought with him that instrument that he had made with his own hands, mainly of silver, in the form of a horse's skull, which was bizarre and new, so that the harmony would be higher in tone and sound, dominating all the musicians who there competed to play. Moreover, he was the best improvisor of rhyming speech of his time. When the duke heard Lionardo's admirable reasoning, he fell so in love with his virtues that it was incredible. And praising him, the duke asked him to paint an altar panel with a nativity inside, which was sent by the duke to the Emperor."[167]

The mentioned Giovan Galeazzo is the son of Galeazzo Maria, nephew of Ludovico il Moro.

Even in this way, however, the story would not hold up. Ludovico il Moro in fact led the Duchy of Milan between 1480 and 1499: first as regent, alongside his nephew Gian Galeazzo Maria[168], and then as duke, on his death, from 1494 until 1499. In that year he had to flee Milan, which had been invaded by the French, to retreat

[167] Giorgio Vasari—The Lives of the Most Excellent Painters, Sculptors, and Architects, Torrentini, 1568—Giunti Editore—Florence.
[168] Son of Galeazzo Maria Sforza, Duke of Milan from 1466 to 1476, year in which he was assassinated near the Milanese church of Santo Stefano by some nobles.

in Innsbruck to his son-in-law, Emperor Maximilian I[169]. The emperor
had married il Moro's daughter Bianca Maria in 1493. During his escape
to Austria in the company of Leonardo, Ludovico il Moro stopped in
Bellagio to see his good friend Marchesino Stanga, who often hosted the
two.

The first version[170] Vasari's story, needless to say, is very different:

> "Lionardo was brought to Milan with great reputation to
> Duke Francesco, who greatly enjoyed the sound of the lyre, to
> play: and Lionardo brought with him that instrument, which
> he had made with his own hands, mainly of silver, so that the
> harmony would be higher in tone and sound, dominating all
> the musicians who there competed to play. Moreover, he was
> the best improvisor of rhyming speech of his time. When the
> duke heard Lionardo's admirable reasoning, he fell so in love
> with his virtues that it was incredible. And praised him, the
> duke asked him to paint an altar panel with a nativity inside,
> which was sent by the duke to the Emperor."[171]

Again, as was previously the case when we analyzed the sources
relating to the relationship between Sir Piero and Leonardo, we cannot
fail to note that Vasari includes in the two versions a series of very
discordant elements that not only add nothing to the narrative but rather
complicate its comprehension.

All Leonardo's biographers agree in ascribing the motivation for
Leonardo's first coming to Milan with the task of playing for the Duke, a
great enthusiast and performer. This is why he brought with him as gift a
silver lyre partly made with his own hands. Vasari lets us know in detail
that Leonardo was an excellent musician, the best among those active in
Milan. He also tells us the artist was the best rhyme improviser of his
time[172], a practice in which the Tuscan actor Roberto Benigni has shown

[169] Maximilian I of Habsburg, (1459—1519) was Emperor of the Holy Roman Empire
from 1493 until his death. Thanks to a policy of marriage and inheritance, he was the
founder of the Habsburg universal empire, despite the military defeats suffered in many
campaigns, in which he did not hesitate to participate personally.
A multifaceted and controversial personality, he was a sponsor and protector of the arts, as
well as a reformer of the kingdom's politics and administration.
[170] The one written in 1550 net of the papal license.
[171] Giorgio Vasari—The Lives of the Most Excellent Painters, Sculptors, and Architects,
Torrentini, 1550—Giunti Editore—Florence.
[172] This way is called *ottavina*, or also octave legato or popular octave or improvised
octave. It's a metric form typical of Tuscany, Lazio and Abruzzo deriving from the eighth

us more than a demonstration of such skill. One of these rhymes, mistakenly confused for one of the rules suggested by Leonardo on how to sit properly at the table, was probably composed by the artist during one of the many court entertainments and banquets he was called to organize for the Sforza[173].

In addition to what is written in the first version, in the second one Vasari adds a detail that is often the object of misunderstanding: the lyre that Leonardo brought with him would have had the shape of a horse's skull. Abiding this annotation, today a facsimile of the instrument Leonardo would have brought to the Duke of Milan is shown everywhere: the head of a monstrous animal with horns, teeth, and strings stretched between the dental arch and the nape of the neck.

My dear Tuscan friend Fabio Chiari[174], a serious and practiced luthier who has been honoring me with his friendship for a long time, has shown for years that the fanciful instrument associated with Leonardo in this second narrative by Vasari is actually contained in a manuscript codex by Francesco di Giorgio Martini[175]. The Florentine artist kept a copy of this codex in his library. The two of them

rhyme (ABABABCC). The popular eighth rhyme is practiced only by *bernescanti* poets (or improvisational poets or winging poets) who improvise their verses among themselves or in front of an audience that sometimes also assigns the subject (or theme) on which the poets have to sing.

[173] "If you want to stay healthy, observe this rule:
Do not eat without desire and have a light dinner,
Chew well and make sure what you intake
is well cooked and of simple shape.
Who takes medicine is not well informed.
Avoid anger and flee the stifling air;
Stand upright after leaving the table;
Do not sleep at midday.
Let the wine be temperate, little and thick,
not outside of a meal or with empty stomach.
Do not wait or linger the toilet.
If you exercise, let it be of little motion.
Don't stay supine and with the head sunk, and well cover yourself at night.
Lay your head and keep your mind content.
Flee from lust and keep a diet."
Codex Atlanticus, Sheet 213 v—Ambrosiana Library, Milan.

[174] Fabio Chiari, luthier—Sesto Fiorentino, Florence.

[175] Ashburnham 361—Biblioteca Medicea Laurenziana.

certainly hung out in Pavia around 1490[176], and it is presumable that Leonardo was very much inspired by the work of Martini, as can be deduced from the comparison between their works, especially in relation to fortification systems.

The manuscript containing the drawing of the fanciful lyre—which, I repeat, has nothing to do with the one Leonardo brought to the Duke of Milan—is a treatise on civil and military architecture now kept in the Biblioteca Laurenziana in Florence. The notes written by Leonardo himself are still visible at in its margins.

As Fabio explained to me, the words "in the shape of a horse's skull" in luthiers' slang referred to the shape of the wooden model used to form the sound box of the stringed instrument, a sort of eight-sided psaltery with the top part wider than the bottom one. This recalls indeed the bare profile of a horse's skull. Unfortunately the fascination of mystery often leads to the construction of fanciful drifts of all kinds, and so the unfounded myth of this instrument was born.

There is a picture taken by my wife, Marion, that portrays myself and Fabio while we were amiably arguing over this very instrument. In the background you can still see the perforated wooden profile "in the shape of a horse's skull" that Fabio needed in order to build a lyre similar to the one that was probably brought to Milan by Leonardo. (See Figure 2.)

That profile, which as noted recalls that of a psalter, is a shape often used also in heraldry, for reasons linked to what music itself represented in the Neoplatonic conception: the vibrational structure of the cosmos required in order to enter the kingdom of heaven. This idea, as we shall see, will also be taught by Cicero.

[176] In Pavia in the Locanda "ad signum Saracini" located in Piazza Grande near the church of Santa Maria Gualtieri. This is documented by the payment receipt issued by the Fabbriceria del Duomo of this city.
Gianvico Melzi d'Eril, Il Sole 24 ore—article dated 30 November 2018.

FIGURE 2 — IN THE FLORENTINE WORKSHOP OF THE LUTHIER FABIO CHIARI. IN THE BACKGROUND THE WOODEN MODEL TO CREATE INSTRUMENTS "IN THE SHAPE OF A HORSE'S SKULL."

The lyre that Leonardo brought as a gift to the duke of Milan, therefore, had nothing as monstrous and imaginative as we are led to believe. It was a very normal arm lyre, perhaps particularly innovative for the period, and enriched with silver inserts such as to allow "harmony would be higher in tone and sound," but nothing more. This instrument was played the same way a violin is played today, by holding the neck with one hand and resting the body on the chin. The strings were played with a bow in the same way that Fabio showed me in a silverpoint drawing by Leonardo, only partially traced over in pen, that's now kept in the Louvre museum[177] in Paris. In the description that accompanies this Leonardo's drawing, you will find that it referred to an archer in the act of shooting an arrow.

I do not understand why scholars insist on ignoring the fact that Leonardo's musical knowledge was the highest point of his knowledge, so much so as to represent the true essence of his cultural heritage.

We will come back to this.

With regard to showing you how the narrative about Leonardo's work is affected, more to tickle your curiosity than anything else, I'd

[177] Inv. 2022r—Musée du Louvre, Des. des Arts Grafiques—Paris.

like to tell you something about the purported "Leonardo's ferry," so called because even today some people believe that it may have been designed by the Florentine genius. In reality this type of boat was already commonly in use on all the rivers of the duchy of Milan before Leonardo's arrival: on the Tanaro, on the Ticino, and of course on the river Adda, where there were once six separate stations set up to cross the river, called "ports." It is therefore more realistic to think that Leonardo simply reproduced the way it worked, sketching it in pencil in his notes, than that he invented it from scratch, even if it does fit the image of the all-round genius that one wants to credit him with at all costs.

Although today the only so-called "Leonardo-esque" ferry still in operation is the one in Imbersago[178], not far from Lecco, the most famous is the one that once connected the Canonica bank with that of Vaprio d'Adda. This is the one illustrated by Leonardo in a drawing preserved in Windsor[179] that depicts the crossing system in front of the house where Girolamo Melzi hosted Leonardo between 1506 and 1507. Someone, again in a totally presumptuous form, mistakenly thought that this boat was an invention of the Florentine genius, perhaps created in a moment of boredom while observing the two banks of the Adda. Something similar was also designed by the aforementioned Francesco di Giorgio Martini. Leonardo, as we have said, possessed a treatise of Martini's[180].

In addition to the one mentioned above, there is another representation of the ferry made by Leonardo that is more important than the others, although no one ever writes of it. I am referring to the one I recently identified in sheet 99 of Manuscript K, preserved at the Institut de France in Paris, which depicts the "port of Cassano," the ferry used to cross the river at Cassano d'Adda to replace a pre-existing wooden bridge destroyed during a battle and never rebuilt. Located in front of the Castle of Cassano and portrayed in another drawing by Leonardo[181], this ferry is the only one mentioned by name in Leonardo's codices. This ferry, obviously much older than the one designed by the Florentine artist, was devised to overcome the destruction of the Benatrusio bridge and allow the connection with the castle of Cassano d'Adda, restored and fortified

[178] Which, however, has nothing to do with the one drawn by Leonardo, for obvious security reasons.
[179] Royal Collection, Sheet RC912400—Windsor.
[180] Ashburnham Codex 361—Laurenziana Library—Florence
[181] Codex Atlanticus, sheet 153 Ambrosiana Library—Milan, erroneously indicated by Gian Vico Melzi as the project made by Leonardo for the Melzi residence in Vaprio d'Adda in an article published in *Sole 24 Ore* on 30 November 2018.

by Ottone Visconti towards the end of the thirteenth century[182]. The castle of Cassano d'Adda at the time was an important Sforza garrison, frequented by, among others, Leonardo and Ludovico il Moro, who perhaps left traces of their passage when they were young in some graffiti preserved in one of the rooms on the ground floor now used for tourism. Federico da Montefeltro, the lord of Urbino who plotted against the Medici in the Congiura de' Pazzi, also passed through here.

Before this brief aside on ferries, we were talking about Leonardo's musical skills. It is precisely the reference to Leonardo's musical skills contained in the Anonimo Gaddiano that makes us understand when the Florentine artist actually arrived in Milan, well before 1482. So we read in the manuscript:

> "He was eloquent in speaking and rare lyre player and
> was teacher of Atalante Migliorotti."

At the time he came to Milan, therefore, Leonardo was the lyre teacher of Atalante Migliorotti, who later became a skilled player and luthier thanks to the teachings received from the Tuscan artist.

Again in Gaddiano, a few lines after, we find written again:

> "And he was thirty years old when he was sent by
> Lorenzo the so-called Magnificent to the Duke of Milan,
> together with Atalante Megliorottj, to present him a lyre,
> as he was unique in playing such instrument."[183]

These first two asides would seem to confirm the hypothesis that Leonardo arrived in Milan in 1482, assuming we give for truthful his date of birth of 15 April, 1452, and not the one in the decade before, as claimed by all his biographers before 1746.

When trying to deduce when Leonardo arrived in Milan, however, in the Anonimo Gaddiano we can find much more:

> "He then returned to Florence, where he stayed for a
> while; and then either out of indignation or due to some
> other cause, while he was working in the Citizen Council
> Hall[184], he left and returned to Milan, where he served the

[182] News published by the newspaper *Il Giorno* on 24 October 2018 by Daniele De Salvo.
[183] Codex Magliab. 17th, 17—National Central Library of Florence.
[184] Known today as Hall of the Two Hundred, Palazzo Vecchio.

duke for several years. And afterward he stayed with Duke Valentino and then in France in several places."

As described in this further passage, it seems that Leonardo's presence in Milan was manifested in three distinct phases:

"a first stay in the company of Atalante Migliorotti, during which the famous arm's lyre was brought to the duke of Milan, after which Leonardo returned to Florence for several years;

a second stay following an unpleasant event or other cause that occurred while he was working in the Citizen Council Hall, where he "stayed for several years";

a third stay, after a first French experience, during which Leonardo poured the bronze horse in honor of the founder of the duchy of Milan, Francesco Sforza, father of Ludovico."

Proceeding backward for greater ease in reconstructing the documentary evidence, the third stay mentioned by Gaddiano refers to the brief experience after 1506. This is when Leonardo was responsible for fortifying the military garrisons of the Milanese territory for the French governor in Milan, Charles d'Amboise. The map of the city of Lecco drawn by Leonardo that I recently found in one of the manuscripts preserved at the Institute de France[185] dates back to this task. This map is very important because, together with those of Milan and Imola, it is the only map of a city drawn by this extraordinary artist. It testifies to the deep bond between Leonardo and the Larian territory.

The second stay, which lasted longer than the first one, must refer to an unpleasant event in Florence, where the artist had returned after the mission that led him to Milan to take the famous lyre to the duke. The allusion made in Gaddiano is clearly the accusation of sodomy made against him in 1476. It also refers more generally to the hostile climate in Florence in those years as consequence of the aforementioned attempts to oust the Medici from political and economic control over the city, which then led to the episode of the Congiura de' Pazzi. This then led to the assassination attempt in the Duomo in 1478, where Giuliano de' Medici was killed and his brother Lorenzo was only wounded.

This second stay in Milan was followed by Leonardo's experience in the service of the duke of Romagna and Urbino, Cesare Borgia, known

[185] Manuscript L, sheets 82v and 83r—Institut de France—Paris.

as the Valentino[186], which began in 1502. Logically, therefore, this second stay can only refer to the period between 1482 and 1499, when Ludovico il Moro was defeated by the French army and Leonardo was forced to leave Milan to find shelter elsewhere.

Unless the author of the Anonimo Gaddiano is confused (which I can categorically exclude, as we shall see), the first Milanese experience in the company of Atalante Migliorotti must have been much earlier than 1476, during the period in which Leonardo was reported to be in Florence "for several years."[187] The doubt that is nourished by scholars, who believe what is written in Anonimo Gaddiano is corrupted by error, is generated mainly by three elements:

"the reference contained in Vasari's second version, in which Leonardo brought the lyre to Duke Ludovico in 1494;

the circumstance in Gaddiano that notes that when Leonardo brought the lyre to Milan he "was 30 years old" (always keeping as true the date of birth of 15 April, 1452, as indicated by the father of the notary Sir Piero);

the fact that, in Gaddiano, it is written that Leonardo went to Milan "while he was working in the Citizen Council hall."

Let us start from this latest aspect, from which it's easier to derive certain dates. One tends to confuse Leonardo's intervention in the Citizen Council Hall with that in the Hall of the Five Hundred, the famous reception hall of Palazzo Vecchio in which, hidden under a fresco by Vasari himself, there would be Leonardo's infamous Battle of Anghiari. This hall was built between July 1495 and February 1496 on commission of Girolamo Savonarola, the Ferrara friar who became the de facto lord of Florence after Piero il Fatuo, son of Lorenzo the Magnificent, was expelled from the city in 1494.

Savonarola wanted to promote a reform that provided a popular and plebiscite orientation of the institutions for the constituent Florentine Republic so that no one else could centralize power in their own hands through the employment of trusted men, as Cosimo the Elder and his nephew Lorenzo had done during the period of the

[186] Cesare Borgia (1475—1507) was son of Pope Alexander VI and brother of Lucrezia Borgia.
[187] "…where he stayed for a while…"

Signoria—and as his son "il Fatuo" had tried to do without success. With the intention of endowing the Florentine Republic with a political power extended to more people, the Ferrara friar therefore ordered the creation of the Council of the Five Hundred (also known as the Great Council), an assembly made up of five hundred citizens, to make the possible rise of a single patriarch more difficult. Savonarola's intention was clearly to stem the overwhelming power of the Medici—that same overwhelming power which, first through Cosimo the Elder and then Lorenzo, contributed to making Florence the cultural navel of the world, the cradle of the artistic and scientific rebirth of the Western world. The Hall of the Five Hundred was also known as the Grand Council Hall to distinguish it from a pre-existing council hall, still located in Palazzo Vecchio but smaller.

The Council Hall then changed its name when Alessandro de' Medici, wishing to give a semblance of democracy to the Signoria, elected the Council of the Two Hundred in 1523[188]. Today the hall houses the City Council of Florence.

In 1537 Alessandro de' Medici was killed, thus leaving a vacuum of power for the only-seventeen-year-old Cosimo I to occupy who, together with Pius V, granted Vasari the license and the privilege to publish the second version of The Lives—the one in which Leonardo's biographical profile appears completely forged.

At the time of Leonardo, access to this room was from the courtyard of Michelozzo[189] through a separate recess for the ballots, the so-called "secret" altar, for which Filippino Lippi executed the famous altarpiece of the Madonna del Popolo, now preserved in the Uffizi Gallery. Why is it important to clarify this distinction? Because in describing Leonardo's movements between Florence and Milan, the author of the Gaddiano makes explicit reference to both rooms, distinguishing them clearly and chronologically.

The first time he refers to a period after the accusation of sodomy in April 1476. In this case the allusion is to the Council Hall:

[188] Officially born on 27 April 1532, the Council of two Hundred accompanied the transition from the Florentine Republic of Savonarola and Soderini to the Medici dukedom. It was composed of 244 members, appointed directly by the Duke.

[189] It is the courtyard accessed from the main door, in Piazza della Signoria.

"While he was working in the Citizen Council Hall,
he left and returned to Milan, where he served the duke
for several years."

The second time, the author of the Gaddiano clearly refers to the
Grand Council Hall:

"He was trying to paint in the Council Grand Hall of
the Florentine palace the cartoon of the Florentine war,
when they defeated in Anghiari Niccholo Picci(ni)no,
captain of Duke Filippo of Milan; he there started to work
on it, as can still be seen today, and with paint."[190]

Then there is then a third passage that gives us an indirect
confirmation that when Leonardo decided to leave for Milan after the
accusation of sodomy (or more likely because of the hostile climate
toward the de' Medici family that manifested in the attempt to dismiss
them through the Congiura de' Pazzi, which ended with the hanging
of Bernardo di Bandini Baroncelli in Bargello Palace), he was clearly
working in the other room—the one accessed through a "secret"
hidden by a painting by Filippino Lippi:

"He started to paint the panel in the palace, which,
based on his drawing, was then finished by Filippo[191] of
friar Filippo Lippi."

Since this painting was "finished by Filippo of friar Filippo
Lippi"[192] it certainly cannot be the panel that the friars of the Servants
of Mary commissioned Leonardo to create for the high altar of the
Annunziata. This panel was left incomplete by Lippi due to his death
in 1504[193]. Vasari gives us the same account of this panel both in the
first and second versions of The Lives:

"He returned to Florence, where he found that the
Servants friars had commissioned Filippino the work of the
panel of the high altar of the Annunziata, for which
Lionardo would gladly have done the work.

[190] It is evident here the reference to the vanished Leonardo's Battle of Anghiari in the
Hall of the Five Hundred, which according to the author of this manuscript, around
1540, would still be visible.
[191] Filippo Lippi (1457-1504), known as Filippino Lippi to distinguish him from his
father, was one of the most significant Italian painters on the Florentine and Italian
Renaissance.
[192] Accomplished
[193] Then finished in 1507 by Perugino

Filippino understood this, as he was a kind person, and stood down the work: and the friars, so that Lionardo could paint it, took him into their house along with all his family, taking care of all the expenses. And there he stayed for a long time, and never began anything. Finally he made a cartoon containing Our Lady and St. Anne with a Christ, which not only surprised all the artists, but once it was finished, for two days there was in the room a parade of men and women, young and the old, who went to see it as one goes to solemn feasts, to admire the wonders of Lionardo, which amazed all those people.

Because one could see in the face of Our Lady all the simplicity and beauty that grace can give to a mother of Christ, showing that modesty and humility, typical in a virgin full of joy upon seeing the beauty of her son, whom she tenderly held in her lap; and while she, with an honest look down, glimpsed the little chile St. John, who was playing with a lamb, the smile of St. Anna who, full of joy, saw her earthly descendants becoming heavenly. Considerations truly from the intellect and ingenuity of Lionardo.

This cartoon, as will be said below, then went to France. It portrayed the beautiful Ginevra d'Amerigo Benci; and he abandoned the work to the friars, who returned it to Filippino, who, being caught by death, could not finish it."[194]

A further confirmation of this chronological reconstruction of mine regarding Leonardo's Milanese visits can be gathered by cross-referencing what Anonimo Gaddiano writes about life and works of Filippino Lippi. The enrichment given by this further narrative allows us to clearly assume how Leonardo was actually working in the minor hall when he decided to leave for Milan, leaving room for Filippino Lippi:

"8. He [Lippi] painted the panel in the minor hall of the Council of the Palace de Signorj, where Our Lady with other figures is, which Lionardo da Vinci had begun to paint, and Filippo completed it upon Lionardo's drawing".

The timeliness of these narratives confirms beyond doubt that Leonardo arrived in Milan well before 1482 and not after, as historians are unanimous assuming.

[194] *The Lives* di Giorgio Vasari, first and second edition, 1550-1568.

To support the hypothesis that he did indeed reach Milan long
before 1482, we can again count on two other manuscripts that are
overlooked by scholars:

- The first manuscript is the usual version of Vasari's
The Lives of 1550, in which, evidently free from external
conditioning[195], the author gives us a more realistic narration
of the facts, compatible with the story contained in Anonimo
Gaddiano.
- The second manuscript is the most important of all
because it was produced by a character who lived at the time
of and deeply knew Leonardo himself: The Chronicles of
Benedetto Dei."[196]

Let us begin to consider what Vasari wrote in 1550, which differs
from what was written in 1568 only in one small but essential detail:

> "Lionardo was brought to Milan with great reputation
> to Duke Francesco, who greatly enjoyed the sound of the
> lyre, to play: and Lionardo brought with him that
> instrument, which he had made with his own hands,
> mainly of silver, so that the harmony would be higher in
> tone and sound."

Some believe that Vasari may have confused the dukes of Milan,
Francesco and Ludovico, father and son. But there is a second passage
that again refers to Duke Francesco[197] also included in the 1568
version:

> "It was said that Sir Piero da Vinci, UNCLE of
> Lionardo, being at the villa, was called by one of his
> peasants who had made a round panel out of a fig tree and
> asked to be taken to Florence for it to be painted on. The
> uncle very happily and willingly did it, as the peasant was
> very practical in catching birds and fishes, and Sir Piero
> was making great use of his skills. He had the panel
> delivered in Florence, but without telling Lionardo who it
> was from, he asked him to paint something on it.

[195] See Pope Pius V and Grand Duke of Siena and Florence, Cosimo I de' Medici.
[196] Benedetto Dei (1418—1492) was one of the closest collaborators of the Medici, for
whom he was a sort of ambassador in the world, a great friend of the Grand Turk (from
whom I have reason to believe that the name given to corn by the Europeans derives).
[197] Like the previous one, in the following version of 1568 it disappears.

One day Lionardo came across the panel, and seeing it bent, rough, and badly worked, he straightens it using flame and gave it to a lathe operator, and from rough that it was, he made it fine and even. And after plastering it to his liking, he began to think of what he could paint on it that would frighten those who came to see it, eliciting the same effect as Medusa's head.

Lionardo then, to create this effect, took it to a room of his that he would not enter if he was not alone, lizards, crickets, snakes, butterflies, locusts, bats, and other strange types of similar animals: from the multitude of which, variously combined together, he extracted a very horrible and frightening animal that could poison with its breath and made the air of fire.

And he made it emerging from a dark and broken stone, blowing poison from its open throat, fire from its eyes, and smoke from its nose so strangely that it seemed a monstrous and horrible thing.

And he struggled greatly in creating it, as in that room the stink of dead animals was too merciless, but Lionardo sensed it not, due to the great love that he had for art. When this work was finished, which neither the peasant nor his uncle wanted any longer, Lionardo told his uncle to send someone to collect the panel, that him it was finished. So one morning Sir Piero went to the room for the panel and banged on the door. Lionardo opened it, saying to wait a little while. He returned to the room and put the panel in the light on the lectern, and adjusted the window to create a dazzling light, then he let Sir Piero come in to see it. Sir Piero at first glance, without thinking, immediately was shocked, not believing that that was the panel, nor believing that the figure he saw was a painting.

And taking a step backward, Lionardo held him, saying, "This is what this work is made for: take it then and carry it with you, as this is the expected purpose of the work."

This thing seemed more than miraculous to Sir Piero, and he greatly praised Lionardo's capricious speech. Then he tacitly bought another panel from a merchant painted with a heart pierced by a dart, and he gave it to the peasant, who felt indebted for life. Sir Piero then secretly sold in Florence the panel by Lionardo to some merchants for one hundred ducats. And in short order it reached the hands of Francesco Duke of Milan, being sold to him for three hundred ducats by the same merchants."

This twofold reference to Duke Francis, which disappeared in the version with the papal license[198] of 1568, if supported by documentary confirmations, would provide us with a series of conclusive data on the chronological question of Leonardo's actual presence in Milan.

The first useful information in this sense would confirm the hypothesis that alleges that Leonardo was actually in Milan long before 1482, since the death of Francesco Sforza that had occurred sixteen years earlier, in 1466. This circumstance would also fuel the doubt previously advanced that the presumed letter that Leonardo wrote to Duke Francesco's son is indeed addressed to Galeazzo Maria and not Ludovico.

The second useful information would be that at that time, Leonardo not only enjoyed a great reputation as a musician, but he was already known as an excellent painter. As Vasari writes, the wheel that "the uncle" Sir Piero swapped by deceiving the poor farmer who had obtained it by cutting a fig tree from his farm, was then sold by certain merchants to Duke Francesco himself at three times the price of purchase.

All if the reference to Duke Francesco was supported by documentary confirmation. And the documentary confirmation, in the most orthodox sense of the term, arrives right on time. Otherwise what would I be writing about?

I've mentioned earlier the very important figure of Benedetto Dei. Benedetto Dei (1418–1492) was the son of a goldsmith, former ambassador to the Neapolitan court, and nephew of a high office of the Gonfalonier of Justice in Florence. His extraordinary and innate diplomatic skills allowed Dei to weave important public relations for the Medici everywhere and with everyone.

Thanks to these skills, Dei became at first an essential collaborator of the Bank of Medici, the monetary activity of the Medici family, and of Pigello Portinari[199], who directed the Milanese branch of the bank until, due to his inexperience in financial administration, he was

[198] See papal censorship

[199] Pigello Portinari (1421—1468) was a banker of Florentine origins. He moved to Milan around 1452, on proxy of Cosimo de' Medici, to take over the management of the Milan branch of the Bank of Medici. He was the patron of the Dominican chapel of San Pietro Martire, near Sant'Eustorgio, better known as the Portinari chapel, and the Palace of Bank of Medici in Via dei Bossi.

replaced by another close ally of the Medici, Francesco Sassetti[200]. It is no coincidence, therefore, that the only frescoes in which Benedetto Dei is recognizable can be found both in the Sassetti Chapel inside the Basilica of Santa Trinità and in the Tornabuoni Chapel inside the Basilica of Santa Maria Novella in Florence. In the first Dei is portrayed together with Lorenzo the Magnificent and Sassetti himself in Domenico Ghirlandaio's cycle of paintings dedicated to the life of St. Francis, dated 1482. In the second, on the other hand, Dei is portrayed by Ghirlandaio in the lunette of the Apparition of the Angel to Zechariah, together with the elite of the Florentine political, economic, and cultural world, as a testimony to the role Dei was commissioned to play.

Actually I must tell you that Benedetto Dei is portrayed a third time by Sandro Botticelli in one of the four paintings linked to the Boccaccio novel of Nastagio degli Onesti, a work commissioned by Lorenzo the Magnificent on the occasion of the wedding of Giannozzo Pucci and Lucrezia Bini.

In this cycle of frescos, it is evident that Botticelli is making an allusion to events connected to the Americas, in particular to the figure of Nastagio Vespucci[201], who was accused of treason for having schemed against the Medici in cahoots with Frederick III of Germany and Enea Piccolomini, future Pope of the Roman Church under the name of Pius II. The allusion to the "American" events contained in this cycle of frescoes is also suggested by the presence in the painting of two caravels and a carafe taking off from the Gulf of Portovenere and by the presence of an unmistakable rock formation called Dame of Mali, a figure 150 meters high situated on a spur of rock overlooking the Atlantic Ocean on the African coast of Guinea.

It was in fact from Guinea that the traditional routes to the Americas departed before Paolo dal Pozzo Toscanelli suggested a more direct route in 1474, as we will see. What is depicted in these four paintings also elevates the "American" events as a possible motive for the killing of Giuliano de' Medici during the Congiura de' Pazzi.

The presence of Dei in this painting by Botticelli is very important because it links him to the fame of the globetrotting ambassador who preceded him. Thanks to this activity, he was able to contribute personally to developing trade in many foreign countries for the

[200] Francesco Sassetti (1421–1492) was a Florentine banker and patron, whose family was a business partner in the Bank of Medici.
[201] Nastagio Vespucci, Florentine notary, father of Amerigo Vespucci.

Florentine merchant houses by building solid diplomatic relations with the most important families in the world, including a particular affinity with the Grand Turk[202]. This in particular helped to define the name under which corn was received in Europe. By virtue of his many travels, Dei donated many of the exotic animals that populated the twin farms built by the Medici and the Sforza. The Medici one is located in the stretch of plain between Poggio in Caiano and Prato, while the Sforza one, called Colombarone, is located outside Vigevano. Leonardo too stayed in the latter, as can be deduced from the note he took describing the system used to irrigate the fields:

> "Scala della Sforzesca, with:
> the more it falls, the more it leaps.
> On February 2, 1494, at the Sforza farm, I drew 25
> steps of 2/3 arms each, 8 arms wide."[203]

Unfortunately both these farms today are in a state of advanced deterioration, thanks to the total neglect of the local and national administrations. And this despite the fact that the recent celebrations for the five hundredth anniversary of Leonardo's death offered them a great opportunity to enhance their value.

The most significant work of Dei was a Chronicle of Florentine art, culture and coin, from 1400 to 1500, a list written in his own hand that is a precise classification of almost all the most important events in the Florentine city. It is essential in the reconstruction of the historical events of the fifteenth century as well as being a diary of all the places he visited.

It is thanks to this collection of memories, for example, that today I can tell you with certainty that neither Leonardo nor Caterina de' Medici invented the fork, which was already in use in both Belgium and Germany in 1466:

> "I was in that year in Brabant [Belgium] and in
> Cologne and I touched and ate with a silver fork."[204]

[202] Ottoman title

[203] Manuscript H, sheet 65v—Institut de France, Paris. Other quotations to the Sforza farm are contained in the Leicester Codex, formerly Hammer, sheets 021r and 032r.

[204] Benedetto Dei, Ms. II.ii.333 f. 37—National Library, Florence.

During his career Benedetto Dei visited Milan many times. Two were notable: the first in 1449, and the second one in 1465—both times in the company of the Medici:

> "I was in Milan the year that Francesco Sforza took it with the sword in hand, and I came back with the Medici..."[205]

The first circumstance to which Dei refers is linked to the victory that Francesco Sforza's army obtained over the Venetian army in the so-called Battle of Monte Brianza, a small hill overlooking the course of the Adda between Lecco and Brivio, which we will come back to when we discuss the Gioconda.

The second circumstance is indeed more significant for us at the moment. It refers to the visit that the brothers Giuliano and Lorenzo de' Medici, then very young, made to Duke Francesco in the spring of 1465. Entrusted by their father Piero[206], the purpose of this visit was to establish good diplomatic relations with all the families who governed the territories in which the Bank of Medici was present: Francesco Sforza and Milan above all, but with him the representatives of other families such as the Este, the Bentivoglio, and others who were business associates of Cosimo the Elder. The partnership between Francesco Sforza and Cosimo the Elder was a long-lasting one that saw the two families linked both politically and economically (because of the Bank of Medici). It also linked them culturally, especially thanks to the role played by Leonardo during the regencies of their mutual heirs, Ludovico il Moro in Milan and Lorenzo the Magnificent in Florence.

The second episode mentioned by Dei is very important for the purposes of our discussion. First because it testifies to the very close alliance between the Sforza and the Medici, Leonardo's two main patrons. Second because it shows us how, within this relationship between the two most important and powerful families of the early Renaissance, Dei played a central role in acting as the glue between the two realities. Third because, indirectly thanks Dei's mention, not only are we able to give a youthful face to some of the main protagonists of Renaissance history—including Leonardo—but also to place the latter in Milan in 1465, thus giving definitive confirmation to both what Vasari wrote in the first version of The Lives and what we read in Anonimo Gaddiano.

[205] Memoirs of Benedetto Dei, ms. Ashb. 644—Laurentian Library—Florence.

[206] Known as *Gottoso*

In the same manuscript that includes the mention of the forks seen above, the author also leaves a very important list of all the people who, during his activity as ambassador and commercial and mercantile consultant of the Medici family, he took to Milan on 15 June, 1480[207]:

> "Memory of 15 of June 1480 of all the Florentine merchants who came to Milan in the time of Benedetto Dei:
> (…) and Luigi Pulci, and Gian Perini, and Tenperano by Messer Manno Tenperani, and Andrea Bellincioni, and Dino Bettini, and Iachopo by Tanai de' Nerlli, and Franc Ciarpellone, and Sir Franc Ghaddi, and Lucha by Maestro Lucha, and Tomado del Bene, and I by Domenicho del Giochondo, and Agnolo Gherardini, and Ant Bartoli de libri, and Bernardo di messer Benedetto d'Arezo, and Bernardo Paghanegli, and Rodolfo di Filippo Ruciellai, and sir Nichollò Figiovanni canzelliero del onbasc[i]adore, e'l conte Ghabriello Ginori, and (…) Antinori, Chappone di Gino Chapponi, and Iachopo Iachopi, and Franc di Meo delia Vacchia, and Salvestro di Dino, and Tomaso Ghuidacci, and Franc Berti, and Ruberto d'Ant di Puccio, and Lionardi di Filippo Bartoli, E LIONARDO DA VINCI PAINTER, and Ridolfo Paghanegli di Pisa, E ATALANTE DELLA VIOLA, and Franc Cieho, and Andrea fratello di Malagigi de la v[i]vuola e (…) of Maestro Mariotto, and Messer (…) Lapacino priest (…)"[208]

The first thing I would like to draw your attention to is that this list does not refer to the people brought to Milan on 15 June, 1480, but to all those whom Dei brought to Milan before 15 June, 1480. That is to say, also in 1465, or 1476, or any other date between 1449 and 15 June, 1480.

Second, it is evident that the Atalante della Viola mentioned by Dei, along with Lionardo da Vinci painter, is the same Atalante Migliorotti mentioned by the author of Gaddiano. During this event, also noted by Vasari, Leonardo was sent to Milan to bring his lyre to Duke Francesco.

This testimony is extremely important, as is the testimony of Antonio de Beatis from Leonardo's bedside in his Cloux retreat, because it is written in Dei's own hand by someone who was

[207] Ms. II, ii. 333, sheet 51 r, National Library—Florence.
[208] Ms. II, ii. 333, sheet 51 r, National Library—Florence.

physically present while the events he reports were taking place. In this story, as in that of de Beatis in 1517, there is neither the mediation of time nor that of interposed people, as there is in the case of what is reported by Vasari or Anonimo Gaddiano. Those biographies gather elements heard from third parties, and for this reason they may in some passages be incomplete, confusing, or contradictory.

Moreover, that Dei and Leonardo knew each other directly is not only a hypothesis. In the Codex Atlanticus, in fact, with his unmistakable handwriting, Leonardo writes:

> "Dear Benedetto Dei, to give you new things here in the Levant[209]. Be aware that in June a giant from Libya[210] has appeared.
> When the imperious giant fell, because of the bloody and muddy earth, a mountain seemed to fall; and in the countryside it was felt as an earthquake, frightening Pluto. And due to the great impact, he stood on the flat earth rather stunned. Immediately the people, believing that he had died of a lightning strike in the great turmoil, like ants rummaging through the body of the fallen man, flowed through the wide limbs and damaged the thick wounds."[211]

At this point it seems to me that I have demonstrated without a doubt, definitively and on a documentary basis, that Leonardo reached Milan for the first time at least in 1465, when Duke Francesco Sforza was still alive.

This assumption is also important in relation to the credibility of the documentary sources analyzed so far, because it actually accredits the information that Vasari includes in the first version of The Lives to the detriment of the corrections made for whatever reason in the second version. This implicitly legitimates the doubt that the painter from Arezzo may have really been "warmly advised" to change his version in accordance with the will more or less tacitly expressed by Pope Pius V and Cosimo I de' Medici to strip Leonardo of the historical, artistic, and cultural role that he actually played during his long life. Unfortunately, if this was the case, this intention has certainly been achieved if still today a work of such profound revision, as the one you are reading, that aims to

[209] It is not clear whether Leonardo or the God is in the Levant. Clearly Leonardo is in Italy, but depending on who is in the Levant the location of Dei changes, of course.
[210] Africa
[211] Codex Atlanticus, Sheet 852r, Library Ambrosiana, Milan.

clean up the biography and the review of Leonardo's work of all the distortions made in the chorus of the centuries is necessary.

The direct testimony reported by Benedetto Dei, moreover, is even more important because it allows us to realign Vasari's first story with that contained in Anonimo Gaddiano, where we have seen a reference to Leonardo's first experience in Milan long before 1476[212]. It was during this first visit to the duchy of Sforza that the musician-artist, accompanied by the faithful Atalante Migliorotti, gave Duke Francesco a lyre made partly with his own hands with silver inserts.

Exactly as Vasari writes in the first version of The Lives.

In this case, according to the officially recognized biography, at that time Leonardo would have been thirteen years old[213]. Despite his very young age and his lack of specific training, he would already be an excellent painter and the best lyre player among those present at the Sforza court. The young musician, moreover, was accompanied by a promising pupil, who in turn became an esteemed lyre player and luthier[214].

So I ask myself: Do the references that would place the birth of Leonardo on 15 April, 1452, and the indications written in the cadastral records of 1458 and 1469, found only after 1746, correspond to the truth, or were they written by the notary Sir Piero and his father Antonio to hide a different identity of the little Leonardo, perhaps as a consequence of an adoption? Perhaps related precisely to the question of succession of that Niccolò of Sir Vanni, the usurer for whom Sir Piero was executor of his will and beneficiary of part of the properties?, Among them was the house in Via del Palagio del Podestà, situated no more than a couple of hundred meters from the Oratory of San Martino built in 1441 by Antonino Pierozzi—the prior of the Dominican convent of San Marco in which a cell was reserved for Cosimo the Elder—to welcome and support the families' victims of usury, and for which he opposed the execution of the will of the notary da Vinci, obtaining property and compensation. Was this perhaps a way for the Medici to financially support Sir Piero? Who knows.

[212] That is when Leonardo was accused of sodomy.

[213] If it is true that he was born on 15th April 1452.

[214] In 1493 Isabella d'Este, Marquise of Mantova, eager to learn how to play the guitar, urged him to build a small one. More likely it was an arm's lyre, the instrument of which Migliorotti was esteemed virtuoso—Treccani Biographical Dictionary

Certainly the "non-legitimate" with which Leonardo is defined as the son of Sir Piero in the cadastral record of 1458[215], or the need for the Anonimo Gaddiano to point out that "despite his not being a legitimate son of Sir Piero, he was for mother born of good blood," or again the uncalled-for need that moves Vasari to specify that the notary da Vinci, with regard to the "nephew" Leonardo, "very good uncle and relative he was in helping him in his youth." would assume a different meaning.

In this case the biographies of the sixteenth century and the direct testimonies of those who knew Leonardo during his life are all unanimous in telling us the story of an old and impaired man who died no younger than seventy-three years of age.

We'll come back to this. Obviously we'll come back, since Leonardo's real, natural parents are identifiable and are also very important.

The time has now come, finally, where we can introduce the informational support contained in the paintings of the fifteenth century into the analysis of a historical narrative that is evidently incomplete, contrived, and distorted with malice.

These works, due to the very high pictorial or sculptural realism that distinguishes them, assume an additional documentary and narrative value that can be homologated in all respects to that of manuscripts.

As Leonardo teaches us from the pages of the Treatise on Painting[216], and as he teaches above all to his pupils and fellow painters, we take note that:

> "Painting [which for Leonardo is the figuration of visible things] has its purpose communicable to all generations of the universe, because its purpose is object of the visual virtue."

[215] Florence, State Archives, Cadaster 796, c. 596r. "Lionardo son of Sir Piero non-legitimate, born from him and from Chaterina, at present woman of the Troublemaker of Piero del Vaccha da Vinci, 5 years of."

[216] The text of this treatise is a posthumous reconstruction of Leonardo da Vinci's annotations and theories on theoretical and practical aspects of painting, thought to have been written by Francesco Melzi who inherited his codices and drawings. According to Luca Pacioli, as can be seen from a letter he wrote on 9 February 1498, the treatise was already completed before the end of the 15th century:

"Having already, with all diligence, completed the book about painting and human movements."

To date there are no complete versions of Leonardo's hand text.

Painting, and consequently drawing, are for Leonardo the medium through which the artist studies and faithfully reproduces the surrounding reality. Reproductive fidelity is therefore an absolute, unbreakable constraint for Leonardo, so much so that when he considered himself unable to reach the perfection with which reality is composed, he would abandon the work in progress.

It is Vasari himself who reminds us, admonishing those who would criticize him for his attitude (and I have read and heard many of these critiques in recent years):

> "It was found that Lionardo, with his artistic intellect, began many things but never finished any of them, as it seemed to him that the hand could not fulfil perfection in art of the things which he imagined, as the idea of some marvelous difficulties was forming, that could not be expressed with the hands, even though they were still excellent.
>
> There were those who had had the opinion (as various are human judgements, many times out of malicious envy) that Lionardo (as with many of his works) started it without the desire to finish it because being so big, and wanting to cast it all in once, he found it extremely difficult... And it may be believed that from this outcome many could have come to this conclusion, since many of his works remained imperfect. But the truth one can believe is that his great and excellent soul, impeded by his excessive generosity and by the constant desire to seek excellence above excellence and perfection above perfection, was the cause of it."[217]

In Leonardo's work even the smallest of details takes on meaning, and for this reason it is never painted by chance. In the treatise just mentioned, Leonardo even shares the strict rules to which an artist must submit in order to obtain a drawing or a painting as faithful as possible to reality:

> "Have a glass as big as a royal half-sheet, and secure it firmly in front of your eyes, between the eye and the subject you want to portray. Then place yourself with your eye far away from the glass, 2/3 of an arm, and hold your head with an instrument so that you cannot move it. Then close or cover one eye, and with the brush and a sharpened pencil, mark on the glass what appears on the

[217] *The Lives* by Giorgio Vasari, first and second edition, 1550—1568.

other side, and then polish the glass with paper and sprinkle it on good paper, and paint it, if you like it, using well the air perspective."[218]

The graphic technique described is well illustrated in a couple of Leonardo's drawings[219] and some by Albrecht Dürer, the extraordinary German engraver who was his pupil thanks to the proximity of the court of Frederick III and Maximilian I to that of the Sforza. (See Figure 3.)

FIGURE 3—LEONARDO DA VINCI, CODEX ATLANTICUS, SHEET 5R, AMBROSIANA LIBRARY, MILAN

It is not accidental, therefore, that in the same drawings the German artist portrays Leonardo himself in the act of exercising this peculiar technique. This specific way of representing reality according to a precise point of observation is a graphic and pictorial principle known as anamorphosis[220], a technique the two artists were among the forerunners in using. Donatello and Filippo Lippi were also early users of

[218] Manuscript A, Sheet 104r—Institut de France, Paris.

[219] Codex Atlanticus, Sheet 5r—Ambrosiana Library, Milan.

[220] It is so called a type of pictorial representation realized according to a perspective deformation that allows the right vision from a single point of view (being instead deformed and incomprehensible if observed from other positions).

anamorphosis—together with Beato Angelico, they were probably Leonardo's true teachers of painting and sculpture.

By neglecting this skill of his, art historians for years have criticized Leonardo's paintings, taking as an example the terrible errors of perspective and proportion contained in the Annunciation[221], one of his first known paintings. Apart from the fact that this painting contains decorative elements of stunning beauty[222] (so much that it makes me doubt that Leonardo's true master could have been Verrocchio), disqualifying Leonardo's work in relation to the errors of perspective and proportion contained in this extraordinary painting means not understanding anything about the work itself.

This was the case until 2006, when the forward-thinking new director of the Uffizi, Antonio Natali[223], put forward the hypothesis that the work, perhaps because it had been commissioned to be placed on a side wall of a room, could have been deliberately conceived in that way by Leonardo using the anamorphic technique. In this way, the viewer could have had a realistic perception of it, something that the client's positioning would not have ensured[224]. It's a bit like the dead Christ by Mantegna, an extraordinary work exhibited at the Pinacoteca di Brera in Milan, whose evaluation cannot be separated from a certain point of observation.

Although Leonardo's clear anamorphic intent is now established, perhaps because of the practical consideration of the exhibition spaces and the dynamic path of the visitors, if you go to the Uffizi, the Annunciation continues to be exhibited offering a frontal view, thus maintaining an error in perspective that was not at all an error.

[221] Oil and tempera painting on a large panel (98×217 cm), datable around 1472. Today preserved in the Uffizi Gallery in Florence, it was found only in 1867 in the small church of San Bartolomeo in Monteoliveto, a small village in the hills south of Florence. For the first time the scene of the Annunciation to the Virgin of the Immaculate Conception is represented outdoor, dictating a manner that would later be taken up by many other Renaissance artists.

[222] I allude to the transparencies of the veil that surrounds the book in front of the Virgin, for example, or to the capital that recalls the same capital portrayed by Ghirlandaio in the *Appearance of the angel to Zaccaria*, in Santa Maria Novella, where, as we have seen, Benedetto Dei is also portrayed.

[223] Antonio Natali, Director of the Uffizi Gallery in Florence from 2006 to 2015.

[224] Antonio Natali, The mountain on the sea. The Annunciation of Leonardo (2006).

What does this teach us? That by interpreting the reality in front of us, we often go into the tortuous paths of the mind looking for who knows what readings driven by external conditioning and personal limits of all kinds. This, of course, is the best case. In the worst, we seek solutions by drawing on the narrow circle of things that it is convenient to say or think, according to speculative mechanisms that are proper to man's weakness. And for this we fall into error. The reality, however, manifests itself before our eyes without veils, just like the emperor walking naked in Andersen's famous fairy tale[225]. It is up to us to grasp it in its integrity. Or not.

In that case we find ourselves in the condition described by Nietzsche. The interpretation of facts replaces reality and assumes the binding anointment as truth[226]. But this does not mean that reality is different from what it is. We often lose sight of the meaning of the word truth, giving it an absolute value. A truth is nothing more than a partial and subjective view of reality.

This is why Leonardo is so imperative in defining pictorial criteria: only in this way can the mediation between the painter and reality tend toward zero. The observer won't come to a different perception, except on the basis of his own visual capacity.

I used to get angry when I read the most bizarre theories that, from time to time, were put forward about Leonardo's work or the Renaissance in general, even when made by the most authoritative scholars, or at least as such they were recognized, as in the case of the proportions in Leonardo's Annunciation. Then I realized that getting angry was useless and that the only way to prevent this from happening again in the future was to deliver a work like the one you are reading. Through this work I can oppose, to whoever wants to read it, elements that have in their simplicity the strength of the obvious. I hope that it might one day contribute to making people consider things for what they are and not for what speculative forms and cultural convenience have suggested.

Let me give you another banal example of how it is more complicated to elaborate a wrong thesis than to read the reality of things in their simplicity.

[225] The Emperor's new clothes (Keiserens Nye Klæder). The Danish fairy tale written by Hans Christian Andersen and published for the first time in 1837 in the volume Fairy tales, told for children (Eventyr, Fortalte for Børn).

[226] Truth is the partial interpretation of reality.

A magazine of the University of Padua[227] recently reported a study, which was published in October 2018 by Christopher W. Tyler[228] in an American magazine, that claimed that the brilliant touch Leonardo had in painting, and in particular his ability to represent the depth and three-dimensionality in his paintings, was due to the strabismus that Leonardo suffered from[229]. (See Figure 4.)

FIGURE 4—THE STRABISMUS OF LEONARDO DA VINCI IN A WORK BY DESIDERIO DA SETTIGNANO. OLD SACRISTY, BASILICA OF SAN LORENZO, FLORENCE.

Leonardo was truly suffering from a slight form of strabismus, as we will see later. But precisely because of this physical defect, together with other peculiarities of his physiognomy that we'll

[227] *The Bo*—Magazine of the University of Padua.
[228] Christopher W. Tyler is a visual neuroscientist, creator of the autostereogram, a stereogram made to create in the human brain a three-dimensional optical illusion from a two-dimensional image. He runs the Smith-Kettlewell Centre for Brain Imaging and holds a chair at City University of London.
[229] Terracotta bust of a deacon dated 1460/1464, work by Desiderio da Settignano—Sacrestia Vecchia Basilica di San Lorenzo—Florence.

analyze later, it will be possible to recognize the portraits that his contemporary artists made of him. They made—or he made, in the case of the Annunciation—a painting in which Leonardo portrayed himself in the role of the announcing angel.

Returning to the study that would lead Leonardo's brilliant pictorial touch in painting back to his light squinting, perhaps it would have been enough to read his advice included in the Treatise on Painting. In doing so, the author of this theory would have known that Leonardo drew or painted with one eye closed, and perhaps he would have refrained from saying such an idiocy!

In the same way, I smile when I read statements that say the landscapes portrayed by Leonardo in his paintings were the work of pure fantasy. They certainly are for those who do not know or cannot recognize or, even worse, do not want to recognize the landscapes that Leonardo portrayed. The backgrounds inserted by the artist in his paintings are all made on the spot, live, and are characterized by a reproductive fidelity respected in the smallest details, so realistic they are in every case.

The painted landscapes do not differ from those that the artist sketched in pencil or pen with such precision and verisimilitude in his travel notes. On the contrary, sometimes it is precisely the recognition of the portrayed landscape that allows us to subvert the erroneous interpretation of a work that is instead based exclusively on the presumptive reading of the references contained. Such is the case for "portrait of Geneva by Amerigo de' Benci," mentioned both in Anonimo Gaddiano and in The Lives of Vasari[230], and now kept at the National Gallery in Washington. And since the landscapes portrayed identify precise points of observation—all located along the network of roads at the time, which developed along old mule tracks—today it is possible to reconstruct step by step the routes travelled by the artist and understand where he was on a given date.

The most relevant example is again the Annunciation, a work in which the landscape even becomes the real protagonist of the scene. Coinciding with the focal, perspective, and chromatic center of the whole painting, the landscape portrayed by Leonardo in the Annunciation identifies a precise glimpse of Lario (better known as Lake Como). Since the work dates back to 1472, this precious confirmation is

[230] As I will later highlight in detail

an indirect validation of the hypothesis that the artist was in Milan well before 1483. These too are documentary evidence, after all, even more solid than the written ones.

The art of the early Renaissance was not only characterized by a very strong figurative realism (Leonardo teaches us[231]), but often enabled the most educated artists to transmit the esoteric elements rooted in the knowledge that animated the main Italian courts after the Council of Florence in 1439. In this way the Neoplatonic artists were able to avoid papal censorship. This was created to circumscribe and contain heresies of pagan origins ascribable to the charismatic figure of Gemistus Pletho, who was perceived as a clear threat to the faithful nature of the Catholic foundation.

Beginning with Pope Pius II, continuing with Paul II, and even more so with Sixtus IV[232], the Church began to oppose not so much to the wave of Humanism that infused the Renaissance, but the anti-Christian pagan drifts that the movement naturally carried within itself. As we have seen Ghirlandaio doing in the cycle on the life of St. Francis conserved in the Basilica of Santa Trinità in Florence, the Renaissance artist occasionally inserted earthly elements that concerned his client (in this case Francesco Sassetti), in a manner that became common in the middle of the fifteenth century.

Through the request to include themselves or personalities of political or artistic importance within a sacred iconography (or in any instance referring to saints or testamentary episodes), often in a very self-celebratory way, the commissioners of the work did not run into the suspicion of ministers and censors of spiritual power, who were almost always Dominicans. This self-celebratory choice by the commissioners offered Renaissance artists a certain iconographic freedom, which allowed primarily them to include in their works elements of pagan derivation. These were not necessarily elements of religious worship or linked to any knowledge inspired by astronomical laws that they would otherwise not have been able to paint, due to the papal restrictions.

In a world devoted to cultural and ideological pluralism, as apparently is the case today, all this may seem anachronistic and illiberal. But the legacy of censorship to which Renaissance artists were subjected has remained strongly rooted in the interpretation that

[231] Treatise on Painting
[232] That planned from Rome the *Congiura de' Pazzi.*

historians still give today. And I am well aware of this, as in these years I have had to endure more than one attack for the mere fact of having exposed what you are reading.

Historians' attitudes however, are not dictated so much by an ideological and cultural factor—or at least not only by that. We cannot deny that a certain conservative inertia in this sense has been maintained. More often than not, this pro-Catholic conservative approach is induced by a self-referential attitude typical of the academic and museum world, and as a result every theory put forward that is different from those shared for years, even if it is solid both in cultural foundations and from a philological point of view, is not even taken into consideration let alone analyzed.

Nothing has changed with respect to the way in which, five centuries ago, Leonardo himself was received by the intellectuals of the time: "Foolish people!"[233]

Returning to the Renaissance works and their correct reading, it must be said that they often incorporate all sorts of different contents far from the religious orientation with which the work is presented and narrated even today. For this reason, omitting the narrative means conditioning the public through a strongly partial interpretation that completely distorts the communicative intent and the substantial content of the work itself. From a conceptual point of view, the work is then no longer that of the artist who made it, limited to the manual skill used to lay down layers of paint or to model the material, but that of the art critic who reinvents it through a personal reading. At least, that's the case whenever the meaning is not dictated by a third entity—in this case the Vatican—who over the centuries has indicated the lines of interpretation to be adopted in order to stem the survival of a cultural system that, at the origin of the Renaissance, was experienced as a threat to be nipped in the bud. This attitude toward interpretation still remains in inertial today, and so any Renaissance work reading alternatives to the academic one is branded with esotericism and as such is considered unfounded and stigmatized.

Yet in some cases certain references are clear, undeniable, and well-founded. If, for example, you observe with attention and without preconceptions of any kind Sandro Botticelli's The Spring,[234] behind the

[233] Codex Atlanticus, Sheet 327v, Ambrosiana Library—Milan.
[234] Painted in tempera on panel, datable between 1478 and 1482, it is kept in the Uffizi Gallery in Florence.

head of Venus impregnated by immaculate conception, you will see two lungs outlined by the branches of the trees behind. In the middle of this figure the "spiritual site" was believed to be located, as it is clearly identified in a drawing by Leonardo at the level of the thymus gland, in correspondence to the sternum, according to a mapping by energy meridians typical of pagan cultures, both Eastern and Western. (See Figure 5.)

food cane
air transit
lung
spiritual site
heart
liver
stomach
belly
navel
bladder
spleen[235]

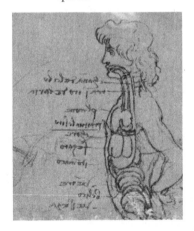

FIGURE 5—SPIRITUAL SITE IDENTIFICATION, LEONARDO DA VINCI ANATOMICAL DRAWINGS, ROYAL COLLECTION WINDSOR, LONDON

The pregnancy of Venus (whose head is deliberately positioned in the center of the lungs indicated above), in the symbology that Botticelli wanted to indicate, presupposes the virginal rebirth of the

[235] Anatomical drawings, Sheet 004 r—Royal Collection, Windsor

regenerated man, according to the concept of the immortal vital spirit that animates the mortal material body. (See Figure 6.)

The Birth of Venus itself—a painting that was probably conceived by Botticelli as complementary to The Spring in terms of form and philosophical references—rising from the waters is animated by the vital spirit blown by the Syzygy on the left of the work. The reference that inspired Botticelli is clearly borrowed from the concept of the vital spirit narrated by Virgil ("Spiritus Intus Alit").

FIGURE 6 — SPRING BY BOTTICELLI, DETAIL. UFFIZI GALLERY, FLORENCE

This ideally refers to a more ancient period, the Egyptian one, in which through the funeral ritual of the opening of the mouth, the vital spirit was freed from the chains of the material body, now decayed, to again become the energy that will revive a new body. Both these concepts were well-known at Leonardo's time, and he then reflected them in his artistic works and writings[236].

Hearing about Egyptian inspiration for Leonardo's work may seem crazy to you, as it did to one of Leonardo's most authoritative scholars

[236] This is the case for example of the painting Tobias and the Angel, a work defined by Leonardo and Verrocchio, 1470/1475—National Gallery London. But at the same time it is the case of Freud's analysis of a childhood memory of Leonardo, from which Freud deduced the artist's homosexuality.

who opposed me years ago to whom I had offered to share what my studies showed. But by the end of this book, it will seem the norm.

Unfortunately not all the works of the greatest Renaissance artists have been able to reach us. And not because of the countless wars fought in more than five centuries or the erosive and corrosive actions of time, as one would expect. Rather, they were spoiled by the Church's wish to hide the knowledge contained within them—knowledge that was not meant to reach the masses, as it could weaken the Catholic foundation.

This was not the only reason why many works were made to disappear. In other cases, some works revealed the occult plots of an event that took place during the fifteenth century. This event, even more than spiritual power, contributed to literally splitting the Renaissance sides in two. I am talking about the alleged discovery of America, of course.

Whatever the reason was, it doesn't matter. Many of the Renaissance works were destroyed so that they couldn't reveal to the masses what was considered inconvenient. Recall the most famous of the bonfires of vanities, the one held in Florence on 7 February, 1497. Following the expulsion of the Medici, the followers of the Dominican friar Girolamo Savonarola seized and publicly burned thousands of manuscripts considered immoral—scores of songs considered profane, and paintings, many paintings, which through their realism could reach even the less educated people, who were not able to grasp the meaning of philosophical writings. Among the works destroyed by Savonarola were also some paintings by Sandro Botticelli, who personally took them to the stake.

The works of many philosophers, poets, and humanists of the time were affected by this same fate. Among them were Marsilio Ficino, Pico della Mirandola, Cristoforo Landino, Agnolo Poliziano, and other authoritative exponents of the Neoplatonic Academy of Florence. They saw many of their works burned, when they were not forced to bring them to the public stake themselves so as not to incur penalties and penances. Vasari himself commented on one of the many fires in which books and paintings containing pagan references were burnt:

> "The following carnival, in which the city was
> customed in making some canopies of stipa and other
> woods in the squares, and on Tuesday evening, for ancient
> custom, burned them and entertain with love dances...

many nude paintings and sculptures, many of which made by
the hands of excellent Masters, were brought to the place, and
likewise books, lutes and songbooks, and great was the
damage, particularly for painting, where Baccio took all the
drawings he had made of the nude man, and Lorenzo di Credi
and many others, named whimperers, imitated him."[237]

I do not exclude the possibility that some of the works made by
Leonardo that are mentioned in sixteenth-century biographies but of
which there is no longer any trace today[238] may also have ended up in the
same way. This despite Leonardo having spent most of his time in Milan
first and then in France, which allowed much of his work to be
preserved. Unfortunately the same cannot be said of his production
before 1480.

Nevertheless, fortunately, most of the artworks containing pagan
philosophical and mythological references, along with those containing
historical references of a political or geographical nature (which were
more difficult for Dominican censors to intercept), have survived intact.
The high figurative realism with which these works were painted or
sculpted allows us today to evaluate them as reliable documentation in the
same way we would written documentary sources, where they can be
traced back to episodes characterized by a certain chronological reference.
Thanks to these paintings, today we are able to review some biographies
and historical facts that have been distorted over time, thus placing them
back where they belong.

The resulting paintings, in detail as well as overall, are surprising and
allow us to approach the artists, their works, and the whole historical
period with fresh eyes. The resulting overall picture tells us a whole other
world, as we shall see.

Let's return to our story. By comparing the biographies contained in
Anonimo Gaddiano, in The Lives of Giorgio Vasari, and above all in the
Cronache of Benedetto Dei, a contemporary Florentine diplomat and a
direct acquaintance of the Florentine genius, it is possible to backdate
Leonardo's presence in Milan to at least the year 1465. This is when, on
behalf of the Medici, he delivered a lyre made by him to Duke
Francesco, who died the following year.

[237] Giorgio Vasari, *The Lives*, the life of Fra Bartolomeo—Giunti Editore 1568.
[238] Leda and the Swan, Madonna Litta, Head of Medusa, Adam and Eve in Eden,
Madonna with Cat, or various portraits such as that of Piero Francesco del Giocondo, or
cartoons such as the one for the Battle of Anghiari for the Great Hall of the Council and
much more, as the list is much longer.

In the choir of the church of Sant'Agostino in San Gimignano, there is an extraordinary cycle of paintings commissioned to the artist Benozzo Gozzoli[239] by Fra' Domenico Strambi, an erudite Augustinian monk of the convent who had obtained the patronage of the Main Chapel from the Dietiguardi family. The entire cycle is located behind the high altar and consists of seventeen frescoes concerning stories from the life of Saint Augustine. Benozzo Gozzoli was a pupil of Giovanni da Fiesole, better known as Fra Angelico or Beato Angelico[240], a great painter who inspired most of the greatest artists of the Florentine Renaissance, including Leonardo. He also collaborated personally with Beato Angelico in the painting of the frescoes in the Dominican convent of San Marco[241] in Florence, commissioned by Cosimo de' Medici, for whom Gozzoli also painted the chapel of the family palace in 1459.

Returning from Venetian exile in 1434, Cosimo had become the de facto lord of Florence[242]. Among the first works he ordered was the reconstruction of the Benedictine convent of San Marco, after having obtained the expulsion of the Silvestrini monks who occupied it and having installed in their place the Dominicans of Fiesole, to which Beato Angelico belonged.

At that time, the prior of the convent of San Marco was that Antonino Pierozzi, whom we have already met a couple of times in the course of this writing as an opponent of the testamentary execution in the inheritance of Niccolò di Sir Vanni curated by the very young notary Sir Piero da Vinci. Pierozzi was also the promoter of the oratory of San Martino and the confraternities that worked in favor of the needy and the Florentine orphans of Bigallo and Misericordia.

The seventeen total frescoes relating to stories from the life of St. Augustine can be dated to the year 1465:

I. Augustine accompanied by his parents to school

[239] Benozzo Gozzoli (1420-1497) was a Tuscan painter, a pupil of Beato Angelico with whom he collaborated in the decoration of the Convent of San Marco in Florence.
[240] A Dominican friar, an excellent painter, he tried to combine the new principles of Renaissance art, such as perspective construction and attention to the human figure, with the old medieval values, such as the didactic function of art and the mystical value of light
[241] They were executed by Gozzoli according to Angelico's design: the Prayer in the Garden in cell 34, the Man of Sorrows in cell 39, the Crucifixion with the Virgin and Saints Cosmas, John the Evangelist and Peter the Martyr in cell 38.
[242]

II. Augustine at school with the grammar teacher

III. Santa Monica prays for her son

IV. Monica weeps Agostino leaving for Rome

V. Augustine disembarks in Ostia and is welcomed by Simmaco, prefect of the city.

VI. Augustine teaches rhetoric and philosophy in Rome

VII. Augustine leaves for Milan

VIII. Augustine arrives in Milan; meeting with Emperor Theodosius I and Bishop Ambrose

IX. Augustine discusses with Ambrose; Monica prays to Ambrose for the conversion of her son; Augustine listens to Ambrose's sermon

X. Augustine's conversion

XI. Augustine is baptized in the Cathedral of Milan by Saint Ambrose

XII. Augustine among the hermits of Tuscia; Augustine gives the rule to the Hermits; Augustine and the child on the beach

XIII. Ecstasy of Ostia; Death of Saint Monica in Ostia; Augustine leaves for Africa

XIV. Augustine consecrated bishop; blesses the people of Hippo

XV. Agostino overcomes Fortunato

XVI. Saint Jerome appears to Augustine

XVII. Funeral of Augustine in Hippo

In the first part of the painting cycle, St. Augustine is depicted as a lay master and scholar until, following his conversion (in the tenth lunette), he became a hermit friar. This transformation, compared to the painting, is anachronistic. The order was actually established only in 1256, and St. Augustine lived in the third century CE. From this anachronism it is possible to understand how the recourse to St. Augustine[243], — as it was to St. Francis in the cycle in the Holy Trinity commissioned to Ghirlandaio by Francesco Sassetti — clearly underlies the intention to emphasize the deeds of a particularly important character who really lived in the age of Gozzoli in the flesh.

A further proof of this reading can be deduced from the fact that the individual characters portrayed here have a recognizable physiognomy that can be traced back to precise historical figures. Moreover, Benozzo

[243] Aurelio Agostino from Hippo (354—430) was a Roman philosopher, bishop and theologian of Latin expression and of Berber origin, who converted to the Christian religion after a trip to Milan.

Gozzoli is considered one of the most faithful portrait painters of his period, so the recognition of the characters he portrays in these frescoes is made easier. It remains to be understood why the artist decided to resort to the stories of St. Augustine's life and which character he intended to paint as St. Augustine.

The reasons why the Tuscan painter, who grew up under the teachings of Beato Angelico, chose to tell the story of the mysterious character through the life of St. Augustine are mainly three:

"St. Augustine is considered the greatest Christian thinker of the first millennium and certainly also one of the greatest geniuses of humanity.

He was a pagan when he was literally kidnapped by the Neoplatonic philosophy, even though it was the Western sort and more Christian than the Byzantine style, which was more faithful to Plato's traditional reading.

It was to Milan that St. Augustine decided to go. Here, thanks to his meeting with the Milanese bishop Ambrose, he converted to Christianity and thus became father, doctor, and saint of the Catholic Church."

It was the bishop of Milan himself, Ambrose[244], who baptized Augustine in the cathedral of the Lombard city in 387 CE.

Let's focus our attention on lunette number VII, which tells of Augustine's journey to Milan. Leaving Rome behind[245] in the company of Giovanni II Bentivoglio[246], here depicted wearing the characteristic red hat, we can recognize on the left, on horseback and wearing a curious and exotic straw hat, Lorenzo de' Medici. His physiognomy, characterized by a particularly flattened nose, makes him unmistakable. Agostino, or rather, the mysterious character he is portrayed as, is with a pinkish beggar, and, more in profile, Giuliano de' Medici, Lorenzo's brother, is the only portrait on foot. (See Figure 7.)

[244] Who then became the patron saint of the city, Saint Ambrose.

[245] Recognizable from the view in the background, where the Pyramid Cestia and the Pantheon are clearly recognizable.

[246] De facto Lord of Bologna since 1464, the year in which his cousin Sante died, and of whom he married the widow, Ginevra Sforza. He was a deep friend and faithful ally of Lorenzo de' Medici.

FIGURE 7 — STORIES FROM THE LIFE OF SAINT AUGUSTINE,
1465. BENOZZO GOZZOLI, CHURCH OF SANT'AGOSTINO SAN
GIMIGNANO, SIENA

The episode Benozzo Gozzoli has accented by painting this lunette is
the journey made on 23 April, 1465, by the brothers Lorenzo and
Giuliano de' Medici on assignment for their father Piero[247] to establish
good diplomatic relations where the Bank of Medici had its branches—in
Milan by Francesco Sforza, and in Venice, where they met the Doge
Cristoforo Moro. During this same journey, they had the opportunity to
visit allies of the Florentine Seignory: Borso d'Este (Lord of Ferrara) and
Giovanni II Bentivoglio, who had just taken over from his cousin Sante,
who died the year before, running the city of Bologna. Giovanni,
brotherly friend of both Lorenzo and Leonardo, married the widow of
the deceased cousin, Ginevra Sforza, daughter of Alessandro, Lord of
Pesaro. To accompany them in the diplomatic role that best suits him is
Benedetto Dei, as he personally wrote in his Cronache:

> "I was in Milan the year that Francesco Sforza took it with
> the sword in hand, and I came back with the Medici..."[248]

Two angels holding an inscription above the minor procession. The
inscriptions respectively mention the commissioner of the cycle, the
name of Benozzo, and the date of execution of the work:
MCCCCLXV[249]. Because it refers to the journey begun by the de'

[247] Known as *Gottoso*
[248] Memoirs of Benedict Dei, ms. Ashb. 644—Laurentian Library—Florence.
[249] 1465

Medici brothers in April 1465 and because the painter portrayed himself on the righthand side in a red dress, it is presumed that this may have been the last lunette of the cycle to be frescoed.

It's obvious that if this fresco alludes to the journey made by the de' Medici brothers to meet Francesco Sforza in 1465, as seems more than evident, it indirectly confirms the thesis that the stories from the life of St. Augustine frescoed by Benozzo Gozzoli in the Church of St. Augustine in San Gimignano conceal the deeds of a prominent figure from the political or cultural life of the time, apparently a contemporary of or slightly older than the other three characters portrayed. Giovanni was born in 1443, Lorenzo in 1449, and Giuliano in 1453.

What do you think? May Benozzo Gozzoli have portraited Leonardo going to Milan to take to Duke Francesco the arm lyre that had been partially built with his hands, as testified by both Vasari and Gaddiano? This is obviously a rhetorical question, knowing well Leonardo's physiognomy during his different ages—physiognomy that soon will be very clear to you too. After all, the affinities between Leonardo and St. Augustine are more than evident. They can be identified both in the role that Neoplatonism had in the cultural formation of both men and in the importance of the trip to Milan. So the choice to narrate the deeds of the young and already talented Tuscan artist by "confusing" them with those of St. Augustine of Hippo is understandable.

Meanwhile you can note that, together with the angel messenger painted by Leonardo himself in the Annunciation of 1472 and the bust of a deacon in terracotta by Desiderio da Settignano kept in the Old Sacristy of the Basilica of San Lorenzo in Florence, this is the third unspoken juvenile portrait of the Florentine genius we meet. This tells us essentially two things: that we can recognize Leonardo's juvenile physiognomy, and that he was already sufficiently renown at the time, judging by the number of works in which he was portrayed at a young age. After all, he had to be known, since in all his biographies, there is no author who does not highlight his beauty, grace, and divinely gifted strength[250]. And there is no artist of the

[250] "In Leonardo stood out for his gifts of great completeness, very generous and educated manners, accompanied by a beautiful appearance"—Paolo Giovio/Rezzonico

time, as we shall see in chapter IX that I have decided to dedicate to the countless portraits of Leonardo, who did not pay him attention.

This dichotomy between an alleged lack of documentary sources on the one hand and the disproportionate number of portraits in which Leonardo is involved inevitably leads us to wonder: Was the intention to hide Leonardo's identity, on the one hand to protect him and on the other one to prevent him from being celebrated for what he personified as the first witness of the entire Neoplatonic Renaissance movement? If that's the case, we could say that Leonardo was twice illegitimate: once as the son (perhaps adopted) of the notary in Vinci, and a second time as a role model of that cultural movement based on the pagan foundations brought to Florence by Gemistus Pletho. Leonardo took up this baton, and the Church worked to stem it with all its strength.

The proof of Leonardo's role lies precisely in the recognition that his contemporaries gave him by placing him at the center of their representations. It's a role for which he will be almost systematically belittled by his biographers, according to the papal will of the time, in order to defend the fragility of the dogmatic culture of Catholicism. It was a role that was certainly not diminished by the earliest biographers, Anonimo Gaddiano and the first version of Vasari's encyclopedic work.

This reading would perhaps help us to understand the role played by Vinci's notary, Sir Piero, in relation to whom Leonardo was considered illegitimate—not so much due to a relationship with a slave, but perhaps because he was adopted to keep his true identity hidden. In such a case, rather than talking about a real adoption, it would be more appropriate to talk about a sort of "notarial trust," in the same way that some investors

"He was so rare and universal that by miracle of nature could be said to have been produced; Nature that not only gifted him of the beauty of the body but also made him master of many other rare virtues"—Anoniomo Gaddiano

"Great gifts rain down from celestial influences on human bodies, many times naturally and sometimes unnaturally, filling one single body with beauty, grace, and virtue in such a way that whatever he approaches, each one of his actions is so divine that, leaving behind all other men, he manifestly makes himself known for a deed (as it is) bestowed by God and not acquired by human nature.

This is what men saw in Lionardo da Vinci, in whom, beside the beauty of the body, which is never praised enough, was the infinite grace in any of his actions, and so great was his gift that whatever difficult things his soul turned to, he made them with ease. Great was the strength in him, combined with dexterity, spirit, and valor, he was always regal and magnanimous.'"—Giorgio Vasari, The Lives

hide their identity in a modern anonymous trust[251]. A whole series of clues converge in this direction.

In addition to those that we will see later, I would like to remind you of what has already been analyzed:

- The notary Sir Piero, "very good uncle and relative he was in helping him in his youth";

- Despite he was not being a legitimate son of Sir Piero, he was for mother born of good blood;

- The same date of birth, 15 April, 1452, noted on the last page of a notarial protocol by the alleged grandfather in the family book, discovered only after 1746 and incompatible with any documentary reconstruction concerning Leonardo's life;

- Inconsistencies about an alleged self-taught education, when in reality Leonardo showed a very deep and precise preparation;

- In 1465—at the age of thirteen, if the inscription in the notarial protocol of Sir Antonio was correct—Leonardo was already publicly celebrated as an excellent painter and musician, so much to have pupils (see Atalante Migliorotti)"

There is then another element that could perhaps offer us another important clue. I am alluding to his hereditary legacy. In the Anonimo Gaddiano is written:

> "He left 400 ecus to his brothers, who had in deposit in Florence in the hospital of Santa Maria Nuova, where after his death no more than 300 ecus were found by them."

Let's be clear: this aside alone tells us nothing, in the same way that, if taken individually, any other element does not assert anything. It is one of the pivotal postulates of mathematics, after all: an infinite number of lines can pass through a single point, but only one line can pass through two points. The same applies to interpretations of the same element. Taken individually, each clue could be interpreted in an infinite number of ways, but when it is combined with other,

[251] The fiduciary entrustment ensures complete anonymity to those who wish to carry out an operation or hold an asset without being recognized.

elements it gives shape to a single, incontrovertible reading that tends toward the reality of the facts.

This could perhaps be the case of the passage noted in Anonimo Gaddiano, completely overlooked by Vasari, which takes on a completely different importance if we consider that in Renaissance Florence, it was mandatory that when a child was adopted, a contract had to be signed. By signing this contract, the adopter (or foster parent) committed to take care of the child "as their own." In the case of a male child, the adopter had to provide for his school education, which consisted of learning to "read, write, and do the abacus."[252] In addition the foster parent had to ensure that the adopted child was routed toward some professional activity so that as an adult he could provide for himself.

From this perspective we can then perhaps interpret two passages contained in Vasari's biography that clearly state that Sir Piero would have led Leonardo to painting through his friend Andrea del Verrocchio, even if this was not necessarily true:

> "Having seen this Sir Piero, and considering the height of that ingenuity, one day he took some of his drawings them to Andrea del Verrocchio, who was a great friend of his, and begged him to tell him directly whether Lionardo, if led toward drawing, would make any profit. Andrea was amazed at seeing the great beginnings of Lionardo and told Sir Piero to make him wait, and ordered that Lionardo should go to Andrea's workshop. Which Lionardo willingly did. And not only did he practice a profession, but all things where drawing was involved. And having such a divine and marvelous intellect, being a great surveyor, he not only worked in sculpture and architecture but turned also to painting.
> [...]
> In his childhood he approached art, thanks to his uncle Sir Piero, along with Andrea del Verocchio, who, while making a panel where St. John baptized Christ, gave Lionardo an angel who was holding some garments to paint; and although he was young, he made him in such a way that Lionardo's angel was much better than the figures of Andrea. This was the reason that Andrea never wanted to touch colors again, outraged that a child was better than him."[253]

[252] *Il Rinascimento dei trovatelli,* by T. Takahashi—History and Literature Editions—Rome 2003
[253] G. Vasari, *The Lives*—Giunti Editore—Florence, 1550.

While the Anonimo Gaddiano does not make the slightest reference to the fact that Leonardo was a pupil of Verrocchio—a circumstance about which I am personally very skeptical as you may have gathered—Vasari does, but with great confusion. In spite of this, scholars give a lot of credit to this version, tracing the episode back to when Leonardo was ten years old or a little more—in 1462, according to the date noted by his alleged grandfather Antonio. This circumstance is in my opinion very doubtful, not only because of the fact that, as now seems more than evident to me, Leonardo was born a decade before that phantom 1452, but also because Verrocchio[254] certainly did not excel in painting. He was undoubtedly an excellent sculptor.[255]

Andrea del Verrocchio began his activity as a goldsmith in Giuliano Verrocchi's workshop (from which he took his name). His first attempts at painting would date back only to around 1465, when he collaborated with Filippo Lippi at the choir of Prato Cathedral. Leonardo therefore, according to Vasari, would have been in his workshop when he was not even an established painter.

Moreover, Vasari himself explicitly mentions the contribution of a very young Leonardo in The Baptism of Christ, a work of 1474–75. In fact, he refers precisely to the extremely polite way in which the young Florentine artist painted the angel on the left as one of the reasons why Verrocchio stopped painting, "outraged that a child knew more than him." But if this was the case, Leonardo in 1472–74 would already have been twenty to twenty-two years old, also according to the inscription that says he was born on 15 April, 1452. He would have been much more than a child, having been over twenty years old and above all having already painted a masterpiece such as The Annunciation, which dates back to 1472. It uses anamorphic technique, by the way, a technique used only by Donatello and Filippo Lippi before Leonardo.

I therefore find it difficult to believe that at that time Leonardo could still have been a pupil of Verrocchio. They certainly

[254] Andrea di Michele di Francesco di Cione known as Il Verrocchio (1435-1488) was a Florentine sculptor, painter and goldsmith, whose school is said to have trained Leonardo da Vinci, Sandro Botticelli, Pietro Perugino, Domenico Ghirlandaio, Francesco Botticini, Francesco di Simone Ferrucci, Lorenzo di Credi, Luca Signorelli, Bartolomeo della Gatta and many others.

[255] The author of Anonimo Gaddiano himself does not dedicate him more than a few lines, underlining almost exclusively his sculptural works.

collaborated, as shown by the backgrounds in The Baptism of Christ made by Leonardo, which depict the same Lombard landscape included in The Annunciation, but certainly not in the pupil-master relationship as described by Vasari.

The fact that Leonardo painted not only the angel but also the Larian landscape on the background of The Baptism of Christ, which is a work from 1472–74, contributes once again to placing Leonardo in Milan before 1482.

As it was for David by Donatello, Verrocchio, too, indirectly helps us to give Leonardo a face. In 1467, the Court of Mercatanzia[256] of Florence commissioned Verrocchio to create the sculptural group of the Incredulity of St. Thomas to be placed in the niche outside the Florentine church of Orsanmichele by Donatello himself. The statue depicting St. Thomas sinking his finger into the wound of Christ's ribs, which every day sees thousands of careless Florentines and tourists from all over the world hurtle through the Via dei Calzaiuoli below attracted by what is written in their guides but unable to see what's in front of their noses, also has the features of a young Leonardo.

In this long digression, I wanted to underline how Vasari's story—according to which Sir Piero would have led Leonardo to art through Andrea Verrocchio, even if contradictory and omitted by Gaddiano—could be an indirect confirmation, even if only nominally, of the contractual obligation imposed upon foster parents to lead adopted minors toward a career.

For females, the matter was simpler. It was enough to deposit a dowry in coins at special deposit institutions, which would be withdrawn when the adopted child found a husband. In very rare cases, this dowry was also necessary for males. It usually happened when male children were adopted by the wealthiest families or in the cases of those children born from the numerous flings that the members of the wealthiest families of the time had outside of marriage. These children were brought up by third parties, but they were guaranteed an income that the testamentary laws did otherwise not guarantee for illegitimate children. The dowry was deposited in a specific public fund called a monte doti, which was set up in the various orphanages and welfare congregations, such as the Spedale degli Innocenti, the Oratorio di San Martino, and the

[256] Today the Gucci Museum, the Court was founded in 1359, had six foreign lawyers and six city councilors and settled commercial disputes between the members of the Arts and Crafts of the city of Florence.

congregations of Mercy and Bigallo. These included also the Hospital of Santa Maria Nuova in Florence, founded in 1288 by Folco Portinari[257], where Leonardo's money was deposited at the time of his death.

I do not exclude the possibility that the young notary of Vinci, who had been well known in Florentine circles at a very young age, may have been called to sign a contract of convenience to assume the illegitimate paternity of the young Leonardo. Thus he would be removed from an identity that might have been too important, both because of the hostile climate in Florence in those years—between accusations of heresy on one hand and guerrillas for territorial and financial control on the other—and to cover for a father with a name too pompous.

[257] Father of the famous Beatrice loved by Dante.

CH. III—UNDERSTANDING THE COURSE OF HISTORY THROUGH WORKS OF ART

The analysis of one of the lunettes that make up Benozzo Gozzoli's cycle in San Gimignano is only a small example of how Renaissance art produced around the middle of the fifteenth century can have a strong documentary value only if these three elements are clear:

- the knowledge of specific historical episodes recalled in the paintings;
- a certain chronological reference of facts and works;
- the ability to recognize individual characters portrayed according to an indisputable physiognomy by comparing known portraits, apart from some small differences that may characterize one portrait from the other according to the personal style of the artist who created them.

Before starting to analyze the other lunettes painted by Benozzo Gozzoli in San Gimignano—especially the analogies between these, the pictorial cycle contained in the Oratorio dei Buonomini in San Martino, and the story of Santa Fina shown in Ghirlandaio's frescoes dedicated to her and preserved in the collegiate Basilica of San Gimignano—I would like to talk about another pictorial cycle by Benozzo Gozzoli, this time painted in Florence. Beyond what its contents tell us, the analysis of this cycle of frescoes is fundamental to understanding the role that art has played in describing some historical events. In particular, I refer to the events that animated the fifteenth century. Without these works, today we would not be able to reconstruct the events that contributed to the formation of the current society.

The pictorial cycle to which I refer is in the Chapel of Magi in Palazzo Medici Riccardi in Florence[258]. This palace was the official residence of the Medici family before they moved, after the decline of the

[258] Residence of the Medici family, designed by Michelozzo in 1442.

Medici Signoria in favor of Savonarola, in the following century, to the more famous Palazzo Vecchio.

Palazzo Medici Riccardi is located not far from the church of San Lorenzo and the convent of San Marco, places that at the time were considered to be under the protectorate of patriarch Cosimo the Elder, to the point that the entire area was called the Medici suburb.

In regard to the aforementioned protectorate, it is worth pointing out a very important aspect unfailingly neglected: In those years both the Dominican convent of San Marco and the one of Fiesole, from which the Blessed Angelico[259] came, marked an anomaly that can perhaps help us understanding one of the reasons that Leonardo was sent to Milan at a very young age. Both convents, in an unexpected way, belonged to the Dominican Congregation of Lombardy, into which all the Lombard convents were grouped, along with the convent of Santa Maria delle Grazie in Milan, in whose cenacle at the end of the fifteenth century Leonardo painted the *Last Supper*.

The Dominicans played a central role in all the political events of the time. This lasted until, after the alleged discovery of America by Christopher Columbus and the royals of Spain, they were supplanted by the Jesuits, to which the current Pope Francis belongs. Columbus himself—or perhaps it would be more correct to say the one whose true identity was hidden under his name[260]—had a deep connection with the Dominicans. This is demonstrated by his calling one of the islands he landed on Santo Domingo and betraying his identity through the signature with which his documents are known: "X ferens," or "bearer of Christ," as the members of the Order of Dominican Preachers identified themselves in public.

The vicar of the Lombard congregation in the years in which Benedetto Dei would have accompanied Leonardo and the descendants of the Medici family to Milan[261] was a certain Tommaso da Lecco[262], who was protected by Pius II and friend of the Great Inquisitor Torquemada. Who knows if the anomaly of the Dominican convents of Fiesole and San Marco belonging to the

[259] Benozzo Gozzoli's painting teacher
[260] Giovan Battista Cybo, ascended to the pontifical throne in 1484 with the name of Innocent VIII.
[261] Spring of 1465
[262] The Dominicans over the centuries: historical panorama of the Order of Preaching Friars, author Fr. Daniele Penone, Dominican Studio Editions

Lombard congregation is not the useful clue that reveals the existence of a sort of diplomatic corridor that favored association in the political, cultural, and economic spheres—on the basis of which the Milanese and the Florentine reality were united. It was an association that was sealed by the alliance between the two most powerful families of the Renaissance: the Medici and the Sforza.

To feed this alliance would have contributed to the diplomatic activity of Benedetto Dei and the active contribution of the director of the Bank of Medici, Pigello Portinari, who in those same years commissioned Vincenzo Foppa to decorate the chapel that bears his name in the Dominican cloister of the church of Sant'Eustorgio, named after St. Peter the Martyr. Born in Verona (1205–1252) to a family of Cathars, Peter was a preacher friar at the time of the founder of the Dominican order, Dominic of Guzmán. The Veronese friar was a strong opponent of the Cathar heresy, and in 1244 he was sent to Florence, where he founded the Venerable Archconfraternity of Mercy of Florence, before being killed in an attack in Barlassina, on the road between Como and Milan. For this he was made a martyr. Perhaps the rumor that wants the Cathar heresy never tamed and protected by Cosimo in the Medici Florence of the fifteenth century has a foundation after all.

Returning to the Medici residence in Florence, it is useful to underline that in those years Palazzo Medici Riccardi housed the greatest artistic collection of the Renaissance. It included Donatello's *David*[263], the famous bronze statue that is today the symbol of an important film prize. Scholars indicate a very controversial year for its execution: some date it to 1427 and others to 1460. That is a gap undoubtedly too wide to be accepted without deeper analysis.

For certain we know that this statue is mentioned for the first time only in 1469 in the chronicles of the wedding between Lorenzo the Magnificent and Clarice Orsini. According to these chronicles, we can determine that the statue was already in the courtyard of the palace during the wedding celebrations. Another certain fact is that Donatello died in 1465, so by necessity the statue must have been completed prior to that date.

The palace was built on commission of Cosimo the Elder between 1452 and 1460. Although this does not exclude the statue being made by Donatello before 1452, it is plausible to think that it could have been

[263] Today the icon also of an important award in the Italian artistic and cinematographic world, the Donatello Prize, indeed

made on commission for Cosimo the Elder to decorate the new
residence. At least, it usually worked like that. Vasari reminds us that
in its location in the garden, the statue was placed on a polychrome
marble pedestal. This work was done by Desiderio da Settignano, the
same creator of the "cross-eyed" deacon bust now in the Old Sacristy
of San Lorenzo.

Being that the sculptor was born in 1430 and had started his
artistic career in the late 1450s, it is reasonable to think that the statue
can be traced back to those same years. In relation to the model
portrayed and the fact that, in all probability, *David* was made
together with another statue of the same sculptor dated around
1457[264].

Donatello's David is important mainly for three reasons:

- This statue represents the first nude relief free of
architectural elements since the ancient Roman era.
- It would inspire Verrocchio to make his own version
of David[265].
- Both Donatello's and Verrocchio's statues depict a
teenaged Leonardo da Vinci.

As I said earlier, I will dedicate an entire chapter to Leonardo's
portraits and the peculiarities typical of his physiognomy, so for now
I'll avoid providing evidence for this statement, of which, as indeed
for all the others made, I have solid supporting elements.

That Verrocchio's David portrays Leonardo is a hypothesis
supported by several scholars, and its resemblance to the Announcing
Angel painted by Leonardo in the *Annunciation* of 1472 is proof. For
now, therefore, just assume that even Donatello in his *David* portrays
Leonardo and that his statue was placed in the center of the courtyard
of Palazzo Medici Riccardi, which at the time represented the
absolute epicenter of political and cultural life throughout the
Renaissance. Not exactly what you would expect for the illegitimate
son of a young notary of the Tuscan countryside and a slave, perhaps
Oriental, don't you think? In reality it is not the only time that a

[264] The Statue of Judith and Holofernes, moved to Palazzo Vecchio in 1495 together with
the David
[265] Scholars are almost unanimous in recognizing in Verrocchio's David a youthful portrait
of Leonardo.

statue of Leonardo is placed in one of the most important places related to the Medici family, as we shall see.

The fact that the Donatello's *David* statue portrays Leonardo becomes extremely essential because:

- it satisfies a more than legitimate curiosity about his appearance as a young man, so praised by his biographers;
- and as it could not be made after 1465 because of Donatello's death, the statue of David indirectly confirms a backdating of Leonardo's birth, again in line with what all his biographers, both contemporary and later, claimed.

Inside Palazzo Medici Riccardi, on the other hand, there was a well-stocked art gallery that conserved, more than likely, works by Paolo Uccello, Botticelli, Verrocchio, Pollaiolo, and Domenico Ghirlandaio, together with collections of semi-precious stones, ceramics from all over the world, and much more.

In the large park on the north side of the palace, there was the notorious Orto di San Marco[266]. Here, under the direction of the sculptor Bertoldo, was the forerunner of what we can consider an academy of fine arts, the first of its kind in Europe. In this academy, thanks to the presence of numerous Roman and Greek statues brought from their countries of origin by Cosimo and Piero de' Medici, young artists could study the classical models in person, learning and reproducing the artistic techniques and the neoclassical iconography and its canons[267].

To further elevate the cultural climate in the palace was the frequent presence of the humanist members of another important academy created by Cosimo de' Medici, the famous Florentine Neoplatonic Academy. Members of this academy were philosophers of absolute value, such as Marsilio Ficino and Pico della Mirandola, and poets of the caliber of Agnolo Poliziano and Cristoforo Landino.

[266] To the north of Palazzo Medici Riccardi there was an enormous green area, a park that represented Medici's hunting reserve, in the center of what was considered the "Medici suburb", where various members of the family had purchased numerous houses. Close to these houses, around 1475, Clarice Orsini, Lorenzo's wife, decided to purchase this green area from the Dominican monks of San Marco.

[267] The *Canon* (from the Greek, "rule") is a lost treatise on the proportions of the human anatomy written by the sculptor Polyclitus around 450 B.C. It is considered to be the first treatise that theorizes the themes of beauty and of the harmony of the sculptural forms, and also had an extraordinary impact on the architectural module. Leonardo's *Vitruvian Man* is inspired by the Canon of Polyclitus.

It was also and especially thanks to them and to the precious contribution of texts and teachers who came to Florence under the guidance of George Gemistus Pletho, the charismatic leader of the Byzantine cultural and religious movement, that the Medici were able to create an environment of wide cultural scope that favored the development of humanistic and scientific thought and Renaissance art, which remains unchanged in the libraries and museums of cities throughout Europe.

Despite of all this, and in spite the fame of his brilliant mind, Leonardo's presence in this milieu is almost never mentioned by modern biographers and scholars. But in those same years, as we have been able to reconstruct in the previous pages, he was already an established musician, painter, and sculptor.

Not just any—the best of all.

It's an omission that arouses more than a doubt.

Anonimo Gaddiano is the one who promptly mentions it. He seems to say the experience at St. Mark's garden preceded Leonardo's first trip to Milan—the one in which, in the company of Atalante Migliorotti, he brought the phantom lyre to Duke Francesco:

> "He stayed at young age with the Magnificent
> Lorenzo de Medici, and he was working in the garden on
> St. Mark's square in Florence on commission."[268]

According to this passage, if Leonardo reached Milan in 1465[269], he would have had to attend St. Mark's garden before that date for obvious reasons. After all, the author of this manuscript is explicit in pointing out that Leonardo worked in the garden on St. Mark's Square "at young age."

Further confirmation comes from the already mentioned lunette in the Tornabuoni chapel in Santa Maria Novella in Florence, in which Ghirlandaio paints the cultural and political elite of Florence: *The Angel Appears to Zacharias.* (See Figure 8)

[268] National Central Library of Florence (Cod. Magliab. XVII, 17)
[269] As I believe I have amply demonstrated and will continue to demonstrate in the course of this work

FIGURE 8 – LEONARDO PORTRAIT IN THE APPARITION OF THE ANGEL TO ZECHARIAH, DOMENICO GHIRLANDAIO, 1486, TORNABUONI CHAPEL, SANTA MARIA NOVELLA, FLORENCE.

Ghirlandaio places the young Florentine artist in the role of the Archangel Gabriel—as Leonardo himself will do in one of his own paintings. Actually, in this case Leonardo is even represented at the center of the painting, while around him are all the greatest humanists, politicians, and Florentine bankers of the Medici lordship, including Benedetto Dei, who accompanied him to Milan in 1465.

In the same cycle, Leonardo is portrayed by Ghirlandaio as the Archangel Gabriel a second time, in an Annunciation that borrows the same Larian landscape represented by the Florentine genius, in clear evidence of emulating him.

Reading of all these frescoes and statues in which Leonardo is portrayed might give you the idea that I am rambling. You may think that they are only the expression of a mannerism through which the painters, who grew up side by side in the various Florentine workshops, tended to imitate one another. But I would suggest the following considerations:

- On one hand, all the other subjects portrayed can be identified with a precise historical character, according to a figurative realism we have already talked about, so it is not clear why Leonardo should be the exception.
- On the other hand, each portrait of Leonardo that I mention differs from the others only by slight nuances, attributable not only to the characteristic pictorial trait of each

individual artist but also to a different age of the subject portrayed.

That is to say that you are observing some youthful images of Leonardo portrayed during the different ages of his growth. This makes all these portraits even more interesting because, if placed beside each other, they describe in a dynamic form his physiognomic mutation over the years.

The last fresco to which I wanted to draw your attention, as it places Leonardo next to all the most influential figures of the Florentine context gravitating around the Medici family, gives us further confirmation that the young artist was already fully integrated into the cultural apparatus of the Seignory at the highest level. This makes it plausible that he was sent to Milan to Duke Francesco as ambassador of that artistic and cultural movement that will soon involve all the European courts—provided he did not participate under a different role, of course.

By now you know that when I say so it is because I already have proof of what I state. Vasari writes:

> "Lionardo was brought to Milan with great reputation to Duke Francesco, who greatly enjoyed the sound of the lyre, to play: and Lionardo brought with him that instrument, which he had made with his own hands, mainly of silver, so that the harmony would be higher in tone and sound, dominating all the musicians who there competed to play. Moreover, he was the best improvisor of rhyming speech of his time. When the duke heard Lionardo's admirable reasoning, he fell so in love with his virtues that it was incredible. And praised him, the duke asked him to paint an altar panel with a nativity inside, which was sent by the duke to the Emperor[270]."[271]

If Palazzo Medici Riccardi embodied the epicenter of the cultural and political life of Florence, the most intimate and reserved place of the entire residence was the Chapel of the Magi, the family chapel located in the residential part of the palace. It derives its name from the frescoes that decorate it, dated without any doubt to 1459. This chapel was one of the first rooms to be decorated once the

[270] Frederick III of Germany
[271] G. Vasari, *The Lives*—Torrentini, Florence, 1550

construction work was finished. What is represented in it assumes absolute importance not only with regard to the Medici and Renaissance history of those years, but also as a real turning point for understanding the entire geopolitical development that, from this moment onward, will contribute to defining today's society. The analysis of these frescoes, as a result of what they depict, goes far beyond the simple historiographic study of Leonardo da Vinci or the Renaissance art in general. It becomes essential for understanding sociological, political, and economic development worldwide.

I am talking about the *Cavalcade of the Magi*, a real masterpiece by Benozzo Gozzoli executed on a direct commission by Piero de' Medici[272]. As a testimony to the absolute importance that this representation must have had, Piero personally followed both the planning and the executive phase.

As noted, Piero the Gottoso (the Gouty) was the son of Cosimo the Elder. Both were celebrated in a 1470 note from Benedetto Dei as being two of the men who gave the greatest prestige to Florence, together with Dante, Petrarca, Antonino Pierozzi, Carlo Aretino, Ridolfi, Scolari, and Capponi[273]. His nickname comes from the fact that rheumatoid arthritis, also called the Medici's disease as it indiscriminately affected almost all branches of the family, was once mistakenly classified as gout[274].

Eloquent in this sense is the portrait of Cosimo the Elder by Pontormo in which the hands of the Pater Patriæ clearly show the effects of this pathology, which was inherited by all his descendants[275]. This painting by Pontormo is said to be the only one, besides a painting by Bronzino[276], to portray Cosimo de' Medici. In reality there is a third representation, though unrealistic, made between the sixteenth and

[272] Known as the *"Gottoso"*, the "Gouty"

[273] Ms. Ashb 644—Laurentian Library Florence

[274] Examining the tombs of some members of the dynasty (grouped in the Church of San Lorenzo), we came to understand that the medical issues of the Medici dynasty were caused by idiopathic skeletal hyperostosis diffused. This disease, with a pretentious name, produces ossifications and calcifications in the ligaments.

[275] The *Portrait of Cosimo the Elder* by Pontormo is an oil painting on wood, datable around 1519-1520 and preserved in the Uffizi in Florence.

[276] Agnolo di Cosimo, known as Agnolo Bronzino or, simply, the Bronzino (1503—1572), was a Florentine painter.

seventeenth centuries by Alessandro Tiarini in the convent of San Marco[277].

All these paintings were derived from a medal whose author remains anonymous. It was made to commemorate Cosimo after his death[278], when in 1465 he was awarded the honorary title of Pater Patriae[279] The medal also appears in a famous painting by Botticelli[280], today hanging in the rooms of the Uffizi Gallery in Florence. It is really curious that there are no other portraits of Cosimo the Elder other than these. Very strange indeed. And not only in consideration of what Cosimo meant to his family but for what he represented in relation to the whole Renaissance movement, which started thanks to his patronage and the decision to bring to Florence the Council of 1439.

in reality there are two more portraits of Cosimo the elder, which I'll mention now for the first time. one is preserved in the cavalcade of the magi, behind one of the two self-portraits with which Benozzo Gozzoli signed the work. a second portrait, equally important given the artist who made it, is by Leonardo himself and appears in a drawing now kept in the Royal Collection of Windsor. (See Figure 9)

We were talking about Piero the Gouty. Piero was the father of Lorenzo (called the Magnificent, who would lead the Seignory after him), Giuliano (who died in the 1478 ambush by Baroncelli during the Congiura de' Pazzi), and three daughters: Bianca, Maria, and Lucrezia. A sixth son is attributed to Piero—illegitimate and born before the marriage contracted in 1444 with the previously mentioned Lucrezia Tornabuoni, to whom was given the name Giovanni but of whom all traces have been lost. At least that's what the biographers say, but you already know that it is not like that.

277 Alessandro Tiarini, The reconstruction of the convent of San Marco. On the right side we can see Sant'Antonino, together with Cosimo and Lorenzo de'Medici, examines the project presented by Michelozzo. Cloister of Sant'Antonino, Museum of San Marco.
278 Occurred In 1464
279 Pater Patriae (Father of the Fatherland) was an honorary title conferred in ancient Rome. The Latin locution usually inscribed on the coins or on the imperial monuments was epigraphically abbreviated as P.P.
280 Sandro Botticelli, *Portrait of a man with medal of Cosimo the Elder*, 1474/5—Uffizi Gallery in Florence

FIGURE 9 — LEONARDO DA VINCI, RL 120833, ROYAL COLLECTION TRUST, WINDSOR.

As we have learned while observing the paintings of St. Francis's life in Santa Trinità in Florence and of St. Augustine in San Gimignano, even in the *Cavalcade of the Magi* the religious subject is only a pretext for representing and celebrating a series of family members or political figures of the time. This figurative phenomenon particularly applies for these frescoes in which the religious episode of the Magi, who bring their gifts to the Redeemer, has pretty much nothing to do with anything.

The pictorial cycle represented here, in fact, constitutes a proper political manifesto that collects a series of characters linked to various degrees by a common alliance. In the same year in which Benozzo Gozzoli painted the *Cavalcade of the Magi* at the Medici Riccardi Palace, Pius II[281] in June 1459 organized the so-called Council of the Diet[282] in Mantua. The declared intention of the pontiff from Pienza was to gather around him all the Christian princes of Europe and declare war on the Ottoman Turks, who, after conquering Constantinople in 1453, were threatening to conquer the entire Byzantine empire. They were already threatening the territories of the Eastern Church. The scarce participation

[281] Enea Silvio Piccolomini, (1405-1468, was elected Pope with the name of Pius II in 1458).
[282] The Council of Mantua of 1459, *or Mantua Diet or Congress*, was convened by Pope Pius II, who was elected the year before, to organize an expedition against the Ottomans who had taken Constantinople in the 1453. His appeal was addressed to the sovereigns of Europe to stop fighting with each other, and join the forces against the common enemy of Christianity instead.

obtained by the Council convened by Pius II was counterbalanced by
the huge crowd gathered around and which actually leads the
Cavalcade of the Magi of Benozzo Gozzoli.

The contrasting forces that were determined through these two
distinct events is the exact picture of how Renaissance society was
drastically split into two factions, distinct and fiercely antagonistic,
separated on the one hand by cultural factors and on the other by
geographic expansionist aims. The fact that one of these two factions
was immortalized in the beating heart of what at the time was the
stronghold of Medici cultural, economic, and political power assumes
then even more importance. On the one hand, we have a Rome-
centric pole, if we want to say so, that identifies with the papacy and
Catholic culture and is deeply dogmatic. On the other hand, we find
a reformist Eurocentric pole, focused on the monolithic association of
two families, the Medici and the Sforza, who worked in a unique
way for the revival of a Neoplatonic culture with a well-marked
humanistic imprint and supported by a considerable scientific
contribution. While the first faction was politically oriented toward
Spain, the second had a strong natural inclination toward those
European nations that were more reformist—Hungary above all.

The price of this contest was much more than the simple political
and economic control of the territories then known. It resulted from
the extremely profitable exercise of the nascent banking industry,
which was made necessary by the sudden growth of mercantile
activities, which were increasingly rich and aimed toward markets
that were growing at great speed.

At stake was also the necessity and possibility[283] of imposing a
different cultural orientation on the society of the time. On the one
hand, the goal was to build a society centered on the dogmatic
culture of Catholicism; on the other hand, it was to build a society
based on a scientific and humanistic Neoplatonic culture in which the
dictates went beyond the law of God to the astronomical,
mathematical, and geometric laws that govern the entire universe.

This was a vision that clearly could not be welcomed with
benevolence by the papacy. On the contrary, the Church did
everything to stem a development that would have compromised the
faith-based recourse of the people as a salvific way to overcome

[283] Necessity for the Church, possibility for the laic society

earthly punishments, seen as a divine test given by God to man to enter the kingdom of Heaven.

It was not only this, however, that split in two the contestants of the time. In the background of the dispute there was much more. There was the control of an entire continent, located thousands nautical miles across the Atlantic Ocean, to which the two factions developed a diametrically opposite approach.

On one side, the Medici-Sforza faction had a friendly and dialogue-based approach to the peoples who inhabited the New World. It was respectful of their historical and cultural traditions to the point of absorbing a large part of it by importing it into the dynamics of their daily lives.

On the other side there was the faction linked to the papacy, whose approach was totally invasive and overwhelming. It was based on a colonialist logic aimed at getting rich by plundering local treasures[284] in great quantity and conquering the territories of the New World, slaughtering the local population. Above all being, the wanted to compensate themselves with an expansion in the West for land lost in the East by the Turkish advance as a result of the fall of Constantinople in 1453.

Today we are led to believe the tale of Christopher Columbus who, wanting to demonstrate the sphericity of the Earth, first among all sailed westward with the intent to reach the Indies. But he landed almost in desperation on the Caribbean coast just when his own sailors were about to mutiny. This is how we are taught that Columbus "discovered" the New World. This colossal whopper, and above all what happened after that fateful 12 October 1492, in the name of converting the savage American natives—who were devoted to who knows what evil pagan cults—to Christianity, with an immense use of force and gratuitous violence, the geopolitical and cultural order of today's society was imposed by papal bills.

Things obviously went in a different way, and I would be a terrible scholar if I did not correlate the "American" events to the economic, political, and artistic development of the entire Renaissance. I would be a terrible scholar of Leonardo particularly, whose life and work were inevitably and profoundly conditioned also by these events.

[284] Suffice to notice that behind the Cathedral in Seville there is a statue made with the gold stolen to the American natives of 2.5 tons; an exaggeration.

Let's analyze Gozzoli's fresco then. Located on the main floor of the Medici residence, this fresco was realized, as already mentioned, in 1459. The pictorial cycle, shown in the attached images, is thus summarized by scholars today:

"On the three major walls is depicted the *Cavalcade of the Magi*, which serves as a pretext to represent a precise political subject that gave prestige to the House of Medici, namely the procession of Pope Pius II Piccolomini, who arrived in Florence in April 1458, directed to Mantua, in company of many personalities.

In that city the pontiff had called princes and ecclesiastical authorities to participate in a meeting during which planning a crusade in defense of Christianity against the Turkish advance in Europe. Pius II was preceded by various Italian princes who stopped in Florence to join the papal entourage: among others, also Galeazzo Maria Sforza, the fifteen-year-old son of Francesco Duke of Milan, and Sigismondo Malatesta, Lord of Rimini, allies of the Medici, who appear portrayed in the scene[285]. The frescoes unfold in scenes around the spectator. One has the impression of admiring the procession without interruption from within a curve of its path. The opulence and exoticism of the Byzantine dignitaries are well represented here and can give us a measure of the surprising impact they had on the Florentine population, including the many artists active in Florence at the time. (See Figure 10, Figure 11, and Figure 12.)

[285] Cristina Acidini Luchinat, Benozzo Gozzoli and the Chapel of the Magi—Milan, 1993

FIGURE 10 — BENOZZO GOZZOLI, 1459, CAVALCADE OF THE MAGI, EAST WALL, CHAPEL OF THE MAGI, PALAZZO MEDICI RICCARDI, FLORENCE

East Wall—In a landscape with almost late-Gothic sensibilities, rich in courtly details such as castles, hunting scenes, and fantastic plants probably inspired by Flemish tapestries, the portraits of the Medici family are placed in the foreground on the wall to the right of the altar. The Medici are personified in the figures on horseback: a young man, perhaps an idealized portrait of Lorenzo the Magnificent in grand style, precedes the procession on a white horse, followed by his father Piero the Gouty and his grandfather and head of the family, Cosimo de' Medici. Both of the older men are riding mules.

They are followed by two Italian dignitaries, Sigismondo Malatesta and Galeazzo Maria Sforza, lords of Rimini and Milan respectively, who were hosted by the Medici in those years. They are represented here to celebrate the political successes of the house. The Malatesta and Sforza families had recently become related to the Paleologi of Byzantium, so they seem to act as "guarantors" of the procession taking place behind them, as if they were protectors allied to the Medici.

Behind them there is a procession of Italian and Byzantine Platonic philosophers, among which the humanists Marsilio Ficino, the Pulci brothers, and the painter Benozzo himself are recognizable. Benozzo looks toward the spectator (according to Leon Battista Alberti's instructions) and you can see the clear inscription on the fabric of the red hat: *Opus Benotii d.* In the same row, according to the scholar Silvia Ronchey,

there is, in three-quarter profile, the true portrait of Lorenzo de' Medici as an adolescent.[286]

In the third row we can recognize a row of Byzantine dignitaries with long beards where perhaps George Gemistus Pletho, Giovanni Argiropulo, Isidoro of Kiev, Teodoro Gaza, and Niccolò Perotti might be depicted. In the next row, you can see a character with a red cap and a rich golden frieze. Almost certainly this is Enea Silvio Piccolomini, Pope Pius II.

The realism of the faces is remarkable and is typical of Renaissance art *South wall*—On the next wall, the bearded character on a white horse is the Emperor John VIII Paleologus of Byzantium. Next to him the three girls on horseback would be the three daughters of Piero the Gouty, sisters of Lorenzo and Giuliano: from left, Nannina, Bianca, and Maria.

FIGURE 11 — BENOZZO GOZZOLI, 1459, CAVALCADE OF THE MAGI, SOUTH WALL, CHAPEL OF THE MAGI, PALAZZO MEDICI RICCARDI, FLORENCE.

West Wall—Finally, on the left wall you can recognize the figure of an old man on a mule, portrait of Joseph, patriarch of Constantinople. He is preceded by Lorenzo's younger brother,

[286] Silvia Ronchey is an essayist, academic and classical Italian philologist. Former associate professor at the University of Siena, is today ordinary of Byzantine Civilization in the Department of Humanistic Studies of the University of RomaTre.

Giuliano de' Medici, with a spotted leopard on his horse. In the same scene are depicted Sigismondo Pandolfo Malatesta and Galeazzo Maria Sforza, and a series of Byzantine dignitaries among exotic beasts like lynxes and falcons."[287]

Perhaps the only part of this description that actually corresponds to what portrayed by Benozzo Gozzoli is when it says:

"The realism of the faces is remarkable and typical of Renaissance art."

John VIII Paleologus in fact died in 1448, and George Gemistus Pletho in 1452. The patriarch of Constantinople Joseph died in 1439, during the council that was held in Florence. Enea Silvio Piccolomini was elected Pope in 1458, so he should have been personified with papal clothes and not in the bishop's robes if it was true that this procession was going to Mantua for the council he had called in 1458.

FIGURE 12 — BENOZZO GOZZOLI, 1459, CAVALCADE OF THE MAGI, WEST WALL, CHAPEL OF THE MAGI, PALAZZO MEDICI RICCARDI, FLORENCE

What is unforgivably mistaken here for Cosimo de' Medici is actually Francesco Sforza. Memorable in this is the playbill of an old American

[287] From Wikipedia—Chapel of the Magi

film production on the events of the Medici family associated with
this very image of Francesco Sforza.

Lorenzo the Magnificent is not actually the one portrayed in
idealized form on a white horse in grand style while leading the
procession. On the contrary, Lorenzo is on foot, portrayed next to his
brother Giuliano, and "escorting" the Magi who lead this
extraordinary cavalcade riding on his horse. This image of Lorenzo is
reminiscent of the one where he is portrayed in another famous
Cavalcade by Benozzo Gozzoli, the one in San Gimignano, where
Lorenzo accompanies Leonardo, who is portrayed as St. Augustine, to
Milan.

Next to Francesco Sforza are Piero the Gouty and Alessandro
Sforza, recognizable by the curious knot on his head, and Lord of
Pesaro and Gradara, who is represented here by the unmistakable
silhouette of the castle that dominates the landscape with its hunting
scenes and plants that are anything but imaginary—exotic, perhaps,
but certainly not imaginary.

Following these are their two sons, respectively Galeazzo Maria
and Costanzo I[288], who in the previous description was mistaken for
Pandolfo Sigismondo Malatesta. Malatesta is totally absent from the
painting, and his figure, which has been overemphasized by historians
(mainly from Rimini), remains secondary in the Renaissance
movement. It's the same with Federico da Montefeltro, also absent
from Gozzoli's representation and his bitter enemy Pandolfo
Sigismondo, who will remain forever overshadowed by the defiled
but emotionally and culturally cumbersome figure of a more cultured
brother. I'm talking about Domenico Malatesta, Lord of Cesena and
son of Pandolfo III Malatesta, and Ottaviano of the Ubaldini
respectively. Both were great humanists in spite of their brothers,
who were instead men of arms and behaved as such throughout their
troubled existence, even competing against each other.

Federico da Montefeltro was a faithful ally of the papacy of Pius
II, which invested him with full powers after having refused Pandolfo
Sigismondo Malatesta. But above all he was an ally of Sisto IV,
participating actively in the Congiura de' Pazzi and deploying six
hundred men of his army at the gates of Florence.

[288] Costanzo I Sforza (1447-1483) will take over from his father as Lord of Gradara and
Pesaro.

Ottaviano of the Ubaldini was a very educated man and a great humanist who in 1475 commissioned Francesco di Giorgio Martini to build the Rocca of Sassocorvaro, famous for its unique turtle-like shape, making it thus impregnable. It was because of this presumed impregnability that during the Second World War the superintendent of fine arts of the Marche Pasquale Rotondi thought to hide ten thousand masterpieces in here from the art collections of various cities[289] to prevent their being stolen by the retreating Nazis or destroyed by Allied bombardments. Someone recently tried ignobly and unfoundedly to besmirch his memory, fearing the hypothesis that the superintendent would have moved in agreement with the Germans, and thus erasing the extraordinariness of his heroic act. Among these masterpieces are *The Tempest* of Giorgione, Leon Battista Alberti's *Ideal City* and many other works by famous artists including Raffaello Sanzio, Piero della Francesca, Carlo Crivelli, Tiziano, Lorenzo Lotto, Paolo Uccello, and Andrea Mantegna.

The character portrayed in the *Cavalcade of the Magi* that in the previous description is mistaken for Giuliano de' Medici, recognizable for holding a spotted leopard on his horse, is actually the previously mentioned Giovanni II Bentivoglio, Lord of Bologna, faithful ally of the Medici and brotherly friend of Leonardo. The spotted leopard (actually a red lynx) was also present in the heraldic coat of arms of Giovanni II Bentivoglio, hence this identification error is doubly unforgivable. Giovanni II Bentivoglio's second marriage would be to the widow of his brother Sante, Ginevra Sforza, who was the sister of Constanzo I and daughter of Alexander, Lord of Pesaro. She is the lady portrayed by Leonardo in the painting that today, through a superficial and summary attribution, is identified with the portrait of Ginevra de' Benci:

> "He Portrayed the Ginevra of Amerigo Benci, a beautiful thing.[290]
> He portrayed in Florence from live Ginevra of Amerigho Bencj, which so well he did, that not the portrait, but the real Ginevra seemed."[291]

[289] Venice, Urbino, Pesaro, Fano, Ancona, Lagosta, Fabriano, Jesi, Osimo, Macerata, Fermo, Ascoli Piceno
[290] Giorgio Vasari—The Lives of the most excellent painters, sculptors, architects, 1550—1568
[291] National Central Library of Florence (Cod. Magliab. XVII, 17)

This painting, preserved today at the National Gallery in Washington, is interesting because it allows us to identify the person portrayed thanks to the very particular use that Leonardo makes of the landscape. It is here recognizable as the valley of the river Foglia di Sassocorvaro as it can be seen from the aforementioned Rocca Ubaldinesca that was commissioned by Ottaviano. I will later dedicate an entire chapter to this subject, a little to give officiality to this study of mine but above all because this is the only one of Leonardo's paintings with a landscape that is not of the Larian lake. It gives peace of mind to those who would like to see in Leonardo's works landscapes of half of Italy, according to the most disparate theses, which are often built more on speculative intents the respect of an unconditional and disinterested love for knowledge.

Returning to Gozzoli's *Cavalcade*, it is clear that the underlying reference to this extraordinary work was meant to decorate the most intimate and reserved place of the palace. At the time, this was the epicenter of the political and cultural life of the most important seigniory of the Renaissance, so this painting is certainly not "the procession with Pope Pius II Piccolomini, and numerous personalities, who arrived in Florence in April 1458, headed to Mantua." On the contrary. I also doubt that this was a family chapel, leaning more towards the hypothesis that it represented a sort of small parliament.

Beyond this personal consideration of mine, the reading that is traditionally associated with this painting is completely distorted and reflects that strongly self-referential way of reading art and history that should not belong to any art scholar or critic. I often smile when reading the phrase "independent scholar." Is there a different way of being one? Theoretically no, at least not from an intellectual point of view. But there are very few studies that do not suffer, perhaps even involuntarily, from external conditioning.

There are two elements that subvert the distorted reading with which the frescoes in this very important chapel are presented:

- who leads the procession; and
- the identification, among the many faces portrayed,

of the portrait of the Pater Patriæ, Cosimo de' Medici.

Once we've identified these two figures, which are absolutely central in the conceptual sense underlying the representation, Benozzo Gozzoli's cycle takes on a completely different interpretation

from the one officially recognized. It connects to a series of other works by artists who were close to the same personages portrayed here, testifying to the fact that a certain knowledge circulated in restricted and connected environments.

The boy with golden curly hair leading the procession is Matthias Corvinus[292], then sixteen years old. When King Ladislaus V[293] died, Matthias became king of Hungary, a position he held until his death in 1490. Matthias I, despite his meagre reputation in the modern Western world, was one of the most influential rulers of the time. He was nicknamed Corvinus because of a black raven (*corvinus* in Latin) in his coat of arms, but the name more likely derived from the Roman family of Corvini.

The Hungarian monarch began collecting books in 1460, the year after his triumphant reception in Florence. At Matthias I's death thirty years later, his library[294] had about three thousand codices[295] and included more than five thousand works by mainly Latin and Greek authors, thus becoming one of the most important cultural centers of the Renaissance. Here you could find texts on philosophy, theology, history, law, literature, geography, science, medicine, architecture, and much more. With the exception of a text by Aristotle in Latin printed in Venice between 1483 and 1484, the texts in the library were all manuscripts: some were original, but most were copies requested by Matthias I, who relied on Italian miniaturists of the highest skill, such as Attavante of the Attavanti, Gherardo of Giovanni of Miniato or Francesco d'Antonio of the Chierico.

To Attavante of the Attavanti, a personal friend of Leonardo also mentioned in one of his codices[296], we can trace that *Liber Musices*[297] mentioned in the opening of the work in which Trivulzio recognized the

[292] Hunyadi Mátyás (1443-1490)

[293] Called the Posthumous, as he was born after the death of his father, Alexander II, King of Hungary, Bohemia and Germany, he was nephew by mother of Sigismund of Hungary, Emperor of the Holy Roman Empire.

[294] The Corvinian Library was established in Buda by the King of Hungary and Croatia Matthias Corvinus and his wife Beatrice of Aragon, between 1458 and 1490.

[295] Called *Corvinae*

[296] Arundel Codex, Sheet 229v—British Library of London.
"I remember how on the 8th of April 1503 myself Lionardo da Vinci lent Vante miniaturist 4 gold ducats in gold; Salaì took them to him and gave them in his own hand. He told me he was going to return them within 40 days."

[297] Liber Musices of Florentius, I-Mt 2146—Trivulziana Library, at Castello Sforzesco in Milan

portrait face of Leonardo da Vinci. It is not unthinkable to believe that that extraordinary manuscript of musical history may have been transcribed by Attavante himself.

Matthias Corvinus also founded a philosophy and art school in the Hungarian capital similar to the Medici one. On the other hand, in 1489 Bartolomeo Fontius, a humanist who lived in Hungary, claimed that Lorenzo de Medici built and designed his own library following the example of the Corvinian library, so great was its fame, making it second only to the Vatican Library.

It is therefore more plausible to believe that the cycle of frescoes by Benozzo Gozzoli refers to the procession that welcomed to Florence the newly crowned king of Hungary, Matthias Corvinus, the king of the Magyars, rather than to the court that accompanied Pius II to Mantua. Even the name by which this chapel is known can help us in this sense.

Today we know only one Hungarian population. Originally, however, as Antonio Bonfini[298]—the historian employed at Matthias I's court who gave him the nickname Corvinus—wrote in a treatise, and as every Hungarian inhabitant will proudly tell you if you ever have the chance to visit that extraordinary country, in 896 there were seven tribes who conquered the territories occupied by present-day Hungary. Today this is commemorated by the huge statue erected in Heroes' Square in Budapest. The most prominent of these seven tribes was indeed the Magyar one, hence the subtle linguistic game that underlies the title of the Gozzoli cycle.

This is made ambiguous, however, by the presence of Byzantine dignitaries in the procession who had a deep cultural and philosophical bond with Florence. They are portrayed in the guise of the astrological priests of the ancient Persian religion Zoroastrianism who, guided by the stars, came to Bethlehem to honor the birth of Jesus.

The painting by Benozzo Gozzoli, therefore, is not the *Cavalcade of the Magi* but the procession of the Magyars, deliberately celebrating their king, Matthias Corvinus, on the occasion of his visit to Florence after his coronation.

[298] Antonio Bonfini (1427-1502) was a humanist, court historiographer of Matthias Corvinus, who in his work Rerum Ungaricarum decades wrote the origins and history of the Hungarian people.

The long deployment of people presents in the fresco, recognizable one by one thanks to the strong figurative realism of the painter, allows us to identify the members of what was not only a political or military alliance but a single cultural identity, cemented in the shape of that Byzantine Neoplatonism embodied by George Gemistus Pletho.

After Pletho's death in Mistra in 1452, his cultural heir was Leonardo da Vinci, who became the main reference point for all his contemporaries. he was supported by all those who were portrayed here by Benozzo Gozzoli: the Sforza, the Medici, the d'Este, the Hungarians of Matthias Corvinus, and the Paleologues, all of whom were supported by a large number of family members, humanists, mathematicians, astronomers and geographers who animated the courts of these noble seigniories and duchies of northern Italy. Among them also is Vlad III of Valachia, better known to the general public as Dracula.

In opposition to this lineup, at the same time the allies of Pius II gathered in Mantua. His declared enemies were not only the Ottomans, who by invading Constantinople in 1453 had threatened the political and cultural hegemony of the papacy in the Western world, but precisely those whom Benozzo Gozzoli intended to gather in a single, celebratory fresco in the private chapel of the Medici family. The real cause of the hostility shown to them by Pius II, as mentioned before, was not only a cultural disagreement or the defense of geopolitical boundaries for containing the advance of the Turkish people. The real, deep, tangible reason for the enormous rivalry that split the Renaissance political fronts in two is linked to an event that will forever change the course of history and determine the geopolitical order of the entire planet.

Which one? We can deduce it from the way Benozzo Gozzoli decided to portray Cosimo de' Medici in his own home, in the most intimate and important room of the family residence. Not, as one would expect, in the role of the house guest intent on welcoming the young king, who was the direct descendant of the powerful emperor of the Holy Roman Empire Sigismund of Hungary, but defiled—almost hidden, I would say. He's portrayed near the man who is considered the father of modern archaeology, Ciriaco d'Ancona[299].(See Figure 13.)

[299] Ciriaco dAncona (1391, 1452) was an Italian archaeologist, humanist, epigrapher and traveler. For his activity of researching historical records, carried out in many Mediterranean countries in an attempt to save them from oblivion and destruction, is considered also by his contemporaries, *pater antiquitatis*, the founder or "*father of archaeology.*"

This particular portrait of Cosimo is striking for his exotic hair, the priestly habit, and the three feathers on his head threaded in a red and gold ribbon. In theory, scholars associate the three feathers on the strip among the family endeavors[300] of the early Renaissance, attributing them to Cosimo the Elder. This endeavor would make its first appearance in the small temple of the Holy Sepulcher, located in the chapel—which is still consecrated—attached to the former church of San Pancrazio in Florence, next to the Basilica of Santa Maria Novella. The small temple, begun in 1457 and completed in 1467, was built as a project by Leon Battista Alberti to collect the future remains of his client, Giovanni di Paolo Rucellai, who died in 1481.

FIGURE 13 — BENOZZO GOZZOLI, 1459, CAVALCADE OF
THE MAGI, WEST WALL DETAIL, CHAPEL OF THE MAGI,
PALAZZO MEDICI RICCARDI, FLORENCE

The magnificent marble inlays that decorate the external walls of the Holy Sepulcher sacellum are in the form of decorated panels and bear the coats of arms of Lorenzo the Magnificent (east apse), Cosimo the Elder (north wall), and Piero the Gouty (west wall—entrance). The coat of arms of Giovanni Rucellai[301] is present on the south wall

[300] The term "endeavors", in heraldry, is generally used to indicate a symbol, chosen by a person such as personal emblem
[301] A sail unfurled in the wind, with the sails loose.

and shows a sail unfurled to the wind with the ropes loose. The Rucellai were a family of very rich merchants, linked to the Medici both from a commercial and familial point of view through the daughter of Piero the Gouty, Lucrezia[302], who married Bernardo Rucellai[303] It is curious that the endeavor of Cosimo the Elder appears for the first time only on a small temple erected after his death and moreover built to house the mortal remains of a third person. In fact it is not the first time this had happened, and perhaps it's not even the endeavor of Cosimo de' Medici.

Again, what was one of the most powerful and influential figures in our historical, political, and financial past is accompanied by inert and unfounded information. The representation that Benozzo Gozzoli makes of Cosimo de' Medici is a real revelation, even if in a few pages it will seem to you the norm, in the historiographic development of the time and net of the censorships and distortions imposed in five centuries of narratives.

The animals, plants, hunting scenes, and geographical representations included by Gozzoli are not at all fictional, as is written in the books or notes accompanying this cycle of frescoes. They belong to the New World. In the same way, Cosimo the Elder is depicted in a clear homage to a very important Incan emperor.

I am talking about Pachacutéc, the emperor who is considered the founder of the Incan empire. Under his rule, the Inca achieved the conquest of vast territories of South America and forged them into a single dominion. Pachacutéc died in 1459, the year in which Benozzo Gozzoli portrayed him in these frescoes through the Florentine Pater Patriæ, with the classic hairstyle of the native South Americans, the typical golden-edged tunic of the high Inca priest, and the three feathers on his head.

I know, you are thinking I am insane. Don't worry, I'm used to it. "But how?" you will say. If America was discovered in 1492, how is it possible that in 1459 the man who is considered the most authoritative member of the Medici family, Cosimo the Elder, is portrayed not in the ceremonial role with which one would expect to welcome the new king

[302] Called Nannina

[303] To the two Baccio Baldini will dedicate one of his engravings, portraying them on the Ship of Fortune, in a representation that will inspire Botticelli's pictorial structure for the Birth of Venus.
The Ship of Fortune by Bernardo Rucellai, 1466, engraving on copper (Ehrengard Meyer-Landrut, Fortuna. Die Göttin des Glücks im Wandel der Zeiten, Berlin 1997, Abb. 41)

of Hungary, but in a corner and even in the role of the last Incan emperor, Pachacutèc?

The answer is very simple: because, as in the case of Leonardo's biography, the story did not unfold as it is written in textbooks. It seems obvious to me, after all. Fortunately, as you will have by now learned to expect from this book, there is a substantial amount of documentary and pictorial evidence that helps you to recompose the question in the right terms and helps me to regain in your eyes a semblance of mental health, even if I did not despise the good dose of madness attributed to me.

The headdress worn by Cosimo de' Medici in this fresco is the "maskaypacha real" (word of Quechua[304] origins), considered overseas an absolute symbol of the Incan imperial power.

The maskaypacha gave to the Sapa Inca[305] the title of governor of Cusco and, starting with Pachacutéc (whose statue was erected in the Plaza des Armas in Cusco a few years ago), of all the Tahuantinsuyo, i.e. of all Peru, the largest empire of pre-Columbian America.

This detail of the painting is very important, as can be easily guessed, not only because of the implicit chronological deductions it involves in order to revise the dates of the first voyages to the Americas but also for a more correct interpretation of Gozzoli's pictorial cycle.

Only the Sapa Inca could bring the most important maskaypacha, which was handed down from one priest to another only in after the death of his predecessor. In a line entirely theoretical, and therefore I assume also symbolic, through this representation of 1459—which coincided with the death of Pachacutéc—Cosimo the Elder was conceptually awarded the charge of Sapa Inca. This supreme priestly symbol consisted of a woven thread the thickness of a finger, which was then wrapped four or five times around the head. At that time there were three types: red and blue for the dominant Incas, black for the lower Incas or those with a minor title, and the llaw'tu, a red-and-yellow tassel (like the one worn by Cosimo the Elder) for the

[304] The term *Quechua* refers to all the individuals who, although belonging to different ethnic sub-groups, have as their mother tongue a language belonging to the Quechua family, constituting the majority of the population of Peru and Bolivia.

[305] Qhapaq Inca (transliterated Sapa Inca in Spanish and Sapa Inka in Quechua languages, also known as Apu (divinity), or simply as Sapa (unique), is the title given to the Inca rulers.

royal family. It was the Acllas (also called Virgins of the Sun, chosen women within the Inca community) who wove the llaw'tu, a long, thin, red wool braid inlaid with gold threads that were for the exclusive use of the royal family.

It was the priest-emperor who celebrated the Inti Raymi, the most important of the Inca festivals, which was linked to the solar cult. It was celebrated in special ceremonial squares at occurrence of the summer solstice. Being considered pagan and contrary to the Catholic faith, with the arrival of the Spanish conquistadores, this feast was definitively suppressed in 1572 by the viceroy of Spain, Francisco de Toledo.

The llaw'tu was also called pacha, a term that expresses the conjunction of space and time, a concept similar to that expressed by the strip that supports Cosimo's three feathers. To complete the imperial ornament there were three feathers of corequenque (the Andean caracara, a black-and-white falcon native to South America) that were threaded in the cordon of woven tassel, exactly as shown in the portrait of Cosimo the Elder.

It is clear, therefore, that the endeavor that is brought back to Cosimo de' Medici and inserted in the small temple of the Holy Sepulcher ideally derives from what he wears in the painting of Benozzo Gozzoli of some years before: a tribute to Pachacutéc, the first Inca emperor, whom evidently Cosimo the Elder had to know by name through the story of some traveler—maybe the same Ciriaco of Ancona, or maybe Benedetto Dei, if not both.

In the frescoes of the Chapel of the Magi, the three nephews of Cosimo the Elder, the daughters of Piero the Gouty, and the sisters of Lorenzo il Magnifico all carry the maskaypacha as well. — (See Figure 14.)

FIGURE 14— BENOZZO GOZZOLI, 1459, CAVALCADE OF THE MAGI, SOUTH WALL DETAIL, CHAPEL OF THE MAGI, PALAZZO MEDICI RICCARDI, FLORENCE

It is not necessary to underline the fact that the association represented by Benozzo Gozzoli[306] between Cosimo the Elder and Pachacutèc—and idealized in the sign of the maskaypacha and the priestly habit with which the powerful Florentine Pater Patriæ is depicted—is very important for the purposes of a historical revision for two reasons. It makes us understand how between the Old and the New Worlds there were existing contacts much earlier than the tale of Christopher Columbus, a story that doesn't hold water once it is analyzed in detail. It also tells us of a relationship between the two civilizations that was evidently friendly, to the point of pushing the

[306] Who not by chance paints one of his two self-portraits right under the Indian.

most important Renaissance families to import customs and habits from the overseas populations, those that Catholics considered little more than indigenous to be civilized.

And also the architecture! The Milanese Lazaretto, for example, made famous by the events narrated by Alessandro Manzoni in *The Betrothed*[307], was built between 1448 and 1450 as a ceremonial square oriented toward the rising sun on the summer solstice. Later it was transformed into a shelter for the sick during the plague epidemics.

The relationship between the Medici alliance and the natives of the new continent was therefore born in a very different way from what history would tell us at a later stage. I am clearly alluding to the genocide carried out by post-Columbian Spanish colonialism and the role played first by the Dominican friars t and then the Jesuits, who were intent on erasing the traces of the ancient culture based on solar worship in order to impose the foundations of the Catholic dogma. That was the same solar cult which, as Giorgio da Trebisonda testified in a public dialogue held in Florence, Gemistus Pletho hoped would be unanimously embraced to settle the religious conflicts between Christians and Muslims.

The perception that between the two populations—the South American and the Medici—there could be a relationship of deep friendship is suggested by another representation of the three feathers, in this case prior to both the fresco by Benozzo Gozzoli (1459) and the inlaid coat of arms in the small temple of the Holy Sepulcher in Florence (1461–1467).

I'm talking about a very special object now kept at the Metropolitan Museum of Art in New York: a childbirth tray. It's the typical commemorative tray in gold and silver with which the most important births of the rich families of the Renaissance were celebrated, evocative of the offer of sweets that traditionally was brought to the mother to recover from her labor efforts. (See Figure 15.)

[307] "The reader has to imagine the fence of the lazzeretto, populated by sixteen thousand plague victims; that space all cluttered of huts and shacks, carts and people; those two interminable porches getaway, on the right and on the left side, full, packed of languishing or of confused corpses, on sacks, or on straw; [...] and here and there, a coming and going, a stopping, a running, a bending down, a rising, of convalescents, of frenetic, of servants."
(Alessandro Manzoni, *The Betrothed*, chapter 35)

FIGURE 15 — COMMEMORATIVE TRAY FOR THE BIRTH OF
LORENZO DE' MEDICI, METROPOLITAN MUSEUM OF ART, NEW
YORK

Created by Giovanni di Sir Giovanni Guidi (known as Splinter),
this tray was created in 1449 to celebrate the birth of Lorenzo, son of
Piero de' Medici and Lucrezia Tornabuoni. Lorenzo was considered
the favorite nephew of Cosimo the Elder and was indicated as the
future head of the seignory. He gave so much prestige to Florence
that he earned the nickname of Magnificent. Painted by Masaccio's
younger brother, this tray was kept in Lorenzo's private
accommodations in the Medici Riccardi Palace in Florence.

In the depiction of Masaccio's brother, the three feathers
associated with the Medici ring (which symbolically replaces the
llaw'tu) are intersected by the family motto SEMPER (which refers
to eternal life). The symbol painted on the tray clearly refers to
Lorenzo, as can be seen from the fact that the coats of arms of the
two parental families, the Medici and the Tornabuoni, are shown in a
tiny upper part of the tray itself. It is increasingly evident that the first
appearance of Cosimo de' Medici's coat of arms cannot be the one on
the small temple of Giovanni Rucellai (whose son, Bernardo, was to
marry one of Lorenzo's sisters, Lucrezia called Nannina. Together
with her sisters Bianca and Maria, Lucrezia in Gozzoli's painting
carries the maskaypacha). The presence of the three feathers on the
1449 tray, as well as backdating their first appearance with respect to
Gozzoli's painting, would further cast doubt on the fact that on the

small temple of Rucellai the inlay with the three feathers could represent Cosimo's coat of arms. It suggests instead that the real owner of the endeavor, borrowed directly from Pachacutéc, was Lorenzo himself.

I must remind you once more that this ornament expressed the highest real and spiritual order of the Inca Empire. If, in the use made of it by Cosimo the Elder and his three nephews, this reference can be considered as a gesture of respect and friendship toward Pachacutéc and the Inca people, with whom it is evident that the Medici must have had some form of contact, the presence of the three feathers on the tray commemorating Lorenzo's birth could confirm once again the friendly relations between some families of a certain European political spectrum and the highest hierarchies of the native peoples of South America. Both Lorenzo de' Medici, called the Magnificent, and Ludovico Sforza, not by chance called the Moro, were of mixed blood—mestizo—which confirms the physiognomic characteristics of the of these two famous characters. (See Figure 16.)

FIGURE 16— LORENZO DE' MEDICI'S PHYSIOGNOMY IN THE FRESCOES OF BENOZZO GOZZOLI AND IN THE BUST OF ANDREA DEL VERROCCHIO

Mind you, it is no coincidence that I used the term *mestizo*[308], which comes from those who are recognized as the first settlers, Spanish and Portuguese. It was originally used to define the individuals who were born of the intersection of European settlers and indigenous Amerindian people. The Spanish and Portuguese were the first to colonize some of the Caribbean islands of the Americas, but not from 1492 onward— rather, between the end of the fourteenth century and the beginning of the fifteenth.

[308] The term mestizo has Spanish and Portuguese origins (*mestiço* in the latter).

To create a further link between the three feathers of the maskaypacha and Lorenzo the Magnificent, a few years later we again see the same Vasari. Before being a good biographer, Vasari was a discreet painter, and he dedicated to the Magnificent one of his works that famously portrayed, among others of Lorenzo's exotic animals, the giraffe[309]. In a banner waving behind Lorenzo on the left of the painting, Vasari once again shows the three feathers inserted in a bejeweled ring and intersected by the inscription SEMPER, exactly as painted by Masaccio on the childbirth tray of Giovanni of Sir Giovanni Guidi. It is clear that this endeavor personally identified Lorenzo.

From the elements mentioned, in particular the representation made by Benozzo Gozzoli of Cosimo the Elder at Palazzo Medici Riccardi, there is therefore no doubt that the acquiring of the three feathers by the members of the Medici family is to be placed in a very close relation with a frequentation of the Americas dating back to at least 1449—well before the date of 12 October 1492, that we read in the history books.

In light of this reading, the entire pictorial cycle of Benozzo Gozzoli takes on a completely different perspective. It discloses the fact that the historical events of the entire fifteenth century had a different development from what we are used to assuming—certainly not by our will. The original plot of these events has been systematically erased from written documents and replaced by a false, distorted and artificial narrative that permeates instead the pictorial and sculptural works as well as the life of the main witnesses of that time.

For this reason, I believe I can affirm without fear of denial—if the reader is not moved by a dose of intellectual dishonesty—that we cannot analyze the evolution of the events that contributed to giving life to the Renaissance, the biographies of the characters who animated it and the works of those artists who deposited them to the memory of the time, without taking into consideration a backdating of the first docking in the Americas.

It is around this contest, in fact, even more than on the cultural and political one, that the entire evolution of the human race of the last five centuries revolves.

[309] Perhaps brought to him by Benedetto Dei on his return from one of his diplomatic missions around the world.

And Leonardo is naturally involved in it.

Directly involved.

For this reason a biographical narrative that involves Leonardo without taking into account what I am going to summarize in the following chapter cannot exist.

.

CH. IV—THE AMERICAS, THE

KNOWN ONES

The topic I will deal with in this chapter could deserve a separate publication. I could pour into it the countless documentary analyses that I have collected and elaborated over the years. The same is true for the majority of the subjects debated in this work, which is necessarily concise and recapitulatory. It is not out of the question that one day I may decide to write it down; in that case, it would be appreciated if some university would grant me the privilege of welcoming me into its ranks and supporting me, both from an economic and organizational point of view, in order to facilitate my research. You cannot imagine how difficult it is to move between museums and libraries without any kind of accreditation, not to mention the research costs that I have had to bear in recent years.

At the same time, being accepted in an important athenaeum could attribute academic blessings to what I've written in this work, and it could become the subject of some degree program. This would allow my work to redirect a historical narrative that, at present, is deeply deficient and partial, as it has been demonstrated.

While waiting to receive offers from an important international athenaeum, therefore, for the purpose of my writing, a brief summary of the "Americas" issue is necessary. It will be useful to define the reasons why the climate in which Leonardo lived and worked were so hostile to the courts that welcomed him.

As we have seen in the previous chapter, the singular and anachronistic way in which Benozzo Gozzoli decided[310] to portray Cosimo de' Medici among the countless figures depicted in the *Cavalcade of the Magi* triggers a legitimate doubt, which may jeopardize my credibility in your eyes: How is it possible that in a 1459 painting we find specific details that, as far as we know today, we should only encounter at least forty years later? The answer is quite simple: because

[310] It's much more likely that it was expressly requested by the person who commissioned the work

the Americas were already known and visited by Europeans for a long time.

Before going any further, I would like to make one thing clear from the start: far be it from me to repeat the usual nauseating theories according to which "the Vikings sailed to America...no, the Chinese...actually no, the Romans, because there is a representation of a pineapple in a Roman chapel...no, but the corn in the Rosslyn Chapel (yes, the one made famous by Dan Brown's work)...and the Piri Reis map of 1513..."

No, none of that.

Let's make one thing clear: America has never been discovered. Not only because it has always existed, as it is undeniable, but because before the Europeans got there, it was regularly inhabited by a population whose astronomical knowledge was far more advanced than that of the Europeans who colonized it. There are representations of it that date back at least as far as the ancient Greek era. I am referring to the work of the great Greek geographer of the first century, Claudius Ptolemy[311], to whose geographical representations all the greatest Renaissance cartographers refer.

Speaking of the "discovery" of America, therefore, is already itself the result of an implicit presumption of superiority of the Western world toward the Native Americans, which is not only inaccurate but totally unacceptable.

Having said that, and apologizing for the intransigence with which I stated it—but it seemed essential to me to understand it if we want to re-establish a state of total pacifism—in Renaissance maps even after 1492, there are many anomalies that are archived with too much superficiality by historians and cartographers as fanciful, idealized representations[312]. They are not labelled as representations necessary for giving a graphic balance to the whole representation just because they are considered "anachronistic" in the course of history as we have been forced to assume. This last laughable justification often concerns the representations of the Arctic and Antarctic continents

[311] Claudius Ptolemy (100- 175) was an ancient Greek astrologer, astronomer and geographer, of Hellenistic language and culture, who lived and worked in Alexandria. Considered one of the fathers of geography, he was the author of important scientific works, the main one of which is the astronomical treatise known as *Almagest and Cosmography.*

[312] Like the absurd thesis that would identify Lorenzo the Magnificent in the one who leads the parade of the Magi.

that in the Renaissance could not and should not have been known, for obvious reasons.

One of these maps is the famous octant projection[313] by Leonardo, included in a page of the Codex Atlanticus[314] previously mentioned. It contains one of those obsessive questions that the artist included next to his drawings, referring in this case to a heart-shaped cartographic projection:

> ...tell me if it was ever done...[315]

The same page contains a total of eight sketches of the terrestrial globe studied by Leonardo, ranging from Ptolemy's conical planispherical projection to the one proposed by Francesco Rosselli[316].

Leonardo showed several times that possessed advanced geographical knowledge, both directly through drawings and paintings (including a planisphere preserved in a Renaissance palace in northern Italy)[317], and indirectly through notes inserted in the codex. One of these recurring notes concerns a globe he owned that was in possession of his friend Giovanni Benci:

> My globe that Giovanni Benci has[318]

I doubt that the Giovanni Benci to whom Leonardo refers is Ginevra de' Benci's husband, whom historians erroneously would claim to be have been painted by Leonardo in 1474. I lean more toward this being his friend Giovanni II Bentivoglio (called with an Emilian inflection Bencivoglio, as was indicated in the family coats of arms in the fortress in

[313] In this projection the spherical surface of the Earth is divided into eight octants, each made flat with the Reuleaux triangle shape.
If transferred on a flexible support, it would be possible to cover the entire surface of a spherical globe with them. The eight triangles are oriented in a similar way as of two four-leaf clovers, one next to the other, with the Earth poles at the center of each leaf

[314] Codex Atlanticus, Sheet 521 r—Ambrosiana Library, Milan.

[315] The same proposed by the so-called Madonna of Navigators, in reality Madonna of Mercy, such as the one already mentioned by Ghirlandaio, in which Lucrezia Tornabuoni, Antonino Pierozzi and the family of Amerigo Vespucci appear.

[316] Florentine cartographer, he is the author of a planisphere of great importance: it is the first map in the world to show and order the entire earth's surface in the form of a cartographic grid that embraces all 360 longitude and 180 latitude. Rosselli was also the first cartographer to employ the oval projection, then used by the greatest cartographers of the 16th century

[317] Besta palace, Teglio (So)

[318] Codex Atlanticus, Sheet 521 r—Ambrosiana Library, Milan.

Bazzano, in Emilia Romagna)[319]. This record denotes how the Florentine artist had knowledge of the geographical representations of the time, as validated by a drawing attributed to his pupil Francesco Melzi that is kept in the Royal Collection of Windsor. This drawing was among the papers that Leonardo brought with him to Amboise[320], and here I propose to compare it to a modern graphic representation of the various continents in order to better grasp Leonardo's figurative punctuality. (See Figure 17.)

FIGURE 17 — OCTANT PROJECTION BY FRANCESCO MELZI, 1515—REF. 01393 ROYAL COLLECTION TRUST, WINDSOR

This octant projection clearly shows the American continent, which had already been officially explored by Columbus at the time and colonized by the Spanish. For this reason it is tolerated by scholars. Faced with this representation, however, no one has ever objected that South America had not yet been circumnavigated by Magellan[321], nor had the presence of Antarctica been detected, though it is accurately depicted and positioned by the Tuscan artist, whose knowledge would still have been far from becoming a certainty. Perhaps it is thought that it is enough to legitimize the discovery of America and attribute it in 1492 to a fictional character like Christopher Columbus to justify all the anomalies contained in

[319] "*Zo*", from *Zoanne*, as in Bologna's dialect is called Giovanni
[320] Also quoted by the already mentioned Secretary of Cardinal Louis of Aragon, Antonio de Beatis
[321] Magellano circumnavigated the Americas in 1520

Renaissance cartography. A sort of "Olly Olly oxen free" of childish memory, in short.

To disprove these representations, the very fact that, theoretically speaking, the circumnavigation of the American continent was not recognized until 1522, when Magellan died and the expedition he led returned to Seville, would be enough. Any geographical representation before 1522 that depicts South America as a large island is indeed to be considered anachronistic. Reality, as always, is written in large print before our eyes. Seeing it, as Goethe said, is not always so immediate if not, in the worst-case scenario, considered inconvenient.

The problem is that taking a critical attitude toward these representations, which are clearly anachronistic, would trigger a series of questions that is not convenient to take into consideration, as they are detrimental to a deliberately artificial historical narrative.

The anomaly of the presence of Antarctica in Melzi's octant projection becomes even more illogical considering that, from 1492 to today, Antarctica—again on a theoretical level—has always been covered with ice. Anyone who wanted to access it by pointing a sextant at the horizon and observing their position with respect to the stars to make a cartographic representation of it would have found it impossible to do. That was the only way to map an entire continent at the time. It's not like they could use GPS and Google Maps.

Antarctica is actually present in a multitude of Renaissance maps. It's in those by the most famous cartographers, apparently respectful of the chronology that takes into account the docking of Columbus in 1492. But it's also in those made anonymously that give us representations of the Earth considered anachronistic by historians, only because they were made in a period prior to that date. Paradoxically, these maps are sometimes even more complete and realistic[322].

The precision with which Antarctica is represented in these maps, especially in the convergence with the southernmost tip of South America—which, as we have just mentioned, was only crossed by Magellan in 1520[323] and communicated no earlier than two years after that fact—does not consent to define these representations as random or fictional. This is despite the fact that in cartography texts, the theoretical existence of a generic Terra Australis has been assumed since ancient

[322] A bit like the 1550 version of Vasari's *The Lives* compared to the revised version of 1568

[323] Cape Horn

times. Its first confirmed sighting took place in 1820 by a Russian expedition[324].

Renaissance geographical knowledge is dated back to the Latin translation of Ptolemy's *Geography*, begun at the end of the fourteenth century by the Byzantine humanist Manuel Crisolora[325] and completed in 1410 by Jacopo Angeli da Scarperia[326], and first printed only after 1475. Among the first Renaissance cartographers, I would obviously mention the Florentine Paolo dal Pozzo Toscanelli, Martin Behaim, Gerardus Mercator, Abraham Oertel, Francesco Rosselli, Henricus Martellus, Oronzo Fineo, Martin Waldseemüller, and Caspar Voppel. Although the first notions of geography and cartography had arrived in Florence at the beginning of the fifteenth century, almost all the most famous Renaissance cartographers were of the German school, as you probably noticed. Curious, isn't it?

Although their maps are officially recognized as being compatible with an inclusive historical reconstruction of Colombian events, in reality these maps are all anachronistic because there is a very accurate representation of the Terra Australis contained in each of them. They're anachronistic, of course, only if we too want to support the joke that those who theoretically assumed the presence of a Terra Australis, and for this reason represented it in a vague and random shape in the maps of their own production, would guess its shape and distance from Asia, Africa, and America by pure luck.

In that precise and sole circumstance we can turn a blind eye to this anachronism, just as we can turn a blind eye to the map dating back to around 1530 and displayed in the Vatican corridors, where Leonardo stayed during his Roman period. This map represents two small isolated islands in the Pacific Ocean that not even with Google Earth you would be able to locate. Imagine at the time, sailing on a caravel.

324 Lazarev and Bellingshausen were the names of the first Russian spotters

325 Manuele Crisolora,(1350—1415), was a Byzantine humanist, whose fame was due to his intense activity conducted in the early 15th century in Western Europe. He made several trips to Italy in the attempt to reconcile the Byzantine Empire, then besieged on several fronts by the Turkish army, with the European states and in particular to the Papal States. During these diplomatic journeys, the intellectual exported the ancient Greek culture and gave new impetus to the knowledge of Greek, creating a circle of scholars around him.

326 Jacopo d'Angelo, also known as Iacopo di Angelo da Scarperia, or Iacopo Angeli (1360—1410), was an Italian Latinist and Greekist

The anonymous representations to which I referred earlier, those where the author and the date of completion are unknown, are contained in some Renaissance palaces or within some famous painters' works. I am alluding to all those representations that can be traced back to a restricted circle of noble lords who were at the service of the duke of Milan Francesco Sforza, almost describing an invisible line of conjunction between them. Coincidentally, these are largely depicted by Benozzo Gozzoli in the *Cavalcade of the Magi* at Palazzo Medici Riccardi.

Without going into the details—only to avoid running the risk of anticipating what I am going to tell you shortly and to spoil the surprise—to make you understand how the presence in these representations of the Terra Australis was not at all a hypothetical and casual exercise, just consider Gerardus Mercator's map[327]. Kremer is famous for his studies on cartography and for having published, in 1569, a map of the terrestrial globe with a new projection called Mercator's Projection[328]. Thanks to this projection introduced by this Flemish cartographer, it is possible to have a map that maintains the globe's angles. The maps thus drawn were used until very few years ago for compass navigation before the advent of GPS[329].

To better grasp the exceptionality and the apparent incongruity contained by the presence of Antarctica in this representation, I propose it in comparison with the corresponding satellite representation of the Earth. (See Figure 18.)

[327] Gerahrd Kremer (1512-1594), was a Flemish mathematician, astronomer and cartographer.

[328] Nova et aucta orbis terrae descriptio ad usum navigantium emendata accomodata— Gerardus Mercator, 1569.

[329] GPS stands for Global Positioning System, a system that locates the longitude and latitude of objects and people through satellites in Earth orbit and allows to know the exact location of a place at any time.

FIGURE 18— COMPARISON BETWEEN MERCATOR'S PROJECTION OF 1569 AND AN EARTH SATELLITE VIEW IN MERCATOR CYLINDRICAL PROJECTION

The depiction of Antarctica in Renaissance maps, even those considered pertinent by historians, is only marginally extraneous to indirectly demonstrating a knowledge of the Americas prior to 1492. In chronological order it shows in an even more macroscopic way the very precise geographical knowledge that could be found on the tables of the main European courts between the fourteenth and fifteenth centuries. There's no doubt about that. How else was it possible to map the Terra Australis with such accuracy?

And note well: I am not talking about a few hundred years, but about centuries and millennia, considering the fact that such mapping could only take place during certain historical periods when, cyclically, Antarctica was at least partially[330] free of ice.

Another useful bit of information for our story is that this knowledge arrived in Florence through the Byzantine humanist Manuele Crisolora, who taught Greek culture at the Studium of Florence[331] for four years and in 1414 was named kin by Emperor Sigismund of Hungary. Why is this information useful to us? Because the Hungarians were indeed among the first to support the expeditions to America, so much so that they were probably the ones who decided its name. The name America, in fact, derives from Emmerich[332], the son of the first Hungarian Catholic king, Stephen I.

It should not surprise you, then, to know that there are at least fifty or so representations of the Americas dating back to a period between 1414 and 1459, whether in cartographic form or simple floral-faunistic or anthropological references. This is the case in the representation of Cosimo the Elder as Pachacutéc, as painted by Benozzo Gozzoli, which was mentioned in the previous chapter.

The most interesting thing of all is that these testimonies are totally compatible with the narrative we have been dealing with so far regarding dates, circumstances, and characters involved. It goes without saying that we are not going to deal with all of them in detail, we will deal with at least the most significant ones so that we can then continue with greater knowledge to tell the story of Leonardo da Vinci's life and works. It is undeniable that the events linked to the first journeys to the Americas and the internal struggle between the European centers of power contributed to the creation of a hostile climate that did not spare Leonardo.

The first curiosity I want to bring to your attention concerns Paolo dal Pozzo Toscanelli[333]. He was considered the greatest Florentine cartographer at Cosimo de' Medici's court, and it is presumed that he transferred his knowledge to Leonardo in the 1470s, although there is no documentary source to prove it.

[330] As some will argue that the ice in Antarctica is miles thick, I am clearly referring to the fact that it was enough for the coasts to be free from it.

[331] The Florentine University opened in 1348 located in Via dello Studio 1, a few meters away from the Duomo of Florence.

[332] Amerigo in Italian

[333] Paolo dal Pozzo Toscanelli (1397-1488) was a mathematician, astronomer and cartographer

On the basis of Ptolemy's *Geography*, Toscanelli drew a planisphere that showed how one could reach the Indies via the Atlantic Ocean. A letter on this topic that he addressed to Ferdinand Martinez[334], canon of Lisbon at the time of Alfonso V[335], is known because it was transcribed by Christopher Columbus[336] in one of his books. In this letter, Toscanelli claimed that the shortest way to reach the East, then identified with Cipango[337], was to sail across the Atlantic.

Unfortunately there is no trace of the Florentine cartographer's planisphere today, but we are left with an indirect testimony, thanks to the German cartographer Martin Behaim. In 1492, he created the famous Erdapfel[338], a globe inspired by that of the cartographer Toscanelli and defined by scholars as "rich in fantastic drawings and legends that perfectly summarize the approximate geographical knowledge of the time."

This globe is very interesting for a variety of elements it contains, such as a gradual degradation of the color assumed by the Red Sea when meeting the Indian Ocean. This alludes to a very particular phenomenon due to some algae that evidently gave the name to this sea, as found in many ancient maps. It gives us an indication, although indirect, for identifying the period to which the representations of the early Renaissance referred, this algae bloom being a fairly rare phenomenon.

The approximate geographical knowledge of the time alluded to in accompanying Behaim's extraordinary globe would concern, among other things, the caravels that approach the Insula Antilia. (See Figure 19.)

[334] Letter that I will report in full later in the chapter

[335] Alfonso V d'Aviz, known as the African (1432-1481), was the 12th king of Portugal and the Algarve.

[336] Or on his behalf, as we shall see

[337] The island of Cipango (Japan) was mentioned for the first time by Marco Polo in *The Million*, pg. 155:
"Zipangu is an island in the east, which is in the high sea 1,500 miles from the mainland"

[338] Literally, *the earthly apple*, preserved at the Nuremberg National Museum, the *Germanisches National museum*.

FIGURE 19 — WORLD MAP BY MARTIN BEHAIM, 1492, DETAIL OF THE ISLAND OF ANTILIA, GERMANISHES NATIONAL MUSEUM, NUREMBERG

The Insula Antilia (island before the island), also known as Septe Ritade (seven cities), by shape and location is can be perfectly superimposed on the island of Hispaniola, where, coincidentally, one of Christopher Columbus's caravels sank: the *Santa Maria*.

On Martin Behaim's planisphere, we read:

> In the year of Christ, 734, the year in which the whole of Spain was conquered by the Pagans of Africa, the Island of Antilia, also called of the Seven Cities, was populated by an Archbishop of Porto, in Portugal, accompanied by six Bishops and a number of Christians, men and women, who fled Spain with their possessions and belongings. In 1414 a Spanish vessel landed near this island.[339]

In 1492, while there was still no news of the landing in America by Christopher Columbus[340]. Martin Behaim would therefore have made a map of the world by copying it from a 1474 planisphere by Paolo del Pozzo Toscanelli. He also included the information that since the year 734, on an island approached by caravels and apparently similar to the

[339] Erdapfel, Martin Behaim's world map, 1492—description accompanying the Island of Antilles—Germanishes National museum, Nuremberg.
[340] Considering he did not return to Spain until the spring of 1493

island of Hispaniola on which Christopher Columbus landed for the
first time, seven Portuguese prelates had lived alongside some
Christians who, in 1414, were joined by a Spanish vessel that landed
on the same island. The same news, with the same reference to the
island of the Seven Cities, is contained in the letter that Paolo dal
Pozzo Toscanelli wrote in 1474 to the Portuguese canon to claim
that the shortest way to reach the Cipango was by sailing west across
the Atlantic Ocean.

What Behaim writes on his globe, therefore, could actually refer
to the geographical knowledge in Paolo dal Pozzo Toscanelli's
possession in 1474. In this case, a fortiori, the strong recurring
similarity between the Insula Antilia and the island of Hispaniola
raises more than a legitimate doubt that the existence (and the correct
shape) of this land was already known before the Colombian
expeditions.

This doubt is further reinforced by the analysis of a manuscript by
Basinius Parmensis[341], a Parmesan poet who moved to the Malatesta
court in Rimini in 1449. Here he composed his greatest work,
Hesperis, an epic poem in thirteen books, in which the Parmesan
poet was called to celebrate the exploits of Sigismondo Pandolfo
Malatesta, the youngest of Pandolfo III's sons. Pandolfo III was a
great leader, a faithful ally of Pope Martin V and King Sigismund of
Hungary, and the first true patron of the Renaissance[342].

Hesperis, which is based on the models of Ancient Greek and
Latin, tells the story of the war conducted by the Lord of Rimini on
behalf of the Florentines between 1448 and 1453—especially those
fought against the great ally of the papacy of the time, the king of
Portugal[343] —and his subsequent return to his homeland as a winner.
The text was delivered to Sigismondo in 1457, immediately after the
death of its author, and given to be published with miniature
drawings by Giovanni da Fano.

Pandolfo Sigismondo was influenced by his charismatic brother
Domenico, who was much more educated and erudite than him, just
as Federico da Montefeltro suffered the overwhelming personality of

341 Also known as Basinio da Parma (1425-1457), he was an Italian humanist and poet
342 Supporting artists of the caliber of Gentile da Fabriano.
343 Alfonso of Trastámara, known as *the Magnanimous* (1396—1458), was a Spanish
prince of the Royal House of Castile, who became King Alfonso V of Aragon. He was
the founder of the Aragonese branch of Naples.

his brother Ottaviano degli Ubaldini, who had commissioned the aforementioned Rocca di Sassocorvaro. It is not unthinkable that the work of Basinio da Parma, as with the construction of the Malatesta Temple[344] in Rimini—which was never completed due to the deposition of Sigismondo Pandolfo in favor of his bitter historical enemy, Federico di Montefeltro, at the hands of Pius II—was intended by the client to attribute to him the merits of some of the striking events of those years experienced personally by his family members. I'm referring so the overbearing father and even more overbearing brother, Domenico, nicknamed Novello, to whom we owe the building of the valuable Malatesta library in Cesena.

In the illustrations that support the text, as well as those inside the Malatesta Temple, there are many references that curiously seem once again to anticipate the story of the alleged discovery of America by Christopher Columbus as we know it from the story transmitted to us by historians. I refer in particular to the references to the Zephyr's land, on which Sigismondo Pandolfo is said to have landed with his beloved Isolde. At the time the island was inhabited by Greek mythology figures, which the manuscript is inspired by: the Hesperides.

The allusion to the first voyages to the Americas goes well beyond the narrative references, which are also very allusive. It cannot be overlooked that Zephyr is a character from Greek mythology who personifies the wind blowing from the west[345]. That is where, it is said, the Hesperides lived—guardians who, according to legend, protected the garden with Hera's golden apples. The Hesperides were geographically located in the far west of the world, beyond what were considered the borders of the inhabited land at the time. This was identified with the border of the non plus ultra[346], where all mortals were forbidden to cross.

The most famous representation of the garden of Hesperides is in Botticelli's *Spring*, where the artist sets the painting we have already talked about in the Boschetto delle Esperidi The Three Graces are identified as the nymphs of the garden with the golden apples. I don't

[344] Built on a previous Franciscan site, the Malatesta Temple was completely renovated under the rule of Sigismondo Pandolfo Malatesta with the contribution of leading artists such as Leon Battista Alberti, Matteo de' Pasti, Agostino di Duccio and Piero della Francesca. Although incomplete, it is considered to be the key work of the Rimini Renaissance and one of the most significant architectures of the Italian 15th century in general.
[345] Warm and gentle breeze
[346] The Strait of Gibraltar.

need to underline the relevance between the golden apples (*pomi d'oro* in Italian) in this garden and the tomatoes (*pomodori* in Italian), which are known to be native of the Americas. In case you had missed it.

In Basinio da Parma's poem, moreover, Sigismondo Pandolfo is the victim of a shipwreck with his beloved Isolde and ends up living in the Zephyr's palace on the namesake island. Beyond the narrative similarity with the shipwreck suffered by the Santa Maria on 25 December 1492 on the island of Hispaniola (one of the largest islands in the Antilles), both the island and Zephyr's palace depicted in the commemorative text are suspiciously reminiscent of the same island reached by Columbus and the fortification built here by the first colonists.[347](See Figure 20.)

The island referred to in this poem is the same one alluded to on Behaim's globe, which includes the text borrowed from Toscanelli and reported by Columbus in his diaries, according to which the island was reached in 1414 by a Spanish vessel. The Insula Antilia can be perfectly superimposed onto Haiti, by shape and geographical location, in the middle of the Caribbean Sea.

[347] Fortaleza Ozama, Santo Domingo

FIGURE 20 — HESPERIS, BASINIO DA PARMA—THE SHIPWRECK AND THE LANDING ON ZEPHYR'S ISLAND BY PANDOLFO SIGISMONDO MALATESTA

To further support this reading, the trees represented by Giovanni da Fano on Zephyr's island, unlike those depicted in the other scenes of the poem, are identical in their shape to those represented in the planisphere of Cantino in 1502 as Brazilian trees. The Cantino planisphere is a map composed of six sheets of parchment glued together that shows the geographical knowledge of the Portuguese empire at the beginning of the fifteenth century. This representation takes its name from Alberto Cantino, an agent of the duke of Ferrara who smuggled it from Portugal to Italy in 1502.

The map depicts the Brazilian coast, which had been discovered only in 1500 by the Portuguese explorer Pedro Álvares Cabral, and shows the African coast of the Atlantic and Indian Oceans with great accuracy and detail. (See Figure 21.)

This planisphere is very important not only for identifying the specific origin of the trees included in *Hesperis*,[348] which will also fill many of the works of the most famous artists of the Renaissance well before 1492[349] but because it depicts the line between the territories divided in 1494 by the Treaty of Tordesillas between Spain and Portugal, to which we will return shortly.

[348] Araucaria.
[349] Leonardo, Botticelli, Perugino, to name a few

FIGURE 21 — DETAIL OF CANTINO PLANISPHERE, 1502,
ESTENSE LIBRARY OF MODENA

Beyond all these references—already sufficient in themselves to
feed more than a legitimate and solid doubt—it is in the Malatesta
Temple in Rimini that the most significant evidence can be found.
These testimonies reveal a knowledge of the Americas prior to 1492,
if possible in an even more detailed way, from the representations of
Peruvian flowers[350] to those of caravels whose sails recall the first
Renaissance planispheres[351].

I refer in particular to a painting by Piero della Francesca[352] dated
1451, which portrays Sigismondo Pandolfo Malatesta kneeling before
San Sigismondo. (See Figure 22.)

[350] The Malatesta Rose is the re-proposal of a flower typical of Peru, called *Ludwigia
Octovalve*, or *Peruvian*, also present in some paintings depicting scenes of Amor Cortese
near Lecco.
[351] With meridians, parallels and line of the tropics, depicted in correspondence with the
bas-relief relative to the constellation of Cancer, which presents the same barren landscape
depicted behind Matthias Corvinus in Palazzo Medici Riccardi in those same years.
[352] Piero di Benedetto de' Franceschi, commonly known as Piero della Francesca (1416-
1492), was a painter and mathematician considered one of the most emblematic
personalities of the Italian Renaissance.

FIGURE 22 — SIGISMONDO PANDOLFO MALATESTA PRAYING IN FRONT OF SAN SIGISMONDO, PIERO DELLA FRANCESCA, 1451, MALATESTA TEMPLE—RIMINI

In this painting, Piero della Francesca portrays George Gemistus Pletho, who died in Mystra[353] in 1452, in the role of San Sigismondo. Malatesta manifested a real veneration of Gemistus Pletho, even after his death.

The Rimini commander said he had found the remains of the body of Gemistus Pletho during a military clash in Mystra in 1456 and took them with him to the Malatesta Temple, where they are still buried today in one of the sarcophagi placed in the arches outside the temple, together with the sarcophagi of other personalities who animated his court. The roof of this same temple, in Leon Battista Alberti's design concept, was to take the shape of the headdress that Gemistus Pletho is portrayed with by Benozzo Gozzoli in the *Cavalcade of the Magi* in Florence, as can be deduced from a medal by Matteo de' Pasti[354].

For what it is worth, my impression is that Sigismondo Pandolfo Malatesta wanted to dress for a role that was not his in order to give himself a different place in history from the one he actually held. For this reason, once he reached power, Malatesta did everything possible to surround himself with decorative and celebratory elements[355] redundant compared to what was his actual cultural and intellectual dimension, which was more devoted to military dynamics and pursuing power on the field than to the humanistic topics. We could say that Sigismondo Pandolfo Malatesta behaved like those who, today, in having to furnish a new house, buy antique books by the meter to demonstrate a cultural cachet that does not belong to them.

Among the decorative elements of the Malatesta Temple was the fresco by Piero della Francesca seen earlier. Initially the fresco decorated one of the walls of a side chapel in the church of San Francesco, on whose original layout Sigismondo Pandolfo later had his temple built. It was a jumble of pagan knowledge that did not please Pius II, as it was too different from the Catholic culture he aimed to protect. For this reason Malatesta was excommunicated by the Sienese pope, with the false

[353] It was the capital of the Byzantine Despotate of the Morea.

[354] Matteo de' Pasti (1412—1468) was a medalist and miniaturist from Verona, active mainly in Rimini.

[355] Like the Hesperis just analyzed.

accusation of having poisoned his first two wives, Ginevra d'Este and Polissena Sforza[356].

Today the painting by Piero della Francesca has been detached from its original position, glued onto canvas, framed, and placed inside the church near the modern sacristy. In the exact center of the fresco is portrayed in profile Pandolfo Sigismondo Malatesta, kneeling with his hands joined in the act of praying to Saint Sigismondo, who is portrayed in turn on the left side, seated on a throne placed above a step in the same way as Beato Angelico's frescoes, which are kept in the convent of San Marco in Florence.

Thanks to the fact that he holds in his hands the signs of royal dignity—the scepter and the globe—and the particular cap (on top of which is the halo in perspective, a trademark of Piero della Francesca), the character in front of Sigismondo Pandolfo Malatesta is more easily identifiable as Sigismondo of Hungary. He was the emperor who, in 1433, invested Malatesta with the title of knight and legitimized his father's direct dynastic succession, together with his brother Domenico, ratifying their mutual seizure of power over Rimini and Cesena.

The fresco, as we see it today, mirrors that same characteristic we've already seen being used several times in the previous pages. Artists used sacred iconographies to portray political or mundane scenes, within which they could then include portraits of their clients or prominent figures of the time. This gave a certain prestige to the owners of the works in question.

Behind the figure of Pandolfo Sigismondo, on the bottom right corner of the painting, are two greyhound dogs curled up, one white and one black. They have an extremely formal elegance, being painted from life with a care worthy of Pisanello's[357] best naturalistic works. They express symbols of fidelity (the white one) and vigilance (the black one).

As usual, this is what is we've been told by art critics and historians. The work, however, describes anything but that. The two greyhounds depicted here personify the Dominican Order, whose

[356] Daughter of the Duke of Milan Francesco Sforza.

[357] Pisanello, pseudonym of Antonio di Puccio Pisano (1390—1455), was a painter and medalist among the major exponents of international Gothic in Italy. Nobody before him had come to such an accurate analysis of the natural world, surpassed only at the end of the 15th century by the inquisitive eye of Leonardo da Vinci or Albrecht Dürer.

fake and crossed positions recall the combination that in heraldry is called *decussato*[358] In 1216 Pope Honorius III gave his approval to the Order of the Preachers friars founded by Dominic of Guzmàn. Playing on the name of their founder and recalling their fidelity to God, he called them "the dogs of the Lord." Hence the pun: Domine-canis (literally Lord-dogs) and Dominicans (by Dominic). It is for this reason that Dominican friars are often represented in Renaissance paintings with the image of two or more greyhounds, mainly black and white, to recall the colors of their robes.

In the representation of Domenico di Guzmàn present in one of the cells of the convent of San Marco in Florence and frescoed by Beato Angelico, the friar is portrayed sitting next to a Christ. Christ holds in his hand what looks like a cornstalk and on his face blows the humid tropical winds, represented by the image of the spit by a regular visitor. St. Dominic, sitting at Christ's feet, is intent on consulting a book on which traces of the abrasion of what appears to be a geographical map are very evident. As I have previously expressed, the friars of this order will play an essential role in all the political events of the Renaissance, including the first voyages to America[359].

Returning to Piero della Francesca's painting in the Malatesta Temple in Rimini, what appears to be a fall of color behind the two characters is instead a clear partial representation of North America. I would not rule out the possibility that the representation of the North American territories on the background of this fresco may be earlier than the image of Sigismondo Pandolfo Malatesta praying before San Sigismondo in the full self-celebrating spirit of the Lord of Rimini, but at the moment any request for further study of the painting I have made has been rejected on several pretexts.

It is curious to note, however, through the aid of two images preserved in the archives of the Federico Zeri Foundation[360]—one relating to the fresco as it can be seen today, with the partial outline of the North American territory, and one of the frescoes as it was in 1943

[358] Also known as St. Andrew's Cross

[359] It is no coincidence that the Island of Hispaniola is named after Santo Domingo de Guzmán.

[360] The Federico Zeri Foundation is a center for research and specialist training in the field of art history. It was established in 1999 by the University of Bologna with the aim of protecting and disseminating the work and figure of Federico Zeri, preserving and enhancing the extraordinary legacy of the scholar: the Library (46,000 volumes, 37,000 auction catalogues) and the Photo Library (290,000 photographs of works of art)

when it was detached from the wall to be transported on canvas—how the background is completely different.

In the first image, we can clearly see the presence of a layer of paint stretched out to cover the geographical representation below. (See Figure 23.)

It would be interesting to know the study of the renovation that restored the painting to its original condition and see if we can understand what was preserved and what was lost from the original painting, since the presence of a clear outline that recalls the territories of North America is indisputable, as is the presence of Cuba peeping out from under the snout of the white greyhound. The garland of greenery above the painting corresponds to the American Great Lakes.

My feeling is that this geographical representation originally belonged to his brother Domenico, whose name was changed in 1433 to Novello, while to Pandolfo Sigismondo we can only attribute his own image in adoration of Sigismondo of Hungary, the image commissioned and affixed by Piero della Francesca during a second stage of painting.

It does not matter for now. What it is important is the dating of this view of America, whose realism and figurative timeliness are impressive enough that we can recognize:

- to the north, the area of the Great Lakes;
- to the south, Louisiana and part of the Gulf of Mexico;
- and to the east, Florida, the entire East Coast including Delaware and Hudson Bay, which was officially discovered by Giovanni da Verrazzano only in 1522.

Regarding Giovanni da Verrazzano, there is a curious plaque on the house in Via Ghibellina 87, which was perhaps inherited by Sir Piero da Niccolò di Sir Vanni, who was mentioned earlier. This plaque, which commemorates Verrazzano's living there, publicly praises the navigator who, upon discovering the Hudson Bay, was finally able to show the whole world that even the Florentines were to be considered great navigators. Given all what has been said so far, it is an inscription that arouses a great deal of hilarity in me, don't you agree?

FIGURE 23— SIGISMONDO PANDOLFO MALATESTA PRAYING IN FRONT OF SAN SIGISMONDO, FEDERICO ZERI FOUNDATION ARCHIVES, BOLOGNA

It also corresponds exactly to the 44th parallel—the same latitude at which the city of Rimini is located.

The timeliness of Piero della Francesca's representation (or that of someone on his behalf) is such that even a couple of minor lakes can be identified whose presence cannot be accidental: Lake Okeechobee in Florida and the lake that bears the name of my wife, Marion, in South Carolina. Just for the sake of curiosity, I would also like to remind you that Piero della Francesca officially died on October 12, 1492, the same date on which Christopher Columbus would set foot in the New World for the first time. On the other hand, Christopher Columbus is said to have been born in 1451, the year in which Piero della Francesca frescoed this map. Just coincidences? I don't think so. Just as it is not at all the result of a coincidence what I'm about to show you.

We spoke earlier about Sigismondo Pandolfo Malatesta and Pisanello. Remember then that Pandolfo's first wife, Ginevra[361], was daughter of Niccolò III d'Este, and that he too was present in Benozzo Gozzoli's cycle. Well, do you want to know when Ginevra d'Este dies? On 12 October 1440! Again this blessed 12 October. This date begins to resonate a little too suspiciously, don't you think?

Pisanello dedicates one of his portraits to Ginevra d'Este. In this portrait, behind the little princess, the coasts surrounding the Gulf of Mexico are once again recognizable, in the states of Louisiana, Florida, Yucatan in Mexico, and Cuba. This is exactly the same area we find behind Pandolfo Sigismondo's body in Piero della Francesca's painting kept in the Malatesta Temple in Rimini. (See Figure 24.)

Again, just a coincidence?

Sigismondo Pandolfo had three wives: Ginevra d'Este, Polissena Sforza, and Isotta degli Atti. The first two wives both died prematurely, a circumstance that earned him an excommunication by Pope Pius II on charges of poisoning. Curiously, however, the portraits of these three ladies can be perfectly superimposed atop one another, as if they were the same woman who over the years only changes physiognomy as she gets older.

[361] Ginevra d'Este (1419—1440) was the daughter of Niccolò III d'Este, Marquis of Ferrara, and of his second wife Parisina Malatesta. She was the first of the three wives of Sigismondo Pandolfo Malatesta, lord of Rimini

FIGURE 24 — PISANELLO, PORTRAIT OF PRINCESS, 1440,
LOUVRE MUSEUM IN PARIS

With regard to Ginevra d'Este, however, out of narrative necessity I
must remind you that the third wife of her father Niccolò III was
Ricciarda di Saluzzo, a small village in Piedmont visited by Leonardo in
1511[362]. In Saluzzo is the Manta Castle, a residence that belonged to
Ricciarda's brother, Valerano di Saluzzo. On the ceiling of this castle is
one of the anonymous representations of the Americas to which I
referred earlier, dated around 1450, that includes Antarctica. It is
accompanied by the inscription of Virgilian memory *Spiritus intus alit.*

Taken individually, each of these dates may be questionable and
could be immediately corrected and moved forward to a later date. The
problem is that these representations of the Americas are many, and all
connected with each other.

Another representation of the Americas dated from the same period,
in fact, can be found in Milan, in front of the Dominican convent of San
Maria delle Grazie, which was part of the Lombard congregation,
together with the Dominican convents of Fiesole and San Marco,

[362] Monbracco above Saluzzo, above the Carthusian monastery, one mile above Monviso,
has a stone, which is white like the Carrara marble, without stains, hard as porphyry or
more. My friend, master sculptor Benedetto, promised me he'll send me a table of it for
the colors.
5th of January 1511
Manuscript G, Sheet 1v—Institute de France, Paris.

historically close to Cosimo de' Medici. In what is today called the
Atellani House[363] —but which prior to 1492 belonged to Manfredi
Landi, a faithful leader servant of Francesco Sforza who in gratitude
gave him this residence in the mid-fifteenth century—there is a
representation of a terrestrial globe very similar to the one in the
Castello della Manta in Saluzzo, with the Americas in plain sight.
Date? Also around 1450.

Manfredi Landi is portrayed, together with Bianca di Savoia and
Francesco Sforza, in a painting in the adjacent church of Santa Maria
delle Grazie. All three are protected by the veil of the Madonna of
Mercy by an anonymous painter. I remind you that these Madonnas
were also called "the Madonnas of navigators" because of the
reference (evidently not at all random) contained in the contour of
the Virgin's veil that recalled the so-called heart-shaped frame of the
first geographical maps. Leonardo himself gives us an example of such
a map on the same sheet containing the octant projection that I
analyzed before[364]. There are several of these Madonnas of navigators,
by different painters and with different navigators portrayed under the
protection of the Virgin's mantle.

As you can already see from these small and brief references, the
characters linked to these geographical representations—which we
could define as "forbidden"—are the same that are depicted by
Benozzo Gozzoli in the *Cavalcade of Magi* or are somehow related to
them. Each one of these characters is linked to the other by kinship
or on the basis of a political and military alliance. They also link their
names to a representation of the Americas that is only apparently
anachronistic, as it was much earlier than that 12 October 1492 when
Christopher Columbus's discovery of America would be dated.

Pisanello is certainly the artist who most of all disseminates in his
works these "occult" testimonies of the New Continent. At the
National Gallery in London, there is a 1438 painting of his to which I
would like to bring your attention. (See Figure 25.)

[363] In which today is located the vineyard that Ludovico il Moro donated to Leonardo.
[364] Codex Atlanticus, Sheet 521 r—Ambrosiana Library, Milan

FIGURE 25 — THE VISION OF ST. EUSTACE, PISANELLO, 1438, LONDON NATIONAL GALLERY

First of all, we should examine this painting because it can help us understand why Domenico Malatesta was nicknamed Novello[365]. Secondly, it takes us back again to that October 12 that, in almost obsessively, comes back and repeats itself every time we meet a character or a representation that, in one way or another, has to do with the Americas. Before I wrote "occult," but it would be more correct to say kept concealed at this point.

The painting by Pisanello to which I refer is entitled *The Vision of St. Eustace*, dated around 1436–1438. Hidden again behind a Catholic iconography, in this case a deer in whose antler appears Christ on the cross[366], the vision to which the title of the work alludes is a clear and

[365] The official biographies trace back the change of name to the nomination, together with his brother Pandolfo Sigismondo, as a palatine knight by the emperor Sigismondo of Hungary, after which he decided to omit the first name Domenico to take the new name of Malatesta Novello.

[366] The image which the story of the conversion of St. Eustace is traditionally represented with

evident profile of South America. On the left side, the Andes Mountains can be recognized.

The same representation of South America and a reference to the Andes Mountains can be found in Palazzo Medici Riccardi in the frescoes by Benozzo Gozzoli, together with some exotic animals. The most evident is the *Marsh Deer*, a deer being chased by a man armed with a spear. The clear intention in this work is recalling one of the hunting rituals of the Gran Chaco, a territory between Argentina, Peru, and Bolivia. This detail tells us not only that the overseas territories were known "on paper" but, as in the representation of Cosimo the Elder in the role of Pachacutéc, it gives us a direct indication that those who were able to make this kind of representations must have had a deep knowledge of local customs. The character who has this very particular "*vision*" is probably Domenico Malatesta, and it is in relation to the discovery of the New World that he changes his name in Novello.

Why am I telling you this? Because on the back of the medal that Pisanello dedicates to Domenico Malatesta, there is the same iconography of the deer with Christ crucified between the horns used in the painting, which unequivocally links the Lord of Cesena to Saint Eustace. (See Figure 26.)

On the right hand side of Pisanello's painting, we can recognize a tiny bear, which we find painted several other times: in the Pilgrim's House in Civate, in a hunting lodge in Oreno[367] traceable back to Galeazzo Maria Sforza on the outskirts of Milan, in Teodolinda's chapel in the Monza cathedral, here with other exotic references such as the previously mentioned three feathers that make up the maskaypacha and some hallucinogenic mushrooms typical of South American indigenous ritual practices. This is the Andean "spectacled" bear[368], also depicted on a modern Peruvian coin. It was also drawn by Leonardo in one of his first works that reached us[369], as well as being the inspiration for the protagonist of an English children's saga: Paddington Bear.

[367] Oreno is the birthplace of Gian Giacomo Caprotti, called Salaì, who has been alleged to be Leonardo's lover but arguably could be his son: "*Milanese by his creation*", as Vasari says in *The Lives*.

[368] Tremarctos Ornatus.

[369] Leonardo Da Vinci. Walking Bear (first half of 1480). Metal tip, cm. 10.3 x 13.3. The Metropolitan Museum of art, Robert Lehman Collection

*FIGURE 26 — PISANELLO, 1445, MEDAL OF DOMENICO
"NOVELLO" MALATESTA, NATIONAL GALLERY OF ART,
WASHINGTON*

In confirmation of the fact that Pisanello's painting actually contains a
geographical reference, in the lower part of the painting you can
recognize one of those representations of the Terra Australis, which are
only apparently anachronistic, as I mentioned earlier.

This painting, as usual, is important in many ways: first because it
offers us a representation of South America dated 1436–38, which makes
it interesting in itself, and second because the painting offers us an unusual
view of the South American continent. I would add that it's a "natural,"
not cartographic, view indeed. I would venture to say that the one
painted by the artist could be compared to a modern satellite image in
which the arid and flourishing areas of South America appear quite
distinct—if I was not afraid that this statement of mine might trigger
uncomfortable drifts and intrusions in areas that at the moment I am not
interested in exploring.

Third, this painting gives us the spark to make a hypothesis regarding
the reasons for Domenico Malatesta changing his name to Novello,
which means "Novelty." Is it perhaps in reference to that New World
that he, as when he was painted in the role of Saint Eustace, was able to
see for the first time before 1438?

There are another couple of aspects related to Domenico Malatesta that do not add up, and they concern his father, Pandolfo III.

Pandolfo III, Lord of Fano, died in 1427 in the same Marchigian city where he was later buried in the loggia of the former church of San Francesco. In 1995 his tomb was opened, revealing two curious aspects: the body of Fano's leader was found mummified, despite Fano being on the seashore (not exactly an environment that would facilitate natural mummification), and he was still wearing his red velvet doublet. After an in-depth analysis, this doublet was revealed to have been dyed with cochineal lacquer, which comes from an insect called Dactylopius *coccus*. It lives on various species of South American cacti, in particular the *Nopalea cochenillifera*.

The most surprising thing that this painting reveals to us, though, is what follows. In the Roman martyrology[370], Saint Eustace is celebrated on 30 September—but only since1584, when Gregory XIII approved the new liturgical book. The celebration of the saints and the iconography of reference, before then, was based on the *Legenda Aurea*, also called *Legenda Sanctorum*, a medieval collection of hagiographic biographies composed in Latin by Jacopo da Varagine[371], a Dominican friar who was also bishop of Genoa, from about the year 1260 until his death in 1298. Still today this manuscript is considered an indispensable reference for interpreting the symbology and iconography inserted in paintings of religious content.

Beyond having many personal doubts about this last statement, for the obvious reasons given so far on the basis of the religious contents of the Renaissance works, do you know when Saint Eustace was celebrated—before Gregory XIII approved the Roman martyrology, currently edited by the Congregation for Divine Worship and the Discipline of the Sacraments[372]?

Ça va sans dir: 12 October!

[370] The *Roman Martyrology* is a liturgical book and forms the basis of the liturgical calendars that every year determine the religious feasts. The first official edition dates back to the 16th century and was approved by Pope Gregory XIII in 1584.

[371] Varazze.

[372] It is the department responsible for everything concerning the liturgy of the Latin Church (it takes care of the compilation of liturgical texts and oversees their translation into the various languages) and the discipline of the seven sacraments (in particular, it examines questions concerning the validity of marriage and order)

What does this tell us? It tells us that the story of the alleged discovery of America by Christopher Columbus is clearly the sum of a series of events that actually occurred over time for those who made the first expeditions to the New World, which clearly took place long before 1492. That's when they were collected in a single story attributed to a totally fantastical character[373] created by the Catholic Church to justify the appropriation of territories, the submission of populations, and the embezzlement of their wealth.

Among the events contributing to form the false myth of the "discovery of America" we include:

- the date of the 12 October;
- the landing on the island called Guanahani by the locals, renamed San Salvador by the Spanish;
- and the shipwreck of the Santa Maria, the largest of the ships, on 25 December on the island of Haiti.

As I wrote earlier, the importance that the events connected with these first trips to America had on Renaissance life were initially manifested through the assumption of a symbolism of clear Amerindian derivation. (See Figure 27 and Figure 28.)

In addition to the maskaypacha worn by Cosimo the Elder or painted on the birth tray celebrating the birth of Lorenzo the Magnificent, I could mention the hairstyles—clearly evocative of those of the Americans natives—assumed by Sigismondo Pandolfo Malatesta, Costanzo Sforza, and Alfonso V, of which I propose an obvious example.

Or I could cite the *Ludwigia peruviana*, a flower that appears among those included in the *Florentine Codex*[374], one of the first chronicles of the New World. This flower also adorns the entire Malatesta temple of Sigismondo Pandolfo Malatesta, but it already appeared on coins minted by the Fano mint, called the "picciolo", that were issued between 1414 and 1439.

[373] Christopher Columbus.

[374] The so-called *Florentine Codex* is the only bilingual edition (Spanish and Nahuatl) of *La Historia Universal de las Cosas de Nueva España*, written by the Mexican Fra' Bernardino de Sahagún and now kept in the Laurentian Library.

FIGURE 27— COMPARISON BETWEEN THE HAIRSTYLE OF KING ALFONSO V OF ARAGON AND THE TYPICAL HAIRSTYLE OF A NATIVE OF THE AMERICAS

That of the "picciolo" Malatesta coin, by the way, is yet another reference to the year 1414, which brings to mind several analogies that would legitimize a direct knowledge of the American continent already at that date.

The circumstance to which Behaim refers in the *Erdapfel*, for example, is taken from a letter written in 1474 by Paolo dal Pozzo Toscanelli. In the letter, a Spanish vessel that would have landed in 1414 in the Insula Antilia, where seven Portuguese prelates had already resided for some time, is mentioned.

Or the fact that in that year, the Infante of Portugal, prince of the Portuguese royal house and first duke of Viseu, was Henry of Aviz, who went down in history as Henry the Navigator. At that time Henry was related to Cleofe Malatesta, cousin of Pandolfo III, to whom Gemistus Pletho will dedicate a funeral ode. It is no coincidence, therefore, that on the coins minted by the Malatesta on which the *Ludwigia peruviana* appeared, there was also the hooked cross of Aviz on the back.

FIGURE 28— LUDWIGIA PERUVIANA IN A DETAIL TAKEN FROM THE CODEX FLORENTINE AND ON THE MALATESTA "PICCIOLO"

As you can see, we have Portuguese on one side and Spanish on the other, united by the dispute over the division of coveted territories This is more than understandable given that both nations overlook the Atlantic Ocean. Or perhaps it would be more correct to say Henry the Navigator was on one side and Alfonso V of Castile on the other.

As you can see, little by little the pieces of the puzzle that describe a struggle for control over the territories of the new continent, which lasted for the entire fifteenth century, and of which traces remain scattered here, there, and everywhere, recompose in the works, in the writings, in the

artefacts, and even in the customs and habits acquired in the daily lives of the characters who, for various reasons, were involved.

That of Christopher Columbus is nothing more than the last chapter of this endless story. An invented story, as I have written before, that does not hold water, and to which there are clear references and testimonies in the historical events that have evidently been drawn on to build that myth. The consequence of this myth-building is that the Church and the royals of Spain, mainly, were able to claim a right of pre-emption and take advantage of the huge wealth and territories belonging to the indigenous people. This determined a totally subjective division of the New World. It was a dastardly act orchestrated by the papacy and carried out through the faithful control of the Dominican friars, later followed by the creation of the Jesuit Order[375]. A criminal act that, since then, continuously shapes modern society. A despicable act, the genesis of which, in the light of what has been shown so far, can be traced back to the beginning of the fifteenth century.

In this can be read in the trends of the various papal dispositions that followed during the fifteenth century, which I will briefly summarize. In 1405 Innocent VII approved the Rule of the Third Dominican Order, that of the Dominican laity, which included the Mantellate, the members of civil society who strived to help the needy. The most famous of the Mantellate is Saint Catherine of Siena[376]. She was the inspiration for the Congregation of Mercy in Florence, the female Dominican convent of San Marco led by Antonino Pierozzi, to which Lucrezia Tornabuoni was very close and which was part of the Medici suburb.

This perhaps explains the presence of a map, later abraded, that was painted on the book in San Domenico's hand by Beato Angelico in the cells of the convent of San Marco. Or it could explain the joint presence of Pierozzi and Lucrezia Tornabuoni in Ghirlandaio's

[375] The Society of Jesus is a male religious institute of pontifical law whose members, called Jesuits, postpone the initials S.I. to their name.
The order was founded by Ignatius of Loyola who, together with some companions, made a vow in Paris in 1534 to preach in the Holy Land (a project abandoned in 1537) and to place himself under the orders of the Pope: Ignatius' program was approved by Pope Paul III with the bull *Regimini militantis ecclesiae* (27th of September 1540).
[376] Caterina di Jacopo di Benincasa, better known as Caterina da Siena (1347-1380), was an Italian religious, theologian, philosopher and mystic.

painting under the cape of the Madonna of Mercy in the company of the Vespucci family.

In 1435 Eugenio IV wrote *Sicut Dudum*, the first reprimand of the Holy See against slavery, addressed to Bishop Ferdinando di Lanzarote:[377]

> And nevertheless we order and recommend to all and each of the faithful Christian of both sexes that, within fifteen days from the day of publication of the present, to be carried out in the place where they live, they return to their former freedom all and each one of those, of both sexes, who previously inhabited these islands, called the Canary, imprisoned since the time of their capture, and subjected to slavery, and let them go for ever, without any exaction or acceptance of money; otherwise, after the aforementioned days, they will incur immediate excommunication, from which they cannot be released except by the Apostolic See or by the Spanish bishop temporarily in office, or by the aforementioned bishop Fernando, and not before having returned to freedom the people thus captured and returned their belongings, unless they are on the point of death.[378]

In 1452 Nicholas V wrote *Dum Diversas*, the bull addressed to Alfonso V of Portugal, in which he is granted the faculty "to reduce into perpetual slavery Saracens, pagans, infidels, and enemies of Christ":

> We, strengthened by divine love, driven by Christian charity, and constrained by duties of our pastoral office, wish, as it is appropriate, to encourage what is relevant to the integrity and growth of the Faith, for which Christ, our God, shed his blood, and to sustain in this most holy endeavor the vigor of the souls of those who are faithful to us and to your Royal Majesty. Therefore, by virtue of apostolic authority, with the content of this letter, we grant you the full and free faculty to capture and subjugate Saracens and pagans, as well as other infidels and enemies of Christ, whoever they may be and wherever they may live; to take all kinds of property, whether movable or immovable, which may be in the possession of these Saracens, pagans, infidels and enemies of Christ; to invade and conquer kingdoms, dukedoms, counties, principalities; as well as other domains, lands, places, villages,

[377] The same to whom Paolo dal Pozzo Toscanelli will later send a letter with directions to reach the Americas without passing through Guinea.

[378] Sicut Dudum, whose official title is *Creator Omnium*, is a bull of Pope Eugene IV dated 13th of January 1435.

It is the first written document to be published by the Holy See against slavery.

fields, possessions and goods of this kind to any king or
prince they belong to and to reduce their inhabitants to
subjugation; to take possession forever, for you and your
successors, the kings of Portugal, of kingdoms, duchies,
counties, principalities; as well as other domains, lands,
places, villages, fields, possessions and goods of this kind,
allocating them to your use and advantage, and to those of
your successors.[379]

In the same year in which Niccolò wrote the *Dum Diversas*,
Enea Silvio Piccolomini[380] arranged the meeting that would lead to
the marriage between Frederick III[381] and Eleonora of Portugal,
relative of Henry the Navigator. The meeting was immortalized by
Pinturicchio in the cycle of frescoes in the Piccolomini Library in the
Siena cathedral, with Nastagio Vespucci, Amerigo's father, in the role
of witness. (See Figure 29.)

Only two years later, in 1454, Nicholas V wrote *Romanus
Pontifex* through which he extended to the king of Portugal the right
of slavery over the Africans of Guinea.

> Therefore we, [...], as we have previously granted
> with other letters of ours, among other things, full and
> complete faculty to King Alphonsus to invade, search out,
> capture, conquer and subjugate all the Saracens and any
> pagans" and the other enemies of Christ. "..... wherever
> they live, with their kingdoms, ducats, principalities,
> lordships, possessions and any properties, movable and
> immovable, possessed by them, and to reduce them into
> perpetual slavery and to occupy, seize and turn to their
> own use and profit and to that of their successors such
> kingdoms, ducats, counties, principalities, lordships,
> possessions and properties, as a consequence of the
> guarantee given by the such concession, King Alfonso or,
> in his name, the aforesaid Infante have legally and
> legitimately occupied the islands, lands, ports and waters

[379] *Dum Diversas* is a bull of Pope Nicholas V dated 16th of June 1452.
It was written, accompanied by the brief *Divine amore communiti*, to the King of
Portugal Alfonso V.
With this bull, the Pope recognized the Portuguese king's new territorial conquests on the
African coast of the Atlantic. It authorizes him to attack, conquer and subjugate the
"Saracens, the pagans and other enemies of the faith"; to capture their goods and lands; to
reduce them to perpetual slavery and transfer their lands and properties to the King of
Portugal and his successors.
[380] Elected Pope in 1458 under the name of Pius II.
[381] At that time Emperor of the Germanic Holy Roman Empire.

and they had and still do own them, and they belong and are
de jure property of the same King Alfonso and his successors;
[…] may they accomplish this pious and very noble task,
worthy of remembrance in the times to come, that we (being
that it favors the salvation of souls, the spreading of Faith and
the defeat of its enemies) consider a duty, which concerns God
Himself, His Faith, and the Universal Church—with great
perfection, since, once removed all obstacles, they will become
aware of having been fortified by the greatest favors and
privileges granted by us and the Apostolic See.[382]

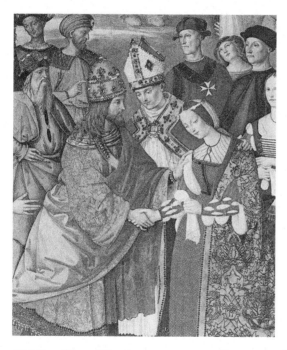

FIGURE 29 — MEETING BETWEEN EMPEROR FREDERICK III AND
ELEANOR OF PORTUGAL, PINTURICCHIO, PICCOLOMINI LIBRARY,
CATHEDRAL OF SIENA

In 1478, with the *Exigit Sincerae Devotionis Affectus* bull, Sisto IV
established the position of General Grand Inquisitor of Spain and the

[382] *Romanus Pontifex* is a bull by Pope Nicholas V dated 8th of January 1454.
Thanks to the support given by the Portuguese sovereign Alfonso to a crusade against the
Turks who had occupied Constantinople (1453), the pope recognized the king's
achievements on African soil, in Morocco and along the coastal side of the Gulf of
Guinea.

Colonies, supported by King Ferdinand II of Aragon, in order to oppose pagan heresies and extend judicial powers over the conquered territories. The first Grand Inquisitor of Spain was the notorious Tomás de Torquemada (1420–1498), prior of the Dominican convent of Santa Cruz in Segovia and confessor to the Catholic kings, Isabella of Castile, and Ferdinand II of Aragon.

In 1481 the *Aeterni Regis* papal bull of Sixtus IV guaranteed Portugal the exploitation of all the lands south of the Canary Islands. It protected what until then had been the known routes to the Americas, until Toscanelli, in 1474, suggested a more direct route. In 1484, through the *Summis Desiderantes Affectibus* bull, Pope Innocent VIII established the repression of witchcraft and heresy in Germany by appointing two local Dominican inquisitors[383] and confirming Torquemada's appointment as Grand Inquisitor of Spain. Innocent VIII—whom I personally believe to be the ultimate creator of and the first executor of the false myth of Christopher Columbus—can be associated with a series of curiosities that tell us a lot about how the events concerning the Americas actually unfolded.

The first curiosity is about his burial. Innocent VIII died on 25 July 1492, i.e., long before Christopher Columbus left Palos de la Frontera on 3 August of the same year and far before April 1493, when the news of the discovery of the Americas would have reached Europe—if Columbus's tale were actually true. Yet on Innocent VIII's tomb in St. Peter's, we find written:

> During his reign the discovery of a New World.

These few sibylline words—which some scholars aver[384] as revealing a total confusion about this whole story—would show that Innocent VIII had long supported Columbus's attempt to reach the Indies by sailing west.

Beyond the now clear evidence that where the New World was located was something known to all, as proved by the countless representations and testimonies that exist and have been reported here

[383] *Summis desiderantes affectibus* is a papal bull promulgated on the 5th of December 1484 by Innocent VIII, in which the pontiff affirmed the need to suppress heresy and witchcraft, appointing the Dominican friars Heinrich Kramer and Jacob Sprenger (authors of the *Malleus Maleficarum*) as inquisitors responsible for eradicating witchcraft from Germany.

[384] Ruggiero Marino.

only in a small portion, there is a double curiosity concerning the physiognomy of Innocent VIII and Christopher Columbus. If we compare the face of Christopher Columbus in the portrait by Rodolfo del Ghirlandaio with that of Innocent VIII's tomb in the Vatican, we discover that the two characters are the same person. (See Figure 30.)

FIGURE 30 — PORTRAITS OF CHRISTOPHER COLUMBUS AND INNOCENT VIII IN COMPARISON

Christopher Columbus and Innocent VIII appear to be the same person in much the same ways as the portrait of the navigator in one of the many Madonnas of Navigators depicted during the Renaissance. I am referring specifically to the *Virgin of the Navigators* painted by Alejo Fernández, an oil painting made as the central panel of an altarpiece for the Casa de Contratación de l'Alcázar chapel in Seville. It makes us smile today to read that someone may have considered this work "the oldest known painting whose subject is the discovery of the Americas."[385] (See Figure 31.)

[385] John Noble, Susan Forsyth, Vesna Maric, Paula Hardy. *Andalucía*. Lonely Planet, 2007, p. 100.
Silvio Bedini, The Christopher Columbus encyclopedia, 1991, p. 318

FIGURE 31 — COMPARISON BETWEEN CHRISTOPHER COLUMBUS AND INNOCENT VIII PORTRAITS

Rereading the letter written by Paolo dal Pozzo Toscanelli to the canon of Lisbon, Ferdinando Martinez, in the light of all that has been shown so far, the whole story takes on a different significance in our eyes:

> To Ferdinando Martinez, canon of Lisbon, Paolo the physician.
> I was pleased to hear your intimacy with your Serene and magnificent king: and although I have spoken many other times about the short route, via sea, from here to the Indies, where spices are grown, which I believe being shorter than the one you do through Guinea, you tell me that now His Highness would now like from me any declaration, or demonstration, so that such path can be understood and undertaken. I could indeed show this with the sphere in my hand, and demonstrate him how the world is; nevertheless, I have deliberated for greater ease and intelligence to demonstrate such route through a chart, similar to those made for sailing. And so I send it to his majesty, made and drawn by my own hand, in which is painted all the far end of the west, going from Ireland to the end of Guinea in the austral land, with all the islands, which lie in all this route: in front of which, straight to the west, lies painted the beginning of the Indies, with the islands and places you can reach: and how much from the Arctic you can deviate towards the equator, and in how much space, that is in how many leagues you can reach

those fertile places rich of all kinds of species, gems, and precious stones. And don't be surprised, if I call West the place where the spices are grown, where it is commonly said to be grown the East: because those who will sail to the west will always find these places in the west; and those who will go by land to the east will always find these same places in the east.

[…]

And from the island of Antilla, which you call" the Island of the Seven Cities, of which you are aware of, till the noble island of Cipango, are ten spaces, which are two thousand five hundred miles, which is two hundred and twenty-five leagues: Island which is very rich in gold, gems and precious stones. And bear in mind that they cover temples, and the royal houses with plates of fine gold. But all these things, being the route unknown, are hidden, and covered; and surely it can be reached.

Toscanelli—who evidently had Ptolemy's *Geography* translated in Florence at the end of the fourteenth century by the Byzantine humanist Manuele Crisolora and completed in 1410 by Jacopo Angeli da Scarperia—not only shows us that he knows of the Arctic Pole but suggests a direct route through which, by crossing the Tropic of Cancer (highlighted in the Malatesta Temple), one could reach the Americas in a shorter time than the commonly travelled route further south, starting from Guinea[386]. This reference to the route through Guinea justifies the presence in Botticelli's paintings of both the caravels and the Lady of Mali previously mentioned, which peeps out in the third episode depicted by Sandro Botticelli, inspired by the Nastagio degli Onesti story, by Boccaccio, but clearly inspired by the events of the first transoceanic voyages. (See Figure 32.)

The Florentine geographer then adds a story[387] that clearly alludes to the Inca people and to their habit of covering their houses and dwellings in gold, as the Spanish conquistadores will later recall when describing the mythical city of El Dorado, the ancient Paititi that sprawled in the center of the Amazonian forest and was found by me in the winter of 2012[388].

[386] "[…] via sea, […], which I believe being shorter than the one you do through Guinea […]"

[387] "[…] And bear in mind that they cover temples, and the royal houses with plates of fine gold. But all these things, being the route unknown, are hidden, and covered; and surely it can be reached […]"

[388] www.paititi2013.com

FIGURE 32 — DETAIL OF THE THIRD EPISODE OF THE CYCLE INSPIRED BY NASTAGIO DEGLI ONESTI, PRADO MUSEUM, MADRID

This last annotation by Toscanelli—which clearly comes from a knowledge of the American territory prior to his writing and which I do not exclude may be the one shown in Benozzo Gozzoli's cycle at Palazzo Medici Riccardi—is probably the primary cause of the ferocity utilized by the papacy, together with the Spanish, Portuguese, and Germans, to finalize its actions. Its aim was to acquire legal rights to the overseas territories by inventing a discovery that would guarantee the rights of exploitation and the possession of the goods confiscated from the natives. These rights and honors, curiously enough, were not granted to Christopher Columbus, despite the fact that he was credited with the discovery of the New World.

In 1493, just a few days after the presumed return of Columbus from the Americas, with the *Inter Caetera* bull, Pope Alexander VI (who was Spanish by birth) divided the exploitation rights of the new territories. He granted the Spaniards the ownership on the territories located to the west of a boundary identified along the meridian placed 100 leagues from the Island of Cape Verde. With this bull the missionaries for the Indies were also appointed. Guess who? The Dominicans.

The following year, 1494, the disposition of Alexander VI was ratified with the stipulation of the Treaty of Tordesillas[389] (as indicated

[389] The treaty was ratified by Spain on the 2nd of July and by Portugal on the 5th of September 1494.

in the 1502 Cantino map seen before). The treaty was signed in Tordesillas, Castile, on 7 June 1494. This unilateral agreement established a division of territories outside the borders of Europe according to an exclusive duopoly between the Spanish and Portuguese empires, identifying the north-south meridian placed at 370 leagues[390] west of the Islands of Cape Verde (off the coast of Senegal) as the limit for considering the territories as belonging to one or the other empire. The New World lands east of this line would belong to Portugal, while all the lands west of this line would go to Spain.

Essentially Portugal was given a minimum slice of Brazil, as depicted in the map of Cantino in 1502, while all the rest of South America was given to Spain, whose royalty were certainly closer to the papacy.

This, briefly, is the story not of the discovery of the Americas but of a literal forced expropriation of the lands of the New World perpetrated against the native peoples. Before the advent of the Spanish rulers and the papal emissaries, these people had been able to know and maintain a friendly and fraternal relationship with some of the most reformist members of the European courts. That is to say, all the exemplars in that extraordinary political manifesto that was represented in 1459 by Benozzo Gozzoli inside the Chapel of the Magi, at the heart of the palace that was the expression of the Mediceo power, with the Sforza and Medici families in the lead. So friendly and collaborative was the established relationship between these families and the native peoples of the Americas that both Cosimo the Elder and Francesco Sforza decided to put a mixed-blood personage, a mestizo, at the head of their powerful families: Lorenzo the Magnificent in Florence and Ludovico il Moro in Milan.

Francesco Sforza even came to commission Filarete to design the project for the city of Sforzinda, which was to represent the city of Milan in the Indies. Cosimo and Francesco, however, by taking this decision, underestimated the greed of the papacy and of some of its allies: Montefeltro, Naples, Spain, and Portugal. From that moment onward, these entities did everything they could to defeat the two families and to get their hands on the treasures and territories of the New World. They issued papal bulls, schemed conspiracies, established tribunals of the Inquisition, etc.

The originals of both treaties are kept at the *Archivo General de Indias* in Seville, Spain and at the *National Archive Torre do Tombo* in Lisbon, Portugal.
[390] 1770 km circa.

The events narrated so far, in a reduced and synthetic form for obvious reasons, constitute the basic framework on which the whole plot of the events that will characterize the fifteenth century rests.

From this moment onward, the rest is history—a sad history of abuses, distortions, dogmatic impositions, and deprivations of knowledge and freedom.

As I often assert in the conferences where I am called to speak all over the world, the real Renaissance basically ended in 1459 with the Council of Mantua convened by Pius II. From then on, it was all and only a great deception perpetrated by greedy and unscrupulous men to guarantee to the Church the greatest power and wealth, before then protecting a theological and spiritual heritage. Everything would be subordinate to the hunger for wealth and virgin territories to be colonized or evangelized. There is nothing belonging to that century that remains untouched: people, facts, politics, and above all art.

Would you ever think that Botticelli's *Birth of Venus*, an iconic work of the Renaissance taken as a symbol of Florence itself and its art, contains hidden within the veils that cover the Virgin rising from the waters one of the first representations of the Americas? It's similar to the way the new continent is depicted in Martin Waldseemüller's map of 1507, the first in which the name "America" officially appears[391]. (See Figure 33.)

FIGURE 33— THE AMERICAS HIDDEN IN THE VEILS THAT DRESS BOTTICELLI'S VENUS, 1483, UFFIZI GALLERY, FLORENCE.

[391] It is a pity that Botticelli's work is dated 1483.

Or would you ever think that, in the four paintings that make up the cycle inspired by the Nastagio degli Onesti[392] story by Boccaccio, which clearly alludes to Nastagio Vespucci[393], Botticelli accuses the occult plots that led to the Congiura de' Pazzi? This can be seen by the concealing in the background the gulf of Portovenere and inserting the Lady of Mali and two caravels and a carrack setting sail.

That's right—it is not three caravels that reach the Americas but two caravels and one carrack[394]. The *Santa Maria*, the flagship of the fleet that reached the Americas, which not surprisingly ran aground on the shores of Haiti, was a carrack. It was heavier and less governable than the other two ships, the *Nina* and the *Pinta*, which were two caravels and therefore had no difficulty in returning to Europe. I bet you anything you like that the masts of the two caravels that made their return to Europe are those resting on the last two pillars near the altar of the Cathedral of Siena, not far from the Piccolomini Library where Enea Piccolomini, future Pope Pius II; Nastagio Vespucci, expert navigator and father of Amerigo; Eleonora of Portugal; and Frederick III, the last emperor of the Holy Roman Empire, are portrayed.

Behind them, not far away, a second fresco depicts Pius II with the gulf of Portovenere behind him and three ships taking to sea. According to tradition, these two "antennas" belonged to the Sienese chariot that fought the Florentine troops in the battle of Montaperti, in the distant 1260. The length of these "antennas," over 16 meters, makes this story not very plausible and leaves room for a more likely hypothesis that they were the flagpole masts of a fifteenth-century ship. (See Figure 34.)

Could they be the ships that returned from the Americas after the shipwreck of the flagship on the island of Hispaniola?

If you add that in the splendid marble inlays on the floor of the cathedral there is a scene that recalls the landing on the Hispaniola island, you have closed the circle.

To think the worst is a sin, but often you are spot on.

[392] Perhaps commissioned by Lorenzo the Magnificent in 1483 as a gift to Giannozzo Pucci on the occasion of his marriage to Lucrezia Bini on that same year. Preserved in Palazzo Pucci, in the second half of the 19th century they were dispersed: three are now in the Prado and only one, the last one, has returned to its original location
[393] Father of Amerigo and painted by Pinturicchio with Enea Piccolomini, Federico III and Eleonora of Portugal in the Piccolomini Library in Siena. .
[394] The Caravel, more agile and suitable for Atlantic crossings, was created in the arsenal of Lisbon and/or in the residence of Prince Henry the Navigator in Sagres, which at the time served as a nautical school and experimental arsenal for Lusitanian explorers.

As you may have noticed, in talking about caravels and carrack I deliberately omitted to mention the name of Christopher Columbus and any date. It seems obvious to me by now that that tale was entirely made up to justify one of the greatest crimes perpetrated against humanity.

FIGURE 34 — CARAVEL FLAGPOLES INSIDE THE CATHEDRAL OF SIENA

Think of the Congiura de' Pazzi. The deaths of Giuliano de' Medici and his lover Simonetta Cattaneo Vespucci—the model from Portovenere who personifies Venus in Botticelli's painting bearing the same name. In the cycle about Nastagio degli Onesti, she is chased and mauled by two dogs, one white and one black, while a knife is stuck in her back, and in the background two caravels and a carrack set sail from the Gulf of Portovenere, as in Pinturicchio's painting in Siena. These are not disconnected from the death of Galeazzo Maria Sforza in 1476 in Melzo or from the accusations of sodomy made against Leonardo and a member of the Tornabuoni family who was a faithful ally of the Medici family.

All these atrocities can be traced back to the criminal plots schemed by the Vatican emissaries with the complicity of interested allies, both foreign and Italian, to take possession of the territories of the New World.

Or think of Renaissance cartography. Why do you think that cartography in those years was monopolized by German cartographers when the cartographic art itself was actually reborn in Florence at the beginning of the fifteenth century and the greatest navigators in history were mainly Italian, Spanish, and Portuguese?

Or again, think of the Inquisitions[395]. It is true that these institutions were originally created to repress pagan heresies of the thirteenth and fourteenth centuries and were later used to condemn those who supported theories contrary to Catholic dogma. But in the fifteenth century they took on a completely different role. Through the establishment of the Spanish, Portuguese, and German Inquisitions, which were entrusted to ferocious local Dominican friars—the Lord's dogs—they were barbarously and shamelessly used to protect the discovery and colonization of the New World while the local populations were plundered of their treasures and stripped of their thousand-year-old culture and knowledge. To give you a rough idea of what was ransacked from them, in the cathedral of Seville there is still a statue made with gold stolen to the natives that weighs two and a half tons.

At this point, therefore, it is no longer so difficult to understand what could have been the real motivation that moved Leonardo to reach Milan.

The same must be sought both in the common desire of Sforza and Medici to create a cultural revival of the arts and sciences[396] that was detached from the dogmatic impositions typical of the Catholic culture and in the need to hastily escape from the witch-hunting climate that breathed in Florence in the 1470s. The need was so great that Leonardo left unfinished a project he was working on[397], as Anonimo Gaddiano reminds us:

> [...] He was sent to the Duke of Milan together with
> Atalante Megliorottj to present him a lyre, as he was unique in
> playing such instrument. "He then returned to Florence,
> where he stayed for a while; and then either out of indignation
> or due to some other cause, while he was working in the

[395] The Spanish Inquisition was established by Sixtus IV in 1478 at the request of King Ferdinand of Spain and his wife Isabella, and was extended to the colonies of Central-South America.
The Portuguese Inquisition was instead instituted in 1536 by Paul III at the request of King John III, and was extended to Brazil.
To these must be added the *German Inquisition*, supported by Innocent VIII, based on a text, the *Malleus Maleficarum* (literally "The Hammer of the Malefices"); it was a treatise in Latin published in 1487 by the Dominican friar Heinrich Kramer with the collaboration of his brother Jacob Sprenger with the aim of repressing heresy, paganism and witchcraft in Germany.
[396] That in the Neoplatonism conception they are one and the same
[397] For what would later be called the Room of the two hundred, later finished by Filippino Lippi

Citizen Council Hall, he left and returned to Milan, where he served the duke for several years.[398]

[398] Cod. Magliab. XVII, 17—National Central Library of Florence.

CH. V—THE MANY

INACCURACIES THAT FUEL

LEONARDO'S CULTURAL HERITAGE

> Due to the excellence of the works of this divine artist, his fame had grown so much that all the people who delighted in art, indeed the whole city itself, wanted him to leave some memorial. And they thought about making him do some notable and great work, someplace where the public would be adorned and honored by such a great ingenuity, grace, and judgment as known to be in Lionardo's works."
>
> And the Gonfaloniers and the great citizens agreed that, as the Council Grand Hall had been newly built, some beautiful work should be painted there; and so Piero Soderini, then Gonfalonier of justice, allocated the hall to him.[399]

This brief passage from the first biography on Leonardo written by Giorgio Vasari testifies to the recognition given by Florence to this extraordinary artist during his lifetime.

The episode recalled here is the agreement that had just been signed by the Gonfalonier of Florence, Piero Soderini[400], in 1503. It was through this document—by popular acclaim, I would say—that Leonardo was asked to decorate one of the walls of the hall of the Grand Council that had just been completed: the famous *Battle of Anghiari.*

The cartoon of this work was immediately defined, by those who could see it, as an excellent and innovative piece. The painting that followed would have greatly deteriorated due to Leonardo's choice of wanting to paint the gigantic work according to a technique used by the

[399] Giorgio Vasari—The Lives of the most excellent painters, sculptors, architects, Torrentini, 1550—Florence.

[400] Pier Soderini (1450–1522) was a life-long gonfalonier in Florence from 1502 to 1512. Gonfalonier was a role in which those who were elected took care of administering the city.

ancient Egyptians and not in fresco,[401] as was customary in the Renaissance.

A note found by Professor Beit Probst, historian and director of the University Library of Heidelberg, in 2005 refers to this same episode. It was written in 1503 by the Florentine chancellor Agostino Vespucci in the margins of a book containing a collection of letters by the Roman speaker Marcus Tullius Cicero and preserved at the prestigious German university:

> Like the painter Apelles, so does Leonardo da Vinci in all his paintings, for example for the head of Lisa del Giocondo and Anna, the mother of the Virgin. We'll see what he's planning to do with regard to the Council Great Hall, of which he has just signed an agreement with the Gonfalonier.[402]

We will come back on this precious testimony, as it will be useful for us to solve once and for all the mystery that has built up around the Gioconda and her enigmatic smile. For now we note the comparison, as expressed by a direct witness, between Leonardo and the great Greek painter Apelles. It is not the only time that the Florentine artist is associated with the great painter of the antiquity, who was praised by Pliny the Elder[403]. Vasari himself, citing Leonardo's pictorial greatness, recalls an epitaph dedicated to him:

HE's BETTER THAN ALL THE OTHERS;
THAN FIDIA, THAN APELLE,
AND ALL THEIR PUPULS.[404]

And that's not even the first one. Bernardo Bellincioni, a court poet at the service of Ludovico il Moro, spoke of Leonardo in the same terms. In a surreal dialogue with the already deceased Galeazzo Maria Sforza, Bellincioni imagined reassuring the duke on the cultural

[401] "And envisaging that he would use oil to paint on the wall, he made a composition of a mixture so thick, in order to adhere to the wall, that while continuing to paint in that room it began to pour, so that in a short time he abandoned it."
Giorgio Vasari—The Lives of the most excellent painters, sculptors, architects, Torrentini, 1550—Florence.
[402] Note from 1503, written by the Florentine chancellor Agostino Vespucci.
[403] Apelles was a Greek painter of the 4th century B.C., praised by Plinius the Elder.
[404] Giorgio Vasari—The lives of the most excellent painters, sculptors, architects, Torrentini, 1550—Florence.

value of the court now led by his son Gian Galeazzo Maria after his departure. Bellincioni wrote:

> From Florence he led here an Apelles…[405]

We have already talked about Leonardo's musical skills, although too briefly. I personally consider his musical abilities and above all what he bequeathed us in this field, both qualitatively and substantively, as perhaps his absolute greatest legacy. This is why it will be worth addressing the topic in a separate publication, precisely because of the innumerable implications that the debate would entail.

On his studies of anatomy, mechanics, hydraulics, fortifications, and all else that has come to us during these five centuries, on the other hand, I don't need to be the one to underline its absolute value. The king of France himself, having been able to experience firsthand the validity of his ingenuity, did everything he could to get Leonardo's services. And the works above all! Louis XII went literally crazy when, being in Milan and seeing the *Last Supper*, had to resign himself to not being able to take it with him to France.

To make up for this impossibility, his son Francis I made produced a tapestry reproduction, which we find today preserved at the Vatican Museums:

> One admires with such an amazement the Supper of Jesus with his Apostles, painted on the wall in Milan, which pleased Louis XII so much that admiring it with passion, he demanded to the listeners if it could have been possible to transported to France by cutting it from the wall, although with such an operation one could ruin the famous refectory where it stood.[406]
>
> The nobility of this painting, both for the composition, and for being finished with an incomparable zeal, made the King of France wanting to take it into the kingdom, so he tried in every possible way, asking if there were architects who, with beams of wood and irons, could have armed it in a way they could transport it safely; regardless of the cost that it was going to bear, so much he desired it.

[405] The Rhymes of Bernardo Bellincioni of Florence, Pietro Fanfani, 1876.
[406] From the Translation of Paolo Giovio's Latin biography by Count Rezzonico.

But the fact that it was made in the wall made Her
Majesty take only the desire with him, and the painting
remained at the Milanese.[407]

Beyond decanting his undoubted intellectual and artistic abilities,
all of Leonardo's biographers are unanimous in underscoring his
beauty, grace, and physical strength. These are characteristics that all
the artists of his time have continually immortalized in paintings,
drawings, and sculptures that portray the Tuscan genius in every stage
of his life since his youth.

This last circumstance indirectly testifies to us how he was
anything but the poor illegitimate son of a slave whose cultural
formation matured by being self-taught.

Thanks to the portraits that are scattered everywhere, today I'm
able to show you with extreme precision the physiognomy and
morphological structure of this extraordinary man, including his
defects. This is unlike those who, even today in celebrating him or
simply illustrating the biography or the work, continue to associate
him with posthumous and caricatured portraits that rarely correspond
to his actual appearance. I can't say whether this bad habit is just a
question related to the image rights or something else, but this
improper and rampant use of a caricatured representation of
Leonardo's face tells you a lot about what the real knowledge of the
character is today.

Although the artist was made subject of universal recognition
during his life, as soon as he died, on 2 May 1519, it seems that
everyone forgot about him and the role he played in contributing to
the cultural, artistic, and scientific development of the entire
Renaissance.

Everyone seems to forget, but clearly that's not the case. More
likely, the simultaneous fall of Lorenzo the Magnificent in Florence
and Ludovico il Moro in Milan undermined those conditions of
patronage that allowed Leonardo to express, in full freedom and
autonomy, the depth of his purest Neoplatonic approach and the
reflection of his genius. The vanishing of these patronage conditions
allowed his image to be veiled by the reflection of a pro-Catholic
ostracism that was aimed at outlining the distorted image of a
character, his art, and his knowledge. He was deliberately belittled in

[407] Giorgio Vasari—The Lives of the most excellent painters, sculptors, architects,
Torrentini, 1550—Florence.

favor of less cumbersome characters more suited to Roman circles—
Raphael Sanzio and Michelangelo Buonarroti above all.

There is a data, when we talk about Leonardo, that is never
underlined enough, related to his manuscript production. They are the
result of studies throughout his whole life and come down to us in the
form of codices, manuscripts, drawings, theatrical sets, and paintings. I am
not referring so much to the more than five thousand sheets scattered
here and there in the world's great museums, collected in twenty or so
notebooks and three large collections. Nor am I referring to the various
treatises published posthumously by various artists[408] on the basis of his
notes, which already constitute the greatest work ever produced that can
be traced back to a single living being.

No.

I am referring instead to what has not come to us, which represents
the most substantial part of the fruit of his genius, now dispersed and
stolen when it has not been deliberately destroyed or, even worse,
wrongly attributed to him in a completely presumptive and unfounded
way[409] almost daily.

The corpus of Leonardo's writings, as I said, consists of over five
thousand pages and represents a small part of his endless production.
Wherever he went, Leonardo used to take with him sheets of paper the
size of an arm, notebooks, and notepads. With his unmistakable writing
from right to left, he almost obsessively noted down everything in the
surrounding world that caught his attention. Starting from the notes that
the artist wrote down, he then drew up projects, designed machines, and
prepared sketches or studies of paintings and sculptures. He studied the
details down to the smallest detail and fixed in his graphic memory the
landscapes that he encountered in the course of his travels, noted down
his expenses, the lists of books owned and read, some meetings, drafts of
letters, and much else.

It is simply illogical, therefore, to think that writings by him before
1478 do not exist. This is especially true if we think that by that date
Leonardo was already able to accurately draw *Landscape with River,* a
work dated 5 August 1475[410], or paint masterpieces with anamorphic

[408] Melzi, Dufresne and others.
[409] See the copies of the Virgin of the Rocks wrongly attributed to him, for example, or
imaginative and biased interpretations of some of his works.
[410] Cabinet of Drawings and Prints at the Uffizi Gallery in Florence.

technique such as the *Annunciation*[411], which I remind you was created in 1472.

By eyewitness accounts[412], we know that at Amboise, Leonardo brought with him an "infinite number of volumes in the vulgar language" written by himself and divided between notes, drawings, and notebooks mixed with the books that were part of his personal library:

> This gentleman has composed so many particular studies of anatomy, as demonstrated in his painting—limbs as well as muscles, nerves, veins, joints, and intestines of both men's and women's bodies—in a way that has never before been done by another person. This we have carefully observed, and he said he has already made anatomy studies of more than thirty bodies between males and females of all ages. He has also composed the nature of the waters, different machines and other things, according to him, including an infinity of volumes all in the vernacular language, which if they come to light will be profitable and very enjoyable.[413]

De Beatis clearly refers to the treaties that Leonardo began to write later in his life, which he bequeathed to Francesco Melzi[414] along with all his possessions, books, and clothes—except for land in Milan, land in Fiesole, and some money deposited in Florence, which I have already mentioned[415].

We also know for sure that many of his works did not survive him, including some portraits or paintings mentioned by Vasari[416] that today we have no trace of, and some manuscripts, as is the case of a

With Leonardo's unmistakable mirrored left-handed writing, it reads: "*Santa Maria della Neve / 5th of August 1473*". It is considered the *first pure landscape design* in Western art, that is treated with autonomous dignity, free from a sacred or profane subject.

[411] Work of 1472 preserved at the Uffizi in Florence.

[412] Antonio de Beatis.

[413] *Travel diary* by Antonio de Beatis, 10th October 1517—Ref. XF28, National Library of Naples.

[414] "And he left in his will to Messer Francesco da Melzio, Milanese gentleman, all the money with all the clothes, books, writings, drawings, instruments and portraits about painting and art and industry, which were there, and made him executor of his will." Anonimo Gaddiano.

[415] Gustavo Uzielli. Re*searches around Leonardo da Vinci*. Florence, G. Pellas Factory, 1872, pp. 202-210.

[416] Head of Medusa, portrait of Piero Francesco del Giocondo, Acquarello of Adam and Eve.

treatise entitled "De Vocie," through which Leonardo investigated the sound waves and vocal abilities of man through the correct use of trachea and vocal cords. Here he also reintroduced the importance of bel canto, a practice of which he was an able performer[417]. We know that this treatise was taken from him in Rome in 1514, as Edmund Solmi told us in 1920:

> In 1514 Leonardo was in Rome involved in the hatred of an intriguing German mechanic, Giovanni degli Specchi, who managed to unleash on him a not insignificant storm of suspicions and charges. It was probably on this occasion that the De Vocie fell into the hands of Messer Battista dell'Aquila, who perhaps examined it for finding the evidence of the suspicions and accusations who were mysteriously circulating on Vinci's account, when all of his writings and every one of his words were twisted.
>
> It is unknown what the subsequent events of the Messer have been: it's only certain that some scattered sheets of paper which originally had to be part of that, today they are found in the Windsor collection, chaotically mixed with other sheets, which have no relation with them, neither for argument, nor of origin.[418]

It is curious to note that while both Louis XII and Francis I did everything possible to have the services and works of Leonardo[419] bought in 1518 by Salai—including the portrait of the Gioconda, as unanimously claimed—at his death, they made no effort to buy (or retain, as they might have claimed) his personal belongings, among which was the multitude of writings constituting the corpus of his supreme knowledge. It was these writings that Melzi was able to bring with him to Milan in 1523.

The grouping state in which these notes are found today, which sees them scattered among the most famous museums and libraries of half the world, is certainly not the original one, since each of them has had a rather troubled and complex story. Initially Leonardo's manuscripts were carefully preserved by Francesco Melzi, who inherited them in 1519. In 1546 Melzi composes *A Treatise on Painting*, using eighteen of these manuscripts, of which six only have been identified among those available today. (See Figure 35.)

[417] As I got to know thanks to Liliana Gorini, member of the Schiller Institute.
[418] Edmund Solmi, 1920—*Leonardo da Vinci's Treaty on the Language* (De Vocie), Braidense Library, Milan.
[419] Fortifications, a Madonna and a Saint Anne and more

FIGURE 35 — TREATY OF PAINTING, FRANCESCO MELZI, 1546, VATICAN CODEX URBINATE, LAT. 1270

While in the custody of this trusted pupil and collaborator in the house of Vaprio d'Adda where Leonardo stayed at the beginning of the sixteenth century, the writings and the inherited drawings were consulted by various humanists, mathematicians, and painters, who perhaps took some with them. It is Vasari himself who testifies to this, reminding us that some of these works were offered to him in Rome by a Milanese painter[420].

Between a theft and a subsequent attempt to return them that was incomprehensibly rejected by Orazio Melzi, Francesco's heir, who had in the meantime acquired the property, part of the eighteen manuscripts used to compose *A Treatise on Painting* disappeared. The first important dismemberment of the Leonardesque inheritance, therefore, must be traced back to the Melzi heirs. The reunited legacy, after the return of the theft made on commission[421] in 1587 by a certain Lelio Gavardi d'Asola, did not interest the Melzis at all.

Curious, isn't it? Imagine if one day an uncle bequeathed all of Leonardo's manuscripts to you. Would you ever say to him, with a

[420] It is thought to be Paolo Lomazzo.

[421] In 1587, a certain Lelio Gavardi d'Asola, priest of San Zeno in Pavia and relative of the Venetian editor Aldo Manuzio, introduced himself into the Villa dei Melzi in Vaprio d'Adda, stole thirteen manuscripts and brought them to Florence and Pisa for the Grand Duke of Tuscany Francesco de' Medici.

Francesco who in the meantime died, so the manuscripts were recovered by a rich Milanese prelate, don Giovanni Antonio Mazenta, who tried to give them back to Orazio Melzi, who, having no interest in them, left him some.

bored attitude and perhaps even puffing, "Yep, drop them in the attic. Thank you"? But that's exactly what happened. Initially left in an attic, the writings were later donated or given away to collectors and libraries around the world at an insulting price.

We owe the second great dismemberment to the sculptor and collector Pompeo Leoni[422], who managed to recover some of the manuscripts used to compose *A Treaty on Painting*, which ended up in Pisa. He left for Spain in 1590 with an unspecified number of manuscripts and the intention of classifying the artistic drawings by separating them from those with a predominantly scientific imprint[423]. And so the Milanese collector dismembered part of the original collections, cutting and moving the pages between them, so as to form the two largest collections into which these manuscripts are still divided today: the over one thousand pages of the Codex Atlanticus on one side and the Royal Collection of Windsor[424] on the other, comprised of about six hundred drawings.

In this same way, Leoni composed at least four other files which, after his death in 1610, were inherited by his son-in-law Polidoro Calchi[425], who in 1622 sold them in turn to the Milanese count Galeazzo Arconati. In 1637 Arconati donated them to the Ambrosian Library, along with another part of the manuscripts and a copy of Luca Pacioli's *De Divina Proportione* containing the Platonic solids designed by Leonardo himself, as he was related to the library's founder, Cardinal Federico Borromeo. Another part ended up in England, where it was acquired by Lord Arundel[426].

Some other manuscripts ended up later on at the Ambrosian Library, in addition to the Codex Atlanticus reassembled by Leoni, which remained there until 1795. That was year in which Napoleon Bonaparte smuggled them to Paris, where they were separated once more. The Codex Atlanticus ended up at the Bibliothèque Nationale de France,

[422] Owner of the House of Omenoni in Milan, where the manuscripts stood for some time.
[423] In order to profit more from the sale.
[424] Royal Collection Trust.
[425] Husband of Pompey Leoni's daughter, Victoria.
[426] Thomas Howard, Count of Arundel (1585-1646), was an English politician and art collector. At his death he was in possession of 700 paintings, on top of a very large collection of sculptures, books, prints, drawings and antique jewelry. A large part of his collection of sculptures, known as "Arundelian Marbles" will be left by his descendants to Oxford University.

while the various manuscripts were taken to the Institut de France. When France was defeated by allied forces in 1815, it was ordered to return the artworks stolen by Napoleon to Lombardy, including Leonardo's codex[427].

The emissaries in charge of the return of the works to Lombardy, however, not knowing that some of the manuscripts had been diverted to the Institut de France, only recovered the Codex Atlanticus, which thus returned to the Ambrosian Library[428]. They left the minor manuscripts to the Institut de France, where they are still today.

Only in part, however. While they were still in France, some of these notebooks were again looted, this time by Guglielmo Libri, a Tuscan mathematician and bibliophile who was also accused of stealing other Leonardo manuscripts in Florence. The theft earned Libri a conviction of ten years in prison, which he never served. In the meantime he had sought refuge in England where, with peace of mind, he was able to sell to Count Bertrand Ashburnham part of the stolen papers.

But not before having detached the papers corresponding to the Codex on the Flight of Birds, which ended up instead at the Royal Library of Turin. A portion of the manuscripts taken from Libri were returned later to Milan, while others stayed in Paris and yet others went to Spain, where some were only found in 1966.

The troubled vicissitudes to which the notes and the numerous sketches by Leonardo went through tell us many things, but they do not solve some doubts that remain unanswered. They tell us that if Italians want to claim ownership of some of Leonardo's works and therefore request their return, they should turn their attention to the notebooks kept at the Institut de France rather than, as I often hear,

[427] And not the so-called Gioconda, which instead was bought in 1518 with the mediation of Salai.

[428] Franz Xaver Baron von Ottenfels-Gschwind, was commissioned by Austria to take back the works of art stolen to Lombardy, as it returned under Austrian rule. He, however, did not obtain all the codex stolen to the Ambrosiana Library, although it was in possession of a detailed note. When he showed at the *Bibliothèque nationale*, he found only the Codex Atlanticus and instead of tracing the others manuscripts, he was satisfied with three other volumes (old copies of Vincian codex which he considered original). The 5th October 1815 issued the receipt "*except for nine volumes of manuscripts handwritten by Leonardo da Vinci, which according to the conservative lords' statement had never arrived at the King's Library*".

toward Mona Lisa, who was instead legally bought by Francesco I. Which is not the Mona Lisa by the way, but we will talk about that in a minute.

Second, this reconstruction relating to the Leonardesque manuscripts helps to understand why some of them went missing, together with the fact that there were also wars, pestilential epidemics, fires, floods, and other vicissitudes that may have destroyed a great portion of them. Also, some of them ended up in Madrid, others in Paris, others in Milan, and some single sheets can be found scattered in Oxford, Venice, or other minor museums, for example. All of these pieces are without a distributive logic and above all without a unitary content logic as a consequence of the continuous dismemberment, theft, and reassembly by petty thieves without scruples.

At the same time, though, this synthetic reconstruction of the facts does not explain how it was possible that the work of a person who in life had an absolute acknowledgement, being elected as a cultural reference by all his contemporaries, has been completely overlooked in its content. Nor does it explain why his work has been the object of subtractions, divisions, lacerations, dispersions and gifts from collectors interested in owning an iconic object rather than the attention of scholars interested in reconstructing its contents.

The only valid explanation that I have been able to give over the years is that the analysis of this multitude of materials has never been really easy. On one hand, there's the difficulty in interpreting a difficult-to-decipher writing. And on the other hand, the Neoplatonic Byzantine orientation of Egyptian and Orphic derivation that underlies the cultural formation of Leonardo has not been understood. It is not understood even today, in fact, as we can see in certain blunders.

The cultural evolution developed after the initial Renaissance period and was modelled on a scientific and cultural approach that was based on canons besides those rediscovered through the study of neoclassicism and compatible with the Catholic orientation imposed by censorship and accusations of heresy. This meant that the new scientific and artistic references that took over[429] caused scholars to lose an attraction toward the contents of his work.

Only in recent years has the interest in Leonardo's uncommon genius come back to fascinate scholars and especially the masses. This is because

[429] Galileo Galilei, Copernicus, Kepler, Athanasius Kircher, Cardano, Giordano Bruno.

of greater accessibility to information via the internet and the election to popular myth that this character embodies today. A real popstar, the object of gossip and all kinds of curiosity.

The interpretive gaps that involve his precious work, however, have remained unchanged over time. This testifies to how deeply rooted was the conditioning that the papal censorship of the Renaissance produced and continues to produce, even in so-called modern society.

The analysis conducted on Leonardo by the father of modern psychoanalysis, Sigmund Freud, was based on the memory of the artist's own childhood dream, which he included in the Codex Atlanticus. This work is exemplary for describing the reflexes of these interpretative gaps.

This bizarre analysis—in addition to the accusation by the authorities in 1478 towards the Tuscan artist in Florence—is the origin of the homosexuality sometimes attributed to him.

Leonardo's note analyzed by Freud follows:

> ...This so distinctly writing about the kite seems to be my destiny because it was in the first memory of my childhood and it seemed to me that, while in my cradle, a kite came to me and opened my mouth with its tail, and many times it beat me with that tail inside my lips.[430]

Returning from America and rather restless about the unsatisfactory experience he had in the new continent, on the evening of 17 October 1909, Freud wrote to his friend and pupil Carl Jung:

> Since my return I've had an idea. The mystery of Leonardo's character suddenly became transparent to me.

A year after writing this letter to his colleague, Freud published the essay *Leonardo da Vinci: A Memory of His Childhood*[431], a work that is still today considered one of the most enlightening examples of the use of the new psychoanalytic science for biographical research.

[430] Codex Atlanticus, Sheet 186 v—Ambrosian Library, Milan.
[431] *Eine Kindheitserinnerung des Leonardo da Vinci*, first printed in 1919 and then in 1923, this essay is considered one of the most illuminating examples of the new psychoanalytic science for biographical research.

Unfortunately, in the pages of this publication, Freud connects the episode recalled by Leonardo of an "oral sexual act, markedly passive, reminiscent of the memory of breastfeeding."

The Austrian psychoanalyst's analysis stems from the assumption that Leonardo was the illegitimate son of the notary Sir Piero da Vinci and a young peasant named Caterina. According to Freud—who evidently refers to a distorted and conformed Leonardo biography[432]—Leonardo would have spent the early years of his childhood, an exclusively in the company of his mother. This is the reason that he should be considered "son of mother only," "son of a vulture".

On the basis who knows which historical sources, since in the opening chapter we have analyzed together all the existing ones, the psychoanalyst comprehends that when Leonardo was five years old, he went to live with his father and his young wife, Donna Albiera, who, not being able to have a child of her own, would have adopted that of her husband, caring for him with all her love[433]. As a consequence of this erroneous assumption, Leonardo's early childhood would have been characterized by a close bond of attachment developed with his non-natural mother, colored with a high probability of erotic valences and the condition of being a "fatherless child".

For Freud, therefore, the *kite-vulture* mentioned by Leonardo in the memory of his childhood is the mother, while the tail that penetrates his mouth would be her penis, as idealized by the child, since the mother should also have played the role of the absent father.

The subsequent realization that the mother did not have a phallus and the consequent disappointment would have induced in Leonardo repressed desire. This desire would have pushed him in adulthood to search for that tenderness in other people that had inspired, during the early years of his childhood, the happy relationship between him and his mother[434]. Subsequent to those first exclusive maternal tenderness, which the analyst can only assume by deducing them from that childhood memory of the kite, Leonardo becomes "a sexually inactive or homosexual subject"

[432] Which I have extensively shown to be deliberately distorted.

[433] In reality we have seen that at the time he was with his paternal grandfather in Vinci, as the notary himself states in the Cadastral register of 1458.

[434] "...the concentration on the object that was once so strongly desired, the woman's penis, leaves indelible traces on the mental life of the child who has pursued this part of the child sex researches with particular accuracy."

S. Freud, Leonardo da Vinci and a memory of his childhood, 1910.

Growing up, Leonardo does not take his mother's place but is his own person, who becomes the model of his objects of love. He then surrounds himself with beautiful and young assistants, known surely more for their sturdiness than for their artistic talents, so that he can love them as his mother loved him. At the origins of this choice of subject, according to Freud, there would be the narcissism that in Leonardo he finds overflowing, induced both by the cumbersome presence of the mother and by the absence of the father.

As a consequence of this childhood experience of his, Leonardo would then have developed that attitude of detachment and disinterest that he would show toward his works, which were often neglected in the same way that his father had neglected him. As a result, the moment of artistic satisfaction would not have been of value to him. Sexuality, having been inhibited in him as a young man, the artist would have learned to repress in adulthood, when he would have sublimated the intellectual thirst, investigation, and experimentation—proper characteristics of his curiosity and genius—to make up for this lack. In addition, by meticulously noting the expenses he incurred for his pupils and lovers, Leonardo would have shown a compulsive mechanism through which he could subdue physical attraction and keep emotions away, so as to regain control of his impulses and direct them toward research.

And Freud would have deduced all this based on a brief childhood memory that Leonardo inserted in the middle of his many notes.

I'm embarrassed in reporting so much nonsense all at once, but it is functional for determining why Leonardo has been subject to countless interpretative distortions. Luckily I am almost done with it.

The final twist of Freud's essay concerns the interpretation he offers of the most famous smile in the history of art, that enigmatic smirk on the face of the *Mona Lisa*. This painting has risen to fame by people misinterpreting and presuming again the words with which Vasari describes the portrait of Francesco del Giocondo's wife:

> He used again the art, as Mona Lisa is so beautiful, of having, while he was portraying her, those who sang and played, and clowns who kept her constantly cheerful, to take away that melancholy layer that painting often gives to portraits. And in this opera of Lionardo there was such

a pleasant smirk that it was more divine than human to see it,
and it was marvelous for not being alive.[435]

Here Freud's analysis rises to border on extreme levels of paradox,
mainly for two reasons: first because the memory immortalized by
Leonardo refers to anything but what Freud takes his inspiration from for
his remote analysis, and second, quite simply, because the *Mona Lisa*, as
anticipated several times, is not the one on display at the Louvre.

Yes, I know what you're thinking right now: "This guy is crazy.
Before he told us that America has not been discovered by Columbus,
now that the Mona Lisa is not the one on display at the Louvre." So,
given that "all the best are crazy,"[436] it is just as I say: Leonardo's portrait
of the Mona Lisa is not the one on display at the Louvre. Careful—I'm
not saying that the one on display in the famous Parisian museum that
millions of visitors every year travel miles to see is a fake. No, no. It's just
another picture, as we'll see.

But let's go back to Freud's analysis now.

When Leonardo met Lisa Gherardini[437] to paint her portrait, he was
just over fifty years old. He had already left Milan and his patron,
Ludovico il Moro (who, according to Freud represented a kind of double
paternal, although he was younger than him, but the psychoanalyst could
not know this), had died.

Any possibility of artistic realization seemed unattainable to him—
according to Freud, let it be clear—so in the smile of the woman in the
portrait, Leonardo would have found the primitive object of his desire for
love: his mother. The smile of the *Gioconda*, which according to Freud
is repeated from that moment onward on all the faces painted by
Leonardo, would therefore embody that of Caterina, the young
unmarried mother who the artist idealized while she cradled him, tender
and attentive, and reassured with her smile:

> When, in the blossom of his years, Leonardo once again
> came across the smile of bliss and ecstasy, which had once been
> on his mother's lips while she was fondling him, he had been
> for a long time under the dominion of an inhibition that

[435] Giorgio Vasari—The Lives of the most excellent painters, sculptors, architects,
Torrentini, 1550—Florence

[436] As the Mad Hatter tells Alice in Alice in Wonderland, the 1865 novel written by the
English mathematician and writer Charles Lutwidge Dodgson, better known by the
pseudonym Lewis Carroll.

[437] Francesco del Giocondo's wife.

prevented him from ever desiring similar caresses from woman's lips. But he had become a painter and so he fought to reproduce the smile with his brush, giving it to all his paintings.

Fortunately, this essay received much criticism, not least in relation to the fact that in German *kite* was translated with *Geier* (vulture). In reality, from a purely symbolic point of view, little changes: the meaning of the analysis and the fundamental error made by the famous psychoanalyst remain unchanged.

Freud, certain of his work, did not worry about the criticisms toward him and the resulting scandal in the psychoanalytic field—so much so that his colleague Jung, who had shown his apprehension for the theory, wrote:

> Precisely on this point I am very relaxed, because I really like Leonardo and I know that he's particularly liked by the few who are able to judge: you, Ferenczi, Abraham, and Pfister.

Despite the criticisms coming from both the world of psychoanalysis and from Leonardo's biographers, this analysis over time has helped to form public opinion, precisely because it was developed by Freud. It provided the foundation on which the image of the homosexual artist who loved his models and students, including Gian Giacomo Caprotti, called Salaì, was formed. Leonardo's sexual orientation is not documented anywhere, except in the indictment he was subjected to in Florence, where he was in fact acquitted.

There's a "but." There is always a "but" with me, otherwise I would not have written this work.

Do you remember Leonardo's words?

> The acquisition of any knowledge is always useful to the intellect, because it can drive away useless things and retain the good ones. Because nothing can be loved or hated without prior knowledge of it.[438]

Or we can quote John Stuart Mill again, if you prefer:

> Truth is ever really known only to those who have attended equally and impartially to both sides and

[438] Sheet 0616 r of the Codex Atlanticus, preserved at the Ambrosian Library in Milan

endeavored to see the reasons of both in the strongest light.

Before forming an opinion—especially if it can influence in any way the action and thinking of others—it is necessary to learn to consider all the information that concerns the subject. Any opinion thus formed will always be less mendacious than that spoiled by inadequate information or ideas derived from an imposed truth, a dogma, which is the prime premise of prejudice.

Digging deeper, then, we find that in analyzing the childhood dream of Leonardo, Freud puts forward a second hypothesis that is not taken into account by anyone—not even by himself. When Freud wrote this essay, he was evidently not very lucid, or objective, or sufficiently informed to notice how laden with speculation and preconceptions his own theory was.

The childish image of the *kite-vulture* that opens his mouth to put his tail in it, says Freud, is indeed for Leonardo associated with the memory of the mother and the idealized desire of the penis that she did not have. But it could also constitute a veiled reference to the Egyptian image of the mother goddess Mut, depicted as bird-vulture.

Also?!

Freud would have conjecturing far less if he had settled on this second hypothesis, thus providing an original interpretation of Leonardo's work and his formation, which no scholar, blinded by the censures of a strongly illiberal period, had been able to do before. Perhaps overwhelmed by the Ego, instead the psychoanalyst decided to venture into that complicated and conjecture-laden analysis, supported by inaccurate data and full of preconceived preconceptions. This, alas, contributed much to a superficial and speculative reading of a character already too thorny himself. After all, Freud has always been obsessed with the concept of "female penis envy," and this analysis, if any were needed, is a further confirmation.

It would have been enough for him to follow the intuition of the mother goddess Mut[439] to bring Leonardo's work back to its original concept rather than the misplaced Catholic stamp imposed by critics and scholars This intuition, when proved to be correct, becomes a *passe-partout*, a skeleton key that allows us to open rooms of knowledge before now inaccessible or which we have before now neglected, assuming a

[439] And Nekhbet before her

different content on the basis of distorted narratives and data—by guilt or incompetence.

Some time ago, a journalist friend at RAI Radio-Journal (whose name I won't mention), responding privately to a melancholy outburst of mine, said to me:

> Showing of an innovative proposal, remember that you will always receive an objection linked to the cultural formation of the opponent. Those of Catholic background will ask you, "Who said it?" those with Jewish or Muslim formation will ask you, "Where is it written?" If you lived during the Greeks' time, for the love of the truth, they would have told you instead, "Prove it," and you prove it. You bet you prove it.

So, what shall I do? I'm going to prove it.

The figure of the mother goddess recalled by Freud is transversal to all the mythologies present in the various cultures located all over the planet, be they religious, philosophical, or only legendary. Which in the end is the same thing.

Each mythological narrative subtracts the myths and iconography from each other, becoming ultimately nothing but stories derived from an initial common story. These then differ from each other over time but only according to a different declination and nuance.

It's a bit like the blue jeans story. Once upon a time, there was only one model—essential, indestructible, and accessible to all, useful to the purpose for which they were created. Now on the market you find a thousand types, useless, very expensive, often inaccessible, and torn before even being sold to you. They are totally unsuitable for the purpose for which jeans were created. But they make fortunes for their producers.

So it is for mythological propositions, including that of the mother goddess. In Egypt, the goddess Mut was considered of paramount importance. Derived from an earlier divinity called Nekhbet, who like Mut was depicted as a vulture, sometimes with multicolored wings and an ankh in her hand[440], this goddess was associated with the flow of the waters from which everything would

[440] The breath of life, the key to life.

have originated for parthenogenesis[441]. The vulture in antiquity was considered to be of female species only and was fertilized by the force of the vital spirit, which would breathe into the mouth of inanimate matter to give it life.

"Spiritus intus alit," as the poet Virgil wrote.

In Christian religious mythology, the figure corresponding to Mut is the Virgin Mary. Parthenogenic conception becomes the immaculate conception of the Holy Spirit that leads to the birth of Jesus. For this reason, in some Renaissance representations, the Virgin Mary was represented with colored wings, such as in the painting preserved in Santa Maria delle Grazie. Francesco Sforza, his wife Bianca of Savoy, and Manfredo Landi, who was mentioned earlier in relation to the Milanese planisphere in which the Americas appear, are depicted in this painting. (See Figure 36).

FIGURE 36 — MADONNA OF MERCY, ANONYMOUS AUTHOR OF THE XV CENTURY, CHURCH OF ST. MARY OF GRACES, MILAN

[441] Parthenogenesis, a term derived from Greek meaning virginal reproduction, is a way of reproduction of some plants and animals in which the development of the egg takes place without the egg having been fertilized.

In the same way, the multicolored wings of the angel Raphael are depicted in the painting *Tobias and the Angel*[442], attributed to Verrocchio but with clear additions by Leonardo. (See Figure 37.)

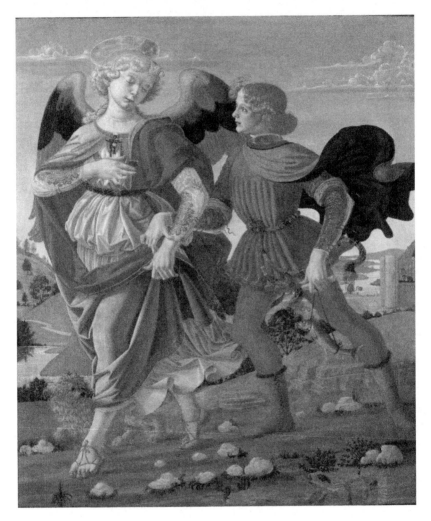

FIGURE 37 — TOBIAS AND THE ANGEL, VERROCCHIO AND LEONARDO DA VINCI, LONDON NATIONAL GALLERY

The iconographic subject of *Tobias and the Angel* was very popular in Florence. This imagery was connected to the

[442] *Tobias and the Angel* is a tempera painting on a panel by Andrea del Verrocchio and Leonardo, dated between 1470 and 1475, preserved in the National Gallery in London.

aforementioned Brotherhood of the Bigallo[443], founded in 1244 by Pietro da Verona as a "militia of faith" against the Cathars heresy and then transformed into a charitable organization in the fifteenth century, when it joined the Congregation of Mercy under the auspices of Antonino Pierozzi, the prior of the convent of St. Mark already mentioned several times in previous chapters.

This painting is treated superficially by historians, being remembered mostly for the authorial attributions rather than for the precious contents with which it was cleverly executed. But it is of absolute importance for understanding Leonardo's work, as it contains in symbols all the essence of Neoplatonic knowledge.

As I said, no scholar seems to have noticed it so far, perhaps being limited in their judgment by the preconceptions and classifications that the Inquisitions have imposed on all Renaissance art. These assumptions are the same as those found in the Freudian analytical reading.

The iconographic pretext for the realization of this work is an episode mentioned in the book of Tobit[444], in which the angel Raphael was invoked by Tobit, a man just and poor, to accompany his son Tobias to collect a debt and watch over him. During their journey, Raphael showed Tobias the safest route and more than once had to come to his aid. He never unveils the fact that he is an angel until the end of the story.

By analogy with this story, the painting is often connected to the young descendants of Florentine families who, in order to gain experience, were sent to cities where the offices of the Bank of Medici were located, accompanied by renowned tutors.

It is too easy to clearly read the events of the young Leonardo, who was sent to Milan at a very young age and was portrayed by the Ghirlandaio in the company of Poggio Bracciolini[445], Francesco Sassetti[446], and many other prominent figures of the political, economic, and cultural world of the Medici's Florence. It is therefore not surprising that Leonardo himself is portrayed in the role of the angel Raphael, whose

[443] In Piazza del Duomo, Florence.

[444] The Book of Tobias is a text contained in the Christian Bible (Septuagint and Vulgate) but not accepted in the Hebrew Bible.

[445] Famous Florentine humanist, who died in 1459, remembered for having put back into circulation, taking them away from centuries of oblivion, several masterpieces of Latin literature.

[446] Florentine banker who will replace Pigello Portinari as head of the Medici Bank in Milan.

multicolored wings reveal his ethereal, spiritual, and virginal
condition, as opposed to the material and carnal nature of Tobias.

This in itself is extraordinary, but it fades into the background.
Contrary to the Catholic foundation that is mistakenly assumed to be
the basis of all Renaissance painting, the reading of the painting
cannot disregard the multiple references to the ancient Egyptian
culture. The presence of the ethereal dog[447] is similar to the one
painted by Mantegna in the *Bridal Chamber*, in the tower of St.
George's Castle[448] in Mantua, which refers to the figure of Anubis[449],
the guardian of the afterlife. There are also countless ankhs[450] painted
around the neck and in the laces of Raphael's sandals as well as the
small cylindrical container in which oil of nard[451] was stored. There is
also the fish in the left hand of Tobias, which refers to the
oxyrhynchus[452], the fish that in mythological narrative ate the penis of
Osiris. Finally there are the cylinders that are also present in the hands
of each statue of an Egyptian pharaoh, whose function was to
rebalance the energy of the material body with the universal one. (See
Figure 38.)

These readings of the work are usually discouraged by the fact
that it is, mistakenly believed that Leonardo had no knowledge of the
Egyptian world, as Prof. Marani[453] told me many years ago with
much presumption and arrogance, while I was politely trying to share
with him part of my discoveries.

[447] And not "*Faded*" by the time, as I read in some reviews.

[448] Part of the best-known Ducal Palace.

[449] In Ancient Egypt he was considered the protector of the world of the dead.
Unlike what is assumed, the Sphinx of Giza before being carved with the features of
Pharaoh Cheops, was a jackal, as the rest of the body still testifies.

[450] Crux Ansata, an Egyptian symbol of eternal life, associated with Mut.

[451] The very precious and expensive oil which the bodies of the deceased were rubbed
with to be mummified.

[452] A term used by the Egyptians to refer to the elephant fish, one of which, according to
Egyptian mythology, had eaten Osiris' penis after Seth had dismembered his body.

[453] Pietro Marani, professor of the Polytechnic University of Milan, considered (unjustly
in my opinion) one of the leading Vincian experts, obsessed with attributing to Leonardo
a Catholic perspective.

FIGURE 38 — TOBIAS AND THE ANGEL, VERROCCHIO AND LEONARDO, DETAILS RELATED TO THE ANCIENT EGYPTIAN CULTURE, LONDON NATIONAL GALLERY

There is one detail that more than any other characterizes this extraordinary painting, however, and gives a deep substantial meaning to the whole work. I allude to the hands of the two portrayed characters. They express musical chords corresponding to their antithetical condition, hence mirroring each other yet rejoining in the middle into a single, harmonious chord. (See Figure 39.)

FIGURE 39 — TOBIAS AND THE ANGEL, VERROCCHIO AND LEONARDO, DETAIL OF THE HANDS REPRESENTATIVE OF MIRRORED MUSICAL CHORDS, LONDON NATIONAL GALLERY

This painting, indeed, hides in itself the synthesis of all the musical and philosophical knowledge in Leonardo's possession, taken from his youthful study of ancient Greek philosophers. This is one of the reasons that led him to Milan to donate a lyre to Duke Francis before 1465.

There is in fact a concept that for a long time has been considered only a philosophical, metaphysical aspect. Rather, it is the basis of quantum physics, which has been well summarized by Heraclitus. I am talking about a concept widely spread in the classical world and then recovered in the Renaissance, the music of the spheres, to describe the necessary knowledge of musical, astronomical, mathematical, and geometric subjects (that is everything that composed the aforementioned quadrivium)[454].

Heraclitus is the philosopher of the "becoming"[455] a concept expressed by the Greek philosopher through the metaphor of the flow of the river water. This image will also be taken up by Leonardo, thought it will invariably be trivialized and traced back to his description for a hydrological study instead of the concept of the transmigration of souls.

Heraclitus's sentence is the following:

> It is not possible to step twice into the same river, nor is it possible to touch a mortal substance twice in its same state, but because of the impetuosity and the speed of change it dissolves and forms, comes and goes.[456]

Not dissimilar to the one noted by Leonardo:

> The water of the river you touch is the last one of what went and the first one of what comes. So the present time.[457]

This is then the same flow of the waters to which the goddess Mut is associated, from which everything would originate through parthenogenesis for the Egyptians. The vital spark that gives birth to

[454] According to the ancients, the Sun, the Moon and the planets of the solar system, as a result of their rotation and revolution movements, would produce a continuous sound, imperceptible by human ear, forming all together a harmony. As a result, everything that has life on Earth would be influenced by these celestial sounds.

[455] Hence the concept Pantha Rai, *everything flows.*

[456] Contained in fragment 91 D.-K. Treaty *About nature.*

[457] Codex Trivulzianus 034v—Trivultian Library, Castello Sforzesco—Milan.

our spiritual, energetic nature is considered a continuous change traceable to an underlying *logos,* a deep harmony that governs the perennial dialectic between opposites. This is harmony the of which the entire universe—is a unique and immense dual system—is composed. This concept that does not differ from the Tao of eastern Asian cultures, which is represented graphically by two opposing forces[458] that united in harmony contribute to form the divine One, the soul, and the essence of all things.

Heraclitus, allowing us to give a definitive and appropriate reading of the *Tobias and the Angel* work, sums up the matter in these terms:

> What is opposition is accord, and from the discordant
> things spring beautiful harmony, and all things happen
> according to strife and necessity.

I will not discuss Leonardo's musical and astrophysical knowledge in depth at the moment, primarily because it affects much of his works and writings. It would therefore be too vast and complex to be summed up in a few lines. Secondly because, as I wrote earlier, music represents the highest peak of Leonardo's cultural heritage. For this reason it deserves an adequately dedicated treatment, for which I already have much of the necessary documentation. I'll be writing that as well, sooner or later.

Returning to *Tobias and the Angel,* the painting tells us two more things. The first is that Leonardo's musical knowledge went far beyond the concept of "music" as we refer to it today, confining it to a staff and the seven notes used to write some more or less articulated arrangements to entertain the courts of the time. This same concept of music, interpreted as harmonization with the vibrational structure of the entire universe, also refers to that manuscript encrypted in gold and preserved at the Trivulziana Library to which I made reference many times, in the frontispiece of which Count Carlo Trivulzio recognizes a portrait of Leonardo[459]. The inspiration for the work, the *Florentinii Musices* mentioned also by Trivulzio, is clearly not a friar named Florenzio who dedicates his work on musical theory to Cardinal Ascanio Sforza, as I heard some claiming. It is precisely the musician Leonardo da Vinci, as it

[458] The Yin and the Yang, the female and male energy.
[459] Liber Musices in Florentius, I-Mt 2146—Trivulziana Library, at Castello Sforzesco in Milan.

is depicted in the *Portrait of a Musician*[460] preserved at the Ambrosian Art Gallery[461].

The fact that the music in the *Liber Musices* is encrypted in gold, moreover, is an explicit reference to the golden music[462] of which the universal harmony is composed. Leonardo will leave us in full an entire composition of golden music, hidden in an extraordinary flight of birds in a fifteenth-century palace in Valtellina, together with the umpteenth representation of the Americas well before 1492[463].

As you can see, it's a little more complex than the simple concept of music in a recreational aspect, limited to musical rebuses or some machines to shoot music with, which is how its musical peculiarities are normally dealt with.

For Leonardo, music has an absolute value. In fact, while "painting is the representation of the visible things, music is representation of the invisible things"[464]. There is a clear allusion to that compendium of harmonic vibrations that understates the first order of all things, of which perhaps the most complete and explicit description is that of Cicero in *De Re Publica*:

> You hear this harmony which is formed by unequal
> intervals calculated according to perfect proportions and
> reproduced by the movements of the spheres. The low
> sounds join the high ones in ever-changing chords,
> because these colossal planetary revolutions could not be
> happening in silence, and nature demands that clear sounds
> echo at one end and dark sounds respond at the other. So
> the world of the stars that has the fastest motion rotates
> with a hasty trill Argentinean, while the submitted lunar
> course emits a slow, cavernous sound. So the spheres
> produce seven distinct tones, and the seven-tone number
> and the core of all that exists.[465]

[460] The *Portrait of a musician* is an oil painting on a panel attributed to Leonardo da Vinci, an attribution that I do not share, dated around 1485 and preserved in the Ambrosian Art Gallery in Milan.

[461] This last circumstance gives us further information about the youthful appearance of Leonardo, whose musical skills were well known in Milan.

[462] From which the Golden Section and the Fibonacci Sequence are derived, and not vice versa.

[463] Hall of the Creation, Palazzo Besta Teglio, 1459.

[464] Treaty of Painting.

[465] Cicero, book X of *De Republica*.

From the continuation of this definition of Cicero, we can perhaps deduce why Leonardo is invited to Milan as a lyre player:

> And the men who know how to imitate on the lyre the concert of heaven have found the way that leads to this sublime realm, in the same way that others have elevated themselves with genius to the knowledge of divine things.

Can we suppose that the young Leonardo was invited to bring to Francesco Sforza the instrument to elevate his spirit? In this case, is he then the young protagonist of the only pictorial remains of the Bank of Medici in Milan, dressed in a red garment and with protruding eyes, so strongly similar to Raphael and intent on reading a work of Cicero, portrayed by Vincenzo Foppa[466]? (See Figure 40.)

FIGURE 40— VINCENZO FOPPA, CIRCA 1464, BOY READING CICERO

As with the ancients[467]— Heraclitus and Plato above all—for Leonardo, music had a function of spiritual elevation, allowing man to be

[466] The *Boy reading Cicero* (or *The Young Cicero Reading)* is a fresco by Vincenzo Foppa from the Medici Bank in Milan, where it was painted around 1464, now preserved at the London Wallace Collection. The work is also documented in the *Architecture Treaty* of Filarete, who recollect the painter's work in the garden lodge and in the halls of the Medici bank.

[467] "There are three pathways to return to Heaven: one is that beauty, or love: the second one of music: the third one of Philosophy." Plotinus, De triplici animae reditu.

"Music is one of the three pathways by which the soul returns to Heaven."

Torquato Tasso, Exhibitions of the author of some of his rhymes, in Works, note to the sonnet CXXXVIII

as one with the vibrational harmonic context of the entire Universe. It is no coincidence that Orpheus and King David were presented as great lyre players, for whom the musical instrument was a means of elevation rather than entertainment.

Like Cicero, Plato also describes the music drawn by the motion of the stars in the tenth book of *De Re Publica,* when he debates the Orphic Myth of Er. Er is a soldier who died in battle, but as he was about to be cremated, he awakened and recounted what he had seen in the afterlife (as both Dante and Orpheus do in searching for their soul mates). After a tortuous journey, Er recounts that the souls of the deceased came within sight of a yarn winder (a symbol of destiny) laid on the lap of the goddess Ananke (also called Necessity):

> The yarn winder was spinning on Necessity's knees.
> At the top, on each of her circles, was a Siren moving,
> dragged too by the circular motion. Each emitted a single
> voice, of a single tone, so that from the eight of them, as
> they were, a single harmony was produced.[468]

The harmony emitted by the yarn winder served as a term of comparison to assess the degree of purity of the souls who came for judgement and decide their fate, a bit like the weighing of the heart in Egyptian funeral rituals.

As you can see, continuously, myths from different cultures chase each other. Borrowing a pillar of classical mechanical physics called the law of conservation of mass, we can say that even in the making of the myth, "nothing is created, nothing is destroyed, everything is transformed"[469] I apologize for this quote, which betrays my education, but if today I am what I am and I can share the result of my studies, it is also thanks to the *mentis form* developed in my years of secondary school and to the teachers who helped to forge it. Especially to them. Would you believe that the teacher I loved the most of all was named Riccardi, like the Medici residence? And those who least could get me excited were named Bandini and Baroncelli, like the guy who stabbed Giuliano de' Medici in the back during the Congiura de' Pazzi?

Returning to the harmony that constituted the method of judgment for the souls of the deceased described by Plato in the Myth

[468] Plato, book X of *De Republica*
[469] Lavoisier's fundamental postulate.

of Er[470], it is precisely the same music of the celestial bodies already described in the same way by Heraclitus, Cicero, Pythagoras, and many other philosophers of that period.

Leonardo, obviously, takes this on too. Regarding Necessity (as the goddess Ananke was called), he writes:

> Necessity is teacher and guardian of nature. Necessity is the theme and inventor of nature and rule of eternal life.[471]

It is not by coincidence, then, that the hand of *Madonna of the Yarn winder*, according to an iconographic scheme undertaken by all Renaissance artists, expresses a musical tetrachord. Leonardo's *Virgin of the Rocks* itself, the original of which is on display at the Louvre in Paris—before Leonardo changed its iconographic structure (as he will do with most of his paintings, following precise indications of a landscape nature)—was born as *Madonna of the Yarn winder*. (See Figure 41.)

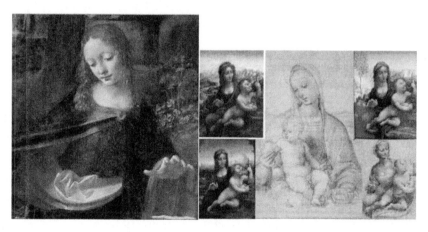

FIGURE 41 — THE VIRGIN OF THE ROCKS, LEONARDO DA VINCI. VARIOUS MADONNAS OF THE YARN WINDERS

The harmony to which all artists and philosophers refer is that consequent to the motion of celestial bodies.

"Amor vincit omnia," wrote Virgil[472]. The main meaning of this sentence is often misrepresented. The love to which Virgil refers is the

[470] Then I also resumed in the Timeo.
[471] Codex Forster III, Sheet 043 v.
[472] Title then given by Caravaggio to one of his famous work.

same one quoted by Verdi in *La Traviata* (love that is pulse of the universe).

It is not loving sentiment but the love of the universal harmony, consisting of that cohesion of vibrations that "everything binds and determines." *Omnia*—all, vincit—binds. The same deep concept is expressed by *Tobias and the Angel*'s hands in Leonardo's painting (as it seems obvious to me to exclude Verrocchio at this point), which bind together in a single harmonic embrace. *Amor vincit omnia*, therefore, does not have that loving sentiment meaning, according to which love wins over everything. Of course not.

The many sounds that make up the celestial harmony were expressed by Leonardo through his famous knots, present both on the dress of the woman mistakenly referred to as Mona Lisa and in the ceiling of the Axis Hall at the Sforza Castle in Milan which—take note—is not a "vegetable tangle of mulberries" as I read in the commentaries of the room but a huge mandala, like those of the Academy da Vici mentioned also by Vasari[473]. knot theory is a branch of mathematics that has applications in subatomic physics, supramolecular chemistry, and biology. Not surprisingly, the iron gate of the Department of Mathematics at the University of Cambridge holds a Vincian knot frieze.

The same interpretation is to be given to Dante[474] when he immortalizes that famous "Love that moves the sun and the other stars" as Leonardo explains again:

> Motion is the cause of every life[475]

Increasingly I hear art critics and historians—or even worse, interested scientific communicators—admonish the public from seeking esoteric meanings in the works of Leonardo (or more generally, of the Renaissance), relegating everything I am telling you to the imaginary sphere of philosophy or proposing distorted readings based on the iconographic facade used by the artists of these works to overcome papal censorship. This approach avoids investigating the

[473] "He also wasted time drawing groups of cords made with order, that from one end it followed to the other, so much to fill a circle, and a very difficult and beautiful one can be seen, and in the middle there are these words: Leonardus Vinci Academy"
G. Vasari, The Lives—Joints Publisher, 1568.

[474] Heaven, Canto XXXIII.

[475] Manuscript H, Sheet 141r—France Institute, Parigi.

depth of the underlying content, which I believe they know very well.

Such is the case of *Tobias and the Angel*, a work that in its contents represents the basis of quantum physics and vibrational theory as it dictates the elementary rule that determines everything that resides in the universe: the unity of opposites. Not by chance it's called uni-verse.

Leonardo, like Plato, Heraclitus, Virgil, Marsilio Ficino, and the Neoplatonists, was a philosopher in another sense, as I anticipated in the opening by quoting Galilei:

> Philosophy is written in this great book which constantly stands open before our eyes (I say the universe), but it cannot be understood unless you first learn the language, and the characters, in which it is written. It is written in mathematical language, and the characters are triangles, circles, and other geometric figures, without which it is impossible to understand humanly word; without these it is a vain wandering in a dark labyrinth.[476]

The second consideration dictated by the painting, obviously, is that Leonardo's knowledge was immersed deeply in the antiquity of Egyptian mythology, just as Heraclitus and Plato did before him. It passed through orphism, which was a culture between the Egyptian and Greek worlds. It inspired Leonardo to create works such as the *Virgin of the Rocks*.

Returning for a moment to the analysis conducted by Freud interpreting Leonardo's childhood dream, you can well understand how in that tail of the kite that penetrates his mouth there is no reference to a passive sexual act, no repression, no connection with a latent homosexuality that the artist concealed. Moreover, in his case, this is not demonstrable in any way with documentation, much less through the distorted analysis of his works. More simply—and the multiple Egyptian references contained in *Tobias and the Angel* prove it—Leonardo alluded to a specific instrument, called *pesesh-kef,* which was used in a ceremonial funeral ritual practiced in the Ancient Egypt: the opening of the mouth ceremony. (See Figure 42.)

[476] The Assayer, 1623

FIGURE 42 — A ROYAL KITE, RHE EGYPTIAN PESESH-KEF

This ceremony was part of the complex religious rituals practiced by that civilization in order to guarantee eternal life to the deceased and free the vital energy that animated his gross, material body. The ceremony allowed eternal life via a cycle of reincarnations that is symbolically identified by Mut, Heraclitus, and Leonardo with the image of the flowing of water in the river. The pesesh-kef was then inserted into the deceased's mouth to separate the lips; for this reason it had a particular shape resembling indeed that of a kite tail, as you can see from the figure that compares a pesesh-kef[477] with a royal kite[478] of Tuscany. This bird's main characteristic is that the male and female specimens do not have visible morphological differences. For this reason, on a symbolic level, the kite was used to represent the primitive androgynous, in which the male and female element are confused into one. It is evident that Leonardo, Tuscan by origin, knew this raptor very well, including the multicolored streaks of wing plumage that dictated the symbolic iconographic choices, first Egyptian and then Renaissance.

The kite and its intrinsic meaning will dictate the iconographic change of the *Virgin of the Rocks*, originally conceived as a *Madonna of the Yarn winder*. This painting has a series of important orphic references, so much so that the landscape in which it is placed

[477] Ref. KHM_ÄS_7902—Kunsthistorisches Museum, Vienna.
[478] The royal kite (*Milvus milvus*) it is a predator bird from the Accipitrids family.

will also be used by Leonardo to build the theatrical set for the staging of the *Fabula di Orfeo* by Angelo Poliziano.

As you can see, it is enough to get away a little from all those mental and cultural forms that condition our daily thinking to see immediately that the story is colored by a thousand shades, enriching itself with variations that are more relevant with the original executive structure of the work.

I'll take advantage of this long digression, which of course cannot be enough to demonstrate all the distortions with which Leonardo's work is represented, to add a couple of arguments that will be useful in the continuation of my writing, the purpose of which I would like to remind you being precisely that of restituting the image of a more truthful Leonardo, both in the biographical traits and in the cultural references that underlie his work.

When the author of the Anonimo Gaddiano describes Leonardo's physical appearance, he highlights a garment that evidently the Florentine genius used to wear, so much that it became a kind of trademark:

> [Nature] that not only gifted him of the beauty of the body but also made him master of many other rare virtues. [...] He was a good person, proportionate, grateful, and of beautiful appearance. He wore a pinkish garment, short to the knee, though longer clothes were worn then, and he had beautiful curly hair that fell to his chest and was kept in good order[479]

In addition to the aforementioned physical gifts, which are found in a multitude of portraits where today we can recognize this extraordinary artist, we acquire from this quote that Leonardo used to wear a pinkish garment[480] that fell only to the knee, not as long as was the male fashion of the time.

The recurring associations with Heraclitus mentioned so far, which also find an indirect mention in *Tobias and the Angel*, have suggested that Bramante portray Leonardo as Heraclitus. The portrait in question is inserted in a painting that is now preserved at the Art Gallery of Brera. It tells us about the philosophical separation between Democritus and Heraclitus, the two philosophers who had an opposite vision with respect to the events of life: the laughing and the crying philosopher. This

[479] Cod. Magliab, magliab. XVII, 17—Central National Library of Florence.
[480] Short men's dress.

contrast arises from the story that Luciano[481] tells in one of his *Dialogues,* in which he imagines that Jupiter and Mercury improvise themselves as traders of philosophers. A scrupulous buyer interrogates one by one the wisemen of the different schools to test the opportunity of the purchase. (See Figure 43.)

During the Renaissance, the conflict of passions between Democritus and Heraclitus focused mainly on the influences of the stars and their arcane echo in the doctrine of temperaments and moods. The laughter of the philosopher whose reason teaches us to abandon the passions of the world is countered by the crying of Heraclitus, the philosopher of becoming, who cannot take his eyes away from the caducity of events.

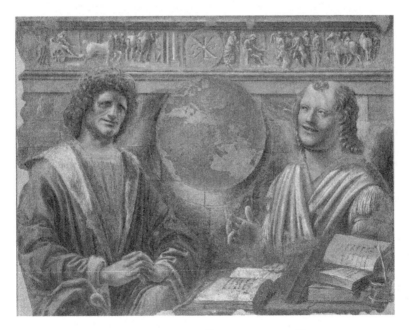

FIGURE 43— HERACLITUS AND DEMOCRITUS, BRAMANTE, 1487, ART GALLERY OF BRERA, MILAN

In the time that overwhelms all things, he feels the tragedy of a world in which the senses trespass in the no-sense, the value in disvalue, what is great and arouses admiration and respect in what is

[481] Luciano from Samosata (120–192) was an ancient Greek writer and orator of Syrian origin, famous for the witty and irreverent nature of his satirical writings.

worthless and deplorable. While the philosopher Democritus is associated with a jovial character resulting from the inevitability of events related to the influences of the cosmos, Heraclitus correlates to a saturnine character—melancholy and linked to the impermanence of things related to his earthly experience.

In the painting at the Brera, Bramante portrays himself as Democritus, while Leonardo is portrayed as a wrinkled and weeping Heraclitus. He is wearing his characteristic pinkish garment, in front of which is placed a book written from right to left. Bramante was not an exceptional painter; if we add to this the need meaning of the saturnine aspect associated with the figure of Heraclitus, I would say that in this case we can exclude this portrait from those that can somehow help us define the appearance of Leonardo. Even the boy who reads Cicero, in what remains of the pictorial decors of the Bank of Medici, wears a pinkish garment, in the same way that Sant 'Agostino wears it in the painting by Benozzo Gozzoli that represents Leonardo, accompanied by brothers Lorenzo and Giuliano de' Medici, as he reaches Milan in 1465.

The same contrast personified by Leonardo and Bramante as the two philosophers Heraclitus and Democritus will be taken up, in inverted roles, by Raphael in the *Disputation of the Holy Sacrament,* a fresco by Raphael Sanzio dated around 1509 and located in the Room of the Signatura in the Vatican. In addition to the famous portrait where Leonardo embodies Plato in the School of Athens, Raphael in fact will portray his fellow artist in the Vatican a total of six times[482], in defiance of those who excluded him from the works in the Vatican and pursued him in every way for his deeply Neoplatonic ideas.

Beyond this, Bramante's painting and the association he proposes between Leonardo and Heraclitus leads us to consider a news story mentioned by all the major international agencies and news outlets in the 2019 summer: the paralysis Leonardo's right hand, which struck him late in life. The news concerns a thesis suggested by two Italian doctors, the neurologist Carlo Rossi and the plastic surgeon Davide Lazzeri. They posit that the paralysis in Leonardo's right hand was determined by a trauma received from the ulnar nerve[483] of the right arm and not from a

[482] Four in The Dispute of the Sacramento (three times as Democritus, one as King David) and two in The School of Athens (the aforementioned Plato and Zoroaster).
[483] Nerve connecting the shoulder with the hand, determining its mobility.

stroke, as was instead assumed years ago by Alessandro Vezzosi[484]. To draw up their[485] diagnosis, the two doctors relied on the observation of a drawing of the end of the sixteenth century by Giovanni Ambrogio Figino[486].

Many are the inaccuracies in this news, which I disappointingly observe having been reported in all international newsrooms, thus contributing to further confusion. The red plaster drawing by Figino that would highlight the impairment on Leonardo's right hand is preserved in Venice at the Academy Galleries, Cabinet of Drawings and Prints, repertory number 834.

According to the two doctors, if it had been a stroke, the hand should have appeared to be contracted, while the position taken in this case is that of the "claw hand," with fingers stretched out compared to the natural position, typical of ulnar paralysis.

As with Freud's remote analysis, the issue is much simpler than that. It's too bad that the two doctors did not consider that the analyzed drawing is indeed preparatory to a painting, today held in a private collection, which Figino himself dedicates to the theme of Heraclitus and Democritus. It was probably artistically inspired by the treatment of a theme that is a classic of philosophy applied to art both by the work of Bramante and that of other artists who are so-called *Leonardeschi*.

Heraclitus, as I said earlier, embodies the philosopher who cries, the one who relates to earthly, material things. This is why he is depicted by Figino with a handkerchief in his hand—in order to wipe away the tears that cross his face (as already pointed out by the deceased Pedretti[487] years ago). In the painting, however, the figure becomes mirrored with respect to the drawing, and the right hand inevitably becomes the left one, thus nullifying the analysis advanced by the two doctors. (See Figure 44.)

[484] An expert scholar of Leonardo da Vinci, founder and director of the Leonardo da Vinci Ideal Museum.
[485] Published on the Journal of the Royal Society of Medicine in London.
[486] Milanese painter and pupil of Paolo Lomazzo, active in the second half of the 16th century.
[487] Carlo Pedretti, perhaps the most authoritative and well-known scholar of Leonardo da Vinci in the world.

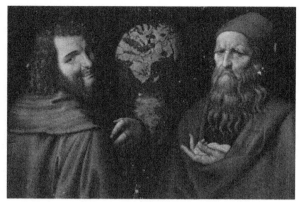

FIGURE 44 — GIOVAN AMBROGIO FIGINO, HERACLITUS AND DEMOCRITUS, ACADEMY GALLERIES, CABINET OF DRAWINGS AND PRINTS, VENICE

De Beatis was the only one of Leonardo's biographers (along with Benedict Dei) to report on circumstances experienced in person. He records the meeting he had with the artist and Cardinal Luigi of Aragon on 10 October 1517 and speaks of Leonardo's disability in his right hand:

> Even if from him, for having contracted a certain paralysis on the right hand, much cannot be expected.
> He has formed a Milanese group that works very well.
> And although the Sir Leonardo cannot color with his usual delicacy, he can still make drawings and teach others[488]

It is equally true, however, that completely theoretically, Leonardo painted and wrote with his left hand. So an impairment confined to his right hand should not have produced any kind of limitation to him.

Theoretically, I was saying. We know in fact that Leonardo was ambidextrous, as it also emerges from a recent study by the Opificio delle Pietre Dure in Florence conducted on the *Landscape with River*, the famous design known to insiders as 8P, from its inventory number, and considered the first dated work of the Florentine artist that reached us[489].

This famous drawing contains two inscriptions: one on the front, drawn according to the famous reversed writing of Leonardo, from right to left: "Day of St. Mary of the snow / day 5th of August 1473." There is

[488] *Travel diary* by Antonio de Beatis, 10 October 1517—Ref. XF28, National Library of Naples.
[489] 5th August 1473.

another on the back written in the ordinary way, from left to right:
"I, Morando d'Antoni, am glad." This is traceable to a note with the
sketch of a contractual template of gratitude, probably referring to a
work that had been commissioned to him. The comparison between
these two inscriptions confirms the fact that Leonardo was
ambidextrous. He wrote the inscription on the front with the classic
"mirrored" writing with his left hand, while for the one on the back,
with ordinary verse, he used his right hand, the one that in old age
got injured.

It's not an uncommon thing, on the contrary. Beyond the skill of
the Amanuensis monks, who wrote simultaneously with both hands
to produce double-copy documents, many of us are born with this
innate capacity. The translator of the French edition of this text,
without whom this publication probably would not have been born,
as a child did it regularly.

The question still remains as to why a disability in his right hand
should have prevented Leonardo from continuing to write and paint,
if he was predominantly left-handed, as it has always been claimed. I
therefore want to add two more contributions about his way to write.

The first contribution concerns what Vasari writes:

> He, with his own strength, constrained every violent
> fury; and with his right hand, he twisted a wall bell and a
> horseshoe as if they were made of lead. With his liberality
> he supported and fed every friend, poor and rich, as long
> as he had ingenuity and virtue. He decorated and he
> honored with every action any dishonored and stark
> room; therefore, it was a truly great gift for Florence the
> birth of Lionardo, and more than an infinite loss his
> death.[490]

Why did Vasari feel the need to emphasize the fact that with his
right hand "he twisted a wall bell and a horseshoe, as if they were
made of lead" if he had not actually been ambidextrous?

Using two hands to write might actually have made a kind of
sense for Leonardo. We know that he wrote his notes with
ferrogallico[491] ink so as to avoid smearing the lines with the part of

[490] Giorgio Vasari—The Lives of the most excellent painters, sculptors, architects, 1550
Torrentini, 1568—Giunti Editore—Florence
[491] Type of black, water-based ink used for most manuscripts. It owes its name and
coloration to the gallate of iron.

the palm that remained in contact with the sheet. It may be that he wrote with his right hand from left to right, which normally happened in official documents, while he used his left to write from right to left, as we can observe him doing in his countless notes.

Leonardo's only signature—and I stress "the only one"[492]—is the one he placed at the bottom of the contract for the *Virgin of the Rocks*, signed on 25 April 1483, between the School of Conception of the Order of the Minor Friars, and the artists Leonardo da Vinci and the brothers de Predis. The contract also established that the work had to be completed by the 8 December of the following year, 1484, for the feast of the Immaculate, and the total compensation was set at 800 lire, to be paid as agreed. It was also established that contractors, the brothers de Predis and Leonardo[493], had to provide for raw materials and gold at their own expense. Leonardo, who was staying with the de Predis brothers, undersigned:

Jo Lionardo da Vinci in witness of what is written above[494]

Writing with his right hand from left to right.

So Leonardo had no preference for the use of one hand rather than the other except for technical reasons. Depending on the direction he wrote, which was usually related to the fact whether he wrote for himself or for others, he used one or the other hand indifferently.

And all those stories that say he wrote from right to left because he was left-handed, but actually not, it was for not making clear the things he wrote, except through a mirror, etc.? Nonsense. Again.

There is an element in considering his way of writing no one as usual has paid attention to. It perhaps can give us an indication as to why Leonardo wrote from right to left.

Leonardo has left us an infinite amount of writing—kilometers and kilometers of texts written from left to right, from right to left, with one hand or with the other but always in cursive. Leonardo hardly ever wrote in block letters. Is it possible that, among the many imaginative interpretations that have been put forward, no one has wondered why? We know today that Leonardo learned his first rudiments thanks to the substantial contribution of texts that the Byzantine dignitaries in the entourage of Gemistus Pletho brought to Florence in the first half of the

[492] I've seen the most disparate signatures being ascribed to Leonardo.
[493] Magister Leonardus de Vintiis Florentinus.
[494] State Archives of Milan.

fifteenth century. We know that he mostly wrote from right to left, and we now know that he almost never used block letters. We also know that he was able to use his right hand very well, to the point he could bend a horseshoe and write official documents, as per the inscription on the back of the *Landscape with River* or the signature under the contract for the *Virgin of the Rocks*.

Can we then assume that his right-to-left writing was simply due to the fact that it was the most normal thing for him, having acquired it from an early age by his masters and the texts that he had studied? Well, it would imply admitting that Leonardo's greatness is largely attributable to the Byzantines and that his formation is linked to the Neoplatonic pagan texts.

But perhaps that's exactly what in these five centuries of obscurantism has been concealed. What do you reckon?

CH. VI—THE IMPORTANCE OF LANDSCAPES IN LEONARDO'S WORKS

> Have a glass as big as a royal half-sheet, and secure it firmly in front of your eyes, between the eye and the subject you want to portray. Then place yourself with your eye far away from the glass, 2/3 of an arm, and hold your head with an instrument so that you cannot move it. Then close or cover one eye, and with the brush and a sharpened pencil, mark on the glass what appears on the other side, and then polish the glass with paper and sprinkle it on good paper, and paint it, if you like it, using well the air perspective.[495]

As I have already written, for Leonardo the continuous observation of reality translates from a figurative point of view into a faithful repetition of it within his work, whether it be drawings or paintings or sculptures. In reproducing what he observes with his own eyes, in fact, the artist adopts a methodical approach that we could define as scientific. It derives from considering the perfection of reality that stood before him superior to anything or form that can be imagined in the fantasy of any human being. Reality outweighs fantasy. All the time. It is the same conviction that led Albert Einstein to say, "Everything you can imagine, nature has already created".

Leonardo puts pictorial art on a higher level than poetry:

> He does not see the imagination with such excellence as he sees the eye, because the eye receives the types, i.e., similarities of objects, and gives them to the impression, and from the impression to the common sense, and there it is judged. But the imagination does not come from the same common sense, except when it goes to the memory, and there it stops and there it dies if the thing imagined is not of much excellence. And here is where we find poetry in the mind, in the poet's imagination, who fantasizes about the same things as

[495] Manuscript A, Sheet 104r—Institut de France, Paris.

the painter, for which imaginings he wants to equate
himself with the painter, but indeed he is very remote
from it.[496]

Since in his personal conception there is nothing that can
overcome the perfection that Nature is composed of, not to mention
nothing that is mediated by the mind of man and related via that
totally conventional instrument that is the word[497], Leonardo adopts
an actual coded method to depict it. This is summarized in several
notes that would be made public after the death of the master in
Treatise on Painting, composed posthumously by his student
Francesco Melzi.

In drafting these rules, Leonardo dictates a series of unbreakable
constraints through which an artist can faithfully reproduce the reality
that comes before his eyes[498]. These same rules are the basis of his
famous nuance, his recourse to perspective, depth (which is obviously
not due to the slight strabismus of which he was affected), the realism
of the colors, shapes, mountains, etc.

Leonardo was so obsessed with reproductive fidelity that in the
event that a work during its course did not prove faithful to the
subject he had to portray, out of respect for the latter he left the work
unfinished. Beware: this was not out of listlessness, on a whim, due to
disrespect for the client, or because he had been abandoned by his
father at a young age, as claimed by Freud in his psychoanalytic
delirium. No. He did it out of absolute respect for Nature and the
laws that determine it. Leonardo, as for Neoplatonist people in
general, described a canon of its absolute perfection. The ancient
Greeks, in fact, defined canon in the shapes and in the mathematical
and geometric relationships that repeat the first rules of Nature, the
absolute synthesis of which is represented by the golden ratio.

In Nature everything is composed according to that vibrational
harmonic order described at the end of the previous chapter. It is
determined by a primary spark that is then modulated and enriched
by the motion of the stars, thus contributing to finding that binding
universal law to which everything is subject. This idea was so well
described by Cicero in *De Re Publica,* and man cannot escape it.

[496] Book on painting, Sheet 006vr—Urbinate lat. 1270—Vatican Apostolic Library.
[497] Grammar rhetoric and dialectics were part of the so-called minor liberal arts.
[498] Whether they were landscapes, faces, things, animals.

In short, it is what is expressed through the *Vitruvian Man*[499], Leonardo's famous representation describing the ideal proportions of the human body according to the assumption "on earth as it is in heaven," as represented figuratively by two men. One is inscribed in the circle, with his arms and legs open to form an X, the anima mundi who responds to the supreme rule dictated by the stars. The other figure is inside the square with his legs joined and arms open to describe a T, symbolizing earthly life. A compass describes the circle, a set square the square.

Democritus and Heraclitus.

Yin and Yang.

Heaven and Hell.

Female Energy and Male Energy.

Sun and Moon.

Light and Shadow.

Black and White.

Armillary Sphere and Hourglass.

High and Low.

Blue and Red.

I could continue with this list indefinitely, but the substance does not change. Everything in the universe refers to a duality that is the basis of our very existence, a duality that we find repeated in the various ways in which man, over time, meant to narrate it, be it with mythological tales or the same artistic representations.

Again: how is it possible that only I thought of turning *Vitruvian Man* upside-down to catch two angels kissing in the pectorals of the man drawn by Leonardo? These two angels, present also in a drawing by Leonardo and then recalled by Marco d'Oggiono and set in the same grotto that would host the *Virgin of the Rocks*, are nothing more than another expression of this primigenial duality, such as Castore and Polluce, Romulus and Remus, and the angels painted by Raphael in the *Sistine Madonna*[500]. The latter all young newlyweds, with doubtful taste,

[499] Academy Galleries, Venice.

[500] This work it is preserved at the Gemäldegalerie Old Masters Dresden and over the centuries it has fascinated Freud, Goethe, Nietzsche and Dostoyevsky, who mentions it in *The Demons, The Teenager* and in *Crime and Punishment*.

According to critics, it is one of the most if not the most beautiful paintings of the master of Urbino, painted between 1512 and 1514 in Rome commissioned by his patron, Julius II of della Rovere, the Pope who had commissioned to Michelangelo the vault of the Sistine chapel and to Raphael himself the immortal Vatican Rooms, probably to pay tribute to the uncle Sisto IV.

hang above the headboard of their bed as a tribute to their love. It does not matter if they ignore that those angels are just a fragment of one of the most famous works of the painter from Urbino: the twins born to Leda, who was impregnated by Cygnus (meant as the constellation).

In this continuous re-enactment of the primigenial duality that permeates the echo of that harmonic concept expressed by Heraclitus, or if you prefer in *Tobias and the Angel*, which is evidently essential in the description of our solar system:

> Opposites are concordant, and from the discordant
> things comes beautiful harmony, and everything happens
> by law of contention.

We can take into account any narrative or artistic representation of the past; the question would not change. Everything inevitably leads back to the balance contained in this duality, whose respect becomes the first purpose of man in his short material experience.

If it is not shared in this way, Renaissance art takes on a different meaning than the one with which the artists conceived their most famous works. Those millions of visitors who go daily to see them in museums and cities of art would only perceive the result of the distortion that has been exerted in their regard over the centuries. Yet the knowledge underlined in these extraordinary works has been accessible to man ever since antiquity. It has been uninterrupted until, through first the religious mythological narrative and then its imposition, man did not intend to build a law of his own, secondary and defective in respect to the natural one. It derives from an artificial divine figure to which can be attributed the determination of a different supreme order.

Leonardo lived in the period when this knowledge again became available to Western man and helped give life to the entire Renaissance movement. Not only was he well aware of this aspect, but he made it the first foundation of his cultural formation and his work.

I smile when I read about the various theses that are put forward to reveal the true identity of the woman portrayed as the Gioconda: some say Lisa Gherardini, some Pacifica Brandani, some a Sforza, some the mother, some a Neapolitan courtesan, and so on indefinitely, depending by the most improbable supporting argumentation. I smile for two reasons: first because it's not the *Mona*

Lisa portrait. This in itself implicitly constitutes the contradiction of all these theorizations, as they start from the Vasari assumption that that is the portrait of the wife of Francesco del Giocondo, but then claim that a woman different from Lisa Gherardini is portrayed.

Above all I smile because the painting does not portray a woman in flesh and blood, a contemporary of Leonardo. It is rather the expression of the same duality described above. In any narrative, whether biographical, historical, or artistic, there is a *fil rouge* one cannot ignore. It is one of the elementary mathematical principles of Euclidean geometry, even before than a logical one. It has been taught to us since primary school:

> An infinite number of lines can pass through one given point; for any two distinct points, there is a unique line containing them.

What do I want to say with this?

I want to tell you that if taken individually, each element analyzed can be interpreted in a way as in its exact opposite. When, however, the same element is placed in a broader analytical or narrative context, as in this case, if it does not respect that invisible *fil rouge* that holds everything coherently bound, every incongruous interpretation automatically decays.

"The essential is invisible to the eyes," said the Little Prince in the novel written by the French aviator Antoine de Saint-Exupéry. With these words Saint-Exupéry intended to use that same plot that for Virgil was the love that binds all (amor vincit omnia) and that for Leonardo was the music of the spheres, that is, "the representation of invisible things."

Given all this, we can say that knowledge itself represents this essential and invisible leitmotif that binds everything into a single logical narrative design. That is why knowledge is so important: because knowledge preserves us from meaningless and inconsistent hypotheses. Let your children and those who manage education and school at the government level know this. Only heaven knows how essential it is to know this in today's decaying society, which sees the world's information severely compromised by a totally uncritical proposal on one hand and by the subjugation of some sources of information with respect to higher centers of primary interest on the other.

Returning to Leonardo's most iconic painting, the one on display at the Louvre museum in Paris, what the woman painted by the artist is meant to represent is nothing more than the expression of that harmonic

duality of the opposites to which Heraclitus alludes in describing the plot of universal harmony.

We'll get there.

We were talking about the landscapes and the essential figurative realism with which the artist approached the reality he intended to depict. According to this assumption, therefore, Leonardo would never have painted a fantasy landscape. It seems almost superfluous to underline it. Yet it is what gets told, unless it is being proved wrong when someone, more for speculative and parochialist spirit than for an actual objective feedback, wants to associate that landscape now with one territory, now with another. One of the rules of haute cuisine, as my dear friend Annie Féolde[501] always repeats, is that everything you find in a dish represents what a chef wants to convey to the guest. The superfluous is banned; you will never find in a course of a Michelin-starred chef a side ingredient or element that does not contribute to the final taste of a dish. So it is Leonardo's painting. In his works no element is superfluous, meaningless, or left to chance.

And what for centuries may seem like mistakes to us, poor, small, and presumptuous observers are actually an essential way to show us the way through which to observe his work. This is the case with the anamorphosis contained in the *Annunciation* seen previously. There is not a single detail painted by Leonardo, even the smallest, that does not represent a precise, substantial reference to something that the artist wanted to convey.

For him it was a necessity, after all.

For him and for the other artists of that period who otherwise would have run into papal censorship that sought, with repression at any cost, to protect the partiality of the religious foundation. Though it was "unfounded," it would otherwise have succumbed to the absoluteness of the Natural Law learned by the ancients and taken on by the Neoplatonist.

This is even more so for Leonardo, whose landscapes inserted in the paintings always play a fundamental role. These never turn out to

[501] Annie Féolde is a world-class French cook, the first chef to receive the 3 Michelin stars in Italy and the fourth in the world, with the Enoteca Pinchiorri, the famous restaurant shared with her husband Giorgio Pinchiorri who is based in Via Ghibellina 87, where it was once assumed to be the house that Sir Piero da Vinci received as an inheritance from Sir Niccolò Vanni.

be the result of a random choice, acting as a simple decoration to the iconographic representation desired by the client. Rather, they become more often than not an integral part of the painting itself, both from a substantive-landscape point of view and from an iconographic-philosophical one.

Without understanding the value of the landscapes in Leonardo's art, it is not possible to fully understand and describe his work. To the contrary. Extrapolating a work from the figurative realism that Leonardo has so widely theorized, it precipitates into the virtuality of that interpretative imagination that the artist himself wanted to prevent through the dictates inserted in the *Treatise on Painting.*

By failing to give Leonardo's landscapes a complete meaning, therefore, the work of this extraordinary and unique artist has been deprived of its originating and essential contents. It is pigeonholed in the canons imposed by that same censorship that has strongly curbed the revolutionary sense that the Renaissance movement was carrying. By trivializing the role that Leonardo attributes to his landscapes, we only perpetuate that medieval obscurantism that deeply contaminated the whole Renaissance in its first steps.

In some cases the landscape for Leonardo even goes so far as to dictate the entire iconographic structure of his work, with results that were often innovative compared to the models used before him.

This last characteristic will contribute to inculcating in his pupils, and in the colleagues who from that moment on will emulate him, a real form of mannerism[502] *ad personam:* "in the manner of Leonardo."

So it was for the *Virgin of the Rocks,* for example, a work that was born ichnographically as a *Madonna of the Yarn winder* and then altered during its course toward the final form that we know today to refer to the "kite" and the orphism previously discussed. This change in the course of the work was carried out by Leonardo through the choice to model the shape of the painted characters according to the profile of a given rocky ridge that lies above the cave in which the scene is set.

This cave is located just above Lecco, near a Celtic ritual site dedicated to the mother goddess. Here it is still possible to witness the phenomenon during the summer solstice when the sunrise impregnates the earth at the exact spot where there is a fertility seat. The cave in

[502] In Leonardo's manner.

question is placed inside the mountain, exactly in correspondence of the aforementioned seat, which represents the womb.

This is also the case for the *Last Supper*. It's found in the choice to propose the frontal alignment of the apostles, whose silhouette is modeled on the profile of the ridges of a characteristic Larian mountain. It's also in the completely innovative separation that Leonardo imposes between John and Christ, which in the traditional iconography usually showed the young apostle ideally bent on the lap of Christ[503] in the symbolic act of rejoining him and completing that duality, described before, between male and female energy.

It's also in *Virgin and Child with St. Anne and a Lamb*[504]. In addition to being inspired by the profile of two Larian mountains[505] to describe the mother/daughter relationship that unites St. Anne and the Virgin, in the movement of the coat of the latter we find an allusion to the kite-vulture. This was inserted to emphasize the virgin character of the Agnus Dei, the son of the Virgin Mary, according to that vision also recalled by Freud, linked to the Dea Madre Mut.

Let me make a further small digression in this regard, so as to give further confirmation to the importance of the dual concept previously hinted at. I apologize for this, but I have so much material collected in all these years of study that I sometimes can't resist the temptation to give you additional reading elements where they fit with the narrative in progress.

In the latter painting, the lamb being grabbed by the child does not represent a reference to the Agnus Dei interpreted in the Christian way, i.e. that of the sacrificial victim who dies on the cross for the redemption of the sins of humanity[506]. It is intended in the sense of its pure being—virginal and androgynous, like the Gioconda or *Vitruvian Man*.

How do I get to say that? Due to what may appear to be a macroscopic lexical error contained in the *Baptism of Christ* of Verrocchio. It has been established that Leonardo painted the angel on the left and the landscape, but evidently a mistake it is not. (See Figure 45.)

[503] Duality (in the womb) denied (separation).
[504] Preserved at the Louvre Museum, Paris.
[505] Legnone and Legnoncino.
[506] Christ.

FIGURE 45 — BAPTISM OF CHRIST, 1473, ANDREA DEL VERROCCHIO WITH LEONARDO AND OTHERS, UFFIZI GALLERY, FLORENCE

At first glance, some might think that the inscription "ECCE AGNIVS ⊃EI" is the result of a macroscopic grammatical error. Actually, it is not. It could also have been readily corrected, given the humanist context of the Florentine Neoplatonism in which both Verrocchio and Leonardo operated. The error, instead, is in the gigantic misunderstanding related to the construction of the myth originated from it, as it was assumed by the Catholic ritual cult. In Greek, *agnos* is the name used for the willow, the shrub with anaphrodisia properties that women who observed chastity during the celebratory rituals of the mother goddess drank an infusion to suppress sexual desire. According to this custom, in Greek the term *agnos* also assumed the meanings *chaste, pure, holy, sacred.* In acquiring from the Greeks the sacred meaning related to the purity and virginal chastity of the mother goddess, by mistake the Romans literally translated *agnos* as *agnus*, a term meaning lamb in Latin. In this way the term lost that intrinsic meaning linked to the characteristics of the willow that it had in the Greek language, so much so that the Latins had to add the adjective *castus,* (chaste) to reframe that concept of chastity and purity expressed in the language of origin.

For this trivial and little-known translation incident, every year hundreds of thousands of innocent lambs end up on the tables of half the world in the symbolic intent of celebrating the son of God being sacrificed on the cross to save mankind. To be honest, the only one here to be sacrificed seems to me to be the poor lamb. Not bad, huh?

To remind us that the painting does not intend to retrace the same gigantic error made at the time by the Romans are several elements, all linked to that Greek matrix that determined the knowledge of the Florentine Neoplatonist academics. I allude, for example, to the hand of Christ, depicted in a symbolic way that is the expression of the *Hieros Gamos* or *Ierogamia*[507] the sacred or divine marriage, a gesture the members of the Pythagorean school greeted one other with to recognize each other.

The greeting in question, which some adherents of the mysterious-conspiracist gathering mistakenly confuse with a satanic, mephistophelic gesture[508], places in conjunction in the ring finger and the middle one, respectively the third and fourth fingers, which represent a symbolic reference to the male and female element. Showing them united "in marriage" symbolically gave life to the new man, regenerated[509], and conceived in the virginal way (therefore not material) by the immaculate reunion of the two complementary energies, the male and the female. The fruit of this union is therefore in perfect harmony with the cosmic order[510], symbolically represented by the spiral placed at the end of the ribbon on which the inscription is affixed.

This synthesis expressed by symbols, which underlies a narrative only on the surface philosophical, is actually the basis of another principle of Euclidean mathematics, perhaps the most elementary and famous. In reality it was already known to the Babylonians and Egyptians years before him: the Pythagorean theorem.

$$(3^2 + 4^2) = 5^2$$

We find this way of symbolically representing the sacred marriage through the hand with the third and fourth fingers united, from the middle of the fifteenth century onward in an infinity of paintings. It

[507] From the Greek ιερογαμία, ιερὸς γάμος, sacred marriage indicates the sacred union or syzygy (conjunction) between a god and a goddess.

[508] Evidently ignoring its true meaning.

[509] Symbolically identified by the number five.

[510] The music of the Spheres, the Harmonia Mundi.

constitutes one of the many forms through which is declined that higher spiritual condition, afferent to an etheric, nonmaterial state which, for example, alludes to the same halo painted on the head of the saints[511].

Once again we find ourselves in the context of that union of the opposites that contributes to the formation of the universal harmony, according to the definition given by Heraclitus and symbolically celebrated by the merge of the hands in the painting *Tobias and the Angel.*

Painting a hand with the third and fourth fingers united, therefore, in the Renaissance was meant to symbolize the spiritual purity of the subject portrayed, strengthened in this case also by the presence of the "Ɔ" written backward.

In this case, the hand painted by Verrocchio (it is evident that it was not painted by Leonardo, as it is so ugly) tells us that the baptized Christ is in that higher, ethereal, sacred, unearthly spiritual condition where the two opposing energies[512] that govern the cosmos, the descending male one and the ascending female one, are perfectly harmonized with each other. It is not by coincidence that Christ on the cross is often represented with the sun (male energy, descending) and the moon (female energy, ascending) on the opposite sides of the horizontal beam. Actually let's say it better: Brother Sun and Sister Moon.

So on a symbolic level we have also sorted out St. Francis. In reality we should also consider the fact that he spoke to birds, but you will soon get there on your own by reading what is coming on the next few pages. Remember that.

The star of David itself, which consists of two triangles in opposing directions—two *tetraktis*[513], in fact—tells of this duality.

There is a phrase by Leonardo that is exemplary for describing the regeneration resulting from spiritual marriage:

> Disunited things will come together and will receive the
> virtue that will give back to human their lost memory.[514]

[511] It is also present in the second self-portrait by Benozzo Gozzoli in the Cavalcade of the Magi, in front of the image of Cosimo de Medici as Pachacutéc.

[512] Yin and Yang.

[513] Quaternary number which represented the primary order of all things for the Pythagoreans.
It determines the structure of the cosmos in the ratios 1, 1:2, 2:3, 3:4 that are the basis of the whole musical theory.

[514] Manuscripts I, Sheet 64v—Institut de France, Paris.

The figure thus composed, as an expression of the sacred union between the male and female element, is the primigenial androgynous, the emanation before the monad[515]. It is called *Rebis*, a term of Latin derivation composed of the union of the words *res-bis* (double matter). It was used in alchemical contexts to indicate the final result of the union of the opposites, *compositum de compositis*, the purity of the *agnos* described by the Greeks.

Graphically the Rebis is represented as a two-headed androgynous figure. It goes without saying that Leonardo does not fail to leave us a personal representation of it, with a human figure who has one foot in the mud (earth) and the other in gold (cosmos). (See Figure 46.)

Leonardo left us more than one representation of this Neoplatonist concept linked to duality. Unfortunately, due to the cultural imprinting imposed by the Church and the reading that art historians give of certain works, there has been a loss of appropriate perceptions.

The most striking case in this sense is *Leda and the Swan*, a lost painting on panel by Leonardo da Vinci dated around 1500. Today only some studies and copies and variants by students and imitators of the painting survive, for a total of nine works. The best examples are at Wilton House in Salisbury, at the Borghese Gallery in Rome, and at the Uffizi in Florence. The first mention of this painting by Leonardo dates back to about 1540, in the Anonimo Gaddiano.

The *Leda* was to be finished during his Milanese stay, and it would seem to confirm the presence of the definitive cartoon being in the Casnedi house in Milan in the early eighteenth century (but later lost) and the realization that most of the existing copies are from the Lombardy circle. In 1590 the original work by Leonardo was documented to be in France by Lomazzo, as part of the royal collections, mentioned along the side with what is mistakenly considered the portrait of Lisa del Giocondo. In 1625 Cassiano dal Pozzo mentioned it being in the same royal collection in Fontainebleau but in poor conservative condition:

[515] Unitary entity, simple, indivisible; in Pythagorean philosophy, the first mathematical element of the universe.
For Eastern philosophy is the Tao, determined by the conjunction of the opposing energies, the Yin and the Yang.

FIGURE 46 — REBIS—TWO-HEADED ANDROGYNE, LEONARDO DA VINCI, 1480, CAMBRIDGE, ENGLAND

> A Leda standing, almost entirely naked, with a swan and
> two eggs at the feet of the figure, from the shells of which four
> children can be seen emerging. This work is very fine but
> rather dry, especially the woman's chest, on the other hand the
> landscape and the vegetation are conducted with great
> diligence; and it is in very poor condition, as being made up of
> three contiguous boards, separating them have caused much of
> the color to peel off.[516]

At the end of the seventeenth century, the tracks on Leonardo's
original painting were permanently lost.

The copy I want to bring your attention to is therefore the one
preserved at the Uffizi in Florence. It has been attributed to the student
Francesco Melzi and is marked by a swan with a curious grayish

[516] Daily Cassiano del Pozzo in France, 1625.

coloration. Dated around 1507, this work is considered the best copy of Leonardo's lost *Leda*. The closeness between its painter, Francesco Melzi, and the Florentine genius suggests a certain reproductive fidelity.

If we consider from a purely figurative point of view the swan painted by Melzi, we notice a series of incongruities that are not such: the orange beak, the grayish plumage, the black legs, and dazzling teeth. Yes—teeth to be envied. It is a pity that swans do not have teeth. Their beaks are characterized by a coloration that shades from orange to black near where the feathers attach, which evidently does not appear in the painting; rather, it is just the opposite. The animal portrayed by Melzi, in fact, is a greylag wild goose (*Anser anser*), as can be clearly seen from the comparison of the picture below. But this is evident only in the upper body; the lower part instead has the black legs of a swan. The legs of a goose are an orange color. (See Figure 47.)

In practice we are faced with a chimera. The chimera is a legendary monster in Greek mythology, later borrowed by the Romans and Etruscans, that was formed from the body parts of different animals. You must know, then, that in ancient Greek mythology, the story of Leda relates that Zeus, the absolute leader of all the gods, is madly in love with Leda. He turns into a swan to mate with her, but only after the girl has turned into a goose to escape him. From the union she will have with Zeus, Leda generates an egg from which the Dioscuri, Castor and Pollux, are born. In this myth, the goose symbolizes a metamorphosis of the swan in its lunar and feminine meaning, where the swan is instead the male and solar light. Thus the animal painted by Melzi in the work preserved at the Uffizi that replicates Leonardo's lost painting is half swan (bottom) and half goose (top), representing that same Hierogamist Marriage symbolically in the Tao, where the yin symbolically indicates the principle, passive, negative, feminine force of the universe, which complements the yang, which speculatively represents the opposite principle, the positive masculine force.

FIGURE 47— DETAIL OF LEDA AND THE SWAN, FRANCESCO MELZI, 1507, UFFIZI GALLERY, FLORENCE, GREYLAG GOOSE, ANSER ANSER

Even la Gioconda, the most iconic painting in the world, is no stranger to expressing this concept. Or, at least, the portrait on display at the Louvre, misidentified with the portrait of Lisa Gherardini, wife of Francesco del Giocondo. In this painting the landscape takes on different meanings, both geographically and philosophically.

In the latter painting, as with the hands of Raphael and Tobias, opposites are represented by the landscapes in the right and left background of the painted lady. These turn out to be mirrored in regard to each other at the mutual point of observation. Their meeting point is where the female figure is sitting. The landscape then describes the meeting of opposites that converge in the place where the lady is portrayed, which is identifiable by the two columns placed on the sides of the painting itself. These columns recall, from a symbolic point of view, the two columns placed at the entrance of the temple of Solomon, Boaz

and Jachin, which are themselves expressions of the material and the
etheric world, Earth and Cosmos. In turn, the female figure portrayed
is likewise referring to this dual concept by representing a self-portrait
of Leonardo in female garb.

The Gioconda, in fact, contains in itself eight different landscapes.
The two main landscapes, those on the left and right of the painting
described above, are represented by the artist to reinforce from a
purely symbolic point of view the concept of duality. They are
represented on two different levels: the landscape painted on the left
is higher in the composition than the one painted on the right. To
put it another way, if we could remove the woman portrayed in the
center from the painting, the waters from the landscape portrayed on
the left would spontaneously flow into the landscape portrayed on the
right via that winding yellow road that is not actually a road. It is the
Adda River, which resumes its course after forming the Lecco branch
of the Lario (a lake that in common parlance is mistakenly called Lake
Como) to give life to Lake Garlate. The river again resumes its course
and crosses all the Brianza, feeds the Naviglio della Martesana in
Cassano d'Adda, and then flows to Lodi and beyond.

The landscapes are thus portrayed by Leonardo as seen by a
hypothetical traveler from two specular points of observation, which
are mutually identified in the opposite landscape. The landscape that
appears on the left of the painting is therefore portrayed from an
observation point located within the landscape on the right, and vice
versa.

On the left side of the painting are portrayed the course of the
Adda[517], the Rocchetta of Airuno, and the Mount St. Martin, which
appears in the background surrounded by the waters of the lake, as
can be seen from a mule track on the coast on Mount Canto[518].

On the right side, on the other hand, mirroring what is depicted
on the left side, you can see the Adda resuming its course at the end
of the Lecco branch of Lario, for the short stretch that has the Azzone

[517] That which seems like a winding path.

[518] The Monte Canto is an *orphaned mountain*, so-called because detached from the
Prealps of Bergamo.

It is the first mountain that is encountered crossing the Padan Plain and at its feet, on the
plain side, there is the village of Sotto il Monte, famous for giving birth to Pope John
XXIII.

It is called the mountain of the friars because of the numerous monasteries and hermit
churches that once adorned it, joined by a mule track.

Visconti bridge, and ending where it feeds the aforementioned Lake Garlate. It laps in the background the Mount Canto on the left and the Mount of Brianza, which houses the Rocchetta of Aiuruno, on the right. This is as it appears from a precise point, this time located on Mount San Martino in the Pian dei Resinelli resort, called Forcellino. You could get there through a valley overlooking the cave of the *Virgin of the Rocks* called Val Calolden. From the Forcellino, you could take a mule track that winds up and down the mountains[519] and joins Lecco with the High Lake. At the time any other type of connection on the lake edge was impossible, for obvious safety reasons. (See Figure 48.)

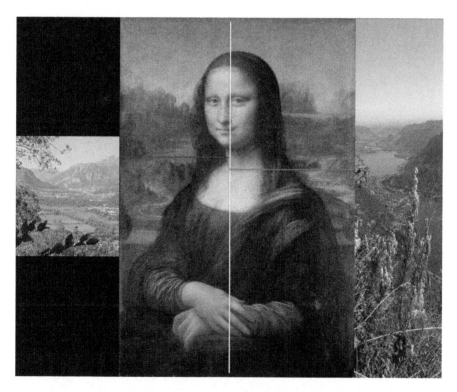

FIGURE 48 — THE LARIAN LANDSCAPE BEHIND THE GIOCONDA. LEONARDO DA VINCI, 1503, LOUVRE MUSEUM, PARIS

It is not the only time that Leonardo plays with the portrayed landscape by dividing it into two projections that offer opposite views of the same scene. The course of the Adda, as it is depicted in la Gioconda,

[519] That 1,300 meters of altitude of the Piani dei Resinelli and 2,400 meters of the Grigne.

in fact, can be found on the left side of the *Annunciation*, while on the right side we find represented the city of Lecco, the Lario, and Mount St. Martin.

As I said, thanks to the two columns we can glimpse on either side of the panel that are joined by a low balustrade, we can also pinpoint the place where the Gioconda is sitting. (You'll excuse me if I keep on calling her Gioconda at the moment, rather than Mona Lisa, but at the moment it's the easiest way to understand each other.) There is a place halfway between the two landscapes portrayed in a way that ideally unites them. This is the Sanctuary of the Rocchetta of Airuno, which features a colonnade and a balustrade perfectly compatible with those present in the painting, to the point that they can be perfectly superimposed. (See Figure 49.)

This specific place turns out to be particularly important because it is here that Francesco Sforza's army in 1449 finally defeated the Venetian army, thus giving way to what would become three years later the Duchy of Milan.

FIGURE 49 — COLUMN OF THE SANCTUARY OF THE ROCCHETTA OF AIRUNO (LC)

It is equally important because it is indirectly mentioned by Benedetto Dei in the passage already mentioned where he gives news of the coming of Leonardo in Milan, accompanied by Lorenzo and Giuliano de' Medici in 1465:

I was in Milan the year that Francesco Sforza took it with the sword in hand...[520]

Do you understand now what I was referring to when I mentioned the thin *fil rouge* that connects this whole story?

The association with the sacred duality that Leonardo expresses in the Gioconda through the use of the Larian landscape is extremely important because, thanks to it and the way in which he portrays his feminine self, we are able to identify a number of the traits of his appearance in addition to the aforementioned strabismus. These traits will be essential in identifying the works in which he is depicted. (See Figure 50)

In this case I refer to two particular pathologies highlighted by the painting that cannot be underestimated[521]. If properly considered, they can help us to say much more on regard of this unique character. First of all, they help us have an objective and direct confirmation of the fact that the woman portrayed is indeed and nothing but Leonardo in the representation of his very personal Rebis. Every artist of that period did it: Michelangelo with the Moses[522], Raphael with San Sebastiano, Van Eyck, Perugino etc. Second because, as I have already mentioned several times, the evidence of one of these pathologies will guide us in the recognition of an almost infinite series of other portraits of him.

We have already partially treated the first detail to which I allude: the infirmity that struck Leonardo in old age, as documented by Antonio de Beatis during the visit to Amboise in 1517. This was the subject of that wild analysis conducted by the two Italian doctors who confused the right hand with the left one and the drawing preserved in Venice without linking it to *Heraclitus and Democritus* pictorial work by Figino.

[520] Memories of Benedetto Dei, Ms. Ashb. 644—Laurentian Library—Florence.

[521] Although they actually were by all Leonardo's scholars.

[522] Where the hands express the numbers 3 and 4, corresponding to the male and female elements.

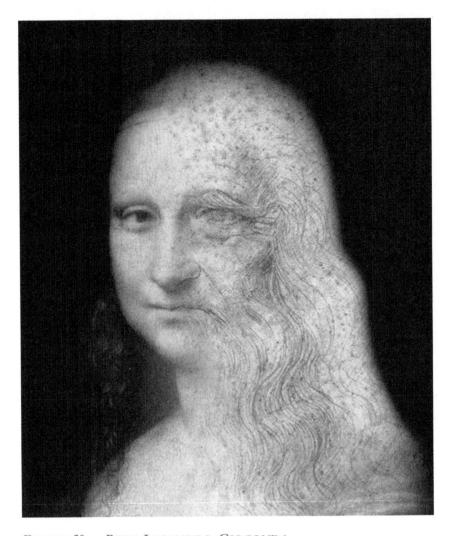

FIGURE 50 — REBIS LEONARDO-GIOCONDA

If we look at the right hand of la Gioconda—as pointed out to me by a Florentine surgeon friend, Tommaso Agostini—we can see what the cause of his disability probably was. (SeeFigure 51.)

*FIGURE 51 — DETAIL OF THE GIOCONDA WITH AN
ARTHROGENOUS GANGLION HIGHLIGHTED ON THE RIGHT HAND,
LOUVRE MUSEUM, PARIS*

The impairment that struck Leonardo in the right hand, limiting its sensitivity and use, is in all likelihood an arthrogenous ganglion[523], a pathology that is very common indeed. The fact that la Gioconda was affected by it—and moreover Leonardo's need to highlight it in a portrait that in theory should have exalted the qualities of the subject portrayed and omitted her defects—is clear evidence of the desire to identify a precise person while placing the emphasis on this impairment.

The same can be noted in the right hand of the Vitruvian man, sketch in which the artist depicts himself. (See Figure 52.)

[523] An *arthrogenous ganglion* (also called a ganglion cyst or wrist ganglion) is a very frequent pathology that often presents itself as a roundish or multi-lobed swelling of hard-elastic consistency of the wrist or the hand.
The cysts are generally found on the dorsal (upper) face of the wrist, less frequently on the front (palm) of the wrist, on the distal interphalangeal joint (mucous cysts) or at the base of the finger.

FIGURE 52 - DETAIL OF THE VITRUVIAN MAN, GALLERIE DELL'ACCADEMIA IN VENICE

The story behind the second detail on which I want to bring your attention, on the other hand, has surprisingly humorous implications, as well as being much more useful to our purpose. I always remind you that we are talking about la Gioconda, the most iconic and famous painting in the world, which has been scrutinized in the smallest details over the centuries by billions of eyes and for which rivers of words, film productions, reproductions, revisitations, and so on have been spent. Well, despite all these attentions, no one has ever noticed the rather macroscopic fact that the woman portrayed in this painting had a growth close to her left eye (the one on the right for the observer). (See Figure 53.)

FIGURE 53 — DETAIL OF THE GIOCONDA THAT HIGHLIGHTS THE PRESENCE OF AN EYE XANTHELASMAS

In choosing to highlight this anomaly, even more than in painting the arthrogenous ganglion on his right hand, Leonardo's desire to give a precise identity connotation to the subject portrayed is clear.

As I said, no one had ever paid attention to this detail until 1976. A doctor specializing in coronary heart disease at Tokyo's Keio University, after having diligently fulfilled his task as Japanese tourist and photographing the famous painting from all possible and imaginable angles, was moved by professional accident. Intrigued by the suspicious complexion of the woman portrayed, which in his opinion was excessively yellowish, he paused to look carefully into the eyes of the *Mona Lisa*.

The facts proved him right.

Dr. Haruo Nakamura—this is the name of the doctor to whom we owe this precious discovery—had in fact noticed the presence of a small impression in the skin between the lower eyelid and the bridge of the nose. Immediately and in the most natural way possible for him, as he was a doctor who specialized in coronary heart disease, he identified it with a xanthelasma.

In medical terminology, *xanthelasma* is a small, subcutaneous collection of a fatty substance consisting largely of cholesterol, most frequently found in the eyelids. Xanthelasma can sometimes be an indicator of an undue increase in blood cholesterol, which turns out to be one of the most important causes of risk for arteriosclerosis. The scrupulous and meticulous Japanese doctor, therefore, thought a bit like Freud did. By virtue of his knowledge and specialization, he immediately launched himself in putting forward what was for him the most obvious thing: la Gioconda suffered from cholesterol and consequently may have also been the victim of a myocardial heart attack. And just as Freud did, so did Dr. Nakamura: he got lost in a glass of water. These doctors are so weird. The simplest solution was right before their eyes, but again it was preferred to give reason to Goethe, not seeing it, than to solve the most trivial of mysteries and come to the most realistic conclusion.

It is not the woman portrayed who suffers from cholesterol but the character in whose clothes he hides—namely Leonardo da Vinci himself. He in fact presented a xanthelasma in the same position as la Gioconda, which can be seen in the comparison of the most famous of his portraits, the sanguine work preserved at the Royal Library of Turin. (See Figure 54.)

FIGURE 54 — COMPARISON BETWEEN THE GIOCONDA AND THE SANGUINE SELF-PORTRAIT IN TURIN

This small, banal growth, incidentally highlighted by the professional accident of a Japanese doctor and since then neglected by the totality of the Florentine genius's scholars, becomes the most objective and reliable evidence for identifying accordingly an infinite number of his portraits. Although it is true that the repositioning of the same face can be traced back to a form of expressive mannerism (which is not true anyway) and because we have seen previously how during the Renaissance there was an absolute ability to identify the various characters portrayed in a given work according to the real physiognomy of the people, it certainly cannot be a defect like a xanthelasma that would end up in the artistic scope of an emulative mannerism. I would understand if it were a mole—the classic *mouche*[524], as the French would say—which at certain times in history was seen as a beauty. But a xanthelasma...

The solution, as mentioned, is banal: the xanthelasma identifies the portraits where Renaissance artists, whether more or less famous, intended to represent Leonardo. Obviously this was only in cases where the figurative context and the physiognomy could justify it. Certainly it was not in every painting.

Would you like an example? The *Portrait of a Musician*, currently preserved at the Ambrosian Art Gallery in Milan represents a youthful portrait of Leonardo, and it is characterized by the evident presence of an xanthelasma.

[524] The thanks to Madame Du Barry, the famous lover of Louis XV.

Would you like another one? The man that Leonardo drew in the center of a circle and a square in the famous *Vitruvian Man* is another youthful portrait of Leonardo. The faces of John and Christ in the *Last Supper* by Boltraffio, Leonardo's Milanese pupil, are again two youth portraits of Leonardo. The list is endless.

I will dedicate a whole, albeit short, chapter to Leonardo's portraits. For now I just needed to show you how, in the use of the Larian landscape behind la Gioconda (which is not la Gioconda, by the way), Leonardo reinforces that dual concept that his self-portrait in women's robes wants to express: the sacred spiritual wedding.

This type of marriage is the same union that, ideally, both Dante and Orpheus try to realize by descending into the underworld to rejoin their beloveds, Beatrice and Eurydice respectively. Clearly it is not a real journey but rather refers figuratively to that inner initiating path of all philosophical and meditative disciplines to which monotheistic religions themselves allude. While Dante manages to reunite with his beloved Beatrice, finally succeeding in seeing the stars with her, Orpheus fails in his intent because he turns to look for the face of Eurydice, thus demonstrating his attachment to material things and losing the opportunity to access the higher spiritual world. This is a risk that Christ, after being resurrected and abandoning his mortal remains, does not want to run. That is why he turns to Magdalene saying, "Noli me tangere"— do not touch me—so that he can access the Kingdom of Heaven and sit to the right of the Father[525].

Let me be clear—and I say this for those same people who want to see in the Pythagorean greeting a mephistophelic sign: Magdalene is not the wife of Christ who gives life to the progeny of the royal blood, as written in Dan Brown's novel. Magdalene represents the ideal female spiritual component that, by joining the male component in the holy marriage, allows Christ to reach the Kingdom of Heaven.

As you can see, again, myths overlap one another in the same way: they are only told with different shading. Every finger point toward the same moon. Unfortunately the "foolish people," to put it in Leonardo's words, will always push you to look at the finger only, preventing you to benefit from the stunning beauty of the moon. I hope to make you reach this goal with my writing instead. Every little shading, in fact, helps to distance us from real knowledge. That is why, although each path may

[525] Gospel according to John 20,17.

seem correct, it is essential to trace back to the source that generated the original story. In this way we can strip the various stories from all the variations that have been imported through time by those who, wanting to obtain a personal benefit, changed it to suit their own ends and purpose, making the told story totally unfounded.

Now you will understand the real reason why, in Leonardo's *Last Supper*, unlike in all previous representations, Christ and John are separated. In Leonardo's accusatory intent, thing that keeps them divided is related to the misuse of the word[526] by Peter. By imposing his hand on John's[527] throat, Peter prevents John's conjunction in marriage with Christ, who are symbolically representative of the male and female energy components.

It is what Eastern disciplines identify as the meeting between the opposing energies ida and pingala, whose conjunction is manifested along the sushumna—that is, the three main energy channels:

- Ida, negative-female polarity of the body associated with lunar energy
- Pingala, positive-male polarity of the body associated with solar energy
- Sushumna the so-called crown

What I want to make you understand through these short inserts here and there, in addition to giving you interpretive keys that you will hardly find elsewhere, is the impossibility of giving a linear reading of Renaissance work, let alone that of Leonardo, without taking into account what the cultural evolution there was in the fifteenth century. This evolution concurred to determine what was inconvenient to express at the time and it still is not convenient to tell. It is no coincidence that for these theorizations I have received many outright attacks in the past. Unfortunately the legacy of the censorship that conditioned the reading of the most famous works of the Renaissance has in fact remained almost intact. On the one hand, this is because of the dominant role that the Catholic institution has played for centuries and still plays in much of the planet; on the other

[526] Represented by the knife held behind his back.
[527] Where the thalamus is, where marriage happens, giving rise to the locution "wedding thalamus."

hand, it's due to the self-referential and celebratory system of the academic world, both in the historical and artistic spheres.

The results of the totally corrupt interpretive inertia of Renaissance work, conducted within the lines that respected the pro-Catholic dictates, are the celebrations for the five hundred years since Leonardo's death, which had just concluded as I wrote this book. These celebrations saw Leonardo diminished in the role of a papier-mâché myth, caught in the dictates of censorship that over time conveyed the contents of his work according to a cultural and economic convenience that does not reflect the real contents of his boundless art and knowledge.

This interpretive approach may perhaps apply to today's art world[528], in which everything is the result of an emotional drive or a narrative for allegorical images. But it certainly does not apply to past history and Renaissance art, which based its very existence on a figurative realism derived from the observation of nature and its guiding rules, called canons.

Let's return to Leonardo's use of landscapes in his works. Neglecting the geographical and symbolic reference that the artist himself has evidently intended to attribute to them means precluding the possibility of understanding their real substantive contents and also running the risk of supporting superficial and precipitous theories, such as those that would connect the landscape of la Gioconda to the Valmarecchia in Montefeltro (Bobbio, Piacenza, or to Buriano (Arezzo). These theories are according to interpretations dictated by superficiality, when not promoted by lower speculative and self-referential purposes.

I also include in this criticism those who, in retracing my studies, tried to argue that behind la Gioconda there was Mount Resegone, mentioned together with Monte San Martino in the beginning of *The Betrothed*, the famous novel by Alessandro Manzoni. Well, if those who had advanced this hypothesis by retracing my steps in search of vainglory had even the slightest knowledge of the real Larian territory[529], they would know that Mount Resegone is the only mountain that could not be seen in the painting, as it would be covered by the silhouette of la Gioconda.

[528] That, in all sincerity, I personally struggle to define art.
[529] And more specifically the Lecco valley, which hosts at least 8 of Leonardo's artistic works.

This mountain is drawn several times by the artist within his codex and would be used to dictate the innovative iconography that describes the outline of the Apostles in the *Last Supper*.

Deal with it: knowledge is an opportunity. It cannot only ever be experienced as a fact of convenience. When this principle is disregarded, I am overcome. I must denounce it.

Returning to Leonardo's use of landscapes in his paintings, after talking about la Gioconda, let's move on analyzing the *Annunciation*. This is the work of the youthful Leonardo in which, for the first time, the iconographic structure of the announcement of the immaculate conception of the Virgin is set outdoors. In this important work, the pictorial construction is such that a certain detail of the landscape becomes the protagonist of the entire representation, as its focal, perspective, and chromatic center.

The detail I'm referring to is a mountain made unmistakable by the presence of two tips[530] that stand out to its left. This detail becomes extremely important not only because it identifies a precise pre-alpine lake location of the Milanese duchy of that time,[531] (it also appears in a detail of *Il Libro d'Ore* by Ludovico il Moro), but because it is also represented by Leonardo from different angles in la Gioconda and the *Baptism of Christ*. It is also the entire scenic setting for the theatrical staging of Poliziano's *Orfeo*, taken care by Leonardo himself. (Figure 55)

The same mountain is painted in a nativity contained in an altarpiece present in the cathedral of Tortona, evidently the work of one of Leonardo's disciples. In this painting, an elderly Leonardo himself is depicted as Joseph.

[530] Peculiar conical conformations of the Lombard Prealps.
[531] Lecco.

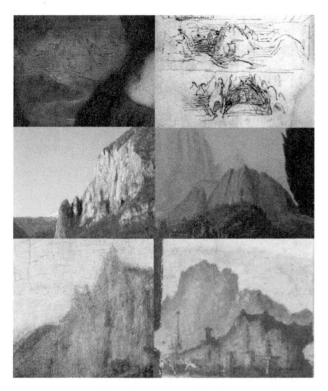

FIGURE 55 — THE LARIAN LANDSCAPE IN LEONARDO'S PAINTINGS AND DRAWINGS

The aforementioned set of Poliziono's *Orfeo* consisted of a mountain that, opening in two halves, revealed the presence of a cave inside, from which the characters of the theatrical work made their entrance on stage. Not by chance it is the same cave in which the Florentine artist sets the *Virgin of the Rocks*, a work that, as I said earlier, is imbued with Orphic references and is overlooked by a rock formation called Nibbio. (See Figure 56.)

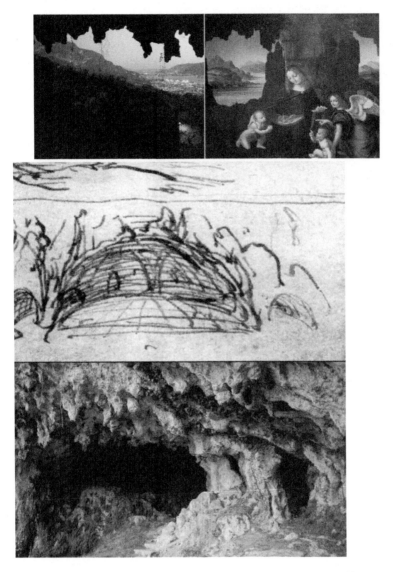

FIGURE 56 — COMPARISONS ON THE CAVE OF THE VIRGIN OF THE ROCKS. LEONARDO DA VINCI

There are two more mountains, no more than a kilometer from this one as the crow flies, that are used by Leonardo in defining the profile of the apostles in the *Last Supper* and in forming the landscape

in which *Bacchus* (formerly titled *St. John the Baptist*) is set: they are Mount Resegone and Mount Moregallo. (SeeFigure 57.)

FIGURE 57 — COMPARISON BETWEEN THE PROFILE OF MOUNT RESEGONE AND THE OUTLINE OF THE APOSTLES IN THE LAST SUPPER

Also the *Madonna of the Carnation*[532] can be linked to the same pre-alpine landscape surrounding Lecco. In this work the rocky elevations at the bottom of the Grigne[533] are recognizable, as seen along the slopes in Piani dei Resinelli. This is where Forcellino is located, the perspective from which Leonardo will paint the right-side landscape behind the Gioconda. It's accessible through a path once used for seasonal relocation of livestock. In this area small wild carnations[534] grow natively. This branch of the Lario also has the native *mapello*[535], a toxic herb that Leonardo painted at the foot of the *Virgin of the Rocks* and mentions twice in the Codex Atlanticus. The first time is when he is talking about Valsassina, the valley located about ten kilometers north of Lecco, and the second time is in the composition of a recipe to be used as an antidote ("repair") against smoke "said *alloppiativo*'[536] in case of inhalation of it:

Valsasina.

[532] Painted in 1473 and preserved at the Alte Pinakothek in Munich.
[533] Drawn and mentioned by Leonardo several times in its codex.
[534] Diantus deltoides.
[535] Aconitum Napellus.
[536] Sleep inducing.

Valsasina comes towards Italy. This is almost of similar
shape and nature. Much mappello grew there. And with
many waterfalls.[537]

"The smoke said alloppiativo. Remove the ryegrass
seed.

Repair: dunk wine spirit in cottonwool, pony tooth
oil, lip oil. Seed and root of

mappello, dry everything and make a powder from it,
incorporates it with camphor, and it is done.[538]

Always connected to this Larian landscape is the painting
depicting the *Virgin and Child with St. Anne and a Lamb*
mentioned above. In this case, the point of observation inspiring the
work is located above the resort called Sommafiume, located on the
eastern side of Upper Lario near two ridges, Mount Legnone and
Mount Legnoncino. These mountains dictate the painted outline of
the Virgin and her mother, Saint Anne, and literally mark the
watershed between Valsassina, Valtellina, the High Lake, and
Valchiavenna.

In the background of the painting, at the bottom left corner, you
can see Lake Mezzola—the very short section of the Adda that
separates it from Gera Lario, the place where the Lario is formed—
the Val Masino and the mountains that separate Italy from
Switzerland, behind which lies the famous resort of St Moritz.

In short: almost all of Leonardo's paintings in which a landscape
appears, whether they are represented in direct way or dictating the
outline of the characters that he puts into the work[539] (in a recurring
way that so that it becomes a real figurative rule for the artist), must
be traced back to the territory that complements the eastern branch of
Lario, especially around the valley of Lecco.

That branch of Lake Como, which turns at noon,
between two un unbroken chains of mountains, all with
coves and gulfs, depending on the protrusion and
indentation of those, comes, almost suddenly, to shrink,
and to take course and shape of a river, between a
headland on the right, and a wide coast on the other side;
and the bridge, which joins the two shores, seems to make

[537] Codex Atlanticus, Sheet 573r—Ambrosian Library, Milan.
[538] Codex Atlanticus, Sheet 950 v—Ambrosian Library, Milan.
[539] Virgin of the Rocks, Gioconda, Last Supper, St. Anne, the Virgin and the child with
the lamb.

this transformation even more sensitive to the eye, and marks
the point at which the lake ceases, and the Adda begins, to
then take again the name lake where the shores, distancing
again, let the water spread and slowdown in new gulfs and
new coves.[540]

This is the way in which Alessandro Manzoni describes Lecco and its
territory, but we would not do Leonardo injustice if we thought that the
famous novelist, with these words, was reviewing the landscapes
portrayed in the works of the Florentine artist. In fact, the correlations
between Leonardo and Manzoni are very close, as we shall summarily see
in the final chapter, although this topic would deserve an entire
publication too[541].

If you have not noticed yet, what Leonardo does through the
landscapes contained in his paintings is describe the portion of the Larian
territory that at that time constituted the northern border of the Sforza
Milanese duchy, along the eastern branch of Lario. The first
representation of this region is contained in a drawing by Paolo Giovio,
one of Leonardo's first biographers. (See Figure 58.)

*FIGURE 58 — MAP OF THE LARIO FOR PAOLO GIOVIO, CIRCA
1520, BRAIDENSE LIBRARY, MILAN*

The first realistic representation of the Lario—except for two maps
from 1480 in which the lake is little more than sketched—can be traced
back to Leonardo's hand. He disguises the unmistakable shape of this pre-

[540] Alessandro Manzoni, The Betrothed.
[541] Work that I've already got ready in one of my desk drawers, actually.

alpine lake—reminiscent of a dancing performer, *La Danseuse du Lac,* as I like to call it—in the hand of the *Virgin of the Rocks* that wraps around the shoulder of John the Baptist. It is certainly an unusual hand for Leonardo's style and is perhaps more reminiscent of a Carlo Crivelli's[542] hand than one of the tapered and gentle hands that Leonardo used to draw and paint. Precisely for this reason, as well as in relation to all the other references included in his works, it is plausible to think that with that anomaly Leonardo intended indeed to give a precise indication to the Lario. (See Figure 59.)

FIGURE 59 — DETAIL OF THE VIRGIN OF THE ROCKS THAT CAN BE TRACED BACK TO A REPRESENTATION OF THE LARIO

I apologize if you see the name Lario written every time when perhaps you are more accustomed to knowing this basin of water happily trapped among chains of extraordinary mountains by the name of Lake Como. Lario is its real name, and even Leonardo, from a strictly nominal point of view, keeps it well separated from Lake Como. This distinction is not only linked to a different geographical orientation, but it is also reflected in a different cultural and political orientation, as Como historically and politically belonged to the faction opposed to the Sforza.

[542] Painter from Veneto of the XV century.

The nominal separation to which I refer comes from a passage contained in the Leicester Codex, formerly Hammer Codex and today in the hands of the Bill Gates Foundation. In it Leonardo talks about the historical effects of the flood and the consequent formation and sediment of seashells[543] along Lecco mountains paths:

> [...] and in the lakes, where the mountains tighten, like Lake Lario, and Maggiore, and Como, and Fiesole, and Perugia, and similar.[544]

As you can see, this territory is continuously in Leonardo's thoughts.

There is only one painting in which the artist uses a landscape that is outside this territory, but it is the classic type of exception that confirms the rule. And it is a very precious exception. It is only through the landscape portrayed in this table, in fact, that we can identify the subject portrayed by Leonardo.

I am referring to the so-called portrait of *Ginevra de' Benci*.

Which clearly is not Geneva de' Benci.

Obviously it is not.

Otherwise why would I tell you?

I will dedicate each of the next three chapters to this painting, as well as to the portraits of Leonardo contained in the works of more or less famous artists and to finally revealing to you the painting that is actually on display today in the Louvre.

Before doing so, however, I would like to complete the analysis on the landscapes portrayed by Leonardo so that we can make a couple more important considerations.

If the Lario area is in almost all of Leonardo's paintings in which a landscape appears, the same consideration can be made about what is contained in the countless drawings, sketches, and notes through which the artist daily recorded what he observed during his excursions in the midst of nature. Each landscape has its own peculiarities, more or less unique. Some more than others, of course, and the presence of the mountains with unmistakable characteristic and shapes helps to recognize them.

The Larian landscape is undoubtedly one of them. It is naturally characterized by mountainous formations whose profile makes it unique and recognizable among a thousand, as Manzoni wrote in what is

[543] Fossils present in large numbers on the Grigne.
[544] Codex Leicester, Sheet 8v—Bill Gates Foundation.

considered the most lyrical moment of his entire novel, the 'Farewell
to the Mountains"—not by chance defined by the literary critics as
"poetry in prose":

> Farewell, mountains rising from the waters, and
> aiming the sky; unique peaks, known to who grew up
> among you, and imprinted in his mind, no less than the
> image of his closest relatives; torrents whose murmur he
> recognizes, like the sound of domestic voices; villas
> scattered and whitewashed on the slope, like herds of
> grazing sheep; farewell! How sad is the step of him who,
> grown up among you, walks away from you! The fantasy
> of the one who voluntarily departs, attracted by the hope
> to make a fortune elsewhere, loses its charm in that
> moment, so the dreams of wealth; he's astounded he made
> up his mind, and would then turn back, if he did not think
> that one day, he will return richer. The further he
> advances in the plain, the more his eye retreats, disgusted
> and tired, by that uniform vastness; the air seems heavy
> and dead to him; he goes sad and apathetic towards the
> tumultuous cities; houses on houses, streets merging in
> streets, seem to take his breath away; and before buildings
> admired by the foreigner, he thinks, with restless desire, to
> the little field in his village, to the tiny house he has
> already set his eyes on, since long ago, and that he will
> buy, returning enriched to his mountains. But what for
> the one who had never pushed beyond those mountains
> not even a fugitive desire, who had composed in them all
> the projects of the future, and it is thrown far away, by a
> perverse power! Whom, detached at once from the dearest
> habits, and disturbed in the dearest hopes, he leaves those
> mountains, to go in search of those unknown that he has
> never desired to know, and cannot with the imagination
> get to a set time for the return! Farewell, native home,
> where, sitting, with a secret thought, one learned to
> distinguish the noise of common footsteps from the noise
> of a footstep expected with a mysterious fear. Farewell,
> house still foreign, house dreamed of so many times in a
> glimpse, passing, and not without a blush; in which the
> mind imagined a quiet and perpetual stay for with a wife.
> Farewell, church, where the soul returned serene many
> times, singing the praises of the Lord; where it was
> betrothed, prepared a rite; where the secret sigh of the
> heart had to be solemnly blessed, and love be commanded,
> and be called holy; farewell! Who gave you so much
> joyfulness is everywhere; and he never disturbs the joy of

his children, if not to prepare them one more certain and greater."[545]

These words are used by the author to color the thoughts of poor Lucia with melancholy mixed with terror. She, being convinced by Fra' Cristoforo after a missed marriage and the failed attempt at kidnapping her by the Bravi, abandons the village of Lecco by boat with Renzo to escape the clutches of Don Rodrigo.

"Unique peaks, known to who grew up among you, and imprinted in his mind": it is obvious that these peaks may appear to be common and from the imagination of the artist to those who live in Vinci, in England, in America, in France, or to those who claim that "Leonardo painted natural landscapes because he was born in the midst of nature"[546] But they are more than familiar to those who, day after day, see them as an integral part of their lives, assuming at every hour of the day a different color according to the golden reflections that the sun projects on them, or coloring themselves with that blue given by the fresh air of cold winter days, as Leonardo writes in his *Treatise on Painting*.

The place where Renzo and Lucia embark to flee the country is the mouth of the Bione River, on the banks of the Adda, not far from the convent of Fra' Cristoforo in Pescarenico. Bione is one of the three main rivers of Lecco[547] that rises at the slopes of Mount Resegone, and after traveling a very short path, flows into the Adda.

You may wonder why I am telling you all this. It is because the spring of this small river is the same one where the Christ, as depicted in the painting by Leonardo/Verrocchio, submerges his feet to be christened. In the landscape portrayed behind Christ, in fact, you can clearly see Mount St. Martino, Mount Melma, and the beginning of Valsassina.

Manzoni begins his story where Leonardo ends, alluding to the short course of the Bione. Or, if you prefer, while in the novel of Manzoni, after the aforementioned farewell to the mountains, Renzo and Lucia from Lecco go to Milan and Monza respectively. Leonardo takes the reverse path, arriving in Lecco from Milan.

[545] Alessandro Manzoni, The Betrothed, Cap VIII.

[546] Alberto Angela, Ulysses, Discovery—Rai3 (Italian public television)

[547] Little more than three strips, along which the city has historically built its past in the textile and metallurgical industry: from north to south they are the Gerenzone, the Caldone and the Bione.

Although we cannot attest to a consequential temporal
continuity, at least three-quarters of Leonardo's drawings in which a
landscape, a mountain, or a lake appears not only refer to the territory
between Milan and Lecco, in the street that eventually developed
along the course of the Adda[548] or the surrounding mule tracks. In the
way they are drawn, the perspective play, and the distances at which
the mountains are located in the individual drawings, by observing
them, you have precisely the impression of the stride of a wayfarer.

The drawings that refer to the landscape with the Larian
mountains in the background are really innumerable. They include
views of individual villages along the course of the Adda[549], the
mountains in the background mentioned above[550], several glimpses of
the lake[551], Valsassina[552] and Valtellina[553], and many, many other views
in which you can recognize the city of Lecco[554]. Leonardo would also
draw the entire map of the city, which I recently found. It is unique,
along with those of Milan and Imola, in being designed by the
Florentine artist. (See Figure 60.)

Surely one has to wonder why Leonardo—and many of his
colleagues and students after him—gave so much consideration to the
Larian territory.

While in the case of his students[555] this emulative spirit is quite
understandable, a little because it is the same landscapes in which they
grew up and a little for the mannerism, it is more difficult to
understand why top artists of the Florentine school portray the
glimpses of the Larian territory painted by Leonardo. Among these
were Domenico Ghirlandaio, Botticelli, Perugino, Pinturicchio,

[548] That at the time marked the territorial boundary between the Sforza Milanese Duchy
and the rival Serenissima Republic of Venice.

[549] Cassano d'Adda, Canonica d'Adda, Vaprio d'Adda.

[550] Mountain St. Martino, Resegone, Grigne, Valtorta.

[551] Lake of Lecco, as Leonardo writes, and the brianzoli lakes of Pusiano and Annone and
the Lambro River that feeds them.

[552] To which Leonardo reserves also several notes contained in his codex.

[553] E.g. The fortification of the Sassella, on the outskirts of Sondrio.

[554] The drawing of the set for the Orpheus by Poliziono describes the Lecco valley seen
from Mount Barro, which it is in front of it.

[555] Those commonly called Leonardeschi are those Lombard painters, active since the
beginning of the 16th century, who were followers in different ways of Leonardo da
Vinci's style: Francesco Melzi, Giampietrino, Marco d'Oggiono, Boltraffio, Cesare da
Sesto, Bernardino Luini, Foppa, Zenale, Solario, Gian Giacomo Caprotti, Ambrogio de
Predis, Francesco Napoletano..

Verrocchio, Luca Signorelli, Lorenzo di Credi, and Bartolomeo della Gatta. This wave of painters, all more or less of the same age, is said to have formed at the workshop of Andrea del Verrocchio.

FIGURE 60 — MAP OF THE CITY OF LECCO, WITH THE PERIMETER WALLS AND HYDRAULIC STUDY OF THE FIUMICELLA THAT CUT THROUGH IT IN THE MIDDLE—MANUSCRIPT L, SHEET 82V AND 83 R—INSTITUT DE FRANCE, PARIS

Although this justifies a certain pictorial homogeneity, personally I do not reckon Verrocchio was to be considered a real master toward them, especially in the case of Leonardo. The latter showed painterly skills superior to those of the supposed master during a period around 1465 in which Verrocchio had not yet received his first public commission. He did have his first pictorial approaches as assistant at the workshop of Fra' Filippo Lippi. Verrocchio, whose real name was Andrea di Michele di Francesco di Cione, learned the art of goldsmithing in Giuliano Verrocchi's workshop, from which his nickname is said to derive.

It does not come as a surprise, then, that Vasari's story of Leonardo and Botticelli putting their hand to the *Baptism of Christ*, helping to complete the work with the execution of the two children on the left-hand side and the landscape, Verrocchio declared that he no longer wanted to paint in his life:

> In his childhood he approached art, thanks to his uncle Sir Piero, along with Andrea del Verocchio, who, while making a panel where St. John baptized Christ, gave Lionardo an angel who was holding some garments to paint; and although he was young, he made him in such a way that Lionardo's angel was much better than the figures of Andrea. This was the reason

that Andrea never wanted to touch colors again, outraged
that a child was better than him.[556]

Verrocchio was undoubtedly a skilled sculptor and close to the
Medici family, for whom in the late 1460s he created the funeral
monuments of Cosimo and Giovanni de' Medici in the Old Sagrestia
in the church of San Lorenzo, the family mausoleum. But there is no
logical connection with the fact that Leonardo could have learned
from him the pictorial and sculptural arts in a period when he was
already superior by far. More likely this group of young artists was
part of a unique school formed right between the Larian Mountains,
of which Verrocchio was a member. For this reason then, each of
them will not hesitate to use these landscapes in their works.

I'm saying this mainly for two reasons. The first is related to the
fact that the territory around the eastern branch of the Lario is littered
with a considerable number of artworks, all of fine manufacturing,
not compatible with any local school of that period[557]. These works,
in fact, are attributable to the Tuscan-Medici period and are dated to
the third quarter of the 1400. Today these works are preserved or
transported to museums from small churches, mainly located in the
Larian Triangle[558], once part of the Duchy of Milan, or they can be
found in private houses located near important street junctions, as I
was lucky enough to see.

In these works we find representations of the medical saints
Cosma and Damiano, who were the protectors of the Medici family.
We found them as originally depicted by Alesso Baldovinetti in the
glass window above the altar of the chapel of the Noviziato, part of
the Basilica of Santa Croce, in Florence, which was commissioned by
Cosimo the Elder in 1445. Oddly (but not too oddly) in this glass
window the protectors of the Medici family wear the same pinkish
garment worn by Leonardo in both the portrait of Bramante, where
he is a young man reading Cicero in the decorations of the Bank of
Medici in Milan by the Foppa, and in the painting by Benozzo

[556] Giorgio Vasari—The Lives of the most excellent painters, sculptors, architects, 1550—
1568.

[557] Half of the 15th century.

[558] The Larian Triangle is an area bounded to the north by the two branches of the Lario,
having as a vertex the headland of Bellagio, while to the south by the lakes of Alserio and
Eupilio/Pusiano.

Gozzoli of 1465, where he is shown traveling to Milan with Giuliano and Lorenzo de' Medici.

Together with these mural representations, in which we can spot the "Pythagorean" hand symbol of Hieros Gamos, we find a lady in bas relief by Desiderio da Settignano[559], finely worked cups in purely Tuscan terracotta, annunciations in which the unmistakable youth profile of Leonardo is recognizable, and female representations that recall in the lineaments the face of the *Madonna of the Carnation.*

This last representation, frescoed on the inner wall of a private house and therefore perfectly compatible from a practical point of view with the landscape painted in the *Madonna of the Carnation,* is one of the few works by Leonardo described by Vasari:

> And among the other things made there, he counterfeited a jug full of water with some flowers inside, where beside the marvelous of the dynamic, he had imitated the dew of the water above them, so that the jug seemed more real than reality.[560]

This important artistic production related to a clear Tuscan sphere— of which I believe few are aware, certainly none in these terms—is strongly discordant with the local artistic production of that same period, both from a pictorial and especially philosophical point of view. It justifies the local presence of a school of Neoplatonic artists of Florentine derivation.

I'm confident in saying, without fear of denial, that the Pythagorean hand represented in the church of Saints Cosma and Damiano in Rezzago, above Bellagio, after the one painted by Benozzo Gozzoli in the Chapel of the Magi in the Medici Riccardi palace and the one of Verrocchio in the Baptism of Christ, may perhaps be one of the very first ever to be painted. The Neoplatonic derivation of this hand is undeniable. (See Figure 61.)

[559] Author of the bust of deacon present in the Old Sagrestia of the Church of St. Lorenzo in Florence, where a teenager Leonardo is portrayed.
[560] Giorgio Vasari—The Lives of the most excellent painters, sculptors, architects, 1550—1568.

FIGURE 61— PYTHAGOREAN HAND—CHURCH SS. COSMA AND DAMIANO, REZZAGO (CO)

The need in Medici's Florence to form a group of artists able to perpetuate the Neoplatonist foundations through their works was necessary to counter the restrictive actions put in place by the Roman Church against pagan heresies, of which Neoplatonism was the spearhead.

It is not surprising, then, to find the same Larian landscapes painted by Leonardo in several of the frescoes that decorate the Sistine Chapel, whose commission was entrusted to those artists who were part, along with Leonardo, of the Verrocchio school: Ghirlandaio, Signorelli, Pinturicchio, Botticelli, Perugino, and others.

The Sistine Chapel, that absolute masterpiece that forms the beating heart of the Catholic institution and where the cardinals gather in consistory to elect the future pope, was built between 1475 and 1481 at the behest of Sisto IV[561], perhaps the most hostile pope to Neoplatonism. And to the Medici family, let's not forget that. He ordered against them, with the help of some unscrupulous accomplices, the Congiura de' Pazzi in 1476. This conspiracy, however, failed miserably because of the incompetence of the executors and the loyalty shown by the Florentines toward. the Medici. So on the suggestion of Lorenzo the Magnificent, and to seal a reconciliation of the pope with the Medici family, while Leonardo was sent to Milan, a group of Florentine artists was summoned to Rome by Pope Sisto IV.

[561] Which is where the name came from.

With Ghirlandaio came Sandro Botticelli, Cosimo Rosselli, and Perugino, who was now Florentine by adoption. Each of these was followed by artists who would soon establish themselves, such as Luca Signorelli, Pinturicchio, Filipino Lippi, and Piero di Cosimo.

It is to one of the many paintings that decorate this extraordinary chapel that I want to turn your attention. I am talking about the *Vocation of the Apostles* by Domenico Ghirlandaio, made in 1481 and part of the decoration of the median register. (See Figure 62.)

FIGURE 62 — DOMENICO GHIRLANDAIO, 1482. THE VOCATION OF THE FIRST APOSTLES, SISTINE CHAPEL, VATICAN, ROME

It is one of the paintings that I show most often in my conferences because, at the top, it presents an opposing flight of birds that ideally join in the center in marriage, thus again describing that meeting of "discordant things" where, for Heraclitus "comes beautiful harmony." The reference to the music of the spheres is obvious, as is the highly Neoplatonist content of the entire pictorial structure of the Sistine Chapel.

It is inspired to Dante's contrapasso law: He who more than others fought the Neoplatonist heresy, Sisto IV, is made immortal by a chapel that bears his name but whose contents are strongly pagan and have clear Neoplatonist inspiration. The art is in complete antithesis to the Catholic foundation that he intended to defend by setting up the Tribunals of the Inquisition and boycotting any artistic and cultural form that had its roots in the Neoplatonism school of Byzantine origins.

The flight of birds represented here is highly indicative, as it refers to an extraordinary flight of birds in which I have been saying for years that Leonardo has hidden the entire score of the music of the spheres.

Ghirlandaio's landscape, on the other hand, is clearly that of a pre-alpine lake, the Lario in this case, which the artist will paint many other times. It precisely emulates the background of Leonardo's *Annunciation*.

The so-called apostles, which the fresco wants to witness the vocation of, are exactly that group of young painters[562] who left the testimonies of the first acquired rudiments in small churches and houses—which at the time were monasteries—around the branch of the Lario. Among them there is Giovanni Argiropulo[563], who was most likely the one in charge of teaching them the Neoplatonist principles.

Personally, I have never considered credible the hypothesis that all these artists may have been students of Verrocchio. I consider it more plausible to think that they all were students of a more qualified academy, in the style of the Company of St. Mark, where the masters responded to the names of Filippo Lippi, Beato Angelico, Desiderio da Settignano, Mino da Fiesole, Donatello, and many other leading artists of the period. Also because, beyond his being already mature both as a painter and as a musician, Leonardo, according to scholars, attended the school of Verrocchio when the latter was not yet known as a painter. The biographies, in fact, place Leonardo in the Verrocchio workshop at the age of ten—that is, in 1462 if he was actually born in 1452. That was a time when Verrocchio was little more than a goldsmith and not yet pupil of Fra Filippo Lippi.

[562] Recognizable one by one for that portraiture trait that Renaissance painters had and we've already walked.

[563] Giovanni Argiropulo was a humanist, writer, translator, academic and Byzantine rector, one of the first promoters of the rediscovery of ancient authors in Western Europe. He took part in the Council of Ferrara and Florence, to which the Byzantine emperor himself, John VIII Paleologist and the patriarch of Constantinople, Joseph II, had come to bring together the Orthodox Church, with the Catholic church. In 1441 he returned to Constantinople, but after the fall of the city to the Ottomans, he took refuge again in Italy, where he was invited to Florence by Cosimo the Elder in 1456, becoming a professor of Greek at the University of Florence.
He was a teacher of Giuliano and Lorenzo de' Medici, of Agnolo Policeno and I have reason to believe that he was also a Greek teacher of the young Leonardo.

Another work in the Sistine Chapel is the *Baptism of Christ* by Perugino. Similar to what is depicted in the *Vocation of the Apostles*, in this painting we find the young Renaissance painters, recognizable one by one, placed by the Lario with the city of Lecco in the background. (See Figure 63.)

FIGURE 63 —PERUGINO, BAPTISM OF CHRIST, 1482—SISTINE CHAPEL—VATICAN, ROME

Once the reading key is found, it then becomes easier to find analogies and make connections and associations in the various paintings. In the case of Pietro Perugino, for example, with the city of Lecco in the background once again. it is impressive the analogy between of one of the characters portrayed in the *Adoration of the Magi* and the character between Cosma and Damiano, as can be seen in the church of Rezzago mentioned before. (See Figure 64.)

FIGURE 64 — MEMBER OF THE MEDICI FAMILY, ADORATION OF THE MAGI BY PERUGINO AND CHURCH OF THE SS. COSMA AND DAMIANO IN REZZAGO (CO)

The small group of young artists just mentioned, which clearly constituted a kind of itinerant artistic and philosophical school as evidenced by the classic red hat of the members of the Fiorentina Neoplatonist Academy, are depicted in the same way in the aforementioned Sassetti Chapel, in the church of Santa Trinità in Florence, again by Ghirlandaio.

On the basis of all this evidence, and the presence of otherwise unmotivated works of these artists in the Larian basin, it is then more than legitimate to assume that given the climate being hostile to the nascent Neoplatonist movement, which was developed on the basis of the knowledge brought to Florence during the council summoned by Cosimo the Elder in 1439, a small group of artists was brought into the Larian territory to be formed there in complete tranquility and security. This hypothesis would also justify the copious use of Larian landscapes present in almost all the paintings from the participants of that pictorial school.

Apart from these disquisitions—which in my opinion outlive their purpose because the preeminent part of the Leonardo's work is its contents more than the figurative style—I would like to bring back your attention, for the last time, to the landscapes immortalized by Leonardo, both in paintings and drawings. Unlike all other artists, he makes a use of landscape that goes far beyond a mere complement to the pictorial work.

The Florentine artist, in fact, never reproduces the same landscape twice, as many other artists do. It may happen that the same mountain is found in multiple drawings or paintings[564], but the perspective it is portrayed with changes every time. More than the landscape portrayed, then, what we must be interested in are the places where he paints them from. These locations are each recognizable and coincide exactly with the roadways of the time. These consisted mainly of mule tracks along which a hypothetical walker could meet safe shelters, such as castles, fortresses, watchtowers, convents, and mansions of local lords, allies of the Sforza who could secure through their loyalty a safe harbor throughout the duchy.

If we tried to identify each of the observation points from which Leonardo draws the landscapes contained in his drawings and paintings on a map of the duchy, we would discover that these describe a kind of linear path that connects a series of trusted shelters with a definite starting and arrival point. The departure is of course Milan.

The destination is the Valtellina, a land north of the duchy, bordering Switzerland and on the way to Innsbruck. Leonardo describes this area in the Codex Atlanticus not only as the land where the ermines are born— so it is not senseless to think of a connection between the lady with the ermine[565] and this land—but also because of a curiosity related to the eating habits of its inhabitants:

> At the top of the Voltolina there is the Mount Borme, terrible and always covered with snow. Here ermines are born. [...] In Bormio there are the baths. [...] Voltolina. Voltolina, as it is said, valley surrounded by terrible mountains, makes very strong wines, and makes so much livestock, that from villagers is known that more milk than wine is made. This is the valley where Adda passes, which runs more than 40 miles towards Germany.[566]

We know that the thermal baths were frequented with a certain assiduity by Francesco Sforza—both those of Bormio and those of Val Masino, the landscape that as we have seen is the background of the painting *Virgin and Child with St. Anne and a Lamb.*

[564] As it's the case for Mount St. Martino, presents in four paintings (Gioconda, Annunciation, Baptism of Christ and indirectly the Virgin of the Rocks) and a drawing (the set for the Orpheus by Poliziano).
[565] Someone says to be Cecilia Gallerani, lover of Ludovico il Moro.
[566] Codex Atlanticus, Sheet 214.

In all likelihood, the point of arrival of this ideal route is a Renaissance palace in Teglio, in the province of Sondrio. This palace belonged to the family of Azzo Besta, who bought it in 1433 to renovate it, and there begins its noble story. This story still seems as anomalous as prestigious testimonies that lead back to Bramante, Filarete, Luca Pacioli, Paolo dal Pozzo Toscanelli, Giuliano da Sangallo—i.e., the elite of the time.

Inside this palace of wonders there is the Creation Hall, a room entirely decorated with frescoes and positioned in the oldest wing, facing northeast (in the direction of the rising sun), while in the adjacent church dedicated to San Lorenzo, there are two portraits of Leonardo allusive to the duality already mentioned of the crying and laughing philosopher. Leonardo in the two portraits holds in his hands an hourglass, an expression of the relentless flow of time, and an armillary sphere, expression of the celestial vault.

The Creation Hall of Besta palace contains the highest concentration of Neoplatonist pictorial testimonies in the world, including geographical and musical knowledge that for the time should not have been available to man, least of all in an almost rural reality like that of Valtellina. The population in the area was devoted to herding and wine production.

The overlap between what was painted in this room with what is contained in Leonardo's codex, the reference date (1459), and the presence of young exponents of the Florentine Neoplatonist school in the territory lead me to affirm that Palazzo Besta, thanks to its defiant and protected position, represents the highest and most precious testimony to the Neoplatonist knowledge existing in the world at present.

To confirm the Leonardo's paternity of this room, there is a kind of "signature"—that is, an odd landscape representation of 20 by 30 centimeters that has nothing to do with the rest of the decorative scheme. Far in a corner, as if it were a postcard, there is a clear view of a small town in Tuscany, probably San Gimignano, which calls to mind all the implications you can imagine for the connections that this delightful town has with the story of Leonardo described so far. (See Figure 65.)

FIGURE 65 — DETAIL OF THE FRESCOES OF THE CREATION HALL OF PALAZZO BESTA, TEGLIO (SO)

Unfortunately the contents of this room are completely distorted and their presence concealed, despite my longstanding efforts to highlight its very high content of Neoplatonist derivation. On this regard too, sooner or later, I will commit to publish a complete study on what this extraordinary room contains.

Could it be the legacy of this particular room that justifies the pictorial references that all Renaissance artists—Leonardo above all—have continually made to the Larian territory? Was it for this reason, then, that Leonardo put the mountain that towers over the city of Lecco at the center of the *Annunciation?* Did he want to announce the place where these "apostles" of Neoplatonism had hidden the essence of their knowledge so that the Church could not erase its memory?

The suspicion, at this point, is more than legitimate.

CH. VII—THE PORTRAIT OF

GINEVRA SFORZA

As mentioned before, not all of Leonardo's paintings that present a landscape refer to the Larian territory.

There is one that is an exception.

Just one.

As in the other paintings, however, even for this one the analysis and understanding of the landscape portrayed becomes essential to understanding the meaning underlying the work, which would otherwise be completely distorted.

I'm talking about the so-called portrait of *Ginevra de' Benci,* created by Leonardo da Vinci in 1474 and now preserved at the National Art Gallery in Washington. (See Figure 66.)

> He portrayed thè Ginevra of Amerigo Benci, beautiful work.[567]
>
> He portrayed in Florence Ginevra of Amerigho Bencj from life, work that he finished so well that it seemed not to be a portrait but the real Ginevra.[568]

With these two brief descriptions, both Vasari and the author of the Anonimo Gaddiano mention Leonardo's portrait of Ginevra, daughter of Amerigo de' Benci, a wealthy banker and collaborator of Cosimo de' Medici, as well as a partner of Piero and Francesco Sassetti in the Geneva branch of the Bank of Medici.

Amerigo Benci was a collector and researcher of Latin and ancient Greek classics, as evidenced by the excellent codex of Plato that he donated in 1462 to Marsilio Ficino. A humanist and protector of writers, philosophers, and artists, Benci became one of the main members and attendees of the Neoplatonic Academy, as well as welcoming scholars and men of art into his Florentine residence. It is assumed that Leonardo was among them, and it is believed that between 1474 and 1480, he painted there the portrait of Benci's daughter Ginevra and left the sketch of the

[567] Giorgio Vasari—The Lives of the most excellent painters, sculptors, architects, 1550—1568.

[568] Central National Library of Florence (Cod. Magliab, magliab. XVII, 17).

Adoration of the Magi (currently at the Uffizi). Then in 1482 he left Florence again for Milan.

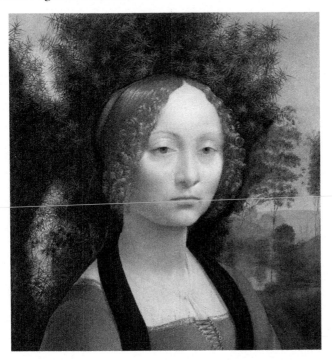

FIGURE 66 — LEONARDO DA VINCI, PORTRAIT OF GINEVRA DE' BENCI, 1474, ART NATIONAL GALLERY, WASHINGTON DC, USA

As in the case of the Gioconda, there is no direct correlation between what is described by biographers and what is instead assumed by scholars and art historians.

The identity of the lady portrayed in the painting preserved at the National Gallery of Art in Washington is assumed by scholars only according to the juniper plant depicted behind the female silhouette portrayed (Ginevra) and the fact that, on the back of the panel, the artist painted a sketch that recalls the emblem of Bernardo Bembo, a diplomat of the Serenissima Republic of Venice who had an epistolary relationship with Ginevra (and perhaps an affair, just to add some spice to the story). On the basis of these few elements, and according to a purely presumptive process, therefore, according to the association with Bembo suggested by the drawing on the back of the

panel, scholars believe that this is the portrait of Ginevra de' Benci mentioned by both Vasari and Gaddiano.

The question, however, is a little different from that.

Ginevra was born in Florence in August 1457 and got married at a very young age, in 1474, to Luigi di Bernardo Nicolini. At the time when she would have been portrayed by Leonardo, therefore, the girl would have been seventeen years old. This data contrasts with the melancholy and decidedly more mature appearance of the image of the woman in the painting. This is the first anomaly.

The comparison between the Bembo emblem and the one on the back of Leonardo's panel, moreover, allows us to say that the identification of the woman portrayed on the basis of the Bembo emblem and their epistolary relationship is bold, to say the least. And not only because of the clear lack of the juniper sprig between olive and the palm present on the back of the panel compared to the emblem of the Bembo. (See Figure 67.)

FIGURE 67 — COMPARISON BETWEEN THE EMBLEM OF BERNARDO BEMBO AND THE ONE BEHIND THE PANEL IN WASHINGTON

It's necessary to know that at an unspecified time and for reasons still unknown (some speak of humidity, some of a fire blazed in the library of Pesaro where the painting was preserved), the bottom of the panel was cut off, and it lost at least a third of its original height. A study of hands executed in 1474 by Leonardo[569] suggests the positioning of the lady's

[569] Sheet 12558, Royal Collection Trust—Windsor, England.

hands in the painting before this cut. To confirm this iconographic hypothesis, there is a bust attributed to the Verrocchio at the Bargello Museum in Florence, known as the *Lady with Primroses*[570], which portrays a lady whose identity is not specified but that has many similarities with Leonardo's painting: the hair, the appearance, and the veil just perceptible on the caste décolleté. (See Figure 68.)

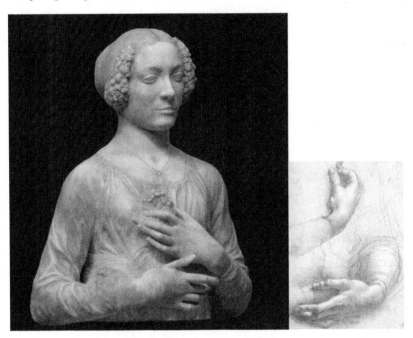

FIGURE 68 — THE LADY WITH PRIMROSES BY VERROCCHIO, HANDS STUDY BY LEONARDO DA VINCI

If the original painting had had the hands, as perceivable in comparison with the similar statue of Verrocchio and the hand study of Leonardo himself, the emblem on the back intended to be linked to the Bembo would be moved up from the center. In fact, observing better the representation on the back of the painting, which has been recovered using a repertory image[571], the damage to the emblem on the back caused by the reduction and today covered by a layer of black paint it is clearly visible. From the black-and-white repertory image, it seems evident that the layer of calcite used to prepare the

[570] Dated a year after the painting by historians, i.e. 1475.
[571] LEONARDO DA VINCE—Geographical Institute de Agostini, 1956.

panel before the laying of the pigment appears to be curiously abraded according to a regular profile on the back side, while there is not an analogue damage in the front side. (See Figure 69.)

FIGURE 69 — DETAIL OF THE BACK OF THE PANEL AS SEEN IN THE REPERTORY IMAGE

The presence of this regular abrasion only on the back side of the panel, a detail certainly not negligible, suggests perhaps the possibility that the damage was voluntarily done to erode an element perhaps uncomfortable or unwelcome.

The answer to this question is found on the front of the painting. An accurate analysis of the territory depicted in the background, in fact, not only confirms this thesis but helps us to understand the true identity of the lady portrayed. We are, in this case, in Sassocorvaro, along the valley of the Foglia River, on the border between the Marche and Emilia Romagna regions. In the background of the painted landscape, it is possible to identify the village of Mercatale, with the characteristic

tortuous course of the Foglia at its origins. This is today distinguishable only when the lake bearing the same name, which was artificially built in the 1950s, is emptied.

I have already spoken to you about Sassocorvaro, mentioning the Ubaldini fortress, a fortification with an unmistakable turtle shape built in 1475 by Ottaviane of the Ubaldini, brother of Federico da Montefeltro, as part of the project of Francesco di Giorgio Martini da Siena. The fortress of Sassocorvaro was perhaps the best work of Francesco di Giorgio Martini and denounced the alchemical soul of Ottaviano of the Ubaldini. The turtle symbolized the union between heaven and earth, that same union symbolized by the Vitruvian Man or the ideal reunion between Tobias and Raphael. It became extremely famous after the war because of the intervention of the superintendent of fine arts of Pesaro and Urbino, Pasquale Rotondi, who brought to safety ten thousand Renaissance masterpieces that would otherwise have been stolen by the Nazis fleeing to Germany, by hiding them inside the fortified walls of the stronghold[572].

On the right side of the painting we can recognize the landscape of the valley of the Fogli and the Apennine formations that stretch toward Lunano, the location where St. Francis in 1213 stopped on his journey to San Leo. On the left side, we find among the brambles of juniper the ruins of an arch that is very important for confirming the correct identification of the place represented and consequently of the lady portrayed.

I am alluding to the remains of Porta delle Coste, which was destroyed in the assault carried out on the city by the Montefeltro army on 26 August 1446, in what turned out to be a fratricidal war. (See Figure 70.)

Standing around this arch—today as then in ruins—all those elements appearing in the painting can be caught, according to that figurative realism recognizable to the Tuscan artist: Mercatale with the typical harbor in the background, today replaced by an industrial hub; the valley of the Foglia; and a full correspondence of the individual hilly elevations that stand out on the horizon.

Given all these circumstances, it is now easier to disclose the identity of the lady portrayed by Leonardo and the circumstances that inspired this commission.

[572] Among others, there were very important works by Raphael and Piero della Francesca.

FIGURE 70 — DETAIL OF PORTA DELLE COSTE, SASSOCORVARO

We mentioned earlier how the painting was originally longer by at least a third of its current dimensions and how the hands somehow recalled Leonardo's preparatory drawing of the work, now preserved at Windsor.

There is a painting by Lorenzo di Credi[573], an artist student of Verrocchio who was very close to Leonardo, that helps us overcome all these presumptions. In this painting, the portrayed lady holds a ring in her hands instead of the bunch of flowers, a detail that helps to give a more appropriate reading to the circumstance to which the work alludes: a wedding. (See Figure 71.)

While it gives us an indication of the context and gives to the painting its original proportions, this detail does not tell us anything about the identity of the protagonists of the marriage that it would announce. Thanks to the collaboration of a dear friend and expert in heraldry, Fabio Bianchetti, I wanted then to examine in depth that anomaly highlighted by the emblem portrayed on the back of the panel, which presents at the bottom an erasure with a curious geometric shape that recalls one of those shields used in heraldry. Even from a strictly graphic point of view, considering the work as it originally appeared, it is clear and obvious that the reshaping of the panel has produced the erasure of an important part of the emblem behind.

[573] Portray of a young woman, Metropolitan Museum of Art, New York.

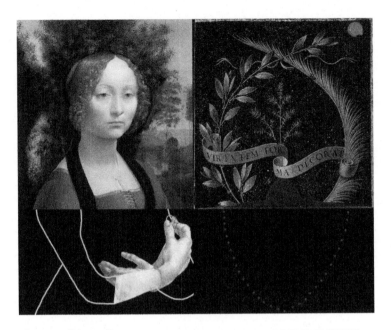

*FIGURE 71 — CORRECT PROPORTIONS OF THE PAINTING
BEFORE ITS RESIZING*

Regarding the remaining part of the emblem after the resizing, I have already highlighted that there is not any accurate correspondence with that belonging to Bernardo Bembo. This is my basis for firmly rejecting the purely presumptive hypothesis according to which the lady portrayed is Ginevra of Amerigo de' Benci mentioned by Leonardo's biographers of the sixteenth century.

The contextual presence of the palm and the olive sprig, from a purely heraldic point of view, would suggest rather a Sforza. In this case, that would be a lady belonging to the Pesaro branch, since after the painting degraded, it was preserved at the Art Gallery of the Ducal Palace of Pesaro. Also, consider the proximity between Pesaro and Sassocorvaro.

The addition of the juniper sprig with those of olive and palm suggests precisely the name of Ginevra, daughter of that Alessandro Sforza who was lord of Pesaro and wanted the construction of the library where the painting was preserved. He was also grandson of

that Francesco Sforza, duke of Milan, to whom Leonardo went in 1465 to bring him his lyre as a gift[574].

From a strictly heraldic point of view, however, in the coats of arms of the Sforza family, the olive and the palm appear disjointed. In the emblem portrayed on the back of the panel painted by Leonardo, they are instead represented united, to form a vegetative uroboros[575], which suggests that the painting may have been commissioned to celebrate a wedding. This circumstance would also be confirmed by the ring displayed in the hand of the young woman painted by Lorenzo di Credi, which obviously takes inspiration from Leonardo's painting.

Thus the anomaly relating to the geometric symmetrical abrasion underlying the emblem of Ginevra Sforza no longer turns out to be so "accidental," leaving me instead presume the presence of a second coat of arms. In this case it would be that of her husband, Giovanni II Bentivoglio—also called Bencivoglio with Bolognese inflection, from which the name Ginevra de' Benci(voglio).

If this last deduction of mine seems fantastical to you, be aware that in the fortress of Bentivoglio of Bazzano, residence of Giovanni II at the gates of Bologna, is identified by a coat of arms in which there are the letters MS ZO, i.e., Messer Zoanne. This name, with Bolognese inflection, was used by everybody to refer to him. The coat of arms also has the unavoidable animal that went with it, a lynx often mistakenly identified as a cheetah. This latter detail allows us to identify Giovanni II Bentivoglio in the cycle by Benozzo Gozzoli at the Medici Riccardi palace, next to Cosimo de' Medici in the costume of Pachacutéc. (See Figure 72.)

To further confirm the identity of the lady portrayed by Leonardo, note the resemblance to Ginevra Sforza as she is depicted in the fresco of Lorenzo Costa (1488) located in the chapel Bentivoglio in Bologna, in the apse of the church of St. Giacomo Maggiore in via Zamboni. At the top of the painting the Madonna with the child is depicted; in the center are Giovanni II Bentivoglio and his wife, Ginevra Sforza; and just below are their eleven children.

[574] Both portrayed by Benozzo Gozzoli in the procession celebrating the arrival of Mattia Corvino in Florence.

[575] Expression of sacred marriage, in which opposites are joint to symbolize primigenial androgyny.

FIGURE 72— THE COAT OF ARMS OF GIOVANNI II
BENTIVOGLIO IN THE FORTRESS OF BAZZANO, AND PARTICULAR
OF THE CHAPEL OF THE MAGI AT THE MEDICI RICCARDI
PALACE IN FLORENCE

A further similarity comes also from comparison with the
polychrome terracotta statue made by Giuseppe Romagnoli at the
end of '800, who faithfully repeats the faces and costumes present in
Lorenzo Costa's fresco. This reproduction highlights a detail present
in the painting on Ginevra's bustier: a bunch of flowers similar in all
respects to that reproduced by both Verrocchio and Leonardo in his
hand study. (See Figure 73.)

It is actually a bouquet of orange blossoms—an auspicious custom
for the bride that was borrowed from eastern Asian cultures at the
beginning of the fifteenth century.

To further reinforce the reasons that would have led Leonardo to
portray Ginevra Sforza on the occasion of her wedding with
Giovanni II Bentivoglio, we need to consider his personal closeness
both to the Sforza family, where he spent much of his youth, and to
Giovanni II, with whom he was a brotherly friend—so much so that
he was portrayed with him at least a couple of times by Benozzo
Gozzoli (in Florence in the Chapel of the Magi, and in San
Gimignano in the church of St. Augustine). The marriage of his
brotherly friend, therefore, would justify the exception to the rule
that requires Leonardo to paint only Larian landscapes.

FIGURE 73 — PORTRAIT OF GENEVA SFORZA, BENTIVOGLIO CHAPEL, SAN GIACOMO MAGGIORE BOLOGNA

If we were to insert the coat of arms of Giovanni II Bentivoglio on the back of the panel, we would notice how the two coats of arms seem to complement each other by describing an uroboros, symbol of spiritual marriage, which is formed in the lower part by the coat of arms of the husband and at the top by the sprig of olive and the palm leaf converging with each other.

On the right side of the painting, moreover, above the village of Mercatale, there is Piagnano and its castle. This castle was inhabited in those years by Count Gianfrancesco Oliva, a man of arms linked to Leone Sforza, brother of Ginevra's father, Alessandro. In 1441, Oliva even became Alessandro Sforza's brother-in-law, as he married the widow of his brother Leone, Marsibilia Trinci. I therefore do not rule out that Ginevra, Alessandro's illegitimate daughter and born only a year earlier, may have been raised in Piagnano by his sister-in-law Marsibilia.

Would these elements of a purely historical and biographical character justify Leonardo's choice to paint Ginevra Sforza in Sassocorvaro, with the valley of the Foglia and Piagnaio in the background? Perhaps in Leonardo's intent there was the clear desire to attribute to the lady portrayed an even stronger identification, reproducing behind her the territory that saw her grow up.

This hypothesis also does not exclude the possibility that Marsibilia Trinci was Ginevra's mother. Marsibilia belonged to the powerful family of the Trinci of Foligno. Her first husband, Leone, was the son of Muzio Attendolo, the forefather of the Sforza family, whose mother was Lucia Terzani of Torgiano, a town not far from Foligno. Knowing the political dynamics that governed marriages and descendants at the time, the choice to raise Alexander's illegitimate daughter with a Trinci—assuming that she was not the natural mother—I would still find it reasonable.

Besides, the area is chock-full of junipers, the same ones that Leonardo paints in the work and that he perhaps degrades with his partial fingerprint. (See Figure 74.)

FIGURE 74 — DETAIL OF THE PARTIAL FINGERPRINT AND OF JUNIPER BRANCHES, AN ENDEMIC PLANT OF THE VALLEY OF THE FOGLIA

Ultimately, therefore, all the anomalies and peculiarities of the painting described so far converge to identify the figure portrayed by Leonardo as Ginevra Sforza on the occasion of her marriage to Leonardo's brotherly friend Giovanni II Bentivoglio in 1464, after being married first to Giovanni's cousin, Sante, who died of illness the previous year. At the time when she married Giovanni, Ginevra was a twenty-four-year-old widow, making her even more compatible with the melancholy grimace of the woman portrayed.

The conjunction of the family coats of arms at the time was also common for spouses, and in the specific case of Ginevra and Giovanni, it was a commonly recurring motif. In the domestic furnishings, in the flooring of the family chapel in Bologna, and in the decorations of their residences, the coats of arms of Ginevra and Giovanni are always joined, testifying to the solidity of the partnership between the Sforza and Bentivoglio families. Which then

means between the cities of Milan and Bologna, but also that of Pesaro, the city where the painting under examination was located. At the time, Pesaro was led by Alessandro Sforza, brother of Francesco, duke of Milan.

Based on this, it is not surprising then that in the cathedral of Pesaro, there is preserved a Madonna of Mercy (always her), by an anonymous author and datable around the mid-fifteenth century. Under a blessing Saint Ambrose[576] (an image dear to the Milanese, used by the Visconti first and then by the Sforza), Ginevra herself is portrayed as the Madonna of Mercy. Her clothes combine the symbols of the Sforza in the blue mantle and of Giovanni II Bentivoglio in the red dress.

As you can see, the elements leading to the identification of Ginevra Sforza in this portrait by Leonardo are many and definitely more solid than the fragile presumptive hypothesis in support of it being Ginevra de' Benci on the basis of the coat of arms on the back of the panel.

We can even hypothesize the reasons that led to a cut of the panel, beyond the undemonstrated hypothesis put forward by historians that the painting may have been partially ruined by humidity or by a fire at the Art Gallery of Pesaro. In light of this new reading, we can perhaps make a third hypothesis to justify the damage suffered by the painting, now preserved at the National Gallery of Art in Washington.

The reduction of the size of the panel and the abrasion of what remained of the groom's coat of arms suggests that the damaging may have been ordered by someone who had an interest in removing from the painting obvious traces of the Bentivoglio family. Perhaps particular events had occurred so that it might have become inappropriate to associate the Bentivoglio family with the Sforza one, such as the fall of Ludovico il Moro at the hands of the French, or more simply, the lord of Bologna might have fallen into the disgrace of someone very powerful. In this case it would even be plausible to think that such an alteration may have been at the mandate of Pope Julius II. He nourished a strong resentment to Bentivoglio, so much to send him out in from Bologna on bad terms in 1506.

Bentivoglio clearly paid for his closeness to families of the Sforza, the Medici, and the Malatesta—that is, all those families who embraced the Neoplatonic Renaissance movement that was unwelcome to the papacy. The Church was interested instead in favoring and supporting families closer to the Vatican, such as the Rovere, Montefeltro, and Corsini.

[576] St. Ambrose was Bishop of Milan at the time of the conversion of St. Augustine, and also the one who baptized him.

Ginevra Sforza herself was exiled and then excommunicated by
Julius II, who out of spite took possession of her castle while the
Bolognese properties were plundered and razed to the ground.
Together with the library, also celebrated by Leonardo in a note
written in 1502, the ducal palace of Pesaro housed an important
collection that included works by Perugino, Mantegna, and other
leading painters, but it was subjected to a devastating fire in those
years.

Should we really assume that the work suffered damage during
the fire in Pesaro in 1514, so much so that it had to undergo a
resizing (though it was still a work by Leonardo and therefore of
absolute value)? Or do we have to assume that the princes of Rovere
may have wanted to eliminate from the work any reference to the
lord of Bologna, i.e. the coat of arms of the Bentivoglio, against
whom they felt a total repulsion, and then blamed a blaze of fire for
the damage. Let's remember that in 1512, Julius II, with the support
of King Louis XII of France, handed over the city of Pesaro to the
princes of Rovere, who were from his own Ligurian clique, and in
opposition to the Bentivoglio.

It doesn't really matter. What it is important is to restore
Leonardo's painting to its correct dimensions—in relation to the
client, and to the subject portrayed and the landscape in which it is
immersed. This would confirm once more, if there was the need, that
being a work by Leonardo, the landscape portrayed always takes on a
primary, substantial value in the understanding of the work.

CH. VIII—THE LADY OF LO'BARDIA

Before venturing into the pages of the last chapter of our journey, during which we will try to retrace his true identity through the thousand and more paintings in which Leonardo was portrayed, and also to give a line of continuity with the two previous chapters, the reason for addressing the Gioconda subject has finally arrived.

The Gioconda, also renown as Mona Lisa, is perhaps the most famous painting by Leonardo da Vinci.

Able to attract millions of tourists every year and made the subject of reproductions of all kinds and types, the Gioconda can be considered a true pop icon of the twentieth century, welcomed by heads of state and celebrated in museums and exhibitions around the world.

The famous "*smirk*" with which Vasari describes her and the almost ethereal sense of indefiniteness that has always accompanied the portrait of this enigmatic woman undoubtedly contributes to the fame of this painting.

Although it may be considered perhaps the most famous and celebrated painting in the world, inexplicably it is the subject of a long series of clichés that I would like to debunk once and for all. Let's start by saying that it is an oil painting not on canvas, as I often read, but on poplar wood of Lombardy origin.

And I stress *"of Lombardy origin"*.

Secondly, contrary to the disappointing claims of all those who see it exhibited in the Louvre, the painting is not small at all. Its actual size, in fact, corresponds to that of a life-size female silhouette. This false perception probably stems from the fact that, being in the past subjected to various damages[577], today between the viewer and the panel a thick, anti-breakthrough glass has been placed, which represents a barrier not only visual, but also perceptive of the portrait. Another aspect to be debunked is related to the property of the piece.

Although one can say a work of art is for anyone who has the benefit of observing it—and even more of understanding it—the Gioconda has always belonged to France.

[577] Acid was poured over it and stoned with a rock by a deranged man

It was brought here by Leonardo himself, and sold in 1518 to King Francis I by Gian Giacomo Caprotti[578].

Those false patriotic motions that sometimes rise up to ask for the return to Italy, therefore, outlive their purpose.

In a not-too-distant past, however, the Gioconda reached Italy for real. It was 1913, when a former employee of the Louvre from a small village near Luino, in the Varese area, convinced that the work belonged to Italy and that it had been pinched by Napoleon, decided to steal it on 20 August 1911, locking himself up overnight in a closet and leaving the museum with the portrait under his coat the following morning.

The theft was daring, to say the least[579].

To exit the museum, Peruggia, as was the thief's surname, had to ask a plumber for help because the handle on the front door had disappeared; once outside the museum he made the mistake of getting on the tram, before being forced to continue his escape in a more comfortable but less anonymous taxi.

Putting the portrait in a suitcase and hiding it under the bed of the guesthouse in Paris where he lodged, the Louvre employee kept it for twenty-eight long months, after which he took it to his home village with the intention of returning it to Italy.

His belief was that as the painting belonged to Italy, it would therefore remain.

His conviction, like that of many Italians to this day, was that the work had been stolen from Italy during the Napoleonic plundering.

As a matter of fact Napoleon did have a minor acquaintanceship with the Gioconda, as he kept it in his bedroom for some time; it was here that the young writer Alessandro Manzoni could see it and be fascinated by it.

Who knows if he was even able to recognize the places he learned to know in his childhood and which are the setting for his famous historical novel[580].

In a completely naïve way and following his patriotic purpose, two years after he stole it, Peruggia went to Florence to resell the work to the Florentine antiquarian Alfredo Geri, to whom he had

[578] Known as Salaì

[579] Stefano Bucci, *Theft of the Gioconda, a hundred years of myth*, article in "Corriere della Sera", 7 August 2011, p. 41.

[580] Obviously a rhetorical question, as we shall see.

previously sent a letter[581] announcing the possession of the painting and explaining why he believed it belonged to Italy.

On December 11, 1913, accompanied by the then-director of the Uffizi, Giovanni Poggi, the Florentine antiquarian fixed an appointment with Peruggia; the two men, immediately realizing that the work was not one of the many forgeries in circulation but the original, with the excuse of wanting to verify the painting's authenticity, convinced him to leave it in their possession.

Once the portrait was retrieved, Peruggia was reported, arrested, tried, defined mentally handicapped and sentenced to prison.

His defense was based exclusively on patriotism, which aroused more than a little sympathy in public opinion, especially after he declared spending two "*romantic*" years in the company of the Gioconda, who in the meantime he had moved from the suitcase under the bed to above the dining table in his kitchen.

There is no doubt that such a picturesque and adventurous theft contributed to the birth first, and the nourish subsequently, of the myth after linked to this work, allowing it to be transferred from the limited cultural sphere of the few to the populism of the masses.

It is a pity that the painting is not the one on display today.

Yes, you understood correctly: the portrait of Lisa Gherardini, known as "*Mona Lisa*", is not the one on display at the Louvre.

Careful, I'm not saying that the version on display is a fake.

Far be it from me to think that.

I am saying precisely that the painting known more than any other in the world is not the portrait of Mona Lisa described by Vasari in *The Lives*, nor the one that, in a testamentary list of 1525 including the property of Gian Giacomo Caprotti, known as Salai, is mentioned for the first time as the *Honda*.

It is just another painting.

Let us proceed in stages.

To date, scholars believe that the Gioconda was painted between 1503 and 1506 and was brought by Leonardo to France in May 1517, where the artist had long been at the service of King Francis I with the

[581] In which he signed himself as "Leonardo".

title of *premier peintre, architecte, et mecanicien du roi* and a pension of 5,000 ecus[582].

While Paolo Giovio makes no mention of the portrait, the first of Leonardo's biographers to write about it, albeit indirectly, is the author of Anonimo Gaddiano:

> He portrayed live [i.e. in front of the subject] Piero
> Francesco del Giocondo.[583]

Gaddiano makes no reference to the portrait of Lisa Gherardini, but only to that of her husband, Piero Francesco del Giocondo. Who speaks of the portrait of the Giocondo's wife is the Vasari instead, from whose written testimony the myth of the "Gioconda" comes to life through a long process of interpretation:

> He took Lionardo to paint for Francesco del
> Giocondo the portrait of his wife Mona Lisa; and for four
> years he left it unfinished, and the work today is with King
> Francis of France in Fontainebleau; in whose head those
> who wanted to see how much art could imitate nature,
> easily could be understood, because here were present all
> the details that can be minutely painted.
>
> The eyes had the glints and those water lines that are
> continually seen in life, and around them were all those
> reddish marks and hairs, which cannot be made without
> great precision.
>
> The eyelashes, for making the way the hairs were
> born in the flesh, where thicker and where thinner, and
> turning according to the pores of the flesh, could not have
> been more natural.
>
> The nose, with those beautiful reddish and gentle
> openings, could seem to be alive. The mouth, with that
> crevice with its ends united by the red of the mouth with
> the incarnation of the face, were not pigments but real
> flesh, it seemed.
>
> In the little jugular notch of the throat, those who
> were intent on looking at it could see the wrists beating:
> and in truth we can say this was painted in a way that
> makes every strapping man tremble and fear.
>
> He used again the art, as Mona Lisa is so beautiful, of
> having, while he was portraying her, those who sang and

[582] Since 1506, although for a long time he went back and forth dealing with the fortifications in the Milanese duchy and went to Florence with the King's approval to resolve the hereditary issues related to the death of the notary Sir Piero.
[583] Central national library of Florence (Cod. Magliab. XVII, 17).

played, and clowns who kept her constantly cheerful, to take
away that melancholy layer that painting often gives to
portraits. And in this opera of Lionardo there was such a
pleasant smirk that it was more divine than human to see it,
and it was marvelous for not being alive.[584]

This is the translation of how Vasari describes Leonardo's work,
including that reference to the phantom "smirk" of the woman who
perhaps misled more than one scholar.

A first misunderstanding is generated by the meaning that the word
takes on today in the Italian lexicon, different from what it probably had
at the time of Vasari:

> "smirk": to smile or laugh with facial contortions that
> express scorn or contempt.[585]

Vasari uses this same term also to describe the smile that Leonardo
painted on St. Anne's face:

> Because one could see in the face of Our Lady, all the
> simplicity and beauty that grace can give to a mother of Christ;
> showing that modesty and humility, typical in a virgin full of
> joy upon seeing the beauty of her son, whom she tenderly held
> in her lap; and while she, with an honest look down, glimpsed
> a S. John little child, who was playing with a lamb, the smirk
> of a S. Anna who, full of joy, saw her earthly descendants
> becoming celestial. Considerations truly from the intellect and
> ingenuity of Lionardo.[586]

In both descriptions it is evident that the word "smirk" is used by
Vasari to describe an *angelic, celestial smile*, anything but malicious, vile
or mocking, as is its meaning today in the Italian language. A second
consideration regarding this comes from a note found in 2005 by the
historian Veit Probst, director of the Heidelberg Library in Germany,
found at the opening of Chapter V.

In this note, written personally in 1503 by the Florentine Chancellor
Agostino Vespucci in the border of a book containing a collection of

[584] Giorgio Vasari—The Lives of the Most Excellent Painters, Sculptors, and Architects,
1550—1568
[585] From the English dictionary.
[586] Giorgio Vasari—The Lives of the Most Excellent Painters, Sculptors, and Architects,
1550—1568

letters by the Roman orator Marcus Tullius Cicero, and still
preserved today at the prestigious German university, we read:

> Like the painter Apelles, so does Leonardo da Vinci in
> all his paintings, for example for the head of Lisa del
> Giocondo and Anna, the mother of the Virgin. We'll see
> what he's planning to do with regard to the Council Great
> Hall, of which he has just signed an agreement with the
> Gonfalonier.[587]

This precious note, once more, provides us with two essential
basic facts: the first one is that in 1503 the portrait of Lisa Gherardini,
wife of Pietro Francesco del Giocondo, was already completed. If, as
Vasari says, it took Leonardo at least four years to paint the work, it
should therefore have begun in 1499, when Leonardo and Ludovico
il Moro were in Bellagio to flee from the French invasion, and not in
1503, the year in which, based on this note, it was already completed.

The second consideration comes from the fact that I do not know
what detail of the portrait of Lisa del Giocondo and Sant' Anna
Vespucci refers to—also because I sincerely find it hard to think of a
parallel between the subjects portrayed in the Battle of Anghiari (to
which Vasari gives ample testimony with his note[588]) and the two

[587] Note written by the Florentine Chancellor Agostino Vespucci in 1503.
[588] *"And the Gonfaloniers and the great citizens agreed that, as the Council Grand Hall
had been newly built, some beautiful work should be painted there; and so Piero
Soderini, then Gonfalonier of justice, allocated the hall to him.*
*As Lionardo wanted to execute the work, he began with a cartoon in the pope's hall,
located in Santa Maria Novella, painting the story of Niccolò Piccinino, captain of Duke
Philip of Milan, in which he drew a tangle of horses and knights fighting a standard,
which was considered excellent and of great majesty for the admirable considerations that
he had in creating that work. In it we do not know any lesser the anger, indignation and
revenge of the horses than of the men; They are entwined with their legs before them,
and they not less vengeful with their teeth than are those who ride on them fighting the
standard, whereas a soldier, with the strength of his shoulders, sets his hands while he spurs
the horse to a run, grasping the pole of the banner, to steal it with strength from the hands
of four others, two defending it with one hand each, and the other with swords in the air
trying to cut the pole; while an old soldier in a red beret, crying out, holds the pole with
one hand and with the other a sword, and strikes a blow to cut off both hands of those
who, gnashing their teeth with force, try with fierce intent to defend their standard; two
figures on the ground between the legs of the horses can be seen, fighting together with
one on the ground and a soldier on top of him, who, raising his arm as high as he can,
with that greater force puts the dagger to his throat to end his life, and the other with his
legs and arms beaten does what he can to avoid death. Nor it is possible to describe the*

ladies portrayed by Leonardo—but it clearly alludes to a "head" and not a bust, as is the portrait of Mona Lisa.

In any case, referring to the child that the Virgin is carrying, Vasari obviously refers to the Saint Anne depicted in the painting and not to the one in the cartoon, in which the lamb is not present.

Having said this, coming back to Vasari's description of the painting, he dwells on a series of praises of the painting that clearly suggests that the work to which he refers cannot be the one that the whole world today recognizes in the painting on display at the Louvre Museum in Paris.

He refers indeed to the hair of the eyelashes and face, beautifully painted (the hair, of course... but the Gioconda has neither hair nor eyelashes), he speaks of the eyes, which "had those lusters and those swamps that are constantly seen in the flesh" and enhances the jugular notch in the throat, all details that do not appear in the painting at the Louvre. (See Figure 75.)

Moreover, although he is so careful and precise in describing certain details of the face, bordering on photographic realism, Vasari makes no mention of the two details that would be profoundly characteristic of the subject portrayed, so much so as to make them absolutely *not* negligible: the xanthelasma present between the eye and nose—strangely underestimated by all scholars—and the arthrogenous ganglion on the back of the right hand, made equally evident by the precise artist's choice to have the right hand over the left.

design that Lionardo made for the garments of the soldiers, which he varied; like the crests and other ornaments, and the incredible skill that he showed in the shapes and features of the horses: horses that Lionardo, by technique, muscles, and gentle beauty, did better than any other master. He drew their anatomy together with that of men, and both in the true modern light. It's said that to draw this cartoon he made a very refined contraption, which raised on closing it and lowered on widening it.
And envisaging that he would use oil to paint on the wall, he made a composition of a mixture so thick, in order to adhere to the wall, that while continuing to paint in that room it began to pour, so that in a short time he abandoned it."
Giorgio Vasari, The Lives, 1550/1568.

FIGURE 75 — DETAIL OF MONA LISA'S EYES. LOUVRE MUSEUM, PARIS

These two not irrelevant details, as we have seen before, that if read correctly would have long ago led scholars to understand the real meaning concealed in the painting, which does not portray a lady of that age, but Leonardo himself in the female features, the expression of that essential philosophical concept present in all cultural and religious denominations—the Sacred or Spiritual Marriage—which is synonymous of that condition of extra-material purity discussed previously.

This is a practice, very fashionable at the time and employed by all the greatest artists, from Raphael to Michelangelo, from Perugino to Van Eyck to name a few, of portraying the artist-self in a character with feminine features.

The most superficial critic justifies this similarity between the various artists and their works with the habit of using one's own image as a figurative model, leaving completely out of consideration the Rebis, a concept deemed esoteric and therefore banned.

Speaking of Leonardo's portrait, Vasari then makes explicit reference to the fact that after four years he worked on it, "he left it imperfect".

The Gioconda, however—imperfect it is not.

It is not imperfect in the landscape, which refers in fact with extreme precision to the Lombard territory that develops around the Lecco branch of the Lario, and it is not imperfect in the features of the protagonist, whose details, of the face, veil and dress, are instead very accurate and defined. At this point it is definitely clear that Vasari is describing a painting that is not the one on display at the Louvre, which we know from a note by the Florentine Chancellor Agostino Vespucci was completed as early as 1503. (See Figure 76.)

FIGURE 76 — NOTE ON THE MONA LISA OF THE FLORENTINE CHANCELLOR AGOSTINO VESPUCCI OF 1503

This last detail triggers a further doubt: for which illogical reason should Leonardo have taken the painting of Francesco del Giocondo's wife halfway across Europe instead of handing it over to the client and collecting the agreed payment, if it is true that only in 1518 he sold it to the King of France?

This should no longer be a surprise.

As I have largely documented, Leonardo's entire life, including his works, is the result of poor presumptions, based mostly on partial reconstructions created long after the period in which he lived, and denied by a large number of documents contemporary to the character.

The first being the date on which Leonardo would have been born, assumed in a totally presumptive manner in 1746 on the basis of a document whose truthfulness cannot be proven and which is in clear contrast with the reconstruction of almost all his biographers—some of whom had the opportunity to meet the Florentine artist in life.

Among them I remember Antonio de Beatis, the personal secretary of the Cardinal of Aragon who, as you know by now, wrote a diary entry about the meeting he had in Cloux with Leonardo on the 10th and 11th October 1517.

Thanks to this precious direct deposition, today we are not only able to acquire important biographical elements about Leonardo, but we can finally clarify once and for all the many inconsistencies that characterize

the reports about the Gioconda, which is what interests us most in this moment.

In his notes, making express reference to a man in his seventies and handicapped in his right hand, de Beatis writes:

> In one of the villages, the Lord, along with the rest of us, went to see the Florentine Leonardo Vinci, more than seventy years old and a prominent painter of our times, who showed us three paintings: one of a certain Florentine lady, a painting with beautiful features made at the request of the now-deceased Magnifico Giuliano de' Medici; the second of a young St. John the Baptist; and one of the Madonna and her son, who are placed in the lap of St. Anne—all perfect, even if from him, for having contracted a certain paralysis on the right hand, much cannot be expected.[589]

Among the paintings mentioned by de Beatis, the portrait of Mona Lisa is evidently missing.

The gap is not insignificant, as the Louvre itself traces the purchase of the Mona Lisa by Francis I, together with the other paintings that Leonardo had brought with him to Cloux. These include a painting with Saint Anne and a Saint John the Baptist, i.e. the same two paintings also mentioned by de Beatis together with one commissioned by Giuliano de' Medici, son of Lorenzo the Magnificent, which obviously cannot be the Mona Lisa.

When Leonardo died, on May 2, 1519, among the belongings divided between Francesco Melzi, Gian Giacomo Caprotti and one of his workers[590], no painting appeared. So we have to assume that those mentioned by de Beatis are those that in 1518 were acquired on behalf of the King of France to be exhibited in his private collection at the Castle of Fontainebleau.

It was Gian Giacomo Caprotti who negotiated the transfer of these paintings with the King's emissaries. In fact, in 1999, among the documents preserved in the *Archives National de Paris*, a receipt was found that attests the payment of a substantial sum[591] for unspecified

[589] Antonio de Beatis' *travel diary*, 10 October 1517—Ref. XF28, Naples National Library.

[590] Battista de Villani.

[591] 2604 Turin Lira.

paintings by Jean Sapin[592] in favor of "Sir Salay de Pietredorain pour quelques tables de paintures qu'il baillées au Roy".

After completing this negotiation, in which Gian Giacomo Caprotti *is presumed* to surrender the paintings left to him by Leonardo, the Milanese artist returns to Milan, gets married, and in 1523 is killed by the French.

In 1990, in the State Archives of Milan[593], the will through which Caprotti left his properties to his wife and sisters was found.

Among the paintings mentioned in the will we find a Leda, a Sant' Anna and a certain painting of a "Quadro de una donna aretrata" for which the line spacing specifies "dicto la Honda", crossed out again and corrected (by the notary?) with the wording "dicto la Joconda".

A subsequent document, also preserved in the State Archives of Milan[594], indicates that one of the sisters of Salai[595] gave a "Ioconde Figuram" to a certain Ambrogio da Vimercate.

Assuming that "Honda, Joconda and Ioconde" are adjectives that can be traced back to the portrait of Lisa Gherardini, of which I have many doubts, it seems increasingly evident that the painting now on display at the Louvre is not the portrait of Lisa Gherardini, the Mona Lisa mentioned by Vasari whose portrait was commissioned by Pietro Francesco del Giocondo to Leonardo and completed before 1503, as testified by the Florentine Chancellor Agostino Vespucci.

And then you will ask yourselves: why, in the light of all this opposite evidence, do we *nonchalantly* assume that the painting exhibited in the prestigious Parisian museum is the Gioconda?

Because in 1625, more than a century after Leonardo's death, during a visit to France, the painting we see today in the Louvre was seen in Fontainebleau by Cassiano del Pozzo.

Cassiano del Pozzo was a Piedmontese art traveler and collector, academic of both the Crusca and the Lincei, first enlisted in the service of the son of the Grand Duke of Tuscany[596] and then, once he moved to Rome, of Cardinal Francesco Barberini, at the time Prefect of the Court

[592] Treasurer of King Francis I.
[593] Janice Shell e Graziano Sironi.
[594] Dated 1531.
[595] Whose name was Lorenzuola and who probably inherited her father's painting.
[596] Ferdinando I de' Medici, son of that Cosimo I who with Pius V granted the License and the Privilege to Vasari for the second version of The Lives, the one revised and corrected according to the dictates of the Catholic Inquisition.

of the Apostolic Signatura[597], whom del Pozzo had the opportunity to
accompany on a diplomatic trip to France in 1625. Here, seeing
Leonardo's painting and mindful of the biographies written by Vasari
and especially by Paolo Lomazzo in 1585[598], del Pozzo expressly
mentioned it in a diary that included the memories of that journey,
rich in geographical and artistic notions, calling it "*the Gioconda.*"

From that moment onwards, the portrait of Lisa Gherardini
commissioned to Leonardo by her husband Francesco del Giocondo
is mistakenly associated with the one now on display at the Louvre,
again *according to a superficial interpretative process based on mere
presumptions that are not reflected in the rich documentation
available.*

In this specific case, I think I can say that the role played by
Cassiano del Pozzo was indeed in good faith. The more I write about
it, in fact, the more I am convinced that the Mona Lisa and the
Gioconda are two different works, and this can partially help to
reassemble the puzzle, albeit only from a nominal point of view.

From a substantive point of view, in fact, what is exhibited at the
Louvre is still not the painting mentioned by Vasari, which in all
probability was an ordinary portrait, although well executed, of the
wife of a wealthy client, and now lost.

In the many documents supporting this whole story, as you may
have noticed, there is nothing to suggest that the term "*Gioconda*"
originated from the name of Lisa Gherardini's husband.

Far from it.

My idea is that the term "*gioconda*", first suggested by Paolo
Lomazzo in 1585, does not identify a family name but an emotional,
spiritual state.

When Vespucci indeed mentions it in 1503, alluding to Lisa
Gherardini, he clearly uses the words "Lisa del Giocondo's head",
while Vasari expressly defines her as "Mona Lisa [...] wife of
Francesco del Giocondo".

After all, one would not understand why Leonardo intended to
paint Lisa Gherardini with his own facial proportions. As I have
anticipated in the chapter on landscapes, we know that by portraying
himself in a female version Leonardo intends to express that superior

[597] The Supreme Court of Canon Law of the Holy Seat.
[598] Paolo Lomazzo was the first to name *Gioconda* Lisa Gherardini's portrait in "Il
Treatise on Painting', 1585.

condition linked to the Sacred, Spiritual Marriage, often contrasted in painting to the material, temporal, earthly condition.

It is the duality expressed by Raphael in the School of Athens[599] by the couple Plato/Aristotle, but above all it is the same duality already analyzed with regard to Bramante's painting that counterposes Heraclitus to Democritus, the crying philosopher and the laughing philosopher, in which the *saturnine character*, miserable and sad of Heraclitus, afflicted by earthly and material pains, is counterbalanced by the *jovial, celestial, smiling character* of Democritus, projected to the immensity of the cosmos according to a recurring theme in the Renaissance that sees Leonardo involved in several portraits in different roles[600].

On the basis of what has been analyzed up to now, then, I firmly believe that the term "*gioconda*" is to be correlated to the *jovial aspect* that the woman portrayed personifies and not to the fact of being the wife of Pietro Francesco del Giocondo.

In fact, we cannot overlook the fact that the terms "*jovial*" and "*giocondo*" are synonymous with each other; this last observation, of a purely linguistic nature, would also find further justification in the famous "smirk" painted by Leonardo both on the face in the portrait in the Louvre and in the smile that Saint Anne addresses to her child: a smile not at all mischievous, mocking or whatever else, but the expression given by her being "full of joy" because "she saw her earthly offspring become celestial".

At this point, however, it is legitimate to ask the more obvious question: if the painting on display at the Louvre does not depict Mona Lisa, who does it depict?

To resolve this dilemma, in addition to de Beatis and the already mentioned landscape that accompanies the painting, objectively Lombard, in our favor there are also some elements that appear to have been omitted in the painting.

These elements are not clearly visible to the naked eye, but have fortunately been highlighted recently with a particular non-invasive technique by a French scholar.

Pascal Cotte, as is his name, is a French physicist co-founder of the Paris-based electronic engineering company *Lumiere Technology*; in

[599] Room of the Signatura, Vatican City, Rome.
[600] In the role of Plato in Raphael's painting, while in Bramante's painting he is portrayed as Heraclitus.

2004 he obtained[601] from the Louvre Museum permission to perform a series of non-invasive analyses on the painting, being able to experiment with a new technique that uses reflected light to analyze the deeper layers of a paint, called *Layer Amplification Method* (Lam).

These analyses[602] led to the revelation of some afterthoughts by the artist, in particular on the overall size occupied by the silhouette of the lady portrayed, a slight rethinking of the finger of the left hand (the one without the impairment) but above all a series of curious abrasions concentrated around the upper part of the head, which the French scholar traces back to the original presence of some hairpins with a pearl on the top, which according to Pascal Cotte were used by women of the Renaissance aristocracy to support the hair and demonstrate their social class.

All very interesting, in reality, with just one small note: the abrasions highlighted by Pascal Cotte's analysis around the head of the woman are not hairpins with a pearl on the top used by Renaissance noblewomen to declare their social status, but are very particular *swords* in use precisely since that time in a very limited area of the Duchy of Milan.

These *swords*, characterized by a "circular breakthrough", clearly refer to the *Sperada*, the typical Lombard hairstyle in use in Brianza alone, on the eastern branch of the Lario around Lecco and in a small strip of land towards Bellinzona, which at the time was ruled by the Sforza. (See Figure 77.)

This very particular hairstyle, typical of Larian women, signaled to the other members of a small community the entry into adulthood, usually coinciding with a marriage proposal, which gave the girl who received it the status of *Promised Spouse.*

This condition allowed her, among other things, to pull up her hair, until then kept strictly loose. After receiving the proposal of marriage, it was for the girl's parents to give the bride-to-be the first sword, which was inserted horizontally in her hair and closed at the ends by two "olives".

[601] But without being granted scientific recognition.

[602] Announced through a BBC documentary, hosted by Andrew Graham-Dixon and titled *The* Secrets of Mona Lisa and a text by Pascal Cotte himself, Lumière on the Mona Lisa. Leonardo da Vinci. Hidden *portraits*—Hudson Hills Press.

FIGURE 77 — DETAIL OF THE ABRASIONS HIGHLIGHTED BY PASCAL COTTE IN THE MONA LISA AND THE TYPICAL SWORDS OF A SPERADA OF THE 15TH CENTURY

From that moment onward, and for every year of marriage spent together, it was for the husband to give his wife the next swords, which were inserted in her hair to form a halo. In this way, from the total number of swords that formed a Sperada, one could understand the number of years that two people had been united in marriage.

The abrasions around the head of the Mona Lisa are therefore not the evidence of the pearly hairpins used by the women of the Florentine aristocracy to style their hair, but of the Sperada, an exclusive symbol of the Larian territory to identify a Promised Spouse.

This particular custom was borrowed from the second half of the 15th century, presumably from that group of Neoplatonic artists who wandered around the Larian territory, who clearly transmitted to the locals the philosophical meaning underlying this particular representation. It is not otherwise explained how the halo, a widely shared icon that expresses the higher spiritual condition that manifests itself with the Sacred or Hierogamic Marriage, is only in this specific geographical area derived into an ornament that becomes the symbol of social status such as the Sperada, which is clearly the emblem of the loving union between two subjects belonging to a very confined community, which is the one coinciding with the landscapes represented by Leonardo in his paintings.

The comparison of the Gioconda's abrasions with the oldest paintings, dating back roughly to 1460/80 and located in the area of Alto Lario, I would say resolve any doubts about it. (See Figure 78.)

FIGURE 78 — VANINETTI HOUSE, SACCO DI MORBEGNO (SO)

Sperada became famous outside the Larian borders only after 1840 thanks to the famous historical novel by Alessandro Manzoni, *The Betrothed*, set by the author in Lecco and its surroundings.

Speaking of Sperada, famous is the passage in which Manzoni describes Lucia Mondella's wedding outfit:

> Lucia was coming out at that moment tight up by her mother's hands. Her friends were stealing the bride, and they were giving her strength so that she would let herself be seen: and she was shielding herself, with the tenacious modesty of the peasant women, shielding her face with her elbow, bending it on her torso, and wrinkling her long black eyebrows, while her mouth opened to a smile. The black and youthful hair, divided above the forehead, with a white and thin rope, was tightened, behind the head, in multiple circles of braids, pierced by long silver pins, which divided around, almost like rays of a halo, as the Milanese peasants still use. Around her neck she had a habit of garnets alternating with gold filigree buttons.[603]

But there is more. As I was saying, there was a moment in her wanderings when the Gioconda ended up hanging in Napoleon Bonaparte's bedroom in Paris. Here a very young Alessandro

[603] Alessandro Manzoni, The Promised Spouses, ch.II.

Manzoni, who went to Paris at the time to see his mother Giulia[604], who in the meantime had married her second husband, Carlo Imbonati[605], was surely able to see and appreciate her. Imbonati was then able to introduce the young Manzoni to the Parisian humanistic circles and to influence, together with Vincenzo Monti[606], his literary style. I do not exclude that the literary and humanistic environment frequented by Manzoni may have had a profound influence on his education and esoteric knowledge, mainly alchemical-Masonic. The fact remains that when, in 1840, the novelist of Lecco origin gave to the press a second edition of his famous historical novel, known as "*fortyth*", he decided to enrich it with illustrations entrusted to a young Piedmontese engraver, Francesco Gonin. When it came to defining the figure of Lucia Mondella, the Promised Spouse, Manzoni imposed on the young engraver to faithfully replicate the Gioconda, who was able to see *de visu* in Napoleon's bedroom.

Sperada included. (See Figure 79.)

Also for this reason, as you can well understand, the references to the Lombard territory contained in the Gioconda are many and go well beyond the simple reproduction of the landscape in the backgrounds, including elements of local tradition that confirm the narrative structure of the work, the Sacred Marriage, leaving little room for different interpretations.

Returning to the de Beatis' diary, we are then finally able to give a definitive answer to the question asked earlier.

If the painting on display at the Louvre does not depict the Mona Lisa, then who is the woman portrayed?

The day after his visit to Leonardo, on 11 October 1517, de Beatis wrote a new page in his diary, this time from the Royal Residence in Blois.

[604] Giulia Beccaria, daughter of Cesare Beccaria, jurist, philosopher, economist and man of letters considered among the greatest exponents of the Italian Enlightenment, a leading figure of the Milanese Enlightenment school.

[605] Carlo Imbonati was a wealthy Milanese aristocrat, whose father founded the *Accademia dei Trasformati*, a cultural circle of direct derivation of the previous sixteenth-century Academy. Imbonati, in addition to the young Alessandro Manzoni, among others, had the opportunity to grow culturally, also Parini and Verri himself.

[606] Vincenzo Monti was a Milanese poet, writer, translator, playwright and academic, commonly considered the exponent par excellence of Italian Neoclassicism.

FIGURE 79 — COMPARISON BETWEEN THE DRAWING FOR THE ENGRAVING OF LUCIA MONDELLA (BRAIDENSE LIBRARY, MILAN) AND THE GIOCONDA

Mentioning the works of Leonardo that he saw collected in a corner to be taken to Fontainebleau, de Beatis writes:

> There was also an oil painting representing a certain
> Lady of Lo'bardia of natural beauty: but in my opinion,
> not as beautiful as Ms Gualanda.[607]

Now, I cannot say how beautiful Isabella Gualandi[608] was, the "Ms Gualanda" mentioned here by de Beatis, but I can say for certain that the "Lady of Lo'bardia" has nothing to do with the Florentine Lisa Gherardini, Pietro Francesco del Giocondo's wife.

For all that has been written so far, it is plausible to believe that the painting observed by Cassiano del Pozzo in 1625 and associated with the nickname given to it first by Lomazzo in 1585, perhaps to underline its divine condition, is in fact "the Lady of Lo'bardia", the painting that de Beatis saw among those purchased a year earlier by the King's treasurer from Gian Giacomo Caprotti for the sum of

[607] Antonio de Beatis' *travel diary*, 10 October 1517—Ref. XF28, Naples National Library.
[608] Daughter of a butler of the court of Alfonso of Aragon.

2,604 tornelli and placed in a corner with other paintings about to be taken to the Castle of Fontainebleau.

As further and definitive support of the philosophical reference that underlies the entire representation[609], in aid of our case is an iconographic peculiarity of Leonardo's, related to the identification of the Larian landscapes in his paintings.

We have seen how the Tuscan artist subordinated the iconographic structure of his own paintings by adapting the silhouette of the portrayed characters to certain landscape references, so to give the work itself a further intrinsic meaning. This singular peculiarity, never explored before and typical of Leonardo alone, was then unconsciously replicated by his emulators.

The Virgin of the Rocks, for example, which as we have said is set in the Grotto of St. John the Baptist in Laorca, above Lecco, was originally conceived according to the recurring iconography as a Madonna of the Spindles; during the work, however, it is modified by adapting the profile of the four subjects portrayed to the outline of a mountain relief above the cave itself, called Nibbio, referring to the same concept of Mother Goddess Mut badly interpreted by Freud.

So too will Leonardo do with the Last Supper.

The preparatory drawings for the work, both the ones kept at the Royal Collection Trust in Windsor and at the ones at Gallerie dell 'Accademia in Venice, included a semi-circular arrangement of the apostles, with Judas sitting on the opposite side of the table and John bent over Christ, according to a recurring iconographic tradition.

Under development, however, the painting radically changes its iconographic arrangement: Judas is aligned with the other apostles, John is separated from Christ (thus symbolically declaring the end of Sacred Marriage by the hand of Peter[610], the true traitor), the profile of the apostles, now arranged in a linear order, is dictated by the unmistakable outline of Mount Resegone, the mountain overlooking the Lecco basin and behind which the sun rises during the summer solstice.

Do you remember the accusation that Prior Bandello made against Leonardo while painting the Last Supper?

[609] The Holy Matrimony, union of opposites.
[610] Allusive to the Church, which through the distorted use of the word, symbolically represented by the knife which he holds behind his back, does not allow Holy Union in Spirit.

> He used to [...] go in the morning at an early hour to
> mount on the scaffolding, because the *Last Supper* is quite
> far above the ground; he would continue to paint, as I say,
> from the rising of the sun until dusk in the evening, never
> taking the brush out of his hand, and forgetting to eat and
> drink. There would have been two, three, four days then,
> that he would not put his hand to it, and yet he remained
> there at times for an hour or two of the day, solely in
> contemplation, lost in thought, judging his figures. I have
> also seen him, on a whim or a tantrum, leave at midday,
> when the sun is in Leo, from the old court where that
> wonderful clay horse was composing, and come straight to
> the Graces and ascend onto the scaffolding to take the
> brush and give one or two strokes to one of those figures,
> and then leave and go elsewhere.[611]

Do you know what Leonardo was really doing?

He scrutinized the Resegone outline, which today as then stood
out on the horizon just behind the north-east facing side on which he
painted the Last Supper.

The link between the city of Milan and the Resegone is as old as
the city itself, as it represented one of the four cardinal points on the
basis of which the Celts built the Nemeton, which formed the first
nucleus of the city, where today stands the Teatro alla Scala. This
almost embryonic bond remained unchanged until the end of the 19th
century, when a building restriction called the *Servitude of the
Resegone* was still in vogue. According to this environmental
restriction, until then it was forbidden to build buildings in the Porta
Nova area that obscured the view of the Resegone. This constraint
was definitively broken in the last decade of the 19th century with the
construction by a certain Luraschi of the first Milanese building in
which concrete was used.

Beyond explaining how the iconographic structure of the Last
Supper took shape, this episode becomes emblematic to tell in all its
drama how, in the name of an alleged progress, that deep and
indissoluble relationship between man and nature, which our
ancestors were well aware of preserving, has prevailed.

The same way in dictating the iconographic choice of his own
work is applied by Leonardo in the painting with St. Anne, the
Virgin and the Child with the little lamb in which the bodies of the

[611] Matteo Bandello, Novella LVII

two women repeat the silhouette of the Legnone and Legnoncino Mountains, which overlook the Lario near Colico, where the Valtellina begins.

Could he then refrain from using this symbolic/figurative method with the most iconic and famous painting in the world, which we can now finally call by its name: the "Lady of Lo'bardia"?

Of course not.

In this case the protagonist profile is dictated by the outline of the Bellagio promontory, which Leonardo knew well because with Ludovico il Moro had often been a guest of the local feudal lord, Marchesino Stanga.

The Bellagio promontory ideally unites in marriage the western branch of the Lario with the eastern one, summarizing in itself that primordial unitary concept that is the first prerequisite for access to the Kingdom of Heaven, as is also written in the apocryphal Gospel of St. Thomas:

> When you make the two one, and when you make the inside as the outside and the outside as the inside, and the top as the bottom, and when you make the man and the woman as one, so that the man is not a man and the woman is not a woman, when you have eyes instead of eyes, hands instead of hands, feet instead of feet, and figures instead of figures, then you will enter the Kingdom.[612]

It's Bellagio making of Lario's two branches only one.

The Lario in fact naturally describes an inverted Y, a letter that in the Renaissance symbolically indicated the Rebis, the two-headed Androgynous; Bellagio, being positioned at the center of the bifurcation of the two branches, seems therefore the ideal choice to symbolize that union of opposites that the painting wants to celebrate.

The fact then that the Bellagio promontory resembles the silhouette of a lady, so damn similar to the profile of the painting displayed at the Louvre in Paris—is this just by chance or can we assume that Leonardo replicates the sinuous profile of the Bellagio promontory to paint the "Lady of Lo'bardia"? (See Figure 80.)

[612] The Fifth Gospel of Thomas the Apostle.

FIGURE 80 — THE BELLAGIO PROMONTORY, DETERMINING THE PROFILE OF THE "LADY OF LO'BARDIA" (SIGNURA DI LO'BARDIA)

Of course, the question is rhetorical at this point in the reading.

With good probability, the portrait that Leonardo made of Lisa Gherardini must have fulfilled the only portrait purpose requested by her client, her husband Pietro Francesco del Giocondo, and I do not exclude that it may have been lost, as it is more than plausible that many of his other works were lost, together with the most important writings.

From a purely symbolic and philosophical point of view, identifying in the work exhibited at the Louvre the "Lady of Lo'bardia" represents great progress in the direction of understanding that neo-Platonic knowledge in the furrow of which Leonardo was raised and of which today, because of the strong obstructionism of which he was the object, we have only a faint and indefinite memory.

I therefore expect that this reinterpretation of the most iconic and famous work in the world will ignite a new interest and enthusiasm not only in this painting, but in Leonardo's entire life and artistic production.

After this exhibition, I hope with all my heart that the sickening research aimed at defining the identity of the woman portrayed or at identifying the landscapes that form her background, moved more by speculative instincts than by the actual desire to know Leonardo's

work in depth, will cease to exist once and for all, if only because they continue to feed and perpetuate that ignoble distorting process of which Leonardo was a victim in life and postmortem.

CH. IX—THE THOUSAND FACETS OF A MAN TWICE ILLEGITIMATE

> And afterwards he stayed with Duke Valentino[613] and then in France in several places. And returned to Milan. And while he was working on the horse to cast in bronze, due to the state revolution, he went back to Florence and for six months stayed at the house of Giovanni Francesco Rustici, sculptor in via de' Martelli.[614]

With this concise description, the Anonimo Gaddiano dates Leonardo's temporary return to Florence after the Holy League[615] drove the French out of Milan, who had become the new patrons of the Florentine artist thanks to the intercession of Charles d'Amboise, French governor of Milan on behalf of the King Louis XII. Charles d'Amboise had been relentlessly wooing Leonardo since 1506.

At the king's express request, Leonardo returned to Milan in 1508, and there he remained until 1511, when the French were driven out. The following year the gonfalonier Pier Soderini was also banned from Florence. This meant that all the conditions that guaranteed Leonardo political protection were gone, and so, after spending a short stay in Rome under the protection of Giuliano de Medici (brother of Pope Leo X), in May 1517 he left for France for good, along with Francesco Melzi, Salai, and his servant Battista de Vilanis.

Here the Florentine artist, now old and handicapped in his right hand, was housed by the king[616] in the castle of Clos-Lucé[617], not far from Amboise. He was honored with the title of "premier peintre, architecte, et mecanicien du roi," with a pension of 5,000 ecus.

The last years of Leonardo's life were very intense and productive, so much so that the majority of the works that have made it to us are

[613] Cesare Borgia, called the Valentino, one of the most controversial figures in history who inspired *The Prince* by Nicholas Machiavelli, Cardinal of the Roman Church and Duke of Romagna and Urbino.

[614] Central National Library, Florence (Cod. Magliab, magliab. XVII, 17).

[615] An alliance signed on the 1st of October 1511, against Louis XII King of France, by Pope Julius II, the Venice Republic, Ferdinand II of Aragon and the Swiss cantons.

[616] Francesco I, son of Louis XII, who met Leonardo during a trip made to Bologna with Giuliano de' Medici.

[617] Where soon after he will meet the canon Luigi de Beatis.

traceable back to these years. He painted the *Virgin and Child with St. Anne and a Lamb*; it is said he collaborated with De Predis on a second version of the *Virgin of the Rocks*[618], which honestly does not have much of Leonardo; he dealt with geological, hydrographic, and urban problems; and he made a study of a project for an equestrian statue in honor of Gian Giacomo Trivulzio, leader of the French conquest of the city of Milan. In April 1509 he announced that he had solved the problem of curved perspective lines, and the following year he went to study anatomy with Marcantonio della Torre at the University of Pavia with the clear intention of mapping the human body and giving forward momentum to medicine:

> The true news of the human figure, which is impossible that the ancient and modern writers could ever give true news of it without an immense and tedious and confused length of writing and time; but, with this very short way of figuring it[619], full and true news will be given. And so that such benefit that I give to men does not get lost, I teach the way to reproduce it with order.[620]

Leonardo's attraction to the anatomical study was evidently aimed at replicating *The Canon of Medicine* written by Avicenna[621] centuries earlier. He proved himself to know the work and philosophy behind Avicenna's work, as can be clearly seen from a caption on the side of a drawing related to reproduction:

> Here Avicenna wants the soul to give birth to the soul and the body to the body.[622]

During this time Leonardo made a series of short trips. He visited Como and ventured to the slopes of Monte Rosa. He stayed with Salaì and the mathematician Luca Pacioli in Vaprio d'Adda, in the province of Milan, where he reproduced as a drawing the ferry that departed from the shore below the house of the Melzi where he dwelled and from where the Naviglio della Martesana departed.

[618] Today at the London National Gallery.
[619] i.e. through realistic drawings.
[620] Book on Anatomy A, Sheet 9v—Royal Collection Trust, Windsor.
[621] Avicenna (980—1037), considered the father of modern medicine, was a Persian doctor, philosopher, mathematician, logician and physicist.
[622] Anatomic drawings, Royal Collection, Windsor.

During this period the young and faithful pupil Francesco[623], who followed Leonardo to France and onwards until his death, was entrusted to him.

During the Roman period, Leonardo devoted himself profitably to his scientific studies. He designed many mechanical things, did studies of optics and geometry, and wrote the treatise *De Vocie,* which was later taken away from him. He searched for fossils[624] on nearby Mount Mario, an old passion of his from the days when, running around on the Grigne[625], he wrote about them in the Leicester Codex[626]. He was prevented from carrying out his anatomy studies in the hospital of the Holy Spirit.

Unlike Raphael, Botticelli, Ghirlandaio, and Perugino, Leonardo did not receive from the papacy any artistic commissions to be carried out in the Vatican, although he resided there. But he dealt with how to proceed with the draining of the Pontine Marshes. The works proposed by Giuliano de' Medici and approved by Pope Leo X on 14 December 1514 were never carried out, though, due to the sudden death of both Giuliano and the Pope.

While in Rome, the artist also began to work on a project with mirrors that were to be used to direct the rays of the sun in order to heat a water tank, which could be employed for the propulsion of machines. The project, however, encountered several difficulties, especially because he couldn't come to an agreement with the mirror specialists that had been brought in from Germany for the purpose.

At the same time, Leonardo tried to resume his anatomy studies, which he had been long conducting in both Florence and Milan. But soon things got complicated in Rome: an anonymous letter accused him of witchcraft. It was probably on this occasion, in the search for elements that could be somehow considered heretical, that the treaty on the voice[627] was taken from him. In the absence of the protection of Giuliano de' Medici and faced with a situation that had become extremely serious,

[623] Author of the portrait that constitutes the basic implant of the Italian cover of this work of mine.

[624] Conch.

[625] Mountains above Lecco.

[626] *"You can now demonstrate as almost all the conchs are not born if not in salt water; and as the conchs in Lombardy have 4 levels; and so all of them, as they are made in several phases; and they are around all the valleys, which overlook the sea."* Leicester Codex, Sheet 36v.

[627] De Vocie.

Leonardo was therefore forced to go to France, where Francis I awaited him with open arms.

If you notice, this brief and hasty reconstruction of the last twenty years of Leonardo's life roughly coincides with the image of him that we have firmly rooted in our mind, as it emerges from what was written in the many codices that have come down to us: a brilliant man, scientist, anatomist, military expert, and creator of hydraulic works.

And what happened to the previous sixty years of life for humanity's greatest genius? I'm referring to when, as little more than a boy, he was brought with his already great reputation to Duke Francesco in Milan to entertain him with his lyre. He was also already acclaimed as a great painter, so much that he was among the first to know and teach the technique of anamorphosis, which was used in the *Annunciation* of 1472.

And great philosopher, let's not forget that. To the point that he was portrayed by Benozzo Gozzoli as Sant 'Agostino while, with Lorenzo and Giuliano de' Medici, he arrived in Milan in 1465.

About this Leonardo, the one more genuine, true, and profound, and in whom the Neoplatonic foundation of Byzantine derivation was strongly rooted thanks to targeted teachings by the most illustrious humanists of the time—what happened? No writing of him, no news or images of the time about him except the few notes contained in the archives of the Florentine register. Neither from him nor about him. How is all this possible?

Yet the anamorphic technique of the *Annunciation*, the musical knowledge inserted in the *Liber Musices* or the instrumental knowledge that allowed him to enchant the Milanese court of Francesco Sforza in 1465, the drawing of *Landscape with River* of 5 August 1473 that shows how he could naturally write in an ambidextrous way—all these suggest that he must have produced works before that date. Where did they go then?

It is not credible for a person to get up one morning, out of the blue, knowing how to do all this stuff without prior leaving a single note, a sketch, a scribble.

It is logical then to think that the missing production of his ingenuity and philosophy and knowledge as it related to these early years of his life—those in which Florence lived a cultural revolution thanks to the graft of knowledge of pagan derivation on the occasion

of the Council of 1439—were strongly opposed by Rome as a perceived threat to the Catholic foundation.

For this reason then Leonardo's youth production, developed in these early years, may have been left in Florence and there destroyed (or at best stolen and concealed, which would give hope that one day it could miraculously reappear, perhaps from some dusty basement of the Vatican archives), when in stress and haste he was advised to leave Florence to return to Milan a second, if not a third, time in 1482.

My conviction, supported extensively by the facts documented so far, is that Leonardo's image as it has come to us has been deliberately distorted over time because it represented for the papacy and the dogmatic Catholic foundation a substantial threat precisely for what he personified, both from a cultural point of view and for the recognition that his contemporaries have unanimously bestowed him.

For this reason I consider Leonardo "twice illegitimate": first on the basis of his status as an illegitimate son of Sir Piero da Vinci, but above all because the knowledge of which Leonardo was the supreme witness was branded as illegitimate by the courts of papal censorship. Since the middle of the fifteenth century, these institutions have done everything to stem the pagan culture of Neoplatonic style of which he was the first referent, after being appointed by George Gemistus Pletho himself.

This second condemnation of illegitimacy, which has always been hanging over his head as a kind of a firebrand, has strongly contributed to the fact that the image and work of this extraordinary character have been deeply contrived, stereotyped, and conformed around an interpretation not so hostile to the Catholic foundation that has since permeated Western culture.

The punishment for this type of conviction is to be made the subject of a partial, implausible narrative aimed at defining the profile of that papier-mâché myth, which Leonardo turns out to be today, based on an endless series of presumptive paths built on the subjective interpretation of distorted documentary elements and on the obvious denial of incontrovertible facts.

Fortunately, as was the case with the events concerning the first trips to America, art comes to our rescue. Careful though: not the art as it is intended today, an expression of human impulses, subjective, whose perception is based on the interpretation of the observer or, worse, of the art critic who dictates a partial subjective reading, but the art of the Renaissance, what for Leonardo was the noblest among the arts as faithful

reproduction of the natural order, supreme to any rule or law man is able to elaborate.

I am aware that this statement will hurt more than one person's feelings, but I have never been afraid to make enemies. It is an objective fact. Art, including music, has now become the manifest expression of Man's inferiority toward Nature. In the attempt to rise above it, and desiring consequently to dominate it and subject to his lowest impulses, Man has insisted on sanctioning the triumph of that individualistic and self-referential subjectivity that represents the foundation of modern society on the granite perfection of the natural world, which is governed by a higher law and in which everything is the integrated part of a single universe.

Everything is one in nature. The Renaissance men understood this well. Everyone is everything, however, according to that law imposed by the countless Inquisition courts, the blacklisting of forbidden books, and the destruction of works in which the Renaissance cultural foundation was expressed in images. The hope is that one day man will be able to awake from this cognitive oblivion, giving birth to a new Renaissance.

Let us then pick up from where this chapter began, i.e., Leonardo's return to Florence:

> And he proved himself in statuary with the three
> bronze figures that are above the door of San Giovanni on
> the northern side, made by Giovanni Francesco Rustici
> but arranged on the advice of Lionardo, which are the
> most beautiful works both of design and perfection ever
> seen in modern time.[628]

The Giovanni Francesco Rustici mentioned here by Vasari is the same Florentine sculptor who hosted Leonardo in 1511 when the artist was forced to leave Milan for the umptieth time, after the French were driven away. This sculptor, educated in the aforementioned Garden of San Marco, worked very closely with Leonardo. Among other works of his that reached us today, we have four terracotta groups[629] inspired by the Battle of Anghiari, the famous painting that the Florentine genius would have tried to make on one

[628] Giorgio Vasari, The lives, 1550/1568—Leonardo da Vinci.
[629] Two at the Bargello in Florence, one at Palazzo Vecchio, also in Florence, and one in the Louvre.

of the walls of the Council Grand Hall[630] with an innovative technique, that failed.

The statues mentioned by Vasari were poured in bronze to be placed above the northern door of the Baptistry of San Giovanni[631].

In this regard, the author of *The Lives* is more explicit in the biographical section dedicated to Giovanni Francesco Rustici himself:

> Giovanfrancesco, having received much credit for these works, the consuls of the art of the Merchants - causing to be removed some grisly marble figures that were above the three doors of the temple of St. Giovanni, made, as it has been said, in 1240 and allocated to Contucci Sansovino those who had to be put in place of the old figures above the door that is toward the Mercy - they allocated to Rustici those that had to be placed over the door turned toward the rectory of that temple, so that he made the same three bronze figures that were there before, which were a preaching St. John between a Pharisee and a Levite, each four arms tall. The commission was indeed very appreciated by Giovanfrancesco, as it was going to be placed in a location so famous and of great importance, and beyond that for the competition with Andrea Contucci. Promptly commencing the work and making a small model, exceeding it with the excellence of the work, he had all the considerations and diligence that such a job required. Once finished, the work was considered in all its parts to be the best ever made and perceived, being those figures of entire perfection and made with terrific grace and skill in their appearance. Equally, the bare arms and legs are very well conceived and attached to the joints, so that it is not possible to do better. And to say nothing about the hands and feet, what grateful attitudes and heroic gravity have those heads? While laying this work in clay, Giovanfrancesco did not want anybody around him but Lionardo da Vinci, who in making the molds, armed them with irons and constantly till the statues were not cast, he never abandoned it, so that some believe, without knowing much more, that Lionardo worked them with his own hands, or at least helped Giovanfrancesco with his good advice and judgment. These statues, which are the most perfect and better conceived than have ever been made in bronze by a modern master, were cast three times and polished in the house where Giovanfrancesco lived in via de' Martelli, same for the marble ornaments that are around the St.

[630] Today the Hall of the 500.

[631] It is considered the most glorious and prestigious monument of Florence, located in front of the Cathedral, not far from the Palazzo Medici Riccardi.

Giovanni, with the two columns, frames, and art insignia
of Merchants.

In addition to the St. Giovanni, which is a vivid and
vibrant figure, there is a chubby figure with a big head,
which is beautiful; with his right arm above his hip, a little
bare shoulder, and holding with his left hand a paper in
front of his eyes, he has his left leg crossed over to the
right one, and he is in a contemplating position to answer
to St. Giovanni, and dressed with two kinds of clothes: a
thin garment covering the naked parts of the figure, and a
thicker mantle above it, made with a series of pleats that is
very elegant and cunning. Similar to him is the Pharisee
who, with his right hand on his beard, with grave attitude,
retreats a little, showing astonishment at Giovanni's words.
While Rustici was making this work, becoming annoyed
by having to ask constantly for money from the consuls or
their ministers, who were not always the same and most of
the time were people who did not value virtue or any
work of value, he sold (in order to finish the work) a farm
that he possessed just outside Florence in Old St. Marco.[632]

Beyond whether these statues can be attributed to Leonardo, and
beyond the undeniable affinity that Leonardo had with Rustici[633], the
surprising thing is that one of these statues is the exact replica of
Leonardo's most famous self-portrait. Is it possible that no one
noticed it before me?

And yet, no more than a decade ago, these statues were restored
by the staff of the *Opificio delle pietre dure* of Florence. They have
since been analyzed in great detail and in depth by scholars, restorers,
and superintendents, but they evidently focused their attentions on
fusion techniques and the references to Michelangelo and the
gospels[634] expressed by these statues rather than worrying about
placing the emphasis on the macroscopic similarity between one of
these statues and Leonardo's most famous self-portrait. (See Figure
81.)

[632] Giorgio Vasari, The Lives, 1550/1568—Giovanfrancesco Rustici.

[633] Who was hosted precisely in Rustici's home in Via de' Martelli, where these statues
were cast at the sculptor's own expenses.

[634] This is what can be gathered from the reviews and studies surrounding these statues.

FIGURE 81 — PORTRAIT OF LEONARDO IN LA PREDICA DEL BATTISTA, GIOVAN FRANCESCO RUSTICI, 1511—BAPTISTRY OF S. GIOVANNI, FLORENCE

I'm talking about the *Preaching of St. John the Baptist,* a scene attributed to Rustici represented by three bronzes more than two meters high and conceived as a dialogue between the Baptist, the Pharisee, and the Levite. The bases underneath the three statues bear three cartouches in Hebrew with the questions and answers from the gospel of John: "Who are you?", "Are you Elijah?", "I am the voice of one crying in the desert."

Leonardo's famous self-portrait, which the Baptist statue is inspired by, is the one on sanguine dated around 1515 and preserved at the Royal Library of Turin. The importance of this validation is absolute, as it gives us a valuable contribution in defining the appearance that Leonardo had in 1511, when the statues were cast. If he was actually born in 1452, by that time the artist would have been fifty-nine years old, which is further denied by the physiognomy of this statue. Moreover, this similarity makes

me think that the famous sanguine self-portrait may have been executed even before this date.

The statue, then, very accurate in the details, confirms the presence of a xanthelasma between the nose and the eye of the Florentine artist. You will agree with me that the presence of this element in a statue cannot be the result of mannerism, for the simple reason that reproducing seemingly secondary details as well as being useless is even more anomalous in a statue than in a simple drawing or painting.

As in the case of the Gioconda... oh, sorry... of the Lady of Lo'bardia, its presence is therefore necessarily due to the explicit willingness of the artist to identify a specific person, who in this case . of the Rustici's Baptist is indisputably Leonardo.

Which, again, helps us understand many other things. First of all, it confirms the thesis that the Lady of Lo'bardia is Leonardo's portrait as a female. Indirectly, this is confirmation that that anomaly in the right hand highlighted in the portrait in the Louvre may be the first instance of the paralysis that struck him in later years, as proven by de Beatis in the chronicle of the meeting he had with the artist in Cloux, France.

Secondly, this similarity shows as the fact that in 1511, a statue with Leonardo's features was placed on one of the city's most valuable monuments. Careful: I am not referring to an iconographic representation of the evangelical meeting between the Baptist, the Levite, and the Pharisee made on the drawing or by the hands of Leonardo. Oh, no. I'm talking about a statue representing Leonardo.

It means that Florence erected a statue with the features of its most famous and beloved citizen on one of the most emblematic structures in the city. If this is not a public endorsement!

It is evident that for his contemporaries to recognize Leonardo's face in that statue was the most obvious thing. At the time, in fact, not only was Leonardo alive but also very popular, so much so that the gonfalonier Pier Soderini commissioned him for a fresco for the Hall of the 500[635] requested by popular acclaim.

All this makes it questionable to assume that to cast it, Rustici had to sell land of his in Fiesole. It makes no sense that the bronze statue, recognized at the time as the most beautiful that has ever been made,

[635] The phantomatic Battle of Anghiari.

placed on the most prominent monument in the city, and reproducing Leonardo da Vinci—who in those years was a kind of idol for the Florentine and Milanese crowds, as well as for the king of France—should be realized at the artist's expense.

Perhaps some did not want to admit he recognition that the whole city was conferring him, and the story of the self-financing had to be invented. It would not be the first time a story about Leonardo has been mystifying, after all.

Either way, would you have imagined that years of censorship, accusations of heresy, blazes, Inquisition courts, and fake reconstructions could be disproved one day by a xanthelasma? Above all, would you have thought that the presence of this fatty deposit could one day be a source of documentary and scientific evidence for reconstructing Leonardo's entire existence, despite years and years of mystification, discrimination, and presumptive reconstructions?

Well, from now on I'm sure you won't forget it so easily, because the xanthelasma—as well as a slight squint, the dimple on the chin and under the nose, the very pronounced under-eye, the protruding eyes, the high forehead, the slightly bulged nose, the arched eyebrows, the fleshy lips, and the dense, curly hair—are all distinctive features of Leonardo's physiognomy.

And there is more. These details become important markers for detecting a whole range of pathologies, some of which are inheritable, as is the case, for example, of the subnasal and chin dimples. These are a typically dominant and hereditary autosomal character,[636] which can help us in hypothesize a blood descent.

Over the years, many have speculated that the *Portrait of a Musician* could perhaps be a youthful portrait of the Florentine genius. (See Figure 82.)

[636] The dominant autosomal hereditary is a form of transmission of a character from one individual to another. Named dominant for the prevalence of the phenotype over other analogues.

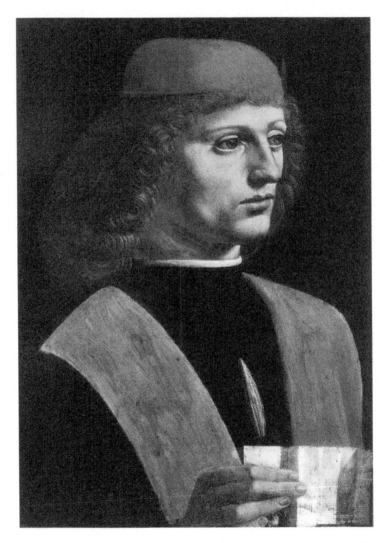

FIGURE 82 — PORTRAIT OF A MUSICIAN—AMBROSIANA ART GALLERY, MILAN

No objection, however, has moved to the authorship of the painting, which is unanimously attributed to Leonardo (with the exception of myself, who actually finds this attribution very far-fetched).

About this painting, dated 1485 and preserved at the Ambrosian Art Gallery in Milan, nothing is known except that in 1671 it was already in the Milanese library. In the past it has been speculated that

it could have been a portrait of Gian Galeazzo Visconti[637]. Someone else instead said it was of Ludovico il Moro. When it was subject to polishing in 1904, the painting revealed the presence of a musical score—until then covered by a light layer of paint—and a lyre plectrum, suggesting that it could be the portrait of a musician.

The enigmatic score is held by the painted fingers in a way that indicates a precise chord and is folded on itself in the clear reference to a canon. It contains the inscription: "Cant... Ang...," followed by a short musical score. The reference to an *angelic canon,* an expression of that music of the spheres that I have previously given ample account of, is evident, and any other musical treatise of the time would confirm it.

From this clue, therefore, someone proposed identifying the man here portrayed with Franchino Gaffurio[638], chapel master of the cathedral of Milan since 1484 as well as composer of a "Cantum Angelicum," i.e., the *Angelicum ad divinum opus;* others[639] have speculated that the subject portrayed could have been the French-Flemish composer Josquin Despre[640], Leonardo's contemporary who was active in Milan in those same years.

When I alluded to a conditioning in the development of knowledge, I was also referring to episodes like this. The fact that Leonardo was an excellent musician—the best of his era, Vasari recalls—is totally ignored by scholars. The hypothesis then that he may be the protagonist of this painting is not even taken into consideration, despite the fact that he wears the cap characteristic of the members of the Florentine Neoplatonic Academy. Evidently Ludovico il Moro, Gian Galeazzo Visconti, Desprez, or Gaffurio — i.e., some of the characters who have been associated with this portrait over the years — were not members of it.

On the other hand, no one has ever dared to question the dubious Leonardo authorship of this painting. Weird, isn't it?

If we want to attempt an explanation, even considering who the venerable Ambrosian Library refers to, we could say that it is more

[637] As described in Federico Borromeo's donation, together with a mysterious "*Head of Petrarca*", this work is cited as Leonardo's work corresponding to the portrait of "*Duke Gio. Galeazzo Visconti.*"

[638] Franchino Gaffurio, (1451—1522) was a musical theorist and composer, singer, teacher and administrator; he embodied the cultured man of the Renaissance, devoted to numerous intellectual and artistic activities.

[639] Carlo Pedretti, *Leonardo, the portrait*—Giunti Editore, 1998.

[640] Josquin Desprez, or Des Prés o Desprès (1450—1521), was a French-Flemish composer.

convenient to support the patrimonial value of a work, even where it is blatantly unfounded, than to reveal its inconvenient contents. After all, it would be enough to compare this painting with an *Annunciation* or to the Louvre *Virgin of the Rocks* (since the one in London is not by Leonardo) to understand how this attribution is without any foundation.

Apart from the issues merely related to the authorship, this painting is extremely important, not only because it portrays again Leonardo in the field that more than any other saw him excel— music—but because it gives us an indirect confirmation of all his physiognomy features just listed: the xanthelasma, a slight squint, the chin and subnasal dimple, the very pronounced undereye, the protruding eyes, the high forehead, the slightly bulged nose, the arched eyebrows, the dense curly hair, and the fleshy lips. Especially the xanthelasma—a defect that would not occur to any artist to reproduce in a painting if it did not precisely identify the person he wanted to portray. (See Figure 83.)

Once the identifying characteristics of Leonardo's appearance have been established, it becomes much easier to draw a methodical guide for highlighting the works where he is portrayed.

In this way we obtain the physiognomic evolution of his face throughout its long and intense existence, including a physiological and progressive protrusion of the lower jaw (due to the loss of teeth), the enlargement of cartilage (nose and ears), and the fall of the soft tissue. What emerges from this simple exercise is extremely surprising: there are a conspicuous number of works—be they sculptures, paintings, or drawings—in which Leonardo is the undisputed subject.

FIGURE 83— PORTRAIT OF A MUSICIAN, DETAIL OF THE XANTHELASMA—AMBROSIANA ART GALLERY, MILAN

Would you have imagined, for example, that the Mercury in Botticelli's *Spring* was a young Leonardo? Or that St. Thomas, in the *Christ and St. Thomas* by Verrocchio, who expresses his disbelief from the newsstand of the All-Saints Church in Florence, under which thousands of tourists and distracted Florentines pass by every day of the year, portrays Leonardo again? From the aforementioned bust of the deacon present in the Old Sacristy of the church of St. Lorenzo in Florence[641] to both *David* by Verrocchio and Donatello, passing through the angel portrayed by Leonardo himself in the *Annunciation* of 1472 and that painted by the Ghirlandaio in the Chapel Tornabuoni in Santa Maria delle Grazie in Florence, just to mention the most resounding and adolescent portraits.

Or I could mention the seven portraits of Leonardo depicted by the hands of Raphael Sanzio in the Vatican Rooms, those of Pietro Perugino and Domenico Ghirlandaio in the Sistine Chapel, Amico Aspertini, Bernardo Zenale, Boltraffio, Marco d'Oggiono, Filippo Lippi, Desiderio da Settignano, Mino da Fiesole, Bernardo Rossellino, Francesco Melzi, Sandro Botticelli, Lorenzo di Credi, Bramante, Francesco di Antonio del Chierico, Vincenzo Foppa, Piero della Francesca , Giovanni Bellini, Albrecht Dürer, Bernardino Luini, Baccio da Montelupo, and so on.

I should also mention Leonardo himself in this list. He not only portrays himself in the *Vitruvian Man* with the xanthelasma in clear evidence, but on many other occasions, considering that most of the anatomy drawings contained in his codex are self-referential. (See Figure 84.)

Actually, I believe that Leonardo in the anatomy drawings often plays to further age himself to investigate what the signs of time on the human body are. He accentuates the protrusion of the jaw, the fall of the soft tissues (eyelids and cheeks), and the curve of the nose.

I could also mention all those paintings by anonymous authors in which the Florentine genius is portrayed a little everywhere he's been: from the Castello of Gradara near Pesaro to the altarpiece preserved at the Art Gallery of the Sforza castle in Milan; on the capitals of the church of St. Maurizio, not far from Santa Maria delle Grazie; or in the church of San Lorenzo in Teglio. Or I could mention his portrait in the Sanfiori chapel in the church of St. Giovanni Battista in Vittorio Veneto, decorated toward the end of the fifteenth century by Antonio Zago, a

[641] The mausoleum of the Medici family, not far from the Medici Riccardi palace.

minor painter of Bergamo who was active in Vittorio Veneto
between 1487 and 1502. In this cycle Leonardo is portrayed as St.
Augustine and placed among the founding fathers of the Catholic
Church. He is wearing the same pinkish dress in which, as we have
seen before, Leonardo was depicted by Benozzo Gozzoli in the
important cycle in the church in San Gimignano.

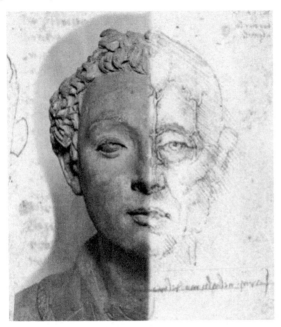

*FIGURE 84 — COMPARISON BETWEEN THE DEACON BUST
WITH THE ANATOMICAL DESIGN IN WINDSOR*

There are hundreds and hundreds of Leonardo's portraits in
circulation, all of which have obviously in common the
representation of the same physiognomic characteristics and above all
the same "physical defects": squint, arched eyebrows, protruding eyes,
bulged nose, fleshy lips, high forehead, subnasal and chin dimples, and
the inevitable xanthelasma. It does not come as a surprise that the
extensive presence of loyal and contemporary representations of
Leonardo's face, precisely because of the role for which his
contemporaries recognized him, was to be an absolute cultural and
artistic reference.

Moreover, if all the biographers who have written about him for
various reasons have unanimously felt the need to emphasize the
beauty, grace, harmony, and strength of his physique from a young

age, it is evident that his appearance was known to everyone from an early age:

> He was so rare and universal that by miracle of nature could be said to have been produced; Nature that not only gifted him of the beauty of the body but also made him master of many other rare virtues.[642]
>
> In Leonardo stood out his gifts of great completeness, very generous and educated manners accompanied by a beautiful appearance.[643]
>
> Great gifts rain down from celestial influences on human bodies, many times naturally and sometimes unnaturally, filling one single body with beauty, grace, and virtue in such a way that whatever he approaches, each one of his actions is so divine that, leaving behind all other men, he manifestly makes himself known for a deed (as it is) bestowed by God and not acquired by human nature.
>
> This is what men saw in Lionardo da Vinci, in whom, beside the beauty of the body, which is never praised enough, was the infinite grace in any of his actions, and so great was his gift that whatever difficult things his soul turned to, he made them with ease. Great was the strength in him, combined with dexterity, spirit, and valor, he was always regal and magnanimous.
>
> And the fame of his name spread so much that not only in his time was he held in high esteem but even more in posterity after his death.[644]

You will understand that, for editorial reasons, I could not report all the portraits found; I will therefore limit myself to show, in the closing of this chapter, a collage of images consisting of a small selection of the portraits of Leonardo in circulation so far identified. At some point I even stopped looking for them, as there are so many in circulation.

Although at the time Leonardo's physical appearance was so popular that an infinite number of artists inserted his face into their works, today when illustrating the stories related to this unique character, only stereotypical reproductions of his face are used: that image of an elderly and bearded painter (emphasized by the typical artist's hat) that lies in the collective imagination.

[642] Anonimo Gaddiano.
[643] Paolo Giovio.
[644] Giorgio Vasari.

Beware, though: it is not the self-portrait preserved at the Royal Library of Turin or the portrait made of him by Francesco Melzi and preserved at Windsor,[645] which are universally recognized as authentic portraits of the Florentine genius, that are being utilized. Rather, it's a series of prints and portraits made after his death, sometimes of dubious provenance, portraying Leonardo in almost caricatured form. Some are like that awful portrait discovered long ago in Acerenza that some would like to attribute to the hand of Leonardo and that it is raging everywhere, as if to further emphasize the insulting image of that myth of papier-mâché that the papal censorship helped to spread and that short-sighted and distracted scholars have perpetrated over time. (See Figure 85.)

This bad habit of wanting to represent Leonardo in his old age, moreover, involuntarily contributes to merging the attentions of public opinion on Leonardo's artistic and biographical maturity. By that time he had lost that freedom of thought and expression granted previously by the protection of the two families to which he was closest to.[646]

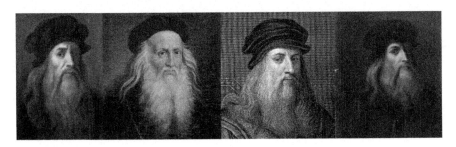

FIGURE 85 — MOST COMMON FANTASY PORTRAITS OF LEONARDO

These images divert people's attentions from what was his most intense and perhaps prolific period from a philosophical and spiritual point of view. I am referring to the period of his youth and post adolescence from which, as I have shown, there is an infinite number of portraits, all perfectly compatible with that made by the student Francesco Melzi. (See Figure 86.)

[645] Francesco Melzi, Portrait of Leonardo da Vinci—Royal Collection Trust, Windsor.
[646] The Medics and the Sforza.

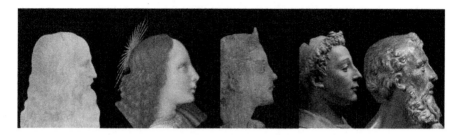

FIGURE 86 — VARIOUS REALISTIC PORTRAITS OF LEONARDO DA VINCI IN DIFFERENT AGES

Returning to the *Preaching of St. John the Baptist* and considering the physiognomic evolution of Leonardo, with a more careful analysis we can realize how all three statues portray Leonardo. The Baptist represents a more youthful portrait, while both the Pharisee and the Levite (cast from the image of one of the many drawings of glabrous men contained in Leonardo's codex), portray Leonardo in two different ages of his maturity. (See Figure 87.)

FIGURE 87 — COMPARISON BETWEEN LEONARDO AND GIOVAN FRANCESCO RUSTICI

Once we've identified the huge number of representations of Leonardo's face and the figurative coherence representing his appearance from adolescence to maturity, we can then make some more precise assumptions about the longstanding parental issue discussed in the opening of the book.

As I mentioned a few lines before, some of Leonardo's features have been inherited form from his parents. While the bags under his eyes, the xanthelasma, the dimple in the chin, and the bulging eyes are genetically inherited from the natural father—which it is clear at this point was not Sir Piero da Vinci, who played only a legal and notary role—the high

forehead, the arched eyebrows, the subnasal dimple, and the tapered shape of the nose are characteristics inherited from the mother.

How can I say that? Simple: thanks to the pictorial art of the time.

The morphogenesis[647] of a person's face is 80% determined by the genetic heritage of the parents. For this reason, many children resemble their parents, sometimes even in an amazing way. This was the case of Leonardo, whose resemblance to his mother was mind-blowing. (See Figure 88.)

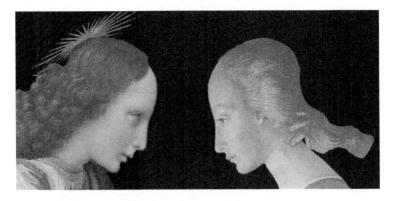

FIGURE 88 — AFFINITY BETWEEN LEONARDO AND HIS MOTHER

The same high hairline, the same nasal profile, the same pronounced lips that suggest a marked under-nasal dimple, the same eye cut. What can appear to be a trivial coincidence, an incidental similarity, turns out instead to be an essential element that can help us to untangle the complex investigation related to identifying who the real parents of this artist were.

The detail we're analyzing is taken from a cycle of frescoes by Domenico Ghirlandaio that is contained in a precious chapel located at the bottom of the right aisle of the *collegiata of San Gimignano,* the same Tuscan city where we find the cycle of Benozzo Gozzoli narrating the deeds of St. Augustine and in whose dress Leonardo is portrayed as a young man.

[647] The process that leads to the development of a certain shape or structure.

Designed by Giuliano and Benedetto da Maiano[648] in 1468, the chapel owes its fame to the mentioned cycle of frescoes[649], in which the events of Saint Fina da San Gimignano[650] are narrated and where her relics are currently preserved.

Fina dei Ciardi (this is the full name of the saint) was born in San Gimignano in 1238. She had a very humble life and from an early age cultivated a total devotion to the Madonna. The sad turning point in Fina's life took place in 1248, when at the age of ten she was struck by a serious illness that caused her a real ordeal of physical pains and family misfortunes. The young Fina relieved these horrors only thanks to her deep faith. As time went by and the disease escalated, her body started to cling to the wood of the table where she had decided to lay down, so much so that her putrid flesh became food for worms and mice. In the meantime, to make matters worse, she also became an orphan. Despite being the victim of all these adversities, however, in her poverty she kept thanking God and increasingly desired for the separation of her soul from the body to join her husband Jesus Christ.

Beyond the way the myth is constructed—through which suffering is followed by the union in spirit with her groom Jesus Christ, a clear allusion to the Sacred Marriage discussed earlier—what interests us about this story is that, once again, using the pretext of representing the life of saints or some evangelical episodes, these frescoes become for the artist the opportunity to tell the stories of characters of the time.

In this cycle of frescoes, as in the one behind the altar of the church of St. Augustine a few hundred meters away, the events concerning Leonardo's life in its various stages are told. In this particular case, it is the illness and the early death of his mother that get reproduced.

The analysis of the painting in its entirety becomes of considerable and unexpected help in supporting some hypotheses. It sheds light on what the real origins of the Florentine genius were and on the basis of all that we have been able to find at the documentary and artistic level so far. These hypotheses, once again, are based mainly on the recognizability of the characters portrayed in the paintings.

[648] An important 15th century Florentine sculptor, author of the altar of Santa Fina in San Gimignano and the pulpit in Santa Croce in Florence.
[649] Dated 1475.
[650] Fina da San Gimignano, born as Fina Ciardi (1238—1253) is revered as a saint by the Catholic Church.

In this case, we're looking at those around the bedside of the deceased. In tears, curved in prayer, and crouching at the feet of the deceased, we find a young Leonardo intent on mourning the loss of his mother. Mercifully holding her hand, we find Lucrezia Tornabuoni, the wife of Piero the Gottoso.

The early death of Leonardo's mother, in addition to ruling out the hypothesis about her visit to Milan and the burial of 1494, becomes extremely important due to the fact that Antonino Pierozzi is here the one celebrating the funeral service. (See Figure 89.)

The combination expressed in this painting that sees Antonino Pierozzi and Lucrezia Tornabuoni united once again recalls ideally the context of those merciful brotherhoods that the Dominican friar helped to develop in Medici Florence, thanks also to the help of noblewomen of social and cultural stature such as Lucrezia.

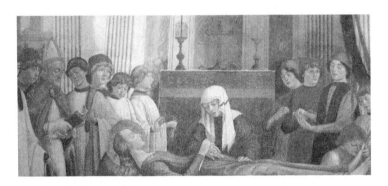

FIGURE 89 — FUNERAL OF SANTA FINA, DOMENICO GHIRLANDAIO, 1475—COLLEGIATA OF SAN GIMIGNANO

As we have seen before, the origins of the Dominican nuns are traced back to the exploits of Caterina da Siena[651], who fought to rescue the one in need when groups of secular tertiaries began to come together to lead common lives and to devote themselves to activities such as education of young women without families. The Dominican Female order of Florence depended on the convent of San Marco, directed precisely by Antonino Pierozzi. The young "Caterinas" were welcomed through an endowment rite called "the

[651] Caterina da Siena, canonized Saint by Pius II, she was part of the Order of the Dominican tertiaries of Siena, called Caped.

caping" and dressing with a white veil, as depicted by Beato Angelico in the Chapter Room[652] of the aforementioned convent in 1441.

I believe that the blue edging of the veil worn by Lucrezia Tornabuoni constituted a kind of hierarchical endowment at the head of the female order. (See Figure 90.)

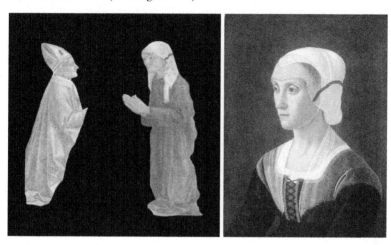

FIGURE 90 — DOMENICO GHIRLANDAIO, PORTRAITS OF LUCREZIA TORNABUONI AND ANTONINO PIEROZZI, NATIONAL GALLERY OF ART, WASHINGTON, VESPUCCI CHAPEL, ALL SAINTS CHURCH, FLORENCE

There is something in the landscapes and characters portrayed in the chapel of Santa Fina in San Gimignano that creates a line of continuity with the frescoes in the Oratory of St. Martino in Florence and those of the cycle of Benozzo Gozzoli in the church of St. Augustine, also in San Gimignano[653], the Chapel Tornabuoni in Santa Maria Novella, and some paintings by Giovanni Bellini and Andrea Mantegna. They are united not only by kinship but also by narrating what happened in the very first years of Leonardo's life.

Thanks to these extraordinary correlations, a breach finally opens in the veil used to obscure Leonardo's true identity through which it is possible to catch new elements that add up to a complete picture that,

[652] The chapter room or simply the chapter is the place where a monastic community meets for a few times throughout the day. After the church and the cloister, it is the most important part of a monastery, or even more of an abbey.

[653] Where it is told about the first Greek rudiments imparted to the very young Leonardo by Giovanni Argiropulo and his dean among the Augustinians.

supported by documentary and pictorial elements, finally allows us to draw the plot of a story that goes far beyond the mere suggestive, so that we can finally clarify Leonardo da Vinci's true identity.

By now I think I have gained some of your trust, so I wish you will excuse the brevity I will have in reconstructing Leonardo's true identity, postponing any more detailed study to future publications.

Before proceeding with this new and final chapter, however, as promised earlier, I attach a collage in which there are collected only some of the many portraits of Leonardo in circulation that so far I have been able to recognize. (See Figure 91.)

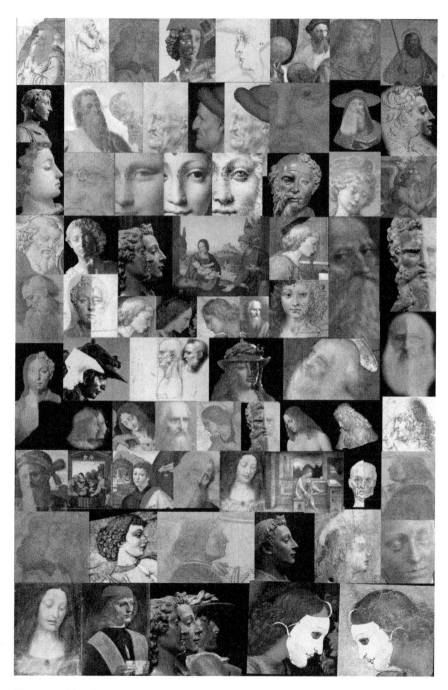

FIGURE 91 - SOME REALISTIC PORTRAITS OF LEONARDO.
VARIOUS AUTHORS, XV AND XVI CENTURY

CH. X—HIS NAME IS JOHN

Having identified Leonardo's mother in the paintings of the artists of the time allows us today to provide the basis for a whole series of clues and documentary evidence about the life of this artist, which for some time had led me to formulate a brief hypothesis, partially anticipated even in the story shared thus far.

This hypothesis had grown in me on the basis of the convergence of some elements contained in the stories of scholars and art historians who otherwise would not find a sustainable logic.

To identify the physiognomy of the mother, moreover, allows us to overcome an objective limit that, proceeding backwards to reconstruct Leonardo's young physiognomy, we would otherwise encounter in the green features of his face.

Paradoxically, once we recognize the mother, we have the opportunity to witness her pregnancy and birth, thus arriving at the true genealogy of Leonardo and identifying the exact date of his birth.

And not only that.

We are even able to formulate a hypothesis on when and why the young Leonardo would be separated from his mother.

We'll arrive step by step, as is my way.

It was noted that Leonardo personifies the role of absolute reference for Neoplatonism, having received the investiture directly from Gemistus Pletho.

Plethon died in 1452 in Mystras, Greece.

He imagined a world guided by natural laws, in which society would be educated by wise initiates who possessed that unique ancient knowledge in which all the existing religions and philosophies converged: Christianity, Judaism, Islamism, Greek and Oriental divinities, the philosophies of Pythagoras and Plato and so forth.

Like many characters of the time, therefore, we find Gemistus Pletho portrayed in an infinite number of Renaissance paintings.

The most important of these is the typical political–cultural manifesto frescoed by Benozzo Gozzoli in 1459 inside the Chapel of the Magi in Palazzo Medici Riccardi in Florence, the epicenter of Medici power and of the entire Renaissance movement that built its advancements around the teachings of Gemistus Pletho himself.

This portrait is of paramount importance because it marks the passing of the baton from Pletho to Leonardo da Vinci, represented by Gozzoli standing behind the master

Gozzoli even decides to portray himself next to them, identifying them in this way as the most influential characters of the entire cycle together with Cosimo the Elder (who not by chance is next to his other self-portrait). (See Figure 92.)

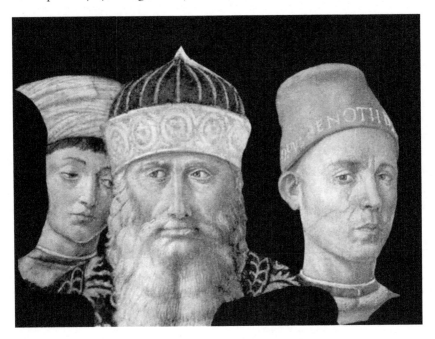

FIGURE 92 —GEMISTUS PLETHO AND LEONARDO DA VINCI—BENOZZO GOZZOLI, 1459, MEDICI RICCARDI PALACE, FLORENCE

The physiognomy of this portrait of Leonardo by Gozzoli follows the one by Ghirlandaio in San Gimignano—where in the role of a young deacon Leonardo weeps in sorrow over his deceased mother—and the bust of a deacon by Desiderio da Settignano in the Old Sacristy of the Basilica of San Lorenzo in Florence, mentioned earlier in regard to his strabismus. (See Figure 93.)

The Old Sacristy is considered one of the absolute masterpieces of Filippo Brunelleschi and of early Renaissance architecture in general, where, not by chance, great artists of that period made important contributions, including Donatello. Commissioned by Giovanni di

Bicci de' Medici[654], the progenitor of the Medici family, whose funeral will indeed be celebrated in this sacristy, the architecture of this extraordinary work dates back to a period between 1419 and 1428, while the sculptural furnishings can be dated between 1428 and 1443.

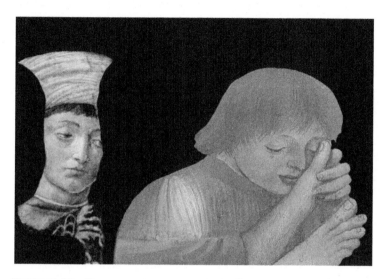

FIGURE 93 – PORTRAITS OF A YOUNG LEONARDO BY BENOZZO GOZZOLI AND DOMENICO GHIRLANDAIO

The Old Sacristy is the only surviving work in which the great Florentine architect took care of the execution until the end of the works and it is universally considered the paradigm of geometric purity and linear elegance. These architectural elements will be developed by Brunelleschi himself later on, such as in the plan of the Pazzi Chapel, or the dead tribunes of the Cathedral of Florence.

The importance of this place is indirectly confirmed by the fact that it was chosen to become the mausoleum of the Medici family, which in that period was at the peak of its political and economic success.

Next to the Sacristy, which significantly was dedicated to St John, in the transept on the left side one finds a chapel designed by Brunelleschi himself which is instead dedicated to Saints Cosma and Damiano. These were the Florentine family protectors, and in the role of one of them

[654] Giovanni di Bicci de' Medici (1360—1429) son of Averardo called "Bicci" de' Medici; he was the first prominent member of the central branch of the Medici family. During his life he succeeded in making a great fortune with the Bank of Medici founded by him and passed his wealth to his son Cosimo.

Leonardo will be portrayed in the church in Mudronno, located in
the Larian triangle just above Bellagio.

The presence of the bust depicting the features of Leonardo in the
Sacristy dedicated to St. John, therefore, is at least suspicious, if not
circumstantial.

As mentioned earlier, Gemistus Pletho is himself depicted in
various paintings, thanks to which we are able to identify his
physiognomy with a certain confidence. (See Figure 94.)

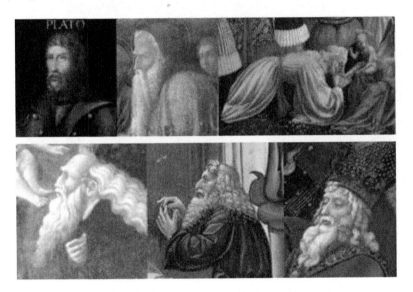

FIGURE 94 —SOME OF THE VARIOUS EXISTING PORTRAYS OF
GEMISTUS PLETHO

One of the greatest experts on Gemistus Pletho is the friend
Moreno Neri, thanks to whom we learn that as well as being depicted
in the Magi Chapel by Benozzo Gozzoli and in some miniatures by
Attavante degli Attavanti[655], the Greek Philosopher is also depicted in
one painting preserved at the Uffizi Galleries in Florence.

This portrait was done by Cristofano dell'Altissimo for Duke
Cosimo I de' Medici, copying it in Como together with at least 280
other portraits from Paolo Giovio's collection, known as the "*Giovio*
series" (484 in total).

655 Miniature of the proem "ad Magnanimum Laurentium Laurentium Medicem patriae
servatorem" of Enneads by Plotinus, translated into Latin by Marsilio Ficino (Ms. Plut.
82.10, col. 3r), 1490, Medicea Laurenziana Library, Florence

Most of these portraits are now exhibited at the Uffizi Galleries in Florence. The painting identified by Neri is thus archived in the registers of the prestigious Florentine museum:

> Caption: on the top "PLATO". Greek philosopher, adviser to John VIII Paleologus during the Council of Florence (1439). He yearned for the universal unity of the churches.[656]

The friend Neri though, who I would like to thank publicly for the support in a tedious querelle moved against me by the Rimini Intelligentsia[657], is still unaware of the fact that the number of portraits in which Plethon is depicted is enormous, for the same reasons as Leonardo's: the public recognition in representing Neoplatonism.

The identification of Cristofano dell'Altissimo's painting preserved in the Uffizi is however important to define a physiognomy of reference, thanks to which I was able to identify Gemistus Pletho in many other paintings of that period.

The second portrait among the ones illustrated is a detail from the Presentation at the Temple, a painting by Andrea Mantegna[658] datable around 1455 and preserved at the Gemäldegalerie in Berlin.

This same iconographic subject is also taken up a few years later by Giovanni Bellini, of whom Mantegna was brother-in-law by marriage to his sister Nicolosia, who is in fact portrayed by the artist on the left side of the canvas, recalling the dual concept of opposites that was widely discussed in the previous chapters.

The importance of this painting is represented by the contemporary presence of Gemistus Pletho, the young Leonardo and his mother (recognizable by the white veil of the *caped* St. Marco on her head) while she is in the act of offering (perhaps "reluctantly offering", given the placement of the hands) her son to the Greek philosopher, advisor to Giovanni VIII Paleologus. (See Figure 95.)

[656] Moreno Neri, Riminiduepuntozero, 11.06.2017—Uffizi Galleries Archives, Florence.
[657] Querelle which focused on my theories concerning the painting by Piero della Francesca with the view
of America, strongly opposed by some local art historians and critics.
[658] The author self-portrays himself on the left-hand side of the painting.

FIGURE 95- ANDREA MANTEGNA, PRESENTATION AT THE TEMPLE, 1455—GEMÄLDEGALERIE, BERLIN.

As mentioned in the opening of the chapter, having identified the physiognomy of the mother allows us, by association, to identify many childhood portraits of Leonardo otherwise impossible to certify, although for some the context is equally strongly circumstantial.

This last aspect is important not so much to define a physiognomic evolution of the character himself, although I can imagine the curiosity in wanting to observe the childish face of Leonardo, but because it confirms that he was subject to particular attentions since infancy.

We can trace this extraordinary, almost obsessive attention to portraying Leonardo from an early age, to a series of causes that have occurred individually or in combination.

In the light of what we now know, we might assume that many wished to celebrate Leonardo because of his role in the cultural evolution of the Renaissance, or because of his undisputed artistic and intellectual abilities.

Indeed, we have frequently recalled, especially through the words of his biographers, just how exceptional was the recognition he

received in life. However, the painting suggests that even from an early age Leonardo was already being singled out.

In this sense it could also be understood why little Leonardo was often portrayed with Gemistus Pletho, with the latter in the role of the Magus who comes from the East to celebrate the birth of the Saviour.

According to the *Gospel of Matthew* (2,1–12), the Magi were a small group of wise astrologers who, following a certain astral conjunction, came from Persia to Jerusalem to worship the one who has been born King of the Jews.

Shall we then perhaps consider the possibility that Leonardo was chosen since birth on the basis of certain astronomical conditions, to keep alive the Byzantine Neoplatonic tradition, otherwise threatened by the Catholic Church?

After all, Renaissance astrology, better known under the name of "*alchemy*", was favored by the *Corpus Hermeticum* of Hermes Trismegistus, translated for Cosimo de' Medici by Marsilio Ficino around 1460, and by the influence of Arab writings and authors who came to Florence for the Council of 1439, which had already introduced the Greek alchemical tradition since the late Middle Ages.

Mantegna's painting too suggests a kind of investiture in this sense, along with many other paintings in which the theme of the adoration of the Magi depicts both Gemistus Pletho and Leonardo's mother.

The episode that inspires this work is the *Gospel of Luke*, in which it is said that Mary and Joseph brought the Child to the Temple of Jerusalem forty days after his birth, precisely to "*offer him*" to God in obeisance of the Exodus command[659] that prescribed this ceremony for every first-born male child.

Shall we then assume that Leonardo was the *firstborn* of some key characters who emerged at a particular time which, astrologically conferred on that unborn child particular gifts[660]? And, according to these gifts, Gemistus Pletho chose Leonardo to continue to spread those Neoplatonic fundamentals he strongly believed in? Vasari's biography would seem to confirm this hypothesis:

> Great gifts rain down from celestial influences on human bodies, many times naturally and sometimes unnaturally, filling one single body with beauty, grace, and virtue in such a way that whatever he approaches, each one of his actions is so

[659] Exodus 13,2. 13, 11–16.
[660] Then fully developed, this is undeniable.

divine that, leaving behind all other men, he manifestly
makes himself known for a deed (as it is) bestowed by God
and not acquired by human nature.

This is what men saw in Lionardo da Vinci, in whom,
beside the beauty of the body, which is never praised
enough, was the infinite grace in any of his actions, and so
great was his gift that whatever difficult things his soul
turned to, he made them with ease. Great was the strength
in him, combined with dexterity, spirit, and valor, he was
always regal and magnanimous.

And the fame of his name spread so much that not
only in his time was he held in high esteem but even more
in posterity after his death.[661]

Or is it just that the birth of Leonardo was such a worldly element
that it was commissioned to all the major artists of the Renaissance,
perhaps because his parents belonged to one of the richest and most
powerful Florentine families of the time?

If this was the case, though, the same criterion should have
applied to many other characters of the time, who were far more
important than the son of a young notary of the Tuscan countryside
and a peasant girl married to an employee of a furnace in Vinci,
named the Troublemaker. Actually it would not be such a remote
hypothesis, if we consider the presence of Lucrezia Tornabuoni at the
bedside of Leonardo's dying mother, as indicated in Ghirlandaio's
paintings preserved in the collegiate of San Gimignano.

In that case, though, who was the father?

Can we really assume that it was the notary Sir Piero in Vinci, as
we are told, or does the hypothesis of the adoption for purely
nominal purposes have substance?

Even after taking into account that his mother died young, while
Leonardo, a deacon, was studying Plato under the didactic direction
of Giovanni Argiropulo, as testified by the pictorial cycle of Benozzo
Gozzoli in San Gimignano that portrays him in the role of Saint
Augustine?

The words of Anonimo Gaddiano come to mind, sounding now
even more sibylline, as well as those written by Leonardo himself:

[661] Giorgio Vasari.

> Lionardo da Vinci, Florentine citizen, although he was
> (not) a legitimate son of Sir Piero, he was of his mother born
> of good blood.[662]
> Naturally, the good men desire to know.[663]

Although there is insufficient documentary evidence to support the belonging of Leonardo's mother to the Tornabuoni family, we cannot deny that the scene involving Lucrezia Tornabuoni—wife of Piero de' Medici, called the Gouty, at the bedside of the woman portrayed in the role of Santa Fina in San Gimignano—triggers legitimate curiosity.

This curiosity is promptly satisfied by Ghirlandaio himself in the frescoes painted in the Tornabuoni family's chapel[664] in Santa Maria Novella in Florence, where, through images, the pregnancy and the delivery of a woman, whose appearance strongly recalls Leonardo's mother, are described.

The commission of these frescoes was given to Ghirlandaio by Giovanni, Lucrezia's brother, husband of Francesca Pitti, who was also involved in charitable works as the most famous sister-in-law.

The chapel's decoration rights originally belonged to the Sassetti family, whose patron saint was St. Francis of Assisi; however, since Santa Maria Novella was in the hands of the Dominican friars, it is said that the Sassetti family had to turn its ambitions to the church of Santa Trinità. This left the field free to the Tornabuoni family, who in the meantime had become related through Piero the Gouty to the Medici family.

My doubt stems from the fact that the Church of Santa Trinità is next to the residence of the Tornabuoni family, so the opposite would have been more logical, even if, from the point of view of prestige, Santa Maria Novella had a completely different appeal.

Besides, what matters for us is that in Santa Maria Novella Leonardo is portrayed twice in the role of the announcing angel.

In reality he is portrayed several more times, but for now I want to get your attention on a different character depicted by these paintings: a virgin, with features reminiscent of those of Leonardo's mother, as portrayed as Santa Fina in San Gimignano. We find her in different lunettes, each about a different episode:

[662] Central National Library, Florence (Cod. Magliab. XVII, 17)
[663] Codex Atlanticus, Sheet 327v, Ambrosiana Library—Milan
[664] The Tornabuoni Chapel is the main chapel of the Basilica of Santa Maria Novella in Florence. It contains one of the largest cycles of frescoes in the entire city, made by Domenico Ghirlandaio and his workshop from 1485 to 1490.

- She appears pregnant, accompanied by Lucrezia Tornabuoni, together with other women who have all been helped to give birth.
 - She gives birth to a child.
 - She names him John[665].
 - Gemistus Pletho, in the role of the magus, stands in her adoration.
 - Her son escapes a massacre of the innocents, ordered by the Roman army.
 - She is presented to the temple.
 - Her son is stolen from her and she is given in marriage to a stranger.

Rather than the events of a member of the Tornabuoni family, this narration seems to refer to one of those young mothers who were taken care of by the various Florentine charity associations that sprang up around the Dominican convent of San Marco under the guidance of Antonino Pierozzi, in which both Lucrezia Tornabuoni and her sister-in-law Francesca Pitti were involved: the *Compagnia del Bigallo*, the *Compagnia della Misericordia* and the *Oratorio dei Bonuomini*.

The events narrated in these paintings would seem to concern one of those young unwed mothers who, for some secret reason, was cared for by Lucrezia more than any other. Was she perhaps one of the tertiaries, part of the Florentine Dominican order of women instituted by Cosimo de' Medici? Was she perhaps the girl depicted by Beato Angelico in the Chapter Hall of the Convent of San Marco in 1441, while she was subjected to the rite of the "caping" and the dressing with a white veil?

The frescoes by Angelico[666] regarding the Incarnation of the Virgin and particularly the Presentation at the Temple[667] requires deeper examination. (See Figure 96.)

[665] *"Johannes est nomen eius"*, as the birth of the Baptist is announced.

[666] Commissioned by Cosimo de' Medici.

[667] Where we find again one woman with the semblance of Leonardo's mother, as depicted in San Gimignano while handing out her son to Gemistus Pletho,

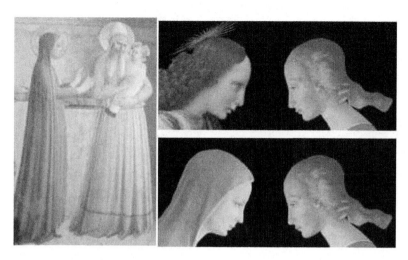

*FIGURE 96 —BEATO ANGELICO, CONVENT OF SAN MARCO,
FLORENCE, 1441. COMPARISON BETWEEN LEONARDO'S AND
GHIRLANDAIO'S PORTRAITS.*

Understanding now that these pictorial cycles conceal events linked
to their clients, a whole series of questions arise:

- Why does Beato Angelico depict her caping but not of
any other tertiaries?

- Why directly involve Gemistus Pletho in the frescoes,
who came to Florence on the occasion of the Council of
Florence only two years before these representations, to the point
of "offering him" the fruit of her womb?

- Does the inscription "*Johannes est nomen eius*" (John is
his name), refer to the words contained in the Gospel when the
birth of the Baptist was presented to Zechariah, or to the first-
born son conceived by the woman protagonist of this pictorial
cycle?

- Does the primogeniture only refer to the mother, which
would be taken for granted given her virginal state, or should it
be also extended to the father, in which case it would take on a
totally different symbolic value?

- Can we overlook the fact that the announcement to
Zechariah of his imminent fatherhood is made by Leonardo
himself in the role of the announcing angel?

- If so, whose son was Johannes? i.e., who was the
character who personifies Zechariah at the time?

Many questions we can try to answer by observing the many paintings scattered all over and around the city of Florence.

For example, why do we find the same girl portrayed as Santa Fina in both San Gimignano and in Santa Maria Novella, also in the Oratorio dei Buonomini of San Martino in Florence, not far from the house that Sir Piero inherited from Niccolò of Sir Vanni in 1449, in via Palagio del Podestà[668] in Florence[669]?

Originally this place was a small church where the wedding between Dante Alighieri and his wife, Gemma Donati, is said to have taken place.

Once its parochial function ceased, this small church was assigned in 1441 to Antonino Pierozzi to host one of those charity works promoted by him with the contribution of the wealthy people of Florentine society of the time.

The *Compagnia dei Buonomini* in San Martino was founded in 1441 with the aim of helping "the shameful poor", those members of wealthy families who for various reasons had fallen into disgrace, and out of shame or reserve did not ask publicly for pittance.

It was rumored that this charitable company emerged to accommodate the rich who were now fallen into disgrace due to excessive taxes and duties imposed by Cosimo de' Medici. This is unlikely since it was thanks to Cosimo de' Medici that Antonino Pierozzi was able to access the Convent of San Marco, where Pater Patriæ himself had reserved a room of his own.

More likely this rumor was spread by Cosimo's worst enemies, in that endless tussle for the control over the Florentine city and its banking activity, fed by the rich commercial traffic also guaranteed by the good Benedetto Dei.

Nevertheless, when the *Buonomini* needed money, they lit a candle at the entrance door of the Oratory; at that point, through a slit still present today on the right side of the entrance door, the citizens could make an anonymous donation to help the needy of the city.

This particular use of the candle to anonymously signal the need for money by the friars has since entered the daily vocabulary: the

[668] Today Via Ghibellina.
[669] Inheritance that we know was contested by Antonino Pierozzi himself, who in the meantime became Archbishop.

phrase "*to be reduced to a flicker*" derives from this habit of the *Buonomini* to ask for offers from the wealthiest citizens.

The presence of the same woman in the frescoes in the Oratory[670], the woman depicted by Beato Angelico in the Convento of San Marco, and from Ghirlandaio in both San Gimignano and Santa Maria Novella, suggests that initially the Oratory may have been established precisely to house the young woman whose pregnancy coincides with the founding of the Association, and who perhaps was intended to be kept in some way separate from all the other "caped".

If so, the approximate date of this birth would be around 1442, as can be derived both from the dates of the frescoes by Beato Angelico and the date of the foundation of the *Compagnia dei Bonuomini* of San Martino.

Living in the 4th century A.D., Martino was the Christian bishop of Tours, where he led a monastic life in a cenobium founded by himself.

According to tradition, when during a downpour he saw a half-naked beggar suffering from the cold, Martino gave him half of his cloak; shortly afterwards the Saint met another beggar and gave him the other half. Once he was undressed, the sky immediately cleared and the temperature became milder, as if summer had returned.

It is in memory of this episode of religious tradition that that little regurgitation of heat in late autumn is called "St. Martin's summer".

As noted earlier, the symbolic use of the cape that was the symbol of St. Catherine and the Merciful of San Marco returns.

Given that the physiognomic similarity between Leonardo and his mother is indeed the hereditary evidence of a blood relationship between them, the dating of this birth would be extremely compatible with that of his biographers, who placed his date of birth between 1442 and 1445.

However this was contradicted three centuries later, by what was inscribed in the Florentine Cadaster and found in 1746 by Giovan Battista Dei.

In the light of these new elements, I am reminded once again of the inconsistency of this date. This is in comparison with the narration of his biographers, both contemporaries and posterns[671]. Given the circumstantial fact that Leonardo was extremely popular in his time, how was it possible for each of these biographers to so clearly confuse his date of birth with the one proposed by the notary of Vinci, found only three centuries after his birth?

[670] Attributable to Ghirlandaio's workshop.
[671] Anonimo Gaddiano, Vasari, Benedetto Dei, Antonio de Beatis.

I am increasingly inclined to think that the involvement of Sir Piero, at that time a very young notary of Vinci, has been induced to protect the real identity of the young Leonardo through a fake adoption.

The hypothesis that the Oratory of the *Buonomini di San Martino* may have been initially chosen to give birth and grow the young Leonardo would justify once again what is written in the Anonimo Gaddiano and in the first version of The Lives of Vasari:

> Lionardo da Vinci, Florentine citizen, although he was (not) a legitimate son of Sir Piero, he was of his mother born of good blood.
>
> So admirable and celestial was Lionardo, nephew of Sir Piero da Vinci, who being a truly good uncle and relative to him, helped him in his youth.[672]

Therefore:

• Assuming that the girl who gave birth to Leonardo may be one of the young women belonging to the Dominican female order dependent on San Marco, and for this reason called with the nickname "Catherine", like the Catherine of Siena to whom the rite of the caping refers;

• assuming that Lucrezia Tornabuoni has actually dedicated particular attention to her in comparison with all the others she visited, for a precise reason;

• and hypothesizing that the birth of her son coincided with an extraordinary astral conjunction to presuppose the involvement of no less than Gemistus Pletho, who at the time represented the highest religious and cultural reference of the Byzantine world;

would all this be sufficient to explain the enormous interest that the birth of Leonardo aroused in the artistic and cultural world of Florence in 1441/1442?

We are left with no alternative but to hypothesize who Leonardo's real father was and to try to discover whether his identity could somehow justify the extraordinary attention that Leonardo's birth aroused.

[672] Giorgio Vasari—The Lives of the most excellent Painters, Sculptors, and Architects, Torrentini, 1550—Florence

To do this, let's begin from where we started.

Regarding the slight strabismus with which Leonardo was affected, I gave the example of the bust of a deacon in the Old Sacristy of the Basilica of San Lorenzo in Florence.

The Sacristy is quite unadorned. Apart from Verrocchio funerary furnishings, the decorations on the walls by Donatello and some polychromes by Della Robbia, there is little else of significance.

The presence of this bust in the mausoleum of the Medici family then arouses more than idle curiosity.

Unless… Leonardo was a member of the richest and most powerful family of the Renaissance and Lucrezia Tornabuoni, linked to the family for various reasons, not least the fact that in a couple of years she'll marry Cosimo the Elder's son, Piero the Gouty, was personally involved.

It is known that the Old Sacristy, designed by Brunelleschi and dedicated to St. John the Baptist, is in terms of family prestige the Medici's answer to the patriarch of the powerful rival family, Palla Strozzi, who in 1418 had a splendid chapel built in Santa Trinità for the burials of his relatives, entrusted to a project by Lorenzo Ghiberti. In addition to those described above, however, there is another very precious artistic decoration not previously mentioned: the dome vault of the *scarsella*[673] overlooking the Sacristy.

This vault was frescoed at the beginning of the 1440s with a huge zodiac of which historians have been unable to provide a reliable explanation, except for presumptive interpretations linked predominantly to events of a political nature.

On a base of azurite, by the use of only gold and the chiaroscuro, the zodiac reproduces with excellent astronomical accuracy a sky of the northern hemisphere, well defined in the partition lines and planets then known, as it appeared on the night of July 4, 1442 over Florence. It is supposed that it could have been made by Giuliano d'Arrigo, nicknamed Pesello[674], under the direction of the astronomer Paolo dal Pozzo Toscanelli, and it would depict a precise cosmological situation of the Sun and the constellations. (See Figure 97.)

The adherence to a model obtained directly from the observation of the celestial sphere is demonstrated by the precision with which the

[673] A particular type of apse of the church, with a rectangular and not semicircular plan.
[674] Giuliano d'Arrigo known as Pesello (1367-1446), Florentine painter, expert in the animalist art

evaluation was made and then transferred inside the dome before the intervention of the painter, as it emerged during the restoration.

FIGURE 97 - ZODIAC IN THE OLD SACRISTY, BASILICA OF SAN LORENZO IN FLORENCE

The dividing lines of the starry vault and the celestial objects placed and marked by a sort of arrow, then scratched with a compass and numbered in some cases, denote the scientific accuracy of the relief and the absolute adherence of the pictorial model to the sky looming over Florence on that date, also confirmed by the astronomical evidence of the time.

To justify this meticulous punctuality, scholars have so far put forward the most disparate hypotheses, among which the best accredited would be the visit of the then King of Naples Renato d'Angiò, who came to the city to recruit alliances and fight a new crusade against the Ottoman Turks.

This hypothesis is quite bizarre, particularly if we consider the scope, linked to the family prestige, for which Cosimo the Elder commissioned the Sacristy to Brunelleschi.

It is more reasonable to think that the absolute adherence of the fresco to the sky of Florence in 1442 that was to be immortalized can be traced back to an important birth, or to the relative baptism, as was the custom at the time.

It may have been dictated by the importance of a primogeniture, which in the case of the very powerful and rich Medici family would certainly represent an event of absolute resonance across half of Europe.

Significantly, at the Uffizi in Florence there is a famous Botticelli round painting titled *Madonna of the Magnificat.* (See Figure 98.)

FIGURE 98 — MADONNA OF THE MAGNIFICAT, SANDRO BOTTICELLI, 1471. UFFIZI GALLERIES, FLORENCE.

Also called *Madonna with Child and Five Angels*, the circular shape of this 1481 painting suggests that it could be hung in an antechamber or bedroom, which would indicate a work for private devotion.

Some art historians have even suggested that the work was commissioned by the Medici to depict the family of Piero the Gouty: his wife Lucrezia would be portrayed as Mary; the young man with the inkwell would be Lorenzo portrayed shoulder to shoulder to Giuliano; behind them the sister Maria; while the two older sisters, Bianca on the left and Nannina, hold the crown.

The identity of the infant in swaddling clothes, on the other hand, assumed on the basis of the dating of the painting, would be Lorenzo's little daughter, Lucrezia.

The Virgin is portrayed in the act of writing on a book the words of Luke's Gospel "Magnificat anima mea Dominum", the opening verse of the canticle with which Mary thanks the Lord for having been chosen as a vehicle of the divine Incarnation[675].

On the left page, instead, we can read some words from the *Benedictus* of Zechariah referred to the birth of the son John the Baptist[676].

There was no detailed mention of the work at the time, as the first definite mention of the painting dates back to 1784, when Ottavio Magherini sold it to the Uffizi.

The iconographic composition was later replicated in five paintings with the same subject, executed by workshop assistants of the Florentine master[677].

The lack of further references leaves room for the most disparate and imaginative interpretations, such as the one that identifies the newborn child in the arms of the Virgin as Lorenzo's daughter.

The reference on the left page of the book, written by the Virgin concerning the announcement given by Zechariah of the birth of his son John the Baptist, however, naturally takes us back to Santa Maria Novella, where Ghirlandaio portrays Leonardo in the role of the Angel who announces the same birth to Zechariah.

It should be noted that Piero the Gouty, son of the Pater Patriæ Cosimo, in addition to the five natural children mentioned, had another son, firstborn, male and illegitimate, who was given the name John, as was the name of the great-grandfather to whom the Medici lineage is traced back to: John de' Medici.

[675] Gospel of Luke, I, 46.

[676] Gospel of Luke, I, 76-79.

[677] Of which one is at the Louvre, one at the Pierpont Morgan Library in New York and one in the Hahn Collection in Frankfurt.

John, mentioned as illegitimate, was born before the marriage celebrated by Piero in 1444 with Lucrezia Tornabuoni, but his traces were completely lost.

Or at least, this is what we are told.

What if, instead, his traces weren't lost at all, but kept hidden because of their importance? Was the birth of Piero de' Medici's first son linked to a very fortunate astral conjunction that led Gemistus Pletho to identify him as the "chosen one" to keep alive that Neoplatonic tradition that the Church would otherwise have obscured?

It would make sense, then, that the references contained in the Tornabuoni Chapel in Santa Maria Novella both to the conferment of the name John[678] and to the Massacre of the Innocents, related to a hypothetical persecution of the Church. This persecution would be dictated by having identified in Piero de' Medici's eldest son the one who should have kept alive the knowledge of that Byzantine Neoplatonism that Gemistus Pletho personified.

In that case, it would have made sense to make the child appear as the illegitimate son of a young notary complaisant in being "a very good uncle and relative [...] in helping him in his youth", thus offering him the protection of an anonymity that the name de' Medici would not otherwise have guaranteed him.

Personally I am convinced that the bond between Leonardo and the Tornabuoni family was only of a charitable nature, linked to the role that Lucrezia played alongside Antonino Pierozzi, although we cannot forget that when Leonardo was accused of sodomy and then acquitted, in April 1476, it was only thanks to the involvement of a member of the Tornabuoni family.

Certainly, it is a too ephemeral element to lead us elsewhere with respect to the charitable hypothesis.

We do have a few more elements though to link Leonardo to the Medici consanguinity.

Some of these elements are of a deductive nature, such as the fact that the only bust exhibited in the mausoleum of the Medici family portrays him as a deacon. Then there is the testimony reported by Benedetto Dei in his Chronicle in which he writes that he accompanied the Medici to Milan in 1465, which is reflected in the fresco by Benozzo Gozzoli

[678] *"Johannes est nomen eius"*.

depicting Leonardo leading the small procession marching towards the city of Milan together with the brothers Lorenzo and Giuliano.

Furthermore, Leonardo is also depicted in an infinite number of paintings, statues and bas-reliefs, sometimes even in the role of Cosmas and Damian, granting him not only the importance of social rank, but some relationship with the same Medici family.

The same freedom and lightness of mind with which Leonardo approached the works that were commissioned to him, that often allowed him to contravene his contractual provisions in order to paint what interested him, showing a lack of dependence on his art to live is perhaps the evidence of a privileged social condition.

Other elements, on the other hand, can be traced back to the genetic sphere, such as certain physiognomic traits or certain hereditary pathologies.

It is clear that the arched eyebrows, the sub-nasal dimple, the high forehead and the tapered shape of the nose are traits inherited from the mother, as can be seen from the comparison of their respective portraits. But perhaps the bags under the eyes, the xanthelasma, the dimple in the chin and the bulging eyes were inherited genetically from the natural father.

And if so, can they be somehow traceable to the Medici family?

The dimple on the chin clearly can. It represents a dominant genetic character, and it is no secret that Piero the Gouty had it. (See Figure 99.)

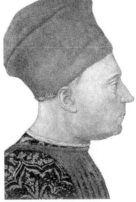

FIGURE 99 – PIERO DE' MEDICI, NICKNAMED THE GOUTY. MINO DA FIESOLE, BARGELLO MUSEUM. BENOZZO GOZZOLI, MAGI CHAPEL, MEDICI RICCARDI PALACE—FLORENCE.

Further characteristic traits of the de' Medici family are the exophthalmos eyes (bulging—protruding) and the pronounced under-eye circles.

These are obvious in portraits of Leonardo in comparison with those of the other members of the de' Medici family. This genetic peculiarity of the members of the Florentine family was noted by the Venetian ambassador in Rome, Antonio Soriano, when meeting the thirteen-year-old Caterina de' Medici, who at the time was staying with her uncle Clemente VII[679].

Speaking of the future Queen of France, he wrote to those who asked in advance for news:

> She is short and skinny, she has no fine features and has protruding eyes like all the Medici.

If then Leonardo really belonged to the Medici family, it meant that he and Caterina of France were in fact linked by a blood relation.

This would be good news to the cousins beyond the Alps[680], as well as my friend Annie: Caterina de' Medici, in fact, is nicknamed "*the Queen Mother*" for having given birth to more than one ruler to the transalpine population.

That Leonardo's eyes were bulging is no secret, as can be seen from many of his portraits, starting from the deacon's bust placed inside the family mausoleum, that Old Sacristy in the Basilica of San Lorenzo. What instead is improperly called "gout", a disease from which Piero de' Medici would have suffered, was in fact a set of pathologies among which there is also an excess of cholesterol in the blood, which is one of the causes of the bags under the eyes and the xanthelasma from which Leonardo suffered.

To this is added a kind of tissue deforming disease, of which all the Medici were affected, as shown by Cosimo the Elder's hands in the posthumous portrait by Pontormo, now preserved at the Uffizi in Florence.

This deforming disease could be the cause of the paralysis induced in his right hand, as testified by Antonio de Beatis da Amboise, or it could also be the cause of an important burdening in Leonardo's physiognomic features with the advancing of age.

[679] Clement VII, born as Giulio Zanobi (1478—1534), natural son of Giuliano de' Medici, murdered during the Congiura de' Pazzi.
[680] The French

This would be easy to check with any standard facial recognition program.

A final consideration concerns the only existing autograph signature of Leonardo, placed at the bottom of the contract that originally envisaged the execution of a triptych for a lay Confraternity of Milan. Here Leonardo would have taken care of the central altarpiece while the Milanese brothers de Predis, where the artist was actually dwelling, would have worked on the two side altarpieces. (See Figure 100.)

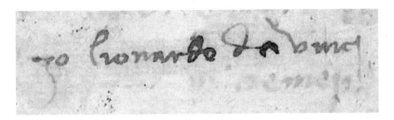

FIGURE 100—THE ONLY AUTOGRAPHED SIGNATURE OF LEONARDO, AFFIXED AT THE BOTTOM OF THE CONTRACT FOR THE VIRGIN OF THE ROCKS, DATED APRIL 25TH 1483—STATE ARCHIVES OF MILAN.

According to an expert analysis[681] carried out on this signature, we learn that:

> Leonardo's signature is written from left to right to confirm his being ambidextrous in the hands. The lowercase initial of the name "lionardo" indicates feelings of inadequacy linked to his origins as an illegitimate son, finding in the competition a social revenge. In this way he gave his Ego a remarkable importance that allowed him to develop exponentially talents and creativity. This is the reason why he emphasizes his identity by adding the word "jo" (I in modern Italian) in front of the name. The vital energy, expressed by the pressure of the pen on the paper and the thickness of the stroke, reveals strength and resistance, but also a certain instability of mood that could explain so many "uncompleted".

In relation to this, Evangelista Predi's signature is also anticipated by the term "Jo", while that of Prior Bartolomeo Scalonio is anticipated by the Latin word "Ego", according to a very normal

[681] Carried out by graphologists Evi Crotti and Alberto Magni.

procedural practice of contract signing, and not for the expression of a boundless ego.

The fact that Leonardo writes it in lower case is simply the confirmation of his habit not to use capital letters, as confirmed by the name and patronymic written below.

> Ego Bartolomeus Scalionus prior...
> Johannes Antonius de Sancto Angello...
> **jo lionardo da vinci in testimonio ut supra subscripsi**
> Evangelista Predi subscripsi
> Iohannes Ambrosius de Predis subscripsi[682]. (See Figure
> 101.)

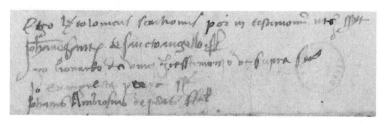

FIGURE 101—ALL THE SUBSCRIBING SIGNATURES AT THE BOTTOM OF THE CONTRACT FOR THE VIRGIN OF THE ROCKS.

In the light of this, then we should not interpret that "jo" differently from the spirit with which it was written, even though I would like it to be read as a contraction of the word "johannes".

After all, this is how it is written in Santa Maria Novella in Florence above the image of the mother holding a little Leonardo. (See Figure 102.)

[682] Milan state archive, contract for the Virgin of the Rocks.

JOHANNES EST NOMEN EIUS!

FIGURE 102 – DOMENICO GHIRLANDAIO. TORNABUONI CHAPEL, SANTA MARIA NOVELLA, FLORENCE.

CONCLUSIONS

"Knowledge sets you free," said Albert Einstein.

Never more than today, however, have the sources of information on which we build our own opinions—and consequently orient our own actions—been so polluted, conditioned from their foundation by dictates of cultural, commercial or political convenience. This pollution has always been achieved through targeted information, masterfully constructed by cunning minds to act on our subconscious. With this modus operandi, for millennia, consumer needs, consensus, and behavioral orientations have been influenced, sometimes even succeeding in justifying wars and mass murders.

Knowledge is beyond all this: it is something absolute, unequivocal, and as such it cannot be experienced as a factor of convenience or an instrument for submission of others.

Knowledge is an extraordinary opportunity, a means of personal growth that, if interpreted correctly, should lead to a unitary collective consciousness, which can be subordinated to a single, incontrovertible parameter: reality.

It is said that one person's freedom ends where another's one begins.

This is true in today's individualistic and self-referential society, in which we do nothing but raise boundaries and barriers, but it is not true in the Universe of which we are an infinitesimal part, where everything contributes to forming a single reality.

True freedom, therefore, is not pursued by chasing partisan dictates, but rather by acting in respect to objective parameters, whose only yardstick are the canons by which reality is composed.

Today, instead, we find ourselves increasingly immersed in the deplorable condition of study described by Nietzsche, according to which the interpretation of facts replaces reality.

Most of the time, these interpretations are the result of targeted actions aimed at building artificial realities. The louder we are able to scream out our reasons, the more partial truths will condition our action and thinking. This reminds me of the image of those medieval fairs, in which the various barkers shouted to the crowd the miraculous properties of their ointments; the bigger they stretched the truth the more ointments they sold.

It is not my intention to go into specific issues; there would be an embarrassment of riches and it would be a useless exercise like putting a

band aid on an infected pustule, a short blanket that would always leave the side uncovered.

There is however a phrase by Leonardo da Vinci that well describes the concept of freedom, and it is inclusive both of respect for other people's opinions and of the need for each of us to be preserved from that insidious submission that is continually exercised against us, namely the tampering with reality.

> The acquisition of any knowledge is always useful to the intellect, because it can drive away useless things and retain the good ones. Because nothing can be loved or hated without prior knowledge of it.[683]

What does this mean?

First of all it means that only an informed opinion allows us to be objective towards our neighbor, and this is already a great form of respect for others' freedom.

Second, to grow an informed opinion has the great merit of making us immune from those conditions to which I alluded earlier, and consequently contributes to our own freedom.

However, it is not enough to gather information here and there on the Internet or read everything that we come across and decide that our opinions are well-founded.

Culture is not synonymous with Knowledge: culture is a set of notions that are assumed to be truthful on the basis of conventions that are often partial, which most people repeat from memory; knowledge, on the other hand, is the path of approaching the reality of things.

Culture is by its own definition something highly subjective, and as such it creates divisions and debates.

Knowledge, on the other hand, tending towards the absolute, combines and unites.

Like every other journey, however, also the approaching path towards reality needs some essential equipment, without which it is not possible to complete it. This equipment includes what once composed the "corpus" of higher education, which were the Quadrivium[684]: Arithmetic, Geometry, Music, and Astronomy.

[683] Codex Atlanticus, Sheet 0616 r, preserved at the Ambrosiana Library in Milan.
[684] Literally "four ways". In the Middle Ages, together with the Trivio, it indicated the necessary formation to approach the theological and philosophical teaching.

Without using a minimum threshold of criticality with which to filter the information we acquire, we would always and however be its slaves, not knowing how to distinguish a priori between those founded in facts and those that are not.

To be truly free, therefore, it is necessary to understand, not to know.

But to understand, it is necessary to develop a criticality. Thus it is necessary to study.

It is not necessary to study everything, but it is necessary to study what is essential to form a criticality that protects us from being subjugated.

In a historical period governed by false information and the ever-decreasing weight of the study of scientific and humanistic subjects in schools, it seems appropriate to emphasize the importance of study, to at least guarantee each of us an acceptable level of freedom.

Do not give weight to who tells you what, or where you found it written; give weight only to what is verifiable and demonstrable. Let's leave dogmas and postulates confined to the study of religions and mathematics...

And then, finally, I would strongly recommend common sense, a lot of it, but this is yet another topic: always distrust slogans and quotations without sources. This will free you from clichés.

Having said that, through the reading of these pages I hope to have been able to bring you a little closer to the understanding of reality and to move away from the singing of the sirens. Sirens are used by those intended to distort the reality of facts and things, turning the events in their favor.

Leonardo da Vinci, The Renaissance and the Americas are just one of the many vehicles through which to approach the understanding of reality.

What I feel like emphasizing at the end of my writing, then, is the methodology with which Leonardo approached Knowledge:

> I know very well that, not being literatus, to some presumptuous person it will seem reasonable to criticize me for being an unlettered man. Foolish people!" They do not know that I could, as Mario said to the Roman patricians, reply by saying: Those who make themselves pride of other's studies, they will not consider mine. They will say that, not being literatus, I cannot articulate well what I want to debate. They do not know that my studies come more from experience than from other people's words, words that were master to those

who well wrote them, and for master I will take them and
I will add in all cases.[685]

Always be curious and critical of everything.

However being "critical" does not mean being against or
"versus". Being critical means not accepting everything sight unseen.
Always question yourself, as children do in their learning phase,
before you take on something as truth.

Only those who have doubts ask themselves questions after all.

With regard to everything I have presented to you so far, the
documentary sources, the paintings and stories contained in this work
of mine, then, all that remains is for me to conclude in the only way I
think being correct:

Evaluate every single word, and only then draw alone your own
conclusions.

Surely some conditioning will have fallen by now, and, even if
only by a little bit, you will be freer than before.

This will repay me for the efforts of these years of study.

[685] Codex Atlanticus, Sheet 327v, Ambrosiana Library—Milan.

To Claudio ...

Before closing, allow me to pay a personal tribute which I wish I did not have to write, because fate is stronger than any of our desires.

After receiving words of surprise, a few minutes before going to press I received this message from a brotherly friend, who only a few days before asked me to send him a preview of the manuscript to fill up that unbearable void created by an implacable disease, in an attempt to deceive the time that was suddenly passing too slowly and the disease that instead was inexorably advancing:

> Sorry Riccardo, but I was unable to go on with the reading. I
> have concentration problems.

Not only I excuse you, Claudio, but you will be terribly missed by all of us.

One day, who knows, we will see each other again somewhere, and then I will tell you who the murderer was...

.

My way of joking is to tell the truth.

It's the funniest joke in the world.

(G.B. Shaw)

Printed in Great Britain
by Amazon

55831167R00220